REDEMPTIVE ART
IN SOCIETY

Redemptive Art in Society

Sundry writings and occasional lectures

CALVIN G. SEERVELD

Edited by
John H. Kok

DORDT COLLEGE PRESS

Cover design by Willem Hart
Layout by Carla Goslinga

Dordt College Press www.dordt.edu/dordt_press
498 Fourth Avenue NE
Sioux Center, Iowa, 51250
United States of America

ISBN: 978-1-940567-01-3

Printed in the United States of America

The Library of Congress Cataloguing-in-Publication Data is on file with the Library of Congress, Washington D.C.

Library of Congress Control Number: 2014934615

Cover: This bronze sculpture by Britt Wikström suggests that helping to place a cloak around an other person's shoulders can be *Caritas* (2006). Artistry too becomes redemptive action when it clothes the handicapped neighbor with quiet, encouraging surprise.

Table of Contents

Abbreviations used throughout this volume:

NA	Calvin G. Seerveld, *Normative Aesthetics: Sundry writings and occasional lectures*, edited by John H. Kok. Sioux Center, IA: Dordt College Press, 2014.
CP	Calvin G. Seerveld, *Cultural Problems in Western Society: Sundry writings and occasional lectures*, edited by John H. Kok. Sioux Center, IA: Dordt College Press, 2014.
AH	Calvin G. Seerveld, *Art History Revisited: Sundry writings and occasional lectures*, edited by John H. Kok. Sioux Center, IA: Dordt College Press, 2014.
CE	Calvin G. Seerveld, *Cultural Education and History Writing: Sundry writings and occasional lectures*, edited by John H. Kok. Sioux Center, IA: Dordt College Press, 2014.
BSt	Calvin G. Seerveld, *Biblical Studies and Wisdom for Living: Sundry writings and occasional lectures*, edited by John H. Kok. Sioux Center, IA: Dordt College Press, 2014.

INTRODUCTION

PROPHETIC SHALOM IN *THEATRUM DEI*

by Adrienne Dengerink Chaplin

"What would art look like that liberates, reconciles, reforms and edifies?" (134) This is the driving question throughout this collection of writings and lectures by Calvin Seerveld. The question is first raised in a lecture given at a conference on "Africa Beyond Liberation: Reconciliation, Reformation, and Development," held in South Africa in 1992 at a time of great social and political transition. Entitled "Necessary Art in Africa: A Christian perspective," the lecture contains the seeds of many of the themes developed in the later lectures and essays. The answers suggested by Seerveld do apply not only to the future of art in Africa. Indeed, part of his message to the African continent is a warning about what happened with North American culture: "In my country on Friday nights youth die by the thousands culturally at the movies, and ten thousands are stunted with their weekend videos" (143). In order to counter this cultural suicide, Seerveld argues that it is imperative to provide sustainable alternatives: "The best defense against attractive superficiality in the arts is a tough, home-bred imaginative fiber" (143). Or, as he puts it elsewhere: "art is like the minerals in one's food, the fiber to one's diet, whose nutritives one hardly notices unless you become malnourished and it is determined that iron or ruffage has been missing from your daily bread" (135). For Seerveld, wholesome bread—artistic, ludic, theatrical—is a recurrent image of the redemptive role of art in society.

Except for "Necessary Art in Africa: A Christian perspective," all the essays in this volume were written by Seerveld after his retirement from the Institute for Christian Studies in 1995 at the age of 65. If it is true, as is sometimes suggested, that this is the time academics get down to their real passions, then this volume will be one to take note of. The theme of art in society has always been close to Seerveld's heart. For him, art by Christians should never be confined to the realm of the church. But neither should art be confined to the realm of "high art"—the often self-enclosed and self-referential circle of artists, dealers, curators, critics,

and so on who belong to what institutional art theorists George Dickie and Arthur Danto refer to as "the artworld." For Seerveld, art and artistry are found across all sectors of society and are an integral component of a nation's cultural wellbeing:

> Throughout the ages people with or without means have participated in making merry: story-telling, dancing, molding clay figurines, painting faces and bodies, sewing festive clothes for special occasions, tapestries, furnishings to sit or lie on, speeches, work songs from black "hollers" in the cotton fields up to "rap" in the city ghetto streets. (15)

Art, for Seerveld, belongs to the very infrastructure of a good society in the same way that a country's economy, transportation system, or media network do: "With a vital artistic infrastructure priming its inhabitants' imaginativity, a society can dress its wounds and be able to clothe and mitigate what otherwise might become naked technocratic deeds" (139). To neglect the arts is to invite a "prophetic" warning:

> If art is integral to human life, and if artistic imaginativity belongs to the infrastructure of societal culture, woe to us if we exclude such sustenance from our diet, if we neglect to bring such imaginative potential captive to the Christ (2 Corinthians 19:3–5), with all of its gift for healing, especially when busy with "development." (143)

Most essays in this second volume assume some familiarity with Seerveld's distinct and unique approach to the arts and the realm of the aesthetic as developed in his earlier works, especially *A Christian Critique of Art and Literature* (1968) and *Rainbows for a Fallen World* (1980). They also build on themes and concepts addressed in the first volume, *Normative Aesthetics*. But, for those not *au fait* with these texts, Seerveld often helpfully includes a brief summary of the way he conceives of "the aesthetic" and "the artistic." Although the aesthetic is linked to artistry, it is broader than that and indeed foundational to it: "Everything humans do has a latent aesthetic feature, an imaginative aspect, which may be well exercised, warped, or still-born, as shows up in one's eating and drinking, sharing caresses, meting out punishment, or voicing prayers" (92). Similarly:

> Underneath artistic practice is the resident imaginative trait of humans we call "aesthetic." All people by nature normally feel, speak, think, believe, and imagine things among the various ways one acts, even if they don't become therapeutic counselors, orators, scientists, evangelists, or artists by profession. (246)

For Seerveld, the aesthetic has to do with imagination, nuance, play,

and style: "There is a nuanceful dimension to all creatures and an imaginative feature within corporeal human life that it makes biblical and historical sense to call 'aesthetic'" (2). Or as he put it elsewhere: "This aesthetic color in life is normally called the style to one's deeds. When that styleful moment or imaginative ingredient that deals particularly with nuance-meaning dominates a person's act and qualifies the result, however brief it be, that deed may be called 'aesthetic'" (92).

When the aesthetic dimension of life becomes a focus of special attention and training a transition takes place from playful aesthetic engagement to professional artistic expertise: "When 'aesthetic' activity goes professional, so to speak, it becomes what I would call 'artistic activity'" (93). For Seerveld, "'Professional' signifies a master craftsman or woman whose amateur love for the trade has been honed with consummate skill" (105). Or: "Aesthetic activity assumes full-blown artistic nature when its imaginative background character crystalizes, you might say, into the determined crafting of surprising objects and events that take on an independent entitary imaginative life of their own" (248).

It is in this context that Seerveld coins what has become his trademark concept: "allusivity." "'Artistry' for me is an object or event of imaginative craftsmanship that has an allusive finish to its independent identity" (50). Or, again: "Artworks . . . are objects or events produced by imaginative humans who have the skill to give media (stone, paint, words, voice) a defining quality of allusivity that brings nuanced knowledge to others who give the object informed attention" (264; see also 201).

Seerveld's distinctive notion of "allusivity" (or "suggestiveness') as the defining feature of art is one of his most enduring contributions to aesthetic theory (and not only Christian aesthetic theory). It certainly invites further specification and refinement, yet it serves as a promising alternative to the more traditional notions of "beauty" or "harmony."[1] For a start, it can help to differentiate art from products which are *merely* beautiful or skillfully made: "Although craft control (*techné*) is basic to art-making, a set of skills is not sufficient to qualify the production of art" (264). More generally, the notion of allusivity can serve as an important normative criterion in the evaluation of art as "good" or "bad," something desperately needed in the confused world of contemporary

1 For a fuller account of Seerveld's arguments to replace critique of the notion of beauty see *Rainbows for a Fallen World,* Chapter 4: "Modal Aesthetic Theory, Preliminary Questions with an Opening Hypothesis" (Toronto: Tuppence Press, 1980/2005), 104–137.

art, whether "secular" or "Christian." It is sometimes assumed that, for something to qualify as "Christian art," all it has to do is contain biblical subject matter or perform a liturgical or evangelistic function. But Seerveld shows that, whatever Christian art may be *about* or *do*, it must at least *also* have an "allusive quality" for it to qualify as art. If art wants to offer "aesthetic bread" to the world rather than stones, it has to meet that basic condition.

This also applies to art that serves non-artistic purposes or operates within institutions that are themselves not artistic—whether ecclesial, political, or commercial. A good hymn, for instance, should not only be singable by a congregation and theologically sound, but also be good musically. Seerveld refers to this kind of art as "double-duty art." He defines it as "art-as-such [that is] *voluntarily* encapsulated, bonded within the defining non-artistic task of another societal institution" (22). For him, "encapsulated art is called upon to meet a double norm: the symbolific allusivity due good art, and whatever the norm is for the host institution with which the encapsulated art is willingly bonded" (96). Art in the service of advertising, for instance, "needs to heed the aesthetic norm of metaphorical allusivity *and* the economic norm of supplying good resources for people's needs" (254).

Seerveld holds that, although prior to 1800 most artistry and music was linked to the needs of day-to-day living—woven rugs, decorated pottery, lullabies, and so on—there was no conscious recognition of the distinct character of the artistic aspect as such. This was enforced by the fact that most skilled art and music had to abide by the requirements of some commissioning body or institution. It was only with the emergence of separate museums and concert halls, and a growing recognition of the unique nature of the artist's task, that we encounter the first instances of what came to be called "autonomous" art, i.e., art that was valued on its own artistic terms. Seerveld writes: "At a certain time in the secularization of Western societal life, artisanry emerged from being enveloped in cultic or utilitarian activities and became recognized as a talented service in its own artistic right" (11).

An instructive debate has taken place between Seerveld and fellow Christian aesthetician Nicholas Wolterstorff on whether this development is to be applauded or regretted.[2] Seerveld sees the emancipation of

2 "Two Writers Engage in Rainbow Action: Nick Looks at Cal; Cal Looks at Nick," in *Vanguard* 10:6 (1980) 4, 5, and 18. Seerveld's piece is reprinted in *In the Fields of the Lord*, ed. Craig Bartholomew (Carlisle: Piquant Press; Toronto: Tuppence Press, 2000), 360–364.

art into a realm of its own as a positive step in the historical process of social "differentiation":

> In my judgement it is . . . normative in any developing civilisation for art to come institutionally into its own as art, just as it is normative for education in a developing civilisation to be differentiated into school institutions for education-as-such in society.[3]

Twenty years later Seerveld restates his position in an essay re-published in this volume, in which he writes: "Such a development [of art coming into its own] is structurally good as well as historically fair, I think" (12).

Wolterstorff disagrees. In a fascinating exchange in which each reviews the other's book (Seerveld's *Rainbows for a Fallen World* and Wolterstorff's *Art in Action*, both published in 1980), they try to spell out their respective agreements and differences. Wolterstorff writes: "Seerveld is of the view that art came into its own in the eighteenth century. I disagree. Art has always been 'in its own.' It never had to come into it."[4] For Wolterstorff, works of art are always inherently embedded in some kind of human activity. They are what he calls "instruments of action." And while "aesthetic contemplation" can indeed be counted as one such action, it is neither the only nor the most important one. Wolterstorff takes particular exception to Seerveld's suggestion in *Rainbows* that "it was good for painting to become *paintings* rather than to stay icons, because paintings are called upon . . . to become full-fledged paintings rather than be crutches for meditation."[5] Wolterstorff reads this as a misguided privileging of "high art" over other kinds of artistry: "Why suppose that music comes into its own only in the concert hall, that it is not in its own in the church?" he asks, and concludes:

> In my judgment Seerveld has here accepted too uncritically the post-Enlightenment idea that art has something special to do with the esthetic, a view that has caused enormous suffering and distortion. What came into its own in the eighteenth century was not art, but *esthetic contemplation*. The purposes of art are and always have been vastly more diverse than serving as objects of esthetic contemplation. And art serving these other purposes does not mark some inferior stage on art's road to fulfillment.[6]

3 Ibid. 4.

4 Ibid. 4.

5 Ibid. 4, Quoting Seerveld, *Rainbows for a Fallen World* (Toronto: Tuppence Press, 1980), 166–167. It should be acknowledged that the wording "crutches for meditations" when referring to icons is not the most fortunate.

6 Ibid. 4.

Revisiting these reviews after thirty plus years, one wonders whether there was a real meeting of minds. Given Seerveld's repeated emphasis on, and obvious fondness for, all kinds of "low" and encapsulated art outside the established institutions, it is hard to see how he could be accused of seeing these as "inferior" to "art-on-its-own." Furthermore, is it indeed the case that for Seerveld the main purpose of art is to serve as an object of "aesthetic contemplation"?

In the end it is Seerveld himself who, in his review of Wolterstorff's *Art in Action,* offers a hint of a solution: "I ask myself whether Wolterstorff's strong drive to emphasize the rightful, relative, multiple place of (fine) art in society has not let him mistake a necessary external relation of art for its definite internal structure."[7] As is clear from much of his writing, Seerveld's conception of art coming "into its own" does not mean that it cannot serve any other social roles—after all, this is what "double-duty art" is all about—but that, *in doing so,* it has to meet the structural, normative condition of imaginative, suggestive allusivity in order to fulfill those roles *qua* art. His argument is that it was only with the emergence of separate art institutions and the recognition of the distinct nature of the aesthetic, that is was possible to see that art, *qua* art, could bring something unique and valuable to human life in addition to whatever other function in society it might also (quite properly) fulfill. Moreover, once art and music acquired their own distinctive space, artists were able to experiment, develop, and establish themselves outside the confines and limitations previously imposed on them by the host institutions they were serving. As such they were free to explore new artistic languages while also allowing, as Seerveld puts it, "audiences, readers, and viewers to mature aesthetically, to become art-educated receivers" (12).

This does not at all mean a detachment of art from the fabric of daily life but, on the contrary, a reconceived *re*-connection with it, on a different but equal footing. Seerveld is certainly not blind to the elitist isolation to which this development has also led, but argues that this is a deviation from its proper purpose: "The purist streak that accompanied differentiation in the Western artworld, and the elitism surrounding the whole affair, is not inherent in the art museum or art gallery, but is a secularist possessive power imposition" (12). Or as he puts it elsewhere: "Our Christian critique should fault the elitist idolatry and willful hermeticism of musea and concert hall in Western culture but not its institutionality."[8]

For Seerveld, public accessibility to musea and concert halls is a mat-

7 Ibid. 19.
8 Ibid. 18, 19.

ter of great importance, like having public access to books in a library: "A library is public because a common good obtains as the indiscriminate quality of the operation open for legitimate use. So 'public' is a people-in-general-rightful-accessibility quality, a very basic obliging object-function inhering all kinds of human activities" (8). Galleries and concert halls ought to be "public gathering-places" where artists can "[cast] their rye bread out upon the waters of passers-by" (12). This means that access to art should never be "short-circuited by the privilege of money, seigniorial rank, technical expertise, or even disadvantaged special interests" (8).

This gives Seerveld a special predilection for art on the streets: public sculptures, street theatre, and so on. Seerveld sees particular potential in the communal conception and production of murals, a theme to which he often returns: "Neighborhood murals on outside walls are public *par excellence*; frescoed walls inside Italian churches of the 1300s were also public. . . . Murals welling up from awareness of a neighborhood are wonderful 'cultural work': artists-training ground in minority community building fully out in public" (18). Favored recurring examples are Mexican muralists Diego Rivera and Orozco, as well as the artists who, as part of a Black community project, painted the *Wall of Respect* in Chicago (17, 70, 134, 249). According to Seerveld, all of these, in their own unique allusive style, gave "a voice to the downtrodden." Just as "street theatre aims to enliven a section of the city with good neighborly jostling, light-hearted, imaginative self-respect" (97), so "[m]urals lightheartedly dress up your environs, show you are imaginatively proud of what you stand for in the city" (70).

For Seerveld, both double-duty artistry and autonomous art can be socially relevant. Both can either affirm or critique the society to which they belong. Since the 1930s there has been a heated debate in Marxist and neo-Marxist circles over the relative merits and failures of autonomous and non-autonomous art. While all participants in this debate shared the strong conviction that art should be socially and critically engaged, exposing and critiquing oppressive structures and systemic injustices, they disagreed on the way in which art could do so most effectively. For Adorno and Marcuse, for instance, art's autonomy was a precondition for artistic integrity and truth and so for its capacity to be socially relevant. For others, such as Sartre and Brecht, art could only become seriously "committed" by serving as a political tool in the struggle for change.

Against this background, Seerveld's position is illuminating because, once again, it draws attention to the importance of art's unique

way of being:

> I think it is a false dilemma to ask whether you need to politicize "autonomous" art to make it societally relevant. If art-as-such has the ethical pith to gain the viewers' confidence and the nerve to cry out for care, healing, and justice most concretely within its hidden, prelingual ambiguities, and the institutional art curators mediate such artistry publicly, to different audiences, then the Lord is praised and the neighbor is served. (9)

Even so, he retains a soft spot for Bertolt Brecht and his de-familiarizing socio-political theatre, which, he says, "deserves a Christian's explorative attention" (90): "I am personally drawn to Brecht's gutsy, Brueghel-Hogarthian underdog slant on what is funny and miserable in our world that too often is passed by on the other side by us comfortable people" (89). Likewise: "As the son of a fishmonger, I sympathize with Brecht's visceral rejection of . . . the Romanticist Broadway Revue escapism" (118), the kind that, as he puts it elsewhere, caters for audiences with a "dinner-plus-show package" and provides a "go-home-with-a-good-feeling" (90). Like Brecht, he supports theatre that "questions any reigning societal order" and exposes their hypocrisy and pretensions (117). He applauds Brecht for the fact that in his plays "the polarity of evil and good, purity versus power, is not tied to social class consciousness" but "infects everybody," and that "the push for subversive action is not a full-blown imperative" but a "subjunctive hortatory appeal to change one's consciousness." Brecht, Seerveld says, can see "the irony that all of us are hostages! even though some are more hostage than others" (117).

Seerveld's sympathetic and insightful comments on Brecht also highlight to me something I had not seen as clearly in his work before: his intense affinity for and love of (radical) theatre in general, whether on the mean streets of Chicago or in a choice venue on London's South Bank. This comes particularly to the fore in two previously unpublished, wonderfully rich essays on theatre in this volume. Both essays are based on lectures given for Christians in the Theatre Arts (CITA) at national conferences in Chicago, the first in 1996, the second in 2007. Reading these two lectures made me realize, I think, where Seerveld's artistic heart truly lies: "For me no artistry is more moving," he told his audience in 2007, "than to be seated in a front row cheap day seat at the Olivier National Theatre on the South Bank in London, England, and sense that the guy who just unobtrusively stepped out of a door on stage set to light up a cigarette is not a janitor, but is David Hare's Bertolt Brecht's *Galileo*" (112).

In his 1996 CITA lecture, he begins an account of a lunch-time play

with disabled performers by saying: "I want to recount for you one of the most unforgettable half hours I have ever experienced," before going on to describe the experience in great detail . . . "I went to this day-care rehabilitation center in a poorer-class outskirt section of the sprawling city of London at 12:30 noon, early September in 1986. For sixty pence I was the only non-inmate person present, along with the orderlies suited in white who were wheeling in the spastic adults, giving an arm to the halt, the blind, and the dumb . . . I stood near, half sat on a cold metal radiator, trying to be inconspicuous . . ." (84).

Friends who have lived in London know that when Seerveld visits the city his single most desire is "to disappear"—to walk the streets of London on his own, to experience the hustle and bustle of city life, eat his sandwiches underneath the arches with the homeless and down-and-outs, and then go and see as much good theatre as he can possibly fit in.

Seerveld has always been attuned to the colorful drama of day-to-day life, particularly that of the city. There is a wonderful passage in the essay on cities where he explains how the city of New York as seen by the modernist art critic Clement Greenberg would have been very different from the one he experienced in the 1940's "loading bushels of fresh porgies and mackerel into the truck of my father down in the Fulton Street Fish Market at 6:00 a.m. on a summer weekday morning under the grand shadow of the Brooklyn Bridge" (48). But it is the transformation of such day-to-day happenings into a work of convincing "make-believe" that characterizes theatre-as-such:

> It is the nature of theatre all right to have its source in "ordinary" real life, but the distinctive glory of theatrical as-if reality, imaging, enacting primary meaning-realities through the sieve of actual imaginative fiction-making deeds, has a wonder all its own that God provides for our edification. (87)

For Seerveld, the key element in theatre is the live connection between actors and their audience, where there is breathing, "intimate two-way communication" (95). Live theatre for him is fundamentally different from reading a script or watching a play on television, something he, quoting the words of playwright John McGrath, compares to "listening to a chamber orchestra over the telephone." In live theatre "something different happens because in theatre the performers assume characters to do the imaginative honors, actors let *personae* other than themselves unveil the nuanced meaning" (95).

This emphasis on the importance of the live event also explains why Seerveld's own lectures often have such a pronounced performance qual-

ity—they should be heard and experienced rather than merely read.

Good theatre, for Seerveld, needs a "troubled cosmic" purview. Such a purview is not a particular genre or form but "the large visionary scope of the playwright's text where a heaven and a hell of sorts are taken as real horizons for human action" (118). As he says:

> If I were a playwright I would saturate myself with the troubled cosmic prototypes, because their horizon allows for inexplicable sin and rare joy to materialize as real dimensions of human struggle rather than confine our deeds to take place within the limits of evil and pleasure, faults and pain. (119)

This is something he misses in the work of Pinter, Stoppard, Sartre, and Camus, but also, finally, in Brecht: "Brecht's drama presents only a militant church, courageously counterpunching in the episodic quagmire of an everlasting struggle to survive by the skin of your teeth, there is no reliable eschaton boding hope" (118). But he *does* find troubled cosmic wisdom in Peter Shaffer's *Yonadab* that "reaches for a 'troubled cosmic' spread by exploring guilt, innocence, intrigue, in the wicked Older Testament warren of King David's court" and in Wajdi Mouawad's *Incendies* that "puts profanity, violence, family secrets, humor, helpless women who persevere and rise above the stupid politicized war in the Middle East, in a panoramic welter of conflict riveted in a set of loose desert sand so hard for the actors to walk through, which stirs every onlooker with heartbreak at what man has made of humanity" (119).

Based on examples like these we are told what Seerveld admires in good play writing:

> Certain playwrights cast the struggle they portray not within a matrix of giving answers, not by taking sides, not by sidestepping the surd of disruptive sin, but by asking the right questions about just-doing that assumes and knows human decisions and acts have everlasting consequences. (119)

Perhaps Seerveld's intimate affinity with the art of theatre should not come as a surprise. After all, his formative academic training alongside philosophy was in English literature. He has wide ranging knowledge of the history of English drama. He has always been fascinated with writing fresh translations of biblical texts, casting *The Song of Songs* himself as a piece of biblical theatre and staging performative readings or singing of biblical passages, whether in plain chant or as the blues. It is important, says Seerveld, "to wean ourselves from a sanitized Bible and develop a sense of how gutsy God talks in the Psalms and prophets, so we can translate the LORD God's worldliwise knowledge of the cracks and cran-

nies of human embodied hearts and God's fiery appeal into trenchant Babylonian speech" (127).

The reference to "Babylonian speech" is not accidental. Ultimately, all theatre and other arts are part of a much broader drama: "In my Reformation faith-thought tradition world reality is called *theatrum Dei*, theatre of God" (85). That theatre is our home, a Jerusalem. But is also a place of exile, a Babylon. Seerveld warns us not to judge this Babylon as Jonah initially judged Nineveh, but to take our cue from Jeremiah, when he told the exiled people of God to work for the good of its surrounding culture, neither hating it nor conforming to it. As Seerveld renders Jeremiah's exhortation:

> Work hard for the shalom of the city to which I have banned you people; pray fervently to the LORD God on behalf of Babylon's inhabitants, because shalom for you is inextricably tied in with the shalom of the city where you find yourselves. (Jeremiah 29:7) (107)

Translated into the world of today this means bringing artistic bread and sustenance to an under-nourished culture, because, says Seerveld, "our measure of shalom depends, says God, upon the healing peace we spread abroad in the idol-crazed urban culture that holds us captive" (107).

We are back where we started. "What," asked Seerveld in 1992, "would art look like that liberates, reconciles, reforms and edifies?" (134) And his answer applies as much to the Babylon of old as to the contemporary cultures of today:

> When artworks, jokes, and cinematic entertainments are living sacrifices of thanksgiving, like the biblical Psalms, weeping with the violated and rejoicing with the grateful (Romans 12:14–21), then a person or a community's artistic performance and products shall be giving non-hegemonic leadership in society that bodes prophetic *shalom*. (23–24)

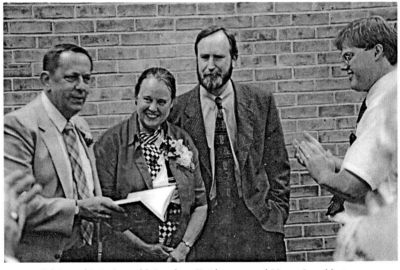

Calvin and Inès Seerveld, Lambert Zuidervaart and Henry Luttikhuizen,
at presentation of the Festschrift, *Pledges of Jubilee*, at Calvin College,
Grand Rapids, Michigan, 1995 (photo by Edwin de Jong)

THE NECESSITY OF CHRISTIAN
PUBLIC ARTISTRY

Public artistry is a historically contested, conflicted idea, as Hilda Heins' recent discussion shows.[1] Especially in our generation where "public" can be taken to mean "popular" or "context-dependent," and professional artists may affect audience-friendly endeavors in order to get corporate funding, "public art" can become a weasel-word phenomenon.

When Aaron Copland's *Appalachian Spring* becomes accredited by the "musical museum," is it then rightly declared to be a *public* artistic achievement?[2] Has John Oswald's technological "plunderphonic" challenge to *private* ownership of authored sounds once and for all exposed the individualistic elitism and monopolistic hubris hidden within the tradition of autonomous art?[3] If contemporary Western society increasingly lacks any "spiritual cohesiveness," and every society-centering cultural power tends to become monolithic and repressive, especially if the totalitarianism is systemically anonymous,[4] is "public art" desirable? How is "public" artistry even possible in our fragmentative culture?

My thesis is that artistry, amateur or professional, must be conceived and produced, performed and contexted with a poignant neighborly love; it "must take our times by the throat," to use the words of British *Pentecost* playwright David Edgar, and give events historic, eschatonic di-

1 H. J. Heins. "What is Public Art? Time, place, and meaning," *The Journal of Aesthetics and Art Criticism* 54:1 (1996): 1–7.

2 Cf. the chapter by Jennifer DeLapp on "Fighting the Musical Museum: Aaron Copland's *Music and Imagination,*" in *The Arts, Community and Cultural Democracy*, eds. Lambert Zuidervaart and Henry Luttikhuizen (London: Macmillan Press, Ltd/New York: St. Martin's Press, Inc., 2000), 108–121.

3 Cf. the chapter by Jim Leach: "Sampling and Society: Intellectual Infringement and Digital Folk Music in John Oswald's *Plunderphonics,*" in *The Arts, Community*, etc. (2000), 122–133.

4 Cf. Václav Havel. "The Power of the Powerless," Vladislav, 36–57.

Published originally in *The Arts, Community and Cultural Democracy*, eds. Lambert Zuidervaart and Henry Luttikhuizen (London: Macmillan Press/New York: St. Martin's Press, 2000), 83-107.

mensions that ignite fresh responses to its elliptical, allusive presentation. The Christian community together must be pregnant with that kind of artistry in public arenas if it is to be worth its salt. By "public," to put it cryptically, I mean "places/occasions with virtually free access for anyone willing to receive what is in common there."

Normative vision

The following philosophical presuppositions help shape the contours of the vision, historical analyses, and direction I lay out below.

First, there is a nuanceful dimension to all creatures and an imaginative feature within corporeal human life that it makes biblical and historical sense to call "aesthetic."

Second, human artifacts and skilled performances that are defined and characterized primarily by this aesthetic quality have been constituted as artworks, of which there is a large variety historically, with multiple, diverse secondary functions.

Third, artistry, like its watershed of human imaginativity, always takes place within a society whose changing, complex institutional set-up conditions but does not determine the normative practice of the communal artistic task.

Each axiom deserves elaboration, so that what I call a "normative vision" will be understood in its historical flexibility.

First, both Eastern and Western historical development in artistic practice and theoretical aesthetics support the thought that playfulness and a "transgressive" allusivity best capture the crux of aesthetic reality. "Beautiful" is a relatively elemental ingredient of whatever is nuanceful, and judicious monstrosities like Grünewald's *Isenheim Altarpiece*, Goya's late "black" paintings, and Anselm Kiefer's *High Priestess* witness to a richly, awfully normative imaginativity at work.[5]

Second, artworks are structured in God's world to need a well-crafted foundation, the melded control of certain media—clay, gestures, the human voice, celluloid—to ground the artist's metaphorically precise symbolification of nuanced meaning. This claim comports well with changes in the history of artistry. The shifts in any given culture—from crafted artifacts and ornamented instruments to objects that are formed

5 Cf. my inaugural address *A Turnabout in Aesthetics to Understanding* (Toronto: Institute for Christian Studies, 1974 {see *NA*: 233–258}); "A Way to Go in the Problem of Defining 'Aesthetic,'" *Die Aesthetik, das tagliche Leben und die Kunste*, ed. G. Wolandt (Bonn: Bouvier, 1984), 44–49; "Imaginativity," *Faith and Philosophy* 4:1 (1987): 43–58 {see *NA*: 27–44}; and "Both More and Less than a Matter of Taste," Acta Academica 25:4 (1993): 1–12 {see NA: 135–144}.

to be worth viewing alone for the imaginative knowledge they tender—seem to be a normal civilizing distinction over time. It is so that every creaturely entity has nuances; so anything can be taken as the object of focused imaginative attention and be treated like art. But deciding philosophically, in fullness of historical knowledge, that artistry has a nature, with a certain province, simply sets flexible limits and orders artists' responsibilities in the panoply of human callings on earth. If one is a nominalist on the nature of art, one's guidelines for artistic task and aesthetic reception will be makeshift and probably lack conviction and direction.[6]

Third, the vision of artistry with its own respected province in the piazza of society stems from the biblical idea that it is God's will for humanity in its dated, located configurations to differentiate multifarious responsibilities in society into limited circles of authority and formative control while these specialties maintain an open care for integrating wholeness. Nomadic and agricultural tribal societies normally still recognize the different offices of shaman/medicine woman and chief, but it is urban settlement societies that seem to mulch best God's creational pull for a society to germinate a network of differentiated services: markets for bartering produce, distinct from road builders of a transport industry, distinct from schools of artisans, distinct from elder storytellers, next to literate scribes, next to hereditary dynastic or charismatically accepted rulers/judges. This creational pulley resident in the very matrix of society I understand to be the LORD's gracious prompting for us humans to avoid any all-encompassing Tyrannical Force (including Walt Disney, Inc.), and to foster the protective hierarchy and responsive mutuality as the crux of justice.[7]

The normative vision arising from these three basic assumptions holds that societal differentiation is all about cultural power-sharing. When sinful men and women allocate cultural authority, often grudgingly, the transaction is fraught with power-plays and violence.

Our particular concern is the place and task of artistry within society. When Giorgio Vasari instituted the first *Accademia del disegno* in 1563 Firenze, and broke the hold of the guilds over the livelihood of the sculpting and painting artisans/artists who were invited to be members of the Academy, this differentiating act set in motion what later came to be called "fine arts," and also instigated the economic guerilla warfare waged between trade guilds of artisans and art academies sponsored by royalty.

6 Cf. my "Identity and Aesthetic Voice of the Culturally Displaced" {infra pp. 29–45}.

7 Cf. my "Dooyeweerd's Idea of 'Historical Development': Respect for Cultural Diversity," *Westminster Theological Journal* 58 (May 1996): 41–61 {see *CE*: 199–209}.

Later on, when the arts were no longer funded by the Medici and popes or by the Louis's and Napoleons in French salons, but by mercantilists, robber barons, and *nouveaux riches*, whose emerging taste for luxury was more comfortable with *Kinder, Kirche, und Küche*, artistes like Gautier, Whistler, Walter Pater, and Oscar Wilde rebelled against patronage. "We cannot do art in thrall to Church, Government, Business, and Family Values," these artistes seem to say. "To be true to our special vocation we must do art for art's sake!"

So the differentiated Western artworld that we inherited several generations back was born in the frustrated anger of leading artists, dandies, and "bohemians" who hated what the major institutions of society stood for and the toadying role many of the populace assigned to the arts. Artists as aesthetes thumbed their nose at the rest of society, and the mainstream of society largely reciprocated, more decorously, with despite, indifference, and neglect. Therefore, with our secularized splintering and disengagement of the Mother Church, with the privatization of family wealth, with growing militant nationalism in modern states carrying conscripted armies busy with colonizing expansion, and with the ever encroaching, behind-the-scenes monopolization of technical power by industrial commerce: in such an out-of-joint society, there was little chance that the differentiated artworld, hunkered down in isolation and nursing its expertise, could be free from want, fear, and vanity, and be inclined to thrive in serving up its particular gift to the neighbors.

But this development of the reciprocal disenchantment of art and society-at-large is not normal, not fated; and it is important, I believe, not to oversimplify the historical trouble, localize guilt causally with scapegoats, and suppose we are now past modern error ("postmodern"). "The economic means of production" are also not the skeleton key to the story, I think, and Hans Robert Jauss has emphasized that literary texts (and artworks) are *also societal agents* (Jauss, 1967, 10–16). Christians know too that we do not fight against institutions any more than we battle against persons of flesh-and-blood, but are struggling with the slippery evil principalities and dynamic powers (δυνάμεις) that systemically infiltrate institutions and flesh-and-bloody persons, including the adopted children of God.

Prospecting orientation

Before I move to the "necessity" in my title, with historical analysis of what to do from the side of the arts in our current circumstances, I need to comment briefly on "cultural" and "artist" and "Christian" and "pub-

lic" to provide orientation for my suggestions on implementation of the "necessity."

Cultural matrix

When Milan Kundera describes Czech culture as a whole, what is at stake, he says, is "lifestyles, customs, artistic traditions, taste, collective memory and daily morality" (Kundera in Vladislav, 1990, 258). Albie Sachs meant much the same in his important paper to ANC political leaders in exile, "Preparing Ourselves for Freedom," when he stated that "the cultural question is central to our identity as a movement . . . culture is us" (Sachs, 1990, 23), as he pleaded for a multi-cultural, multi-lingual, multi-faith country to be the new South Africa. T. S. Eliot's largest sense of culture sharpens the point further by posing "the culture of a people as an *incarnation* of its religion" (Eliot, 1948, 33).

If one accepts this lay of the term, then "culture" refers to a serious, not so sharply defined, constellation or conglomerate of various zones of patterned activities and formed customs that envelop a person. The culture one inhabits is life-pervasive, a way of life, a cultivated routine largely shared and consensual, often present subliminally, both steadying and, at times, disturbing. It is important, I think, to keep "cultural" distinct from "artistic," although they are related. "Culture" is broader. If the United States is engrossed in a *Kulturkampf* "culture wars," and wants to make "the arts" its battleground, one must not be deluded into thinking that if we solve the artistic problems we will have exorcised what troubles the culture. And I find it hard to believe that if a country gets its culture together as "a people," not to say "politically in order," the integration of the arts in society will necessarily follow.

My humanity is not swallowed up in my aesthetic taste, is not wholly at stake in my citizenship, and I am not defined completely even by my cultural habitat, although the artistic depth or superficiality, the political strictures or liberties, and the cultural riches or poverty I experience daily deeply impinge upon my life history. Sin may be simple, a devious, protean violence and waste of God's gifts, but creaturely reality is complex, and the restoration of infected human cultures takes more than focused, embattled effort. Genuine historical cultural reformers know, I believe, that the blessing of cultural *shalom* is neither a human achievement nor a *deus ex machina*, but is the Lord's answer to aching, obedient petitions, including remedial, redirected actions.

The artist as *demiourgos*

I wonder whether it might help offset the many destructive images and expectant misconceptions of an artist's calling if artists of our day could own the old name of δημιουργός. In Homer's idiom *demiourgos* is "some talented one who works for the people"; and Homer lists in the *Odyssey* as examples "a prophet or a physician or a carpenter or a bard; such as these are welcome guests all over the boundless earth" (17.383–6). *Demiourgos*, "a constructor of material, a builder for a public," overlaps, says Walter Shewring (1984, 10–12), with the Greek word ὁ τεχνίτης "ingenious designer, a tradesman fashioning something of quality workmanship"—which is the term Scripture uses to report that Aquila, Priscilla, and Paul were professional tent-makers (Acts 18:3). *Demiourgos* would be a name that recalls the artisan legacy of differentiated artists in society and honors the know-how and professional qualities required for artistry—God bless all amateurs who do not need to be worthy of their hire—but that also respects the artist's properly honed skill to present parabolas of meaning for people, without burdening artists with the onus of being "legislators of the world" or "prophets" who can divine how to put our fallen Humpty-Dumpty of society back together again. Although, if one deflates the unbiblical Romantic notion of "prophet" as revolutionary rabble-rouser who sets everybody else straight, and one understands "an artist who (sinfully but forgiven) follows Christ" to be exactly no more than a prophetic builder of diaphanous shelters for others, *a skillful performer of truth*, that is, a collector and provider of nuanced meaning for people that, like manna, is trustworthy, then it may be that artists indwelt by the joyous wisdom or righteous anger of the Holy Spirit can be prophetic.

I realize that if someone asks an artist upon occasion, "And how do you keep busy?" . . . even if the reply comes trippingly off the tongue, "I am a prophetic *demiourgos*," the response might easily be, "A pathetic what?"

But then as artist you could explain that in the Newer Testamented book of *Hebrews* God, by exception, is referred to as τεχνντης καὶ δημιουργὸς, architect and builder of foundations for a wholesome, everlasting city (Hebrews 11:10), and you just happen to be an adopted apprentice in the program: you build surprises of tones from animal gut strings and hammered metal that cello and French-horn people with excitement and peace; you invent marvelous intrigues of motherly courage and fantastic tempests in scenes acted out to spellbind people; you compose lilting songs to stir in both older and younger people alike knowl-

edge of that rare, bittersweet reality of mutual love; you heal wounds of those who mourn losing so much lifetime to depression by your fashioning necklaces of alliterated consonants, sprung rhythms, and assonant vowels for their necks, which gentle the people back to remembering possibilities of hope. . . .

"Christian" artistry?

I have heard Madeleine l'Engle, Rudy Wiebe, and other gifted Christians who are professional artists emphatically deny that they do "Christian art." I understand their desire to be accepted by secular peers solely on the merits of their artistry. They also signal a general embarrassment with the term "Christian," the way Václav Havel explains to Left-leaning Western peace movement activists the reticence of "dissidents" in Eastern Europe to take their "peace" rhetoric seriously, since for thirty-seven years people in Czechoslovakia were saturated with "peace" and "democracy" that were merely a newspeak tissue of lies (Havel in Vladislav, 1990, 164–67). "Christian" throughout the world sounds like "Western exploitation."

Is the word "Christian" really worth saving if its history has the insufferably smug, urbane tarnish of Joseph Addison, who, on his death bed, said to visitors, "Come and see how a Christian dies"; and if today in North America "Christian" has an overhead overlay of the TV-wide, grinning smile of a glad-handing testimony that the lord-lord has given me success? Are "real" Christians like Edward Curtis's "vanishing" American Indians, and should we photograph a few now to show to posterity?

Because Scripture asks believers to do things "in the name of Jesus" (Mark 9:38–41, Philippians 2:5–11, Colossians 3:16–17) and expects the Lord's disciples to "suffer as Christians" (Philippians 1: 27–29, 1 Peter 4:12–16) in any kind of culture, I'd like to find a way to give the phrase "Christian artistry" ("Institute for Christian Studies," "Coalition of Christian Colleges and Universities") biblical grit rather than drop it as a cheap show. Yes, there is bound to be confusion. When the original "Institute for Christian Art" was begun in Chicago[8] we inevitably had to explain: this is not a church endeavor; our artists do not just paint Madonnas with haloes; Henk Krijger's style is not the Good Housekeep-

8 The Institute for Christian Art was an independent guild of young artists who did art work in close proximity to master artist Henk (Senggih) Krijger in a free-flowing workshop situation in Chicago (1969–71) and then Toronto (1971–74.) From 1974–79 it became an alternative art gallery in Toronto called Patmos Art Gallery. Cf. *Hommage à Senggih: A retrospective of Henk Krijger in North America*, ed. J. de Bree, catalog design and production Willem Hart, on the occasion of an exhibition at Redeemer College, assisted by Mary Leigh Morbey.

ing model for all others. The imaginative name change to "Patmos" in Toronto was a better conversation-starter with people off the street: this is simply an island where a committed community of artists sees visions of Christ's Rule a-coming, and their artworks bear a (faint) watermark of that troubled, expectant conscience.

For artistry to be Christian artistry does not mean that it must add something, or advertise dogmatically that it stands up for Jesus. My experience is that there will be, nevertheless, a slight whiff of scandal about Christian artistry (in between the lines of Christian scholarship, too), and not just an anonymous normativity—the scandal and stigmata of identifying with the persecuted ones who follow the Christ (Matthew 5:10–12). One can detect in Christian artistry the spirit of being as homeless toward earthly possessions as Jesus was, yet brimful with gladness thanks to the wine and figs provided by the LORD, because of God's covenantal faithfulness to your "cultural," cultivating, believing forebears. Why could we not imaginatively restore the normal, winsome, biblical scandal to the name "Christian" in the land rather than leave it to go vain on the lips of little ingrown anti-Christs—so confusing to disbelievers?

Public

"Public" is very difficult to pin down conceptually, because the commonality "public" assumes changes. There are public rest-rooms; church worship services are public; most roads today are public thoroughfares. But many public highways prohibit mountain bikes and hitchhikers; what happens in church worship is prescribed and overseen by elders or clergy; and public toilets are not free-for-alls, but are restricted to certain "private" activities.

It may help to think of "public" as jural space, legal movement, a realm—or, as Hannah Arendt puts it, a common world that extends beyond an individual's span and is a shared reality (1958, 50–6). A library is public because a common good obtains as the indiscriminate quality of the operation open for legitimate use. So "public" is a people-in-general-rightful-accessibility quality, a very basic obliging object-function inhering all kinds of human activities. When "public" is the feature that characterizes the conversation/discourse or transport/transit or announcement/publicity at hand, the claim to civic attention entails special responsibilities, which should not be short-circuited by the privilege of money, seigniorial rank, technical expertise, or even disadvantaged special interests. "Pubic deed" needs to be carried out for the commonweal in conjunction with the people-at-large.

Walter Lippmann's lament for his nation, already more than a generation ago (1955), argued that *The Public Philosophy* of Ciceronian rationality and human good will, with its doctrine of constitutional democracy, had become discredited in the West by "the Jacobin conception of the emancipated and sovereign people." So the practice of humanist civility in public life and even the possibility of a public fabric was ending (Lippmann, 1955, 123, 136–8). Jürgen Habermas's concern to transform the comfortable bourgeois structure of "the public sphere" in a way that will still allow a reasoning, informally organized "public discourse" to ride herd on both the state and market-economy individualism voices a similar unease with the deteriorating "refeudalization" of public life. Our mass societal reality today, where political government lists toward the bureaucratic rule by no-one, continues to shrink what is public: shopping malls, national radio, newspapers, the mail, our commonwealth, is not or is hardly public, but is "corporate private." "[T]he only thing people have in common is their private interests" (Arendt, 1958, 69).

Conditioning historical ferment
Why is there a *necessity* of Christian public artistry in culture today? Do we mean a logical necessity or a matter of life and death urgency—a kind of historical imperative? Do we have any concrete avenues in mind, if it is so that differentiated artistry is out of joint with society, and American-based popular culture, along with exported military armaments made in the USA, have people dancing and dying in the dark worldwide?

The necessity of Christian public artistry is the old-new song that D. H. Th. Vollenhoven sang in 1932 on *The Necessity of a Christian Logic* (*De Noodzakelijkheid eener Christelijke Logica*). The "necessity" is the light yoke of fulfilling the law of Christ by being Spirit-filled, simply hearing one another's burdens with the fruit at hand (Galatians 5:22–6:2). The fact that the arts, since Lamech's day (Genesis 4:16–24), in King David's reign (1 Chronicles 16), through centers like Ephesus (Acts 19), Alexandria, Paris, and more great cities, have had an urban place, also primes the arts for doing what the woman Wisdom does in the biblical Proverbs (1:18–33; 8:1–9:18): appeal to all and sundry, including simpletons, publicly from the housetops and at the city gates, that is, before the video screens and in the shopping centers, "Come in here!"

I know that the city of Grand Rapids, Michigan, could at times appear to some as a stand-in for Mark Twain's Hadleyburg; Toronto the Good is really an ancient Nineveh at heart, and Jonah has shown up as "The Toronto Blessing"; old Amsterdam plods stolidly on as a Babylon

where graduate students are still exiled; all of which makes the fat Bashan cows of Sioux Center, Iowa, look like promised land. Yet I am very grateful to the educational institutions from those cities that sponsored this conference to give voice to the point that the arts are embedded in the very quality and direction of society, and therefore should not be a fringe on the theoretical garment, or marginalia in reformers' agendas busy with socio-economic issues, political studies, and philosophy, as, in their neglect, they often are.

It seems to be widely accepted by academics that the dominant paradigm of Western, synthetic Christian, rationalist humanism is finally coming apart at the seams. If that be so, it is curious why so much of Eastern Europe, the African continent, Southern Asian, and many South American countries are in a hurry to catch up to the "cutting edge" of our violent culture. Maybe what Henry James called the typically American trait of "perpetual repudiation of the past" has something to do with it. The well-meaning hegemonic abusers and the colonized peoples of the world, and any newcomers, want to forget the past, wish to be postcolonial, postmedieval, postmodern, post-Christian, and start over.

But fresh starts in cultural history, even after forfeiture of the organized church to hold up the standard of the gospel, do not deny that the past is always present, but demand cultural repentance and cultural forgiveness for what is indeed there on the record. We need endeavors to move *beyond* poverty and affluence, and *beyond* kitsch and master pieces (that reveal aesthetic poverty and bring on artistic pollution). I really believe that the Reformation Christian tradition, scarred, embattled, mean though it be, has the biblical grit and an embarrassment of reflective resources, to learn from the Orthodox, the Roman and Anglo-Catholic, the holiness Christian traditions, in order to rally Christ's body for communal cultural diaconate work in our unhinged world society, which will be neither postmodern nor premillennial. We have the biblical cosmic goods that will not impose an ethnic Western cliché, but will be able to listen to and help other peoples worldwide who come to know Jesus as Lord to gain their own integrity and stamina to withstand the carnivorous principality of Commercialism/Mammon, and weave their own cultural colors into the common cloak worn by the followers of the Christ who are persecuted for right-doing, including artistic right-doing.

Anti-normative institutional constellations in society have tremendous constrictive power on whether and what artistry takes place; but artistic form-style and content do not mirror-image societal realities in lock-step fashion. It is part of the vulgarized heritage of Marxism, wrote

Kundera in 1980 (just after his country stripped him of his citizenship), to exaggerate the importance of the political system to art and literature (Kundera in Vladislav, 1990, 258). Even when a society is tyrannized by a Fascist dictatorship, or when monopolistic cartels control the marketing and distribution of, for example, breakfast cereals or cinematic artworks, independent film directors and producers do occur (Michael Moore's *Roger and Me*); and artworks constructed in a lonely artist's studio occasionally do win prizes and give glimpses of *shalom* to people, before they are cruelly forced to be stored again in someone's garage because they do not belong to a stable in Soho.

From my understanding, at this stage of my development, persons are not by nature "institutionalized," actually prisoners in institutions, as Foucault intimates, nor are individual humans necessarily in dialectical tension with an established church, state, business, family, city, university. Such friction disturbs life when things go bad. But normally such historically differentiated institutions are like superimposed hologrammic realities flush with my existence, habitats where I experience connected sustenance. What does, however, face everyone historically as scholar, as fishmonger, or as artist is this: how can the conditioning historical status quo of our society, which is not normal, be made more normative and fermentative for the exercise of my societal service *coram Deo*.

Let me dare be concrete if incomplete, with show and tell in three areas that correspond roughly to what I learned early on from Bill (*Risky Business*) Romanowski when he sat me down once long ago for six hours straight viewing MTV: "There is high art out there in society (10 percent), folk art (10 percent), and popular art (80 percent), and there is quality and drivel in all three kinds." I shall illustrate the ferment Christian artists face and engage in the artworld, in the aesthetic playground, and in what I call double-duty artistry.

Art-as-such in the artworld

At a certain time in the secularization of Western societal life, noted earlier, artisanry emerged from being enveloped in cultic or utilitarian activities and became recognized as a talented service in its own artistic right. Next to fresco painting on church walls as *biblia indoctii* you have huge canvases of oil paintings produced by the art-workshop of Raphael and later Rubens for patrons who wanted Humanist splendor. Gradually the literary-allegorical coefficient of painting was excised, and Watteau, for example, introduced a painterly fabric whose idiom of images itself carried the narrative. Much later, Cubist painterly experiments with collage

evidenced a highly sophisticated move to incorporate daily life cigarette wrappers, newspaper classifieds, and theater ticket bits into the rarefied design of kaleidoscopic color, texture, and painterly composition in order to bespeak ways that make refuse work (as well as overcome the aura of vacationing bourgeois pleasures impressionistic painting projected). Painterly art became indeed painterly art-as-such.

One could also notice how once the newfangled texts called "novels" appeared in England, which you were supposed to read not as somebody's real diary or well-written letters, not as a sermon or actual travelogue journal, but simply for the sheer imaginative verve of the story: again, like painterly artistry becoming art-as-such, novels carved out their own literary character and readership, which then continued to become more solidly literary. Flaubert's deadpan fictional prose was not direct speech ("I shall now possess"), nor indirect speech accounts ("She said that she would now finally possess"); he instead described things for the reader by self-reflective statements ("She is going to possess now the pleasures of love"), which left subtly indefinite whether the sentiment was characteristic for the persona of Madame Bovary, or was the author's bona fide judgment on the act, or lay ambiguously somewhere between, heightening the allusivity (example from Jauss, 1967, 68).

That is, painterly art in salons for public viewing, Dickens' serialized novels keeping readers waiting on tenterhooks for the postal express, *Kammermuzik* moving slowly into public concert halls, all allowed for the refinement of artistry to highlight its peculiar artistic service. Such a development does ask audiences, readers, and viewers to mature aesthetically, to become art-educated receivers; but such a development is structurally good as well as historically fair, I think. The purist streak that accompanied differentiation in the Western artworld, and the elitism surrounding the whole affair, is not inherent in the art museum or art gallery, but is a secularist possessive power imposition. Not until after the French Revolution was the Louvre open to the public. And many of the commercial art galleries on Cork Street in London, England, today ask prices, demand mark-ups, and exclusive sales rights that are practically criminal. Yet an art gallery and art museum, like a concert hall, like a published novel, is creaturely, structurally sound in a differentiated society; they ought to be public gathering-places. And it is a necessity for Christian artists to be presenting their professional artwork there, casting their rye bread out upon the waters of passers-by.

The painting *Art as a Metaphor for Childbirth*, no. 1 (1986) by the Australian Warren Breninger [*NA* #13] portrays a woman drained of en-

ergy after pushing forth a baby—muscles contracting—exhausted from straining in labor. The somewhat swollen features highlighted by an unreal shine of white like sweat and grounded by the rough opaque black line underneath neck and head sunken back into the pillow; as if one is reduced to the basics of humanity in such an ordeal, cast the tired woman into stark relief. The black-blue across the cheeks and mouth hint at soreness, while the wisps of leaves in the dark seem to dance and skip wistfully, as if easier times might wait in the wings. There is a sense of distance and uncompromising estrangement in the piece, which yet shows a fascination with the labor of bringing forth life. There is softness and love, as I see it, within the hardness. Its wry title wants to say, I think, "That's me too as male artist, as (Christian) artist, my friend."

Christine Anderson in New York City quotes Masaccio's fresco with powerful effect in her *Historical Dislocations in the American Landscape: The Expulsion (after Masaccio)* (1987) [*NA* #9]: the monotonous grid of a housing development is a place in the American landscape of banishment! Is middle-class sameness, which is nowhere because it is everywhere, a result of the curse? Suddenly you realize that the standardized, colorless family ranch home, even its cherished detachment, is a mark of the Fall. So we paint bright tropical colors on the van used for the annual vacation trek to get away from it all, a somewhat wistful, forlorn *memento Paradisus.*

Canadian artist Gerard Pas staged a *Red-Blue Crutch Installation* (1986–7) [*NA* #20] that takes the basic crutch, stigmatized by primary colors, through a contorting metamorphosis, as if the crutch going through the twelve stages of the cross is finally brought to its knees, transfigured by the imagination into a docile, balanced pyramid of expectant waiting. Another Pas watercolor titled *Vision of Utopia* (1986) [*NA* #21] goes boogie-woogie exuberant with color to celebrate an apotheosis of a trinity of crutches flying above a red rectilinear throne above a blue triangle; Kandinskyesque slivers of geometric figures are pulled loose from their Mondrianic Calvinist rigidity into the vortex of an unseen power in this ascension or assumption of the crutch, in anticipation of the day when the lame shall indeed leap for joy.

Murmurs of the Heart [*NA* #14] by Joyce Recker from the United States uses precious purple heartwood with chicken wire to form a delicate, lovely ribcage for the levitated heart of a rock caressed smooth by wind and water, as if pulsing above kindling that keeps it suspended, alive. There is something private and protected, warm and gentle, but sharply pointed and precarious about the whole ensemble. The uncanny

shaft of light introduces cathedral dimensions without disturbing the intimacy. You can almost hear an Ingmar Bergman soundtrack of Anton Webern's harmonies tumbling nearby; complementing the murmuring heart's exacting, still, chaste, crucial finesse.

These are examples for me of Christian artistry, artworks-as-such breathing a spirit of biblical wonder at God's grace mixed with a troubledness about the ravages of human sin. I think it is a false dilemma to ask whether you need to politicize "autonomous" art to make it societally relevant. If art-as-such has the ethical pith to gain the viewers' confidence and the nerve to cry out for care, healing, and justice most concretely within its hidden, prelingual ambiguities, and the institutional art curators mediate such artistry publicly, to different audiences, then the Lord is praised and the neighbor is served. But when the prestigious d'Offay galleries give serious showtime to the preemptive kitsch of Andy Warhol and Jeff Koons,[9] and the London Tate sells color photographs of Koon's trashy, living porn statues, discretely of course, in its bookshop, injustice is served, I dare say, if not the Big Lie, which falsely indicts observers for failing to find aesthetic satisfaction where there really is none.

Professional artists can do only so much in keeping in mind that the artistry they conceive and produce is destined for the neighborly public. It behooves art institutions to facilitate such connection, rather than frustrate mediation by posting costly entrance fees and projecting an aura of *hauteur*. But an art museum is not more normatively public if it pushes itself forward as a business. The Art Gallery of Ontario turned *The Barnes Exhibit* (1995) into a hard-sell venture to make money—which the enterprise did, ending each tour of the show with a sales room full of kitsch items, Cézanne on ash trays and Renoir on T-shirts. An art institution's pulling in the masses runs amuck, it seems to me, if it turns art reception into a shopping trip. Art museums and art galleries do better to emphasize their schooling service. Art institutions need to develop their nature as a park, a place where people take time to play with their imaginativity. Governments and Getty philanthropists will do well to grasp the civic and national good and charitable wisdom there be in arm's-length funding of such public "carnival" (Bakhtin)—not as Midway!—occasions for artistry to reach out to various communities.

It would be a biblically attuned practice, I think, to make it standard policy for art museums, art galleries, art expositions, to protect its public

9 Peter Smith reported to me this terse, apt judgment on Koons made by Roger Scruton in his Peter Fuller Memorial lecture at the Tate Gallery, London, England, on 25 May 1995.

character with an oral one. When literacy enters an oral culture, those who do not learn to read and write suddenly become illiterate rather than members in full of the culture as they previously were; so the literate need to hold the non-literate and their insights in honor. When people visit the public artworld and do not understand the artistic idiom, especially graphic artworks need to be bespoken, translated, interpreted by voice in a hands-on, look-here, what-do-you-see fashion, to honor the newcomers' ordinary savvy and help them orally unlock the flavor of artistry, if it is worth their imaginative time. (Redeemer College, Ontario, assigns this task to its art history majors for every art show.)

And to insure the public character of a "redemptive" art institution, one should go out into the hedges and byways and bring them in by the carloads—seniors, underprivileged kids, philosophers—not to save souls, but to talk live to them about what they experience, that is, to pour artistic perfume over the least of their bodies. Most inner-city delinquents don't even know you can walk in for free to an art gallery or museum for a look-see and a drink of water (Coles, 1975, 185 -202). The practice I am proposing for standard policy would be like giving away a raft of free tickets to the poor for "our college or university thespian productions" or holding at least one performance of every run of a play on a "pay-what-you-can" basis, as the alternative theater scene in Toronto does (in return for the Canadian government grants they receive). If that were standard policy it might affect what you perform, because "public" is a place where strangers have faces.

The playground of aesthetic events and cultural workshops

The underground to art is aesthetic life (Seerveld, 1980, 49–54), that bubble of imaginativity resident in human nature that surfaces in ordinary affairs like having fun, playing around, making music, inventing games, putting on skits. Such "grass roots" events have always been with us, as children's games attest worldwide. Home-made lover poems go back to the one uttered by Adam at the first sight of Eve (Genesis 2:23):

> Bone of my bone, flesh of my flesh,
> she shall be called wo-man,
> for she was won-from man.

Throughout the ages people with or without means have participated in making merry: story-telling, dancing, molding clay figurines, painting faces and bodies, sewing festive clothes for special occasions, tapestries, furnishings to sit or lie on, speeches, work songs from black "hollers" in the cotton fields up to "rap" in the city ghetto streets. This

unspecialized welter of occasional, celebrative activity is the milieu of minstrelsy, *commedia dell'arte*, pick-up "tall-story-telling" contests, jazz jam sessions, where becoming good at playing banjo on your front porch may lead to forming your own local band, and developing a knack to be humorous may start you off becoming a stand-up comedian able to interact well, extemporaneously with responders to your jokes.

It is close to such improvisatory aesthetically inclined, learning-the-ropes activity of people for which Albie Sachs wanted "cultural workers." Sachs' first concern was to turn the ANC leadership away from an anti-apartheid fixation to a positive, window-opening attitude: how do we disenfranchised people prepare to contribute culturally to the well-being of the whole country? We need "cultural workers" to lay foundations: literacy officers, teachers of basic skills with flair, study environs—every woman needs a room of her own with paper, books, ink and pen if you want journalists and story-writers. We need "cultural workers" who encourage people wherever they are to respect their peoplehood-tradition-faith identity, and to gain that self-respect by bodying forth its community life imaginatively: you can see it—there we are!

The lush green carpet of grass sod growing in the rubble before the neighborhood toilet outhouse in Top City, South Africa, where I was as a guest, told me the quiet power of aesthetic-life integrity and what that can do for community confidence. Out near the edge of squatters' camps, where they meet a government road, you found in the 1980s what the media called "township art" [#1]. A gaily painted, sculpted tree looks like an acrobatic dancer doing a headstand while juggling a doughnut of a tire between the legs, as a tread peels off; or is it an animated stand with ropes and life-saver to rescue people in trouble at the "border"? This is the kind of "cultural work" Sachs wanted fostered, not "Protest Art" like a Tanzanian agitprop piece by Francis Msangi entitled *Bastion of Apartheid: the Dutch Reformed Church* (1980s), with its heavy-handed leer at the enemy.

The Wall of Respect at 43rd and Langley (1967–9) [#2], Southside of Chicago,[10] is also edifying, because it was born out of William Walkers and Sylvia Abernathy and a dozen other artist leaders at home in the local community there who, in the tradition of Diego Rivera and the Mexican Marxian muralists of the 1920s, Orozco and Siqueiros, aimed to give voice to the downtrodden there and claim kinship with Muddy Waters,

10 This photograph was taken while I was showing it to Bob Goudzwaard in February 1970, on a day so bitterly cold it was safe for two white men with a car to be there briefly around high noon. A year later this *Wall of Respect*, except for a couple of panels, was destroyed by fire.

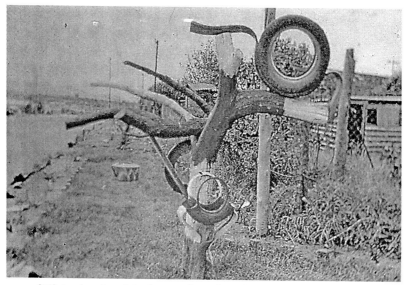

[#1] A cultural work in the townships of South Africa, 1980s, anonymous

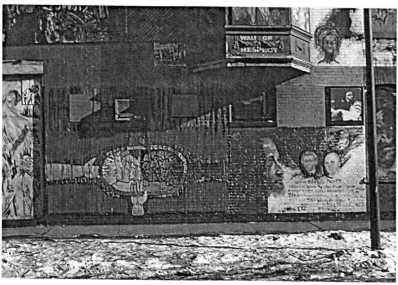

[#2] William Walker and colleagues, *The Wall of Respect*,
lower panels, 1967-69 (destroyed in 1971)

James Baldwin, Malcolm X, Rev. Martin Luther King Jr., Mohammed Ali, Sidney Poitier, and other "greats" who were pictured in the mural. Behind this 1967 mural is also the 1930s precedent of the WPA organized by the Roosevelt administration and its Federal Art Project, which

paid artists $94 a month during the Depression for six-and-a-half hours of work per day, five days a week, to do "top quality" works on demand, posters for government bureaus, and murals in post offices—since artists need to eat too (Bernstein in Sorell, 1979, 8–11). *The Wall of Respect*, however, was a community project aimed at black self-respect *and* reconciliation with everybody. The ellipse on the red brick has angry white and black faces in a standoff, but there are brown and white hands reaching toward one another with the word PEACE inscribed around the confrontation.Neighborhood murals on outside walls are public *par excellence*; frescoed walls inside Italian churches of the 1300s were also public. Rand Afrikaans Universiteit in Johannesburg makes available each year to the graduating class a wall in the Student Commons for their mural painting, which usually celebrates extracurricular high points and also includes vivid commentary on political events of the year. Every college should have a student mural space for community-building.

Murals welling up from awareness of a neighborhood are wonderful "cultural work": artists-training ground in minority community building fully out in public. Whether the mural simply accompanies the square where office-workers eat their lunch, or identifies the Hispanic Mission district of San Francisco, or suddenly alters your scary impression of the bad King's Cross section of London, England, [#3] with a huge, exciting dinosaur interrupting the halves of a rainbow in a waste back lot: murals can give to airy nothingness a name, place, a Kilroy-was-here familiarity

[#3] King's Cross alley, London, England, 1970

[#4] Netherlands mural at Toronto Pearson Airport, 1972-73 (now destroyed)

[#5] Ontario College of Art students Uldis Gailus and Harry Pavelson,
mural on walls of Leon Kaminsky's scrap metal establishment, Eastern Avenue,
Toronto, 1975 (now destroyed)

kind of identity. Toronto airport murals welcome visitors cheerfully with badges of their country [#4]; there is a bit of truth in every stereotype. Murals lightheartedly dress up your environs, show you are proud of what you stand for, like the Toronto junkyard dealer who paid a couple of Ontario College of Art students hourly wages to paint the history of junkyard disposal on the outer walls of his establishment [#5].

Such eventful *aesthetic* activity is peculiarly folk-like because, as "cultural work," it is most immediately tied into daily life, community concerns, and as community endeavor it often necessarily employs less skilled labor. Mural-makers are also not bent upon probing and ferreting out refined nuances in a professionally exacting manner and giving the subtleties independent entity character, as it were, a lasting object without the author showing. Aesthetic "objects" like murals still proudly show the folk stump of their umbilical cord. Mural-makers like agitprop theater can go heavy-handedly wrong if they pretend to be art-as-such, yet make their nuanced point poster-clear. But agitprop theater, says Brecht, can bode daring simplifications that go to the crux of a matter like a caricature, and silhouette in an astonishing economy of image the hidden secret (Brecht, 1964, iii). So "walls of respect" and "township art" are a serious playground for cutting one's aesthetic teeth and seem to be immensely rich in communal connections.

The tour made by poet Fred (*Bunk Among Dragons*) Tamminga and Matth (drummer-painter-printmaker) Cupido across Canada in the 1970s was an aesthetic event. It took a terrible cost on their personal lives, but the inhabited places they visited—Canada is a very wide, un-inhabited country—lit up exultingly, because Tamminga and Cupido gave immigrant (Dutch) Christians an aesthetic voice that showed they were not just dancing *met klompen* among the tulips below sea level: they were a covenanted people able to stomp on dragons! Tamminga and Cu-pido were "cultural workers" fertilizing God's people and curious strang-ers who showed up with good aesthetic manure. If that image does not sound dignified enough, it is precisely the way I have always thought of the high calling of teaching: you spread good manure around the roots of your students, water them well; if the Holy Spirit shines on the plants, they shall grow strong and bear hardy, tasty fruit.

Sietze Buning was also an aesthetic event: a roving poet who knew and loved the Kuyperian Reformed community in Midwest America to the last supralapsarian fold of its stubborn, God-fearing mentality. Sietze gave the people of Middlesex, Iowa, their verbal *Wall of Respect*, because they could talk a kind of dialect familiarly *and* respectfully simultaneously

with God—now that's "class"! like the Queen. I'm not certain whether it is a shame or a profound, ironic judgment that noted Christian publishing houses did not rush to print and distribute Sietze Buning's "cultural" manure, a folk poet laureate of God's people.[11]

That is, the "playing around" capacity native to human nature, busy intransitively, as it were, in all our ordinary daily activities, is the ontic watershed for art-making. This native aesthetic bent for ludic moments also occurs in transitive fashion for the nonce, yet remains more immersed within the pell-mell flow of daily life than making objects and events structured to have specific, independent, "artistic" character. People who exercise this frolicsome *aesthetic* ability as apprentices, trying out their ability to be professionally imaginative, I would call, with Albie Sachs, "cultural workers." And those who purposely carry on as *aesthetic* practitioners, for whatever reason, deserve supportive attention rather than sophisticated putdowns. For years Paul Lawrence ("We Wear the Mask") Dunbar wrote "dialect poetry" because only that way, he thought, could he keep his uneducated black audience listening; *The Great Wall of Los Angeles* (1976–85) employed 350 unskilled inner-city youths to complete the aesthetic project (Baca in Lacy, 1995, 132–34, 138); annual ethnic carnival celebrations in major world cities attest to respected imaginative traditions of various peoplehoods: aesthetic practitioners can do premeditated, finely tuned, keenly imaginative deeds brimming over with folk participation. Site/place-specific and community-oriented occasionality stand out in such valuable imaginative work. One could say that folk poets like Sietze Buning and authentic folk musicians (before they go electronic) remain artistically aesthetic in their "ministry."

Right here I will just note a crucial historical point: the Dada movement in Zurich and New York around 1914 recognized the enormous vitality that inheres in the exercise of aesthetic life in human society, which underlies and is the residual resource for all art-making A clue for our understanding Dada is that it trades on aesthetic life, however, without respecting either its honest propaedeutic naiveté or its community voice, while pretending to be unsophisticated and people-friendly. The edge of event and occasion in "cultural work" over the enduring object/entity-locus of art-as-such is exploited by first-generation Dada and second-generation New York Pop Art; and (conceptual) eventuality is set dialectically in opposition to any admirable, fixed treasures as if

11 *Purpaleanie and Other Permutations* (1978) and *Style and Class* (1982) are published and still available from Middleburg Press, Box 166, 403 Third Street NW, Orange City, Iowa 51041, USA.

process and transiency be the pearl of great price because then you can defer having to make a permanent bad choice or be tainted by possessing a covetable object.

But Dada in its historically important and legitimate critique of the current aestheticized artworld, and many of Dada's anarchic, anti-art successors, with an "of-by-and-for the people" duplicity, ruined aesthetic practice by forcing it (or by having it co-opted) into the "high-art" circuit of fashionable society Dada initially meant to undermine. The moment of insight in Dada goes wrong in the way you go wrong if you do a good deed and then immediately hand out a press release about it. Such a turn—Cindy Sherman's selling her self-portrait photograph for $16,000 in the Entwistle & Co. Gallery in London, England (July 1995)—is not spirited, I think, in the grass-roots way that generations of quilting Mennonite women in Manitoba were led to do enriching "cultural work": there is a perverse twist infiltrating the wholesome contemporary recognition of how art-as-such will be a hot-house plant and become artificial unless beneath it be a community vibrant with a tempered *aesthetic life*.

Double-duty artistry:
art-as-such encapsulated by non-artistic institutions

I leave for another time a developed exposition of double-duty artistry, that is, art-as-such *voluntarily* encapsulated, bonded within the defining non-artistic task of another societal institution.

I have in mind liturgical art fit for church/synagogue/mosque, including its confessional chant and hymnody; portrait and memorial artworks subservient to friend and family concerns for commemorating persons and deeds; monumental art needed by governments to honor justdoing and to remember significant political events, including national anthems and civic parades; advertising art, which carries the double yoke that the artistry-text and image be pregnant with imaginative nuancefulness but also promote sound stewardship, that is, bring good resources to the attention of people who need them.

This is also the locus for investigating popular art geared to fostering the social entertaining dimension of human lives, which has become massively sophisticated and important since the advent of machine-induced leisure and the invention and exponentially proliferated use of radio, cinema, TV, and video since the 1930s in the West, and now worldwide. Electronic wizardry, where art is wedded to the technical versatility of machines, also deserves assiduous attention as to its particular doubleduty complexity, both generating imaginativity and displaying astound-

ing instrumentality.

What is peculiar about encapsulated artistry—whether it be brought to birth by non-artistic concerns and requirements, as is usual, or whether it be initiated by an artist's willing engagement to divert artwork come of differentiated age into other than aesthetic interests—what is peculiar about such intentionally encapsulated art products is that the piece or event is called upon not only to meet the aesthetic law of symbolic allusivity with skilled control of media, but that it also needs to satisfy, internally consonant to the art piece, the norm for the other kind of activity the artist has agreed and is dedicated to serve. Encapsulated artistry has a primary double duty co-principally up front.

We should realize, however, that encapsulated art is not necessarily the preferred way for artists to be publicly responsible, nor is it a guaranteed way. I think, for example, of monument artistry, which is art-as-such rightfully engaged in a political task. Much politically encapsulated art in national war museums[12] is utterly irrelevant to both history and normative artistry, misleading would-be patriotic citizens into a chauvinism of "our country and God *über alles*," as if any victory means just-doing. Artistry does not need to be bonded to a non-artistic institution in society to be societally pertinent: public service depends upon the diaconal slant of the artistic production itself, granted that its public service may be undone by multiple other societal forces.

To sum up: within the prospect of what needs attention regarding the production, distribution, and reception of artistry in society is not only establishing the communal artistic place and task of professional art-as-such in society, and the place of aesthetic events ("cultural work") in society, but also conceiving the important, non-exploitative, legitimate requests and deployment (encapsulation) by non-artistic institutions in society of (Christian) artistry. I have argued that it is a necessity for all such varieties of aesthetic activity and human artistry to grab hold of our times by the throat and show the eschatonic horizons of Christ's Rule a-coming, and to give God's handicapped creatures a voice. I have also presented certain evidence of the worth of Christian public artistry as a contribution of Christ's body toward sharing the commonweal.

12 Cf. J. Snyman, "Suffering In High and Low Relief: War Memorials and the Moral Imperative," *Pledges of Jubilee: Essays on the arts and culture, in honor of Calvin G. Seerveld*, ed. Lambert Zuidervaart and Henry Luttikhuizen (Grand Rapids: Eerdmans, 1995), 179–209; and Dirk van den Berg, "Sculpture, Power, and Iconoclasm: The Verwoerd Statue," *South African Journal of Art and Architectural History* 6:1-4 (1996): 10-25.

We should remember Trotsky's wisdom that artists are the rearguard in society (Trotsky, 1960, 159–60, 236–8) and keep thinking in a Kuyperian way: simply be faithful as *demiourgos* (as worker-priest, preacher-tentmaker, teacher-artist, parent-poet), simply be faithful in your God-appointed, holy task as one generation in the host of generations coming and going in bittersweet service of the Lord of the universe. When artworks, jokes, and cinematic entertainments are living sacrifices of thanksgiving, like the biblical Psalms, weeping with the violated and rejoicing with the grateful (Romans 12:14–21), then a person or a community's artistic performance and products shall be giving non-hegemonic leadership in society that bodes prophetic *shalom*.

For Christian artists to know they are embedded in an aesthetic community living by true faith, all those who follow the Christ need to exercise our mutual membership with (professional) artists in the calling to aesthetic obedience: art counselors (aestheticians, art critics, art historians) need to serve up wisdom for both the simple-minded and the professionals; art mediators (curators, theater and film producers, gallery directors) are asked to provide the interconnective leadership to generate reliable aesthetic and artistic production; and art public (every man, every woman, and every child on the street) is enjoined to receive artworks and artistic performances with informed taste and neighborly critical, enabling support.[13]

A key to biblically motivated public artistic action and formation of its necessary aesthetic well-springs in our day is, I believe, to recognize and share imaginatively the suffering of the world neighbors God gave us, never to rest in educated irony, and to move onward step by step in hope doing what is just. Of the three things Scripture says remain—faith, hope, and love—the most human of these is hope.

Britt Wikström's installation of five poles and figures for an Amnesty International artistic invitational, entitled *Cathedral of Suffering* [#6], should be sited on an American Christian college campus (for example, marooned in the lovely small lake outside the windows of Calvin Theological Seminary in Grand Rapids, Michigan). The vulnerable woman figure is bent to shield herself helplessly from the unstopping attack; the little child, arms raised to protect its face, has its own solitary grown-up pole; the spread-eagled man is crucified between the torture of hanging from two poles; and the empty pole stands waiting for another victim. Evil and human sin are insatiable. As you walk away from this poignant

13 My restricted focus in this essay dealing with *aesthetic* responsibilities does not gainsay the need for political, economic, civic, and educational obedience to Christ's Rule.

[#6] Britt Wikström, *The Cathedral of Suffering*, 1994

double-duty artistic testimony to our own horrendous permitting of such terror happening even as you read these words—too cruel for earth to bear it, and chillingly unacceptable to the heavens, placeless—it occurs to you that maybe the empty pole is meant for yourself.

The Peace Tree [#7] was conceived by the Christian sculptor white man Gert Swart together with various local black community arts project organizations in Pietermaritzburg, South Africa, where at the time violence was among the worst for trouble spots in the crying beloved country. A group of "cultural workers" built this

[#7] Gert Swart and friends. *Peace Tree*, 1991-92

aesthetic object of gaily painted tires in December 1991, and put it in the very center of the city near its old war memorials, converting necklaces

of death into suspended trinkets filled with laughter and a gut prayer imaginatively bodying forth hope in the public square.

Finally, as a beckoning token one could remember Georges Rouault's *Sarah* (1956) [*NA* #87], who in older age bore a child named "Laughter" (Isaac), Rouault's allusive metaphor, I think, for the resurrection life to be found in the power and glory of Jesus Christ. Rouault's quiet *art-as-such* work *Sarah* is a brilliant offering to anyone in public with eyes to see (and ears to hear whoever will be talking with you in the art gallery about the artistry). It welcomes anyone publicly to the peace of what it means to be biblically "Christian," following the Lord until the Christ returns, when all jubilee breaks out.

Bibliography

Anderson, B. *Imagined Communities: Reflections on the origin and spread of nationalism* (London: Verso, 1983).

Arendt, Hannah. *The Human Condition* (Chicago: University of Chicago Press, 1958).

Bernstein, J. M. *The Fate of Art: Alienation from Kant to Derrida and Adorno* (Cambridge: Polity Press, 1992).

———. "Introduction" in *The Culture Industry: Selected essays on mass culture by Theodor W. Adorno* (London: Routledge, 1991), 1–25.

Brecht, B. *Brecht on Theater: The development of an aesthetic*, trans. John Willett (New York: Hill and Wang, 1964).

Bristol, M. D. *Carnival and Theater: Plebeian culture and the structure of authority in renaissance England* (London: Methuen, 1985).

Butler, C. *After the Wake: An essay on the contemporary avant-garde* (Oxford: Clarendon, 1980).

Chambers, I. *Popular Culture: The metropolitan experience* (London: Routledge, 1986).

Chicago, J. and S. Hill. *Embroidering Our Heritage: The Dinner Party needlework* (Garden City: Anchor, 1980).

Clifford, J. *The Predicament of Culture: Twentieth-century ethnography, literature, and art* (Cambridge, MA: Harvard University Press, 1988).

Cockcroft, F. J. Weber, and J. Cockcroft, *Toward a People's Art: The contemporary mural movement* (New York: Dutton, 1977).

Coles, R. "The Art Museum and the Pressures of Society," in *On Understanding Art Museums*, ed. S. E. Lee (Englewood Cliffs: Prentice-Hall, 1975), 185–203.

Crow, T. "Modernism and Mass Culture in the Visual Arts," in *Modernism and Modernity: The Vancouver conference papers*, eds. B. H. D. Buchloh, S. Guilbaut, and D. Solkin (Halifax: Nova Scotia College of Art and Design, 1983).

Crow, T., M. Rosler, C. Owens, et al. "The Cultural Public Sphere," in *Discus-*

sions in Contemporary Culture, ed. H. Foster (Seattle: Bay Press, 1987).

Debord, G. *La société du spectacle* (Paris: Éditions Gérard Lebovici, 1987).

Eliot, T. S. *Notes towards the Definition of Culture* (London: Faber and Faber, 1948).

Felperin, H. *Beyond Deconstruction: The uses and abuses of literary theory* (Oxford: Clarendon, 1985).

Goudzwaard, Bob and H. de Lange. *Beyond Poverty and Affluence: Towards a Canadian economy of care* (Toronto: University of Toronto Press, 1995).

Griffioen, Sander. *The Problem of Progress* (Sioux Center: Dordt College Press, 1985).

Habermas, Jürgen. "The Public Sphere" (1964), trans. S. and F. Lennox, *New German Critique* 1:3 (Fall 1974): 45–55.

Hunter, J. D. *Culture Wars: The struggle to define America* (New York: Basic Books, 1991).

Huyssen, A. *After the Great Divide: Modernism, mass culture, postmodernism* (Bloomington: Indiana University Press, 1986).

Jameson, F. "Postmodernism and Consumer society" (1982), *Postmodern Culture*, ed. H. Foster (London: Pluto Press, 1987), 111–25.

Jauss, H. R. *Literaturgeschichte als Provokation der Literatur-Wissenschaft* (Konstanz: Konstanz Universitätsverlag, 1967).

Kouwenhoven, J. A. *Half a Truth is Better than None: Some unsystematic conjectures about art, disorder, and American experience* (Chicago: University of Chicago Press, 1982).

Lacy, S., ed. *Mapping the Terrain: New genre public art* (Seattle: Bay Press, 1995).

Leach, Jim. "Sampling and Society: Intellectual infringement and digital folk music in John Oswald's *Plunderphonics*," in *The Arts, Community and Cultural Democracy*, eds. Lambert Zuidervaart and Henry Luttikhuizen (London: MacMillan Press/New York: St. Martin's Press, 2000). 108–121.

Lippmann, Walter. *The Public Philosophy* (New York: Mentor, 1955).

Lyotard, J. "Réponse à la question: qu'est-ce que le post-modern?" (1982), *The Postmodern Condition*, trans. R. Durand (1983) (Minneapolis: University of Minnesota Press, 1988), 71–82.

Maritain, J. *Man and the State* (Chicago: University of Chicago Press, 1951).

Mayo, J. M. *War Memorials as Political Landscape* (Westport: Praeger, 1988).

McGrath, J. *A Good Night Out: Popular theater—audience, class and form* (1981) (London: Methuen, 1989).

Mitchell, W. J. T., ed. *Art and the Public Sphere* (Chicago: University of Chicago Press, 1992).

Polhemus, T. *Street Style: From sidewalk to catwalk* (London: Thames and Hudson, 1994).

Rookmaaker, Hans R. *De Kunstenaar een Profeet?* [1965], translated as "The Artist as a Prophet?" in *The Complete Works* (Carlisle: Piquent, 2005), 5:169-187.

Rosenberg, H. *Artworks and Packages* (New York: Dell, 1969).

Sachs, Albie. "Preparing Ourselves for Freedom" (1989–90), in *Spring is Rebellious: Arguments about cultural freedom*, eds. I. de Kok and K. Press (Cape Town: Buchu Books, 1990).

Said, E. W. *The World, the Text, and the Critic* (Cambridge, MA: Harvard University Press, 1983).

Shewring, W. *Artist and Tradesman* (Marlborough: Paulinus Press, 1984).

Schultze, Quentin, R. Anker, J. Bratt, W. D. Romanowski, J. Worst, and L. Zuidervaart. *Dancing in the Dark: Youth, popular culture, and the electronic media* (Grand Rapids: Eerdmans, 1991).

Seerveld, Calvin. *Rainbows for the Fallen World: Aesthetic life and artistic task* (Toronto: Tuppence Press, 1980/2005).

Shusterman, R. *T. S. Eliot and the Philosophy of Criticism* (New York: Columbia University Press, 1988).

Sorell, V. A. ed. *Guide to Chicago Murals: Yesterday and today* (Chicago: Chicago Council on Fine Arts, 1979).

Steiner, G. *Real Presences* (Chicago: University of Chicago Press, 1989).

Taylor, B. "After Post-Modernism," *Art Monthly* 104 (March 1987): 5–9.

Trotsky, L. *Literature and Revolution* (1922–23), trans. R. Strunsky (Ann Arbor: University of Michigan Press, 1960).

Twitcheil, J. B. *Carnival Culture: The trashing of taste in America* (New York: Columbia University Press, 1992).

Vladislav, J. *Václav Havel: Living in truth* (London: Faber and Faber, 1990).

Vollenhoven, Dirk H. Th. *De Noodzakelijkheid eener Christelijke Logica* (Amsterdam: H. J. Paris, 1932).

Williams, R. *Culture and Society 1780/1950* (New York: Harper and Row, 1958).

Zuidervaart, Lambert. *Adorno's Aesthetic Theory: The redemption of illusion* (Cambridge, MA: MIT Press. 1991).

Zuidervaart, Lambert and Henry Luttikhuizen, eds. *The Arts, Community and Cultural Democracy* (London/New York: MacMillan/St. Martin's, 2000).

My sincere thanks go to graduate assistant researcher Hamish Robertson for tracking down leads in this project.

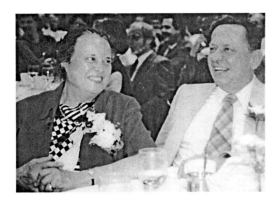

Inès and Calvin Seerveld at celebration of Festschrift, *Pledges of Jubilee*, 1995 (photo by Edwin de Jong)

ON IDENTITY AND AESTHETIC VOICE
OF THE CULTURALLY DISPLACED

I will speak as a person who is handicapped by being culturally at home in a rich tradition of Reformation Christianity filtered through a Dutch ethnic background.[1] Since my native cultural neighborhood is on the other side of the secularist tracks, I feel kinship with the disadvantaged minorities overridden by both a former dominant rationalism and the current fashion of calling any eschatonic narrative into question as mastermindingly oppressive.

This simple declaration of my handicap for entering the academic chess game on an embroiled topic is not meant to be a polemical assertion of my Christianitude,[2] but rather it is meant to attest how difficult it is for the insiders of institutional power—which most of us present[3] are—to hear the voice of the other solitudes.[4] And to preclude your stereotyping the speaker, which Bhabha correctly says entails both phobia and fetish,[5] let me add that I am not politically far right, I do not believe in proselyting audiences, and though I am the son of a fishmonger, I have brown eyes, am left-handed, and have never, by sticking my finger in an

1 Written with special thanks to Gideon Strauss, University of the Free Orange State in Bloemfontein, who introduced me to Mudimbe and Appiah's writings, and to Phyllis Rozendal, York University in Toronto, for discussion on the "other solitudes." Thanks also go to Ruth Kerkham, Hamish Robertson, and Scott Macklin, who diligently assisted me with library research.

2 This is an allusion to Wole Soyinka's critique of Leopold Senghor's concept of "Negritude" when Soyinka remarked that a genuine tiger does not need to proclaim its own tigritude.

3 This is the text of a lecture presented at the Learned Societies of Canada meeting in Montreal on 1 July 1995, before the Canadian Society of Aesthetics.

4 Linda Hutcheon and Marion Richmond, eds., *Other Solitudes: Canadian multicultural fictions* (Toronto: Oxford University Press, 1990), 1–5, 7–12.

5 Homi K. Bhabha, "The Other Question: Homi K. Bhabha Reconsiders the Stereotype and Colonial Discourse." *Screen* 24:6 (1983): 18–36.

Published originally in *Towards an Ethics of Community: Negotiations of difference in a pluralist society*, ed. James H. Olthuis (Waterloo: Wilfred Laurier University Press, 2000), 200-216.

earthen mass of dirt and stones, saved a Dutch town from flooding.

Let me focus on a fierce debate current among philosophically trained cultural leaders from various African countries, and just suggest how their struggle might relate to certain fundamental historical realities faced by the praxis of First Nation artistry of Canada in our generation. The complex problem I probe is this: is it possible for a fourth-world culture[6] to avoid both idols of the tribe and ethnocidal assimilation by the entrenched, dominant, civilizational power? Are there good ways for an other, diverse community to establish its own vibrant cultural and artistic identity in the world, or is such a prospect utopian?[7]

Professional Philosophy versus Ethnic Native Cultures
In the African philosophical discussion of cultural identity, on the one hand Paul Hountondji (Benin-Nigeria), Peter Bodunrin (Nigeria), and Kwasi Wiredu (Ghana) press for secularity, a neutral rationality (somewhat as Habermas does)[8] so that philosophy can be professional, scientifically critical philosophy the way mathematics is theoretical mathematics,[9] unencumbered by folkloric African residues.

Hountondji, Bodunrin, and Wiredu are current voices that reject leaders of the recent past. In order to combat a century of European colonializing exploitation, statesman Leopold Senghor (Senegal) had championed Negritude, to rally black self-respect throughout Africa, in the firm belief that cultural independence is a prerequisite for political independence.[10] Similarly, Sartre's ringing co-affirmation of the black Orpheus poet's going as *vates* to claim Eurydice from the European Pluto exile,

6 "The Fourth World is the collective name for all aboriginal or native peoples whose lands fall within the national boundaries and techno-bureaucratic administrations of the countries of the First, Second, and Third Worlds. As such, they are peoples without countries of their own, peoples who are usually in the minority and without the power to direct the course of their collective lives." Nelson H. H. Graburn, ed. *Ethnic and Tourist Arts: Cultural expressions from the Fourth World* (Los Angeles: University of California Press, 1976), 1.

7 Rasheed Araeen, *The Other Story: Afro-Asian artists in postwar Britain* (London: Haywood Gallery, 1989), 83.

8 Sander Griffioen, "De betekenis van Dooyeweerds ontwikkelingsidee," *Philosophia Reformata* 51 (1986): 83–109, especially 101–102.

9 Alwin Diemer, ed., *Symposium on Philosophy in the Present Situation of Africa* 30 August 1978 (Wiesbaden: Franz Steiner, 1981), 9. (Cited as Diemer.) With contributions by Odera Oruka, Peter Bodunrin, Paulin J. Hountondji, and others.

10 Olusegun Gbadegesin, "Negritude and Its Contribution to the Civilization of the Universal: Leopold Senghor and the Question of Ultimate Reality and Meaning" in *Ultimate Reality and Meaning* 14, 1 (March 1991): 30–45, especially 31, 37. (Cited as Gbadegesin.)

using the French language![11] was a well-meant endorsement in 1949 of revolutionary activity, but was veritably an obfuscative romanticizing of the "pre-contact" African past.[12] There is, says Bodunrin, no pure original "Africa" on which to build an autochthonous African philosophy.[13]

The earlier Pan-Africanist movement forged by Afro-American Alexander Crumwell (1819–98), Edward W. Blyden (1832–1921), and W. H. B. DuBois (1868–1963), who were intent on fixing a non-European black identity, reached its culmination in Kwame Nkrumah's (Ghana) post-World War II speech in Liberia on "Africa for the Africans!" But we need to demythify Africa, says Hountondji. "Africa is no more than the geographical place name it is"[14] because the plurality of ancient *poleis* and multifariousness of indigenous tribal cultures on the continent called Africa belie any unanimous homogeneity.[15] Pan-Africanism, like Zionism, assumes an antiracial racism, and remains entrapped in the detractive, bogus problematics of the oppressors.[16] There is no essential African philosophy: there is only a set of written discourses, a collection of heterogeneous, open philosophical texts in Africa whose cultural values are like venereal diseases, owned by no one ethnic people.[17] "I speak as an anxious African," says Wiredu: we need to grow up and grow out of traditional "folk thinking," and separate worthwhile aspects of our tradition from what is superstitious, like "pouring of libations to the spirits of our ancestors on ceremonial occasions."[18]

On the other hand, figures like K. C. Anyanwu (Nigeria) and Ngugi wa Thiong'o (Kenya) find this (modernist) rejection of ethno-philosophy and native culture too antiseptically quick, committing the very error it faults—ethnocentrism. What in the world validates converting the particular Western mould of *philosophia perennis* secularized to neutral

11 Jean-Paul Sartre, "Orphé Noir," trans., John MacCombie in *"What Is Literature?" and Other Essays* (Cambridge: Harvard University Press, 1988), 296–98, 300.

12 Godwin Sogolo, *Foundations of African Philosophy: A definitive analysis of conceptual issues in African thought* (Ibadan, Nigeria: Ibadan University Press, 1993), 203.

13 Bodunrin in Diemer, 13.

14 Hountondji in Diemer, 41.

15 Gbadegesin, 43.

16 Kwame Anthony Appiah, *In My Father's House: Africa in the philosophy of culture* (New York: Oxford University Press, 1992), 43f. (Cited as Appiah.)

17 Paulin J. Hountondji, *African Philosophy: Myth and reality* (1976), trans. Henri Evan with Jonathan Ree (Johannesburg: Hutchinson University Library for Africa, 1983), 175–79.

18 K. Wiredu, "How Not to Compare African Thought with Western Thought" from *Ch'indaba,* republished in Richard A. Wright, ed., *African Philosophy* (Lanham: University Press of America, 1984), 149–62, especially 150, 152, 159.

theoretical analysis, to be the universal criterion for all philosophy everywhere? Why should the paradigm of Plato's categorical framework, whose anthropology assumed slavery and whose theory on the nature of art was wrong, and Aristotle's logic, which pretends to go timelessly beyond dated, human experience,[19] be the norm for rigorous African (or Eastern) critical reflection and wisdom?[20]

If we grant that the era of Negritude counter-racism became itself counterproductive, because the *prises de parole* handicapped European-educated African thinkers and artists as "primitives" and disallowed their setting their own agenda;[21] and while it is indeed a mistake—to vaunt independent national identity nationalistically or fetishize one's tribal roots—there is no way to escape the ruinous imperialism overrunning African countries unless there be an African literature in African languages. The forced imposition of foreign languages—English, French, Portuguese—upon people speaking Hausa, Yoruba, Igbo, Zulu, Venda, Swahili, Kiswahili, says Ngugi wa Thiong'o, dislocated those unprotected people's actual lives, because language is the memory bank of a people, and literature in people's language defines its outlook, its own ethos. To have one's mother tongue repressed by bureaucratic governing overlords, and to find one's oral heritage of stories truncated, stunted from continuing in literature because one's tribal literati publish in world-market languages, is simply devastating to a people's dignity.[22]

So acclaimed Kenyan novelist Ngugi wa Thiong'o acted consequently from his jail cell in 1977 and decided henceforth to write novels only in the Gikuyu language. In 1986 he also wrote his last English essay, "Decolonising the Mind." "From now on it is Gikuyu and Kiswahili all the way,"[23] to service his people's deep-structural need for a self-respecting cultural identity and, along with world literature in translation, try to decenter from the Kenyan literary educational program stalwart pillars like Matthew Arnold, T. S. Eliot, and F. R. Leavis.[24]

19 D. H. Th. Vollenhoven, *De Noodzakelijkheid eener Christelijke Logica* (Amsterdam: H. J. Paris, 1932), 48–50.

20 K. C. Anyanwu, "The Idea of Art in African Thought" in *Contemporary Philosophy, A New Survey, African Philosophy*, vol. 5 (Dordrecht: Nijhoff, 1987), 235–60, especially 237–40.

21 V. Y. Mudimbe, *The Invention of Africa: Gnosis, philosophy, and the order of knowledge* (Bloomington: Indiana University Press, 1988), 39. (Cited as Mudimbe.)

22 Ngugi wa Thiong'o, *Decolonizing the Mind: The politics of language in African literature* (Nairobi: Heinemann Kenya, 1986), 310–17, 327–30.

23 Ibid. xiv.

24 Ibid. 90, 98–101.

Complications and Options for Africans

Despite the sharp leadership difference between what look like no-name philosophers to the adherents of native culture and what seems to be a hole-in-the-corner parochiality flirting with racism to the professional secular theorists, fairly common to all the disparate peoples and cultures of sub-Saharan Africa is the sorry past of colonialized defeat. Foreign explorers and enterprising merchants took charge of the land, domesticated the natives' ways to European customs, and introduced superior technology, which along with medical and transportational benefits and sundry conveniences upset the local economies. Pertinent for our North American understanding of the aggrieved response of formerly colonized peoples in Africa (and the First Nations peoples of Canada) is to realize that their traditional mode of life with its spiritual framework was desecrated, decimated, and that the cultural body of their communal consciousness was violated, literally raped—penetrated and discarded.[25]

The philosophical conundrum is that violence, paved with the best intentions, happens whenever a secular culture, whether idealist or pragmatist, that is technologically more specialized and powerful, confronts a less differentiated society whose culture is less technically developed and still wrapped uncontroversially in the practice of worshipping invisible beings. For example, when written language and literacy invades an oral culture, the former full-orbed, preliterate world where the lore and rich consensus of age-old knowledge was passed on by word of mouth of the elders suddenly becomes an illiterate world, disadvantaged by not being able to keep records with abstract precision for unfriendly scrutiny.[26] Or, when a tribal culture that is open to the wild, wonderful, and fearful in terms of agency by familiar but uncanny spirits is breached by an industrialized, urban, urbane mentality that casts unsure societal relations into the functional matrix of inanimate billiard balls' causality, suddenly the *One Hundred Years of Solitude* kind of miraculous and magical earthy mix of strange realities is taken to be the superstition of mana and tabu, something "primitive," not really worthy of an enlightened humanity. So the Western secular mind trivializes a deeply committed acceptance of numinous presence and the power of curses in the world.[27]

Why does advanced *techné* paired with the concentrated reductive force of secularization apparently, as a matter of fact, always overpower the traditional, non-experimental, minding-its-own-regular-business

25 Mudimbe, 2–4.
26 Appiah, 130–33.
27 Ibid. 120–24.

kind of culture? Must the meeting of diverse cultures truly be confrontational, discriminatory, disruptive, cast in terms of the stronger and the weaker with winners and losers?

Cultural identity, like ethnic inheritance, I think, is seldom thoroughbred, never simple, but normally intricately compounded with a people's political identity, wealth-to-poverty identity, mother tongue and acquired languages identity, faith-in-where-the-buck-stops (Yahweh, Allah, Jesus Christ, the Almighty Dollar) trust identity.

Any kind of cohering community, civilization, any dated and located (also in diaspora) grouping of society with a proper nameable identity—Asante kingdom, Dutch, Muslim, Latin people, South African—has a polymorphous complexity to its particularity. Trouble comes when one relative feature of the community's identity is fixed upon absolutely, rigidly conceived, yoked with other characteristics as requirement, or given final binding authority also for persons who do not choose to belong, to identify with that given community. Whenever nationality, economic class, language or creed, ethnicity, the construct of race or gender, style or education, is given overriding exclusivist weight in defining an individual's adherence to a human community, the normal enrichment each factor brings to the particular identity goes askew. (Perhaps what one fundamentally trusts is non-negotiable; but while one has the right to be a martyr, it is not legitimate to make martyrs of others.) Naturally, says Al-Amin Mazrui (Nigeria), a novelist employs the language of one's people, in sheer thankfulness for the ethnic watershed that nurtured his or her writing artistry; but when Ngugi wa Thiong'o berates Chinua Achebe and Wole Soyinka as Afro-European turncoats to the political aspirations of their people, Ngugi wa Thiong'o has made language ideological, since linguistic heterogeneity is not determinative against political unity.[28]

Kwame Anthony Appiah (Ghana) supports the point that cultural identity is a crucial ingredient of peoplehood, but still relative, with the startling assertion, "The truth is that there are no races."[29] Todorov shows that racism and witch hunts do not entail the existence of races and witches, says Appiah, and adds, "Nations are real enough, however invented their traditions."[30] That is, Harvard professor Appiah does not suffer the embarrassment Kwasi Wiredu has in pouring a libation of respect for one's ancestors. "I am an Asante man," says Appiah, "a Ghana-

28 Al-Amin M. Mazrui, "Ideology or Pedagogy: The linguistic indigenisation of African literature." *Race and Class* 1 (Summer 1986): 63–72, especially 64–65, 69–70.

29 Appiah, 45.

30 Ibid. 175.

ian, an ecumenical Methodist Christian, Cambridge educated, polyglot, and would not even mind throwing a sacrificial lamb to a river crocodile in the funeral ritual of determining who will inherit the authority as head of the *abusua,* my matriclan."[31] My melee of a cultural identity is not a shameful, uneasy syncretism, says Appiah, but still enjoys the oral accommodative, enchanted world Africans recognize as their traditional inheritance. My conglomerate cultural identity has not been shattered by the scientistic, positivistic, individualistic climate of aggression, mobility, and pointed oppositions with which modernity prickles. The crux for us people caught in the uncomfortable earthquake zones of deep underground cultural realignments today is to maintain a challenging cultural integrity rather than let cultural identity fall into an eclectic, confused, disparate muddle.[32]

V. Y. Mudimbe (Zaire), however, takes a more morose position than Appiah's brokering for a cultural identity, because Mudimbe believes the acculturation process of peoples, which is historically normal everywhere, world without end, has been warped on the African continent by colonialist discourses, which are still in force today, in spite of the occasional rousing Marxist, socialist, and nondescript angry spokespersons over the years. The Western invention of Africa rests on a triple subtext of the exotic savage, higher and lower cultures, and the ethnographic anthropological search for and reification of primitiveness. The *episteme* of conversion and conquest hidden in these patterning discourses, says Mudimbe, has robbed our peoples of their own stories; hence, the cultural identity crises. We intellectuals need to reinvent the African past, because the present legends conveniently mitigate the violence of the Same in dispensing with us Others.[33] "Western reception of artistry fashioned in Africa today, taking its otherness as both monstrosity and *corpus mirabiliorium,* has not qualitatively changed since the first reports of the sixteenth and seventeenth centuries,"[34] when the handiwork of craftsmen and women in Africa was collected as curios. Since Mudimbe considers history writing to be always a special pleading by the arrogant, self-centered Same, Mudimbe with Foucault would deny privilege to any center, and find strategies for regional Others to permanently recapitulate history-keeping until they are free to think of themselves "as the starting

31 Ibid. epilogue, 181–92.
32 Ibid. 54, 119–30, 134–36.
33 Mudimbe, 67–69, 192–96.
34 Ibid. 191.

point of an absolute discourse."[35] So Mudimbe puts artistic action more or less on hold.

Since artistry is critical for cultural identity, however, "What is to be done?" (as Lenin said), What is being done? Do not produce African art complicit with the national bourgeois and international elite market for exotica—do not become an Otherness machine, writes Sara Suleri with stilettos of irony, because the exotic Other is, as Yambo Ouologuem (Mali) asserts, a cheap self-identity, still concocted within the master-slave dialectic.[36] African tourist airport-art is the epitome of "post-colonial" neocolonialism: there is no gunboat diplomacy and no political disenfranchisement in producing and distributing such "neo-traditional" craft for export, and money sends everybody home happy; but the African birthright of tigritude is sold for a mess of potage, consumed as bookends.[37]

If one looks philosophically upstream, as Mudimbe suggests,[38] to uncover the silent source of this denaturing exotic Africa locked in mortal embrace with monolithic Western commerce, one would begin to question, I think, the underlying same/other binary problematics, despite its fashionableness for rhetorical purposes today. If identity/difference, the same/other, centre/margin is all there is—*tertia non datur*—then one's artistic activity and hermeneutic is forced into a standoff of power plays.[39] The ontical possibility of mutual cultural reciprocity is denied. The oversimplified lineup also evacuates multiple, rich, circumstantial specificities, which can frequently mediate longstanding difficulties.[40] Categorical binarisms usually falsify realities, and the resident conceptual stalemate only prolongs the culture wars that have been ontologically certified.

Once the underside of this basic ontological polemic is self-consciously adopted as point of entrance, and the Other has refused to be assimilated by the dominating center, us/them induces "protest art." Art protesting "them" can be blatantly propagandistic like Msangi's "Bastion

35 Ibid. 27, 33–34, 198–200.
36 Cited in Appiah, 156–57.
37 Appiah, 148–49; Mudimbe, 11–12.
38 Mudimbe, x–xi.
39 Wlad Godzich, "The further possibility of knowledge" in Michel de Certeau, *Heterologies: Discourse on the other,* trans. Brian Massumi (Minneapolis: University of Minnesota Press, 1989), ix–xi.
40 "I, at least, worry about our entrancement with the polarities of identity and difference partly because the rhetoric of alterity has too often meant the evacuation of specificity partly because too many African intellectuals, captivated by this Western thematic, seek to fashion themselves as the (image of the) Other. . ." Appiah, 72.

of Apartheid: The Dutch Reformed Church" (Tanzania, 1980s), or modified to political satire in a velvet corkwood painted caricature of Prime Minister P. W. Botha with white blinders on (Phutuma Seoka, 1985). The permutations for "protest art" in South Africa have been endless, often sadly mocking black compliance before the cement brick wall of Western "world" concerns.

But Albie Sachs (African National Congress Minister of Culture in exile, who lost a whole arm to a car bomb planted by the political far right when he returned, and who is currently [1995] Supreme Court Justice of the united coalition government of South Africa) broke out of the self-perpetuating reactive aesthetics with an eloquent 1989 position paper on "Preparing ourselves for freedom." To make art a weapon of political struggle, a tool against apartheid, he contends, denatures the power of art to be nuanced and imaginatively ambiguous, restricts the full orb of themes that human art normally treats, harps on attacking the enemy, and tends to minimize art quality so long as the message is politically correct.[41] Whoever would be a free people and lead in a non-hegemonic manner toward the multilingual, multicultural, multifaith society of the new South Africa needs to celebrate artistically what one lives for: "culture is us"—in all our pied multifariousness, with the pulsing confident beat of our folk music and dance.[42] "[W]e do not plan to build a non-racial yuppie-dom which people may enter only by shedding and suppressing the cultural heritage of their specific community."[43]

Artistic Evidence of Hope in South Africa
I have seen the kind of uncommercialized, non-protesting, ethnically flavored open-to-the-neighbor art Albie Sachs' vision would engender. Even in the South African shantytowns presided over by police gun-control towers one finds the wonderful aesthetic touch of a grass carpet tended to grow in the rubble before the communal toilet outhouse; or at the edge where the squatters' camp meets a government road there will be a piece of what came to be called in the 1980s "township art" [#1].

Wood carvings by local black artists can snapshot an expert head-block in the secular religion of soccer, or portray a mother (Dian Cormick, 1990) straining to hold back her sons, with the theme Käthe Koll-

41 Ingrid de Kok and Karen Press, eds., *Spring Is Rebellious: Arguments about cultural freedom by Albie Sachs and respondents* (Cape Town: Buchu Books, 1990), 19–22 (Cited as De Kok and Press.)

42 Ibid. 21–23, 27–28.

43 Ibid. 25.

witz often treated, "Don't let the men go to war." Or the celebrated Jackson Hlungwane (1923–2010) whose four-meter high *Adam and the Birth of Eve* (1985–88) presents a solemn, ungainly giant figure with Eve ethe-really evolving out of the head and shoulder portions while the dangling legs, hand, and arms are from their children Cain and Abel [#8]; in the palm of the upper hand is an egg, not a stone, says Hlung-wane, a hint on how men and women should treat one another. His *Altar of God*, with figures of God, angel Gabriel, metal cross, and wooden solar arc over heaped stones, blends Tsonga beliefs and articles of biblical faith idiosyncratically. The altar was more at home in the Mbhopkota village in Gazakulu, northern Transvaal, on the site Hlungwane calls "the New Jerusalem," where he lived, carved, and preached to his following. In the Johannesburg Art Gallery it is gentrified, like taking the welter of cascading sound of black spirituals sung in a church on the south side of Chicago and having it concertized by the Robert Shaw Chorale, Schubertianized, you could say. But the fact that *Altar of*

[#8] Jackson Hlungwane, *Adam and the Birth of Eve*, 1985-88

God was originally not made for sale or show still comes through.

If one wants to be pulled back to raw South African artistry, one can contemplate this small painted clay piece [#9] done by a nine-year-old child in Durban whose craft-class school assignment was "Make something you've seen recently," a tire-necklaced human figure burned beyond recognition.

[#9] Anonymous piece from school class assignment in Durban, South Africa.

Major Afrikaner artist Andries Botha learned indigenous crafts to acculturate his sophisticated artistic conceptions into pieces that reconcile quite divergent milieu, like this artwork [*NA #82*] entitled *Baptism for the fallen ... and those taken darkly* (1991). It acts like an epitaph for those who have mysteriously died and been found—washed up face down by the waves, like the prone black figure. The eddy of water waves is woven from thatching grass by master Zulu builder Maviwa and women weavers Myra and Agnes Ntshalintshli from Drakensberg. It is difficult to see, but the upper half of a living woman-figure of wire mesh is emerging from a silver fish's mouth, whose scales are composed of soda-can tops. The waves of grass are warm and friendly, caressing the living and the dead. Some die in the flood of water; some like Jonah are saved by a fish—*ichthus*—and disengorged up on the shore.

A final example is a celebrative artwork in Pietermaritzburg, Natal, where violence and murder have been almost the worst in South Africa [see #7]. A Christian sculptor, white man Gert Swart, together with various local black community artists and grassroots organizations, built *Peace Tree* with gaily painted tires around Christmas time in 1991. They put it in the very centre of the city near its old Boer War memorials, converting necklaces of death into suspended trinkets filled with laughter and a poignant hope, in public space, for "Cry, the beloved country."

Concluding Theses to Orient Policies

There are three theses I could distill from what I have analyzed so far:

1. While hatred for the former colonialist guardians and current neo-colonialist manipulative policies may make some kind of sense, says Mudimbe, anger is no longer important or helpful for disadvantaged people to become culturally (artistically) mature.[44] To live from handouts and/or festering bitterness stymies a human community from ever taking root in what it stands for. Root art in what is an identifying goodness of one's diversity for the neighbor.

2. While the "once bitten, twice shy" postmodern mentality toward Archimedean point commitment for one's core identity is understandable, to avoid the fragmentation of legitimating any local cultural leftovers whatsoever, says Appiah, we would do well to follow the lead of those novelists and artists who identify with *la négraille*, the nigger-trash of whatever date and place,[45] the poor, which you always universally have with you, especially if you are middle class. To enable the culturally weak and diverse to sound their voice in the human choir, the culturally dominant need to convert their strength into at least enough restraint to listen to the offbeat song, strange shapes, and speech only partially intelligible to them.[46] Let stifled, peaceable contributions to the commonweal be made public.

3. Mainstream connoisseurs, theorists, and educators need to relax enough to recognize that "cultural work" like agitprop theatre, didactic posters, protest songs, imaginative events like the *Peace Tree*, which are not refined art ready for gallery, museum, and concert hall do, however, belong in the larger aesthetic world as critical training ground for grassroots culture to develop historically an artistic voice that has communal identity.[47] Without exacting conformity to mainstream quality art fashion, nurture what shows promise.

Our Canadian Scene

The struggle to be ethnically at home with a cultural identity even as one's community is in the process of change for good and/or ill in the

44 Mudimbe, 36.

45 Appiah, 152.

46 "To keep multiculturalism from becoming just a complacent cliché, we must work to grant everyone access to the material and cultural conditions that will enable the many voices of contemporary Canada, to speak—and be heard—for themselves" (Hutcheon: 15–16).

47 Junaid Ahmed in De Kok and Press, 123–25.

world at large, which I have sketched, resonates with Canadian concern to make earnest with the multicultural perplexities of our inherited environs. I have not yet seen enough or talked with enough First Nation artists to try to formulate a taxonomy of our complex problematics. At the risk of being simply an academic WASP kibitzer from the sidelines let me end by noting very briefly three troubles, and make a wish.

1. George Swinton reports how amazed Inuit John Tiktak was when he was flown in from Rankin Inlet to Winnipeg in 1970 for his first ever "one-man show," which Swinton had arranged. Tiktak was flabbergasted to see dozens of his carvings to be held in the hand all exposed separately together. After the 1970 show Tiktak went home, writes Swinton, and started to mass produce pieces, which became hollow echoes of the original work.[48] And I have read testimonies by Inuit carvers in their own script that so painfully protest just a little too much that "Inuit carve, not just for the money."[49]

 Was Swinton's generous act the kiss of Midas? Are we *kabluna* prudent enough to let the Innu have their graphic art speak their own language, or has our touch made it pidgin Inuit artspeak, an astounding cold and remote voice—in exile?[50]

2. Bill Reid was trained in the European goldsmith speciality and describes himself in refashioning old West Coast Indian themes in today's world as an "artifaker."[51] When Reid fashioned his incredible *Phyllidula: The Shape of Frogs to Come* [#10] he invented something artistically new in cedar wood that is not faking migrant Haida mythical frogs, but astounds your imagination with its poised, froggy animal mystery. The impressive showpiece [#11] *The Spirit of*

48 George Swinton, "About My Collecting Inuit Art" in *The Swinton Collection of Inuit Art* (Winnipeg Art Gallery, 13 September to 8 November 1987), 8.

49 ᐃᓄᐃᑦ ᐸᐅᕝᓯᖅᑕᒥᔪᐊᓇᒧᑦ ᐱᔪᐃᓇᓖᑦ (Repulse Bay: 25)

50 "Currently there exists a growing degree of Eskimo [*sic*] ethno-centricity, and the political pressures are such that the governmental agencies—more so the federal than the territorial—are vitally interested in supporting the Inuit's cultural aspirations. On the other hand, economic pressures and so-called 'purely commercial' pragmatism are posing an almost irresistible threat. In spite of good intentions, our white culture together with our educational system (which is at best inadequate and at worst corrosive) plus the increasing influx of transient and inherently parasitical whites further menace the Eskimo's [*sic*] chances of continued existence and identity." George Swinton, *Sculpture of the Inuit* (1972), rev. ed. (Toronto: McClelland & Stewart, 1992), 143.

51 The term "artifaker" comes from Bill Holm in Karen Duffek and Bill Reid, *Beyond the Essential Form* (Vancouver: University of British Columbia Press with UBC Museum of Anthropology, 1986), 40.

[#10] Bill Reid, *Phyllidula: The Shape of Frogs to Come*, 1984-85

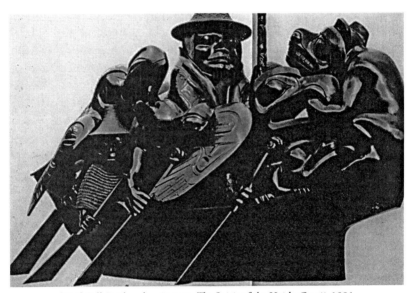

[#11] Bill Reid and assistants, *The Spirit of the Haida Gwaii*, 1991

Haida Gwaii (1986-91) at the Canadian embassy in Washington, DC, however, seems to me to strain under the making of a Haida artist. The official video, *The Spirit of Haida Gwaii* (48 minutes,

[#12] Douglas Cardinal Associates,
Canadian Museum of Civilization, 1980s

1991),[52] presents the Haida creation myth in Walt Disney animated
cartoon form(!), calling into question, it seems to me, the very au-
thenticity of taking Haida ethnicity seriously, especially when Reid's
piece has a tongue-in-cheek resemblance to Emanuel Leutze's staged
icon of *Washington Crossing the Delaware* (1851).

Or is Bill Reid's black canoe with shaman and undomesticated
animals afloat, without a flag to plant somewhere, precisely the kind
of ironic fillip Neil Bissoondath recommends—speaking from the
privilege of success—to keep ethnicity from narrow-minding our
humanity?[53]

3. After designing St. Mary's Church in Red Deer (1968) with its cam-
panile-type towers and an almost Romanesque softness, with walls
undulating curves, Plains Metis Douglas Cardinal has gone on to
put his trademark on the Canadian architectural landscape [#12].
A Plains Indian experiences the aggressive, motorized, urban, North
American environment, says Cardinal, like a momentary lapse of

52 *The Spirit of Haida Gwaii* was directed by Alan C. Clapp, scripted by Robert Bring-
hurst, produced by Deluxe Production Canada Ltd. in Vancouver, and funded from
the Montreal Office of the Royal Bank of Canada.

53 Neil Bissoondath, "I am Canadian," *Saturday Night* (October 1994): 11–22, espe-
cially 18.

reason, which has become permanent. You are no longer an earth-ling walking upright on the sacred earth among fellow creatures, grasses and animals, to whom you are connected; in the secular city all the people seem bent on adversarial destruction. But "every act is spiritual," says Cardinal,[54] and to stay sane you have to carry "your own native reality" around with you into the killing fields of a government-sponsored major architectural project made of stone. Cardinal believes in soft power, he says, female power, because it is resilient.[55]

Cardinal's Metis wisdom sometimes sounds like Tao philosophy crossed with Norman Vincent Peale's "positive thinking," but Cardinal is resolutely hi-tech: there is not a single drafting board in his entire architectural firm headquarters in Ottawa; all architectural planning and designing is done on computers. But Cardinal returns, as an Orthodox believer would to Mount Athos, to a Native camp for the sweat-house healing and centering of Metis rituals. "The Canadian Museum of Civilization," he writes, "is a true monument to our people. I went to the ceremonial lodge and I was given the vision. It is a vision of taking technology and creating something positive with it and maintaining my way of being in doing it."[56] How could Cardinal's brilliant idiolect in Metis dialect giving color to the Canadian idiom be complemented by other rooted ethnic diversities, rather than remain a brilliant solo?

My wish is that mainline intellectuals who are serious about furthering the identity and aesthetic voice of the culturally diverse, who have become displaced in our secularized Western culture, think long range and slowly, even to the extent of learning, let's say, the Ojibwa language.[57] My wish is that without losing a systematic philosophical rigor the theoretical aesthetics we practice could pull the horizon of wisdom into focus so we could proactively, at arm's length recognize the neighborhooded nature of humans (cf. Heidegger's *Mitsein* of *Dasein),* the normality of different faith-deep communities,[58] where vision permeates one's varied

54 Douglas Cardinal, *The Native Creative Process: A collaborative discourse between Douglas Cardinal and Jeanette Armstrong* (Penticton: Theytus Books, 1991), 92.

55 Ibid. 96.

56 Ibid. 112.

57 Basil H. Johnson in Daniel David Moses and Terry Goldie, eds. *An Anthology of Canadian Native Literature in English* (Toronto: Oxford University Press, 1992), 99–104.

58 "If modernization is conceived of, in part, as the acceptance of science, we have to

relative ethnic, political, economic, lingual, philosophical identities, and then foreground the surprising complementary joy there can be in sharing diversity by way of artistry, or even philosophical discourse, in the press of life and death affairs.

decide whether we think the evidence obliges us to give up the invisible ontology. We can easily be misled here by the accommodation between science and religion that has occurred among educated people in the industrialized world, in general, and in the United States, in particular. For this has involved a considerable limitation of the domains in which it is permissible for intellectuals to invoke spiritual agency. The question how much of the world of the spirits we intellectuals must give up (or transform into something ceremonial without the old literal ontology) is one we must face: and I do not think the answer is obvious" (Appiah 1992:135).

From Ghost Town to Tent City:
Artist Community Facing Babylon and the City of God

I saw the best minds of my generation destroyed by madness, starv-
ing hysterical naked,
dragging themselves through the negro streets at dawn looking for
an angry fix,
angelheaded hipsters burning for the ancient heavenly connection to
the starry dynamo in the machinery of night,
who poverty and tatters and hollow-eyed and high sat up smoking in
the supernatural darkness of cold-water flats floating across the
tops of cities contemplating jazz,
who bared their brains to Heaven under the El and saw Moham-
medan angels staggering on tenement roofs illuminated,
who passed through universities with radiant cool eyes hallucinating
Arkansas and Blake-light tragedy among the scholars of war,
who were expelled from the academies for crazy & publishing ob-
scene odes on the windows of the skull,
who cowered in unshaven rooms in underwear, burning their money
in wastebaskets and listening to the Terror through the wall. . . .
(Allen Ginsberg, *Howl*, 1956).

And one strong angel picked up a rock, big as a millstone, and heaved
it into the lake, saying:
"That's the way—boom!—the great city of Babylon shall get the
heave and never be found again.
The sound of guitarists and folk singers and flautists and trumpeters
shall nevermore be heard in your city;
no artist, in any of the arts, shall be found any more in your (great)
city.
The sound of the mill (stone grinding) shall be heard among you no
more forever, and
the lamp light shall shine no more among you forever, and
the voice of the bridegroom and the bride shall nevermore be heard
among you

Keynote address for the Christians in the Visual Arts conference at McGill Uni-
versity, Montréal, Quebec, 19 June 1997.

—your businessmen were the bigshots of the earth!—
nevermore, because all the people were misled by your clever artistry.
They found blood too in that (city) Babylon, blood of prophets and
saints and all those (believers) who were butchered to death on
the earth. . . ."
(Revelation 18:21–24).

Beat Generation folks—Jack Kerouac (1922–69) and Ginsberg
(1926–1997) met at John Dewey's Columbia University—were angry
at the wasted debris of the urban scene in America, and incensed at the
Beautiful People of politics and the Jet Set strutting around stark rav-
ing naked in their fashionable, double-breasted postwar '50s clothes. The
Beat artists of the '60s were no longer willing to be Ralph Ellison's *Invis-
ible Man* (1952). Also the Beats knew New York City and San Francisco
not the way middle-class people did but more the way James Baldwin's
characters tasted *Another Country* (1962).

The paragraph from Revelation 18 in the Bible tells of a great city
called Babylon facing an Apocalypse Tomorrow, and it seems that the arts
and artists are implicated, along with bigshot businessmen, who misled
people and therefore became extinct, it says, under the commercialized
smog of Mammon.

If we take the biblical passage I read with Allen Ginsberg's *Howl* for
our horizons and touch of existential reality, how will it shape what we see
and understand of the topic I was asked to address: *L'Art et la foi en ville?*

It seems evident that the New York that Alfred Stieglitz photo-
graphed in 1910 as *The City of Ambition*, and the one I experienced in
the 1940s loading bushels of fresh porgies and mackerel into the truck of
my father down in the Fulton Street Fish Market at 6:00 a.m. on a sum-
mer weekday morning under the grand shadow of the Brooklyn Bridge,
and the New York that art critic Clement Greenberg commandeered in
the 1970s, were quite different cities with the same name. The identity
of a city, like the character of artistry, and the cash value of somebody's
faith, changes over time. So the dated identification being made of a city
is important as well as whose eyes and ears, hands and feet, are calling
the shots.

Carl Sandburg's *Chicago* of 1914–16:

HOG Butcher for the World,
Tool Maker, Stacker of Wheat,
Player with Railroads and the Nation's Freight Handler;
Stormy, husky, brawling,
City of the Big Shoulders...

is only a myth to those in the 1960s bunkered down in high-rise hell on the near Southside in the Robert Taylor "renewal" Project.

Before I talk about the vital intersections of our cities and the art-world, the city of God and the presence of CIVA,[1] let me try to say briefly for orientation how I understand "city," "art," and "faith."

City, Artistry, Faith

A city like a village is a permanent settlement of people in a specific location with shelter, with gardens for food and domesticated animals, specific occupations and tools, place for storage, time for training children to work and remember by stories what their earlier generations did. **A city is at core a site-specific neighborhood**, a village or town, **grown complex.** A city has a citadel center of those governing, a stronghold where ruling decisions are made and records are kept and defended. A city holds shrines, temples, special buildings, or arenas for rituals and celebrations by the populace before a god. A city has a cemetery as well as a marketplace. And a city has a border to its territory—like the black-smith's hut and forge that marks the extremity of an African tribal village. Territory outside the walls of the city, on the other side of the railroad tracks, beyond the "city limits," is extremely important to the health of the city, like a watershed.

Naturally this skeleton of "city" I have just sketched needs to be historically embodied—we'll do that—but I am proposing not an "ideal" city, not an εἶδος (form-model) à la Plato for the true πόλις: I am positing that a city with such salient features is a good institution, a provision the Creator God set up for humans to structure our interactive human sociability within, a public sharing of gifts, civic intercourse. How humans in history have filled out the creational contours of cityscape—already Cain built a city, says Genesis 4:17—is our signature on God's promissory note, and we humans in history have produced *nephilim*, monsters.

But cities have staying power despite generations of poor builders or series of devastating conquerors—Damascus, Jerusalem, Rome, Paris, cleft Berlin, Johannesburg—because God's firm grip to have humans constitute cities for common weal and common woe is a provident blessing humans live under no matter what vocational task one assumes, and no matter whether our faith be Jewish, Christian, Muslim, Buddhist,

1 Christians in the Visual Arts (CIVA) is an organization begun in 1979 that now has over 1300 paid memberships. Its purpose is to support artists, serve the church, and be fully present in engaging the present culture.

Hindu, animist or secular Humanist.

"Artistry" for me **is an object or event of imaginative craftsmanship that has an allusive finish to its independent identity.**
An artist will always be an artisan, a skilled worker, trained or self-taught to bring material or media like live bodily movement, spoken words, or voiced tones to a sensuous metaphorical kind of result we call choreographed dance, rhetoric, human song. Art can be distinguished gingerly from craft in that art is not a well-formed decorated tool: art like a jewel may have many external functions but as artistry, like a jewel, its peculiar vested nature is not to be a tool but to be a work particularly of and for imagining response. (Sometimes it is more valuable to have a tool than an artwork; so no valorization is intended by the distinction.) Artistry provides an audience, viewers, and readers, not instrumental know-how so much as knowledge of nuances, subtleties that are real in the world and can be discovered if the artwork is indeed imaginatively conceived and received in its oblique, symbolific mode of being there.

Artistry also is suffused with the vision and spirited commitment of its makers, whether it be the nonfigural, geometrically regular colors of Turkish Muslim calligraphy or the pained, sophisticated lines of dandy Baudelaire in *Les fleurs du mal* ("Un voyage à Cythère"):

>—Ah! Seigneur! donnez-moi la force et le courage
>De contempler mon coeur et mon corps sans dégoût!

As with my opening systematic gambit on "city," here too with "artistry": the inescapable dated/located historical character of art must be spelled out and taken seriously to be helpful for our analyzing the vital intersections of *l'art et la foi en ville* because Medici Firenze in the 1500s AD, Hitler's Berlin, and Reaganomic supple-side USA load the equation of city and art quite differently.

Also, an enormous diversity of artistry will show up historically: from Lascaux cave talisman drawings to ancient Greek cast bronze *algamata* of the Olympic gods and goddesses, from crude *e voto* pictures about miraculous healings to profound icons in Mount Athos monasteries meant to fix one in the presence of the holy, from sumptuous baroque church music to Käthe Kollwitz's posters motherly damning war and army generals to hell, from Chagall's lovely stained glass tribute to Chicago in the Art Institute of Chicago to the brash artistic perversities of the *Helterskelter* exhibition in Los Angeles in 1992, "L.A. Art in the 1990s."

So it is fair game to talk about vanity and quality, species of art, historical stages, borderline services of art objects, and changing percep-

tions. All I've done so far is hint that God likes artworks and was happy with Adam responding to the creation of Eve with a poem:

> This is now bone of my bones
> And flesh of my flesh;
> She shall be called "woman,"
> For she was taken out of man. (Genesis 2:23)

God also explicitly sent the Holy Spirit upon Oholiab and Bezaleël and seamstresses to carve gold and sew vestments to praise the LORD in the wasteland tabernacle (Exodus 28:1–5, 31:1–11). Anybody gifted with skilled imaginativity, as amateur artist or professional imaginator, is called by God to let your art-making be a thank-offering to the Lord, a deed of love for your neighbor, showing care for the wood-grain and precious dyes, viscous textures and *mirabilia* in God's world, along with the prayer that, please God, your gift to me of artistry may also generate a livelihood. . . ?

And "faith" is what distinguishes us corporeal humans from animals: we are prone to pray, to worship . . . the glorious Sun, the mystery of fertility, the power of human rationality or ingenuity—**Faith is the primordial existential attachment a person has to whatever one takes to be God,** the Final court of appeal, whether it be Allah, Science, the God revealed historically in Jesus Christ, or so many Orgasms a week. Faith is the certain trust one has of being rooted in the love of the true God whose Word created the world, or faith is the sincere, deluded assurance of being safe in the strength of some idol (Hebrews 11:1–2; cf. Isaiah 44:1–20).

Faith in the resurrected/ascended Jesus Christ as Lord of daily creatural life at large and history of the world at length: that **saving faith which is sure and certifies your meaningful existence beyond the grave, according to the Bible, is a gift of God anointing you to a royal priesthood in the order of Melchizedek** (Psalm 110, Ephesians 2:1–10, 1 Peter 2:9–10).

So the position I hold out to you on faith is that every human wagers on some god or other and lives, in communion with others of like mind, out of that faith one takes for granted[2].

A Humanist faith trusts Humanity to come through in spite of centuries of failure and on-going world-war cruelty. A Christian faith trusts the triune God revealed in Jesus Christ, witnessed to by the Holy Scriptures,

2 Disbelieving atheists, you could say, fool themselves the way Homer's Odysseus tricked the Cyclops by naming himself Οὖτις [No Man] (9:364–408). The atheist says in his heart, "There is no god" (cf. Psalms 14/53).

finally to come through in spite of a corruptible Church and our history of hypocritical human sin. It is a mark of the secularized, post-christian faiths in people facing a disenchanted world that often has them second-guessing one's underlying faith-commitment; many secularized people tend to harbor a stifled, disintegrating certainty on what counts for life and death.

Whatever the faith of a community be, that faith impacts both artistry and city life.

Our Status Quo: The City as Cultural Capital

You get to know a city by walking its streets. The way a cat brushes against your legs to put its smell on you, one needs to let the city brush against you on foot. I have lived in the cities of Amsterdam, Florence, Rome, and Basel during the '50s; my wife and I made our home in a Chicago suburb for the '60s; and our family has experienced the fairly normative city life of Toronto since 1972. A panhandler being ticketed by Metro police at a subway exit and asked to move on knows Toronto differently than the post-theatre yuppie crowd entering one of Ed Mirvish's establishments for a late night drink, bite to eat, and coffee. How do you assess whether a city is normal and a good place for you to go take out your artistic marbles and play?

As I researched the topic I discovered how cities throughout the ages seemed to breathe the same dynamic and vision that gave cachet to the art of its day. The ancient Hellenic *polis* highlighted social encounters and space for public use, but its magnificent temples of formidable columns open to the sky had no place for mercy, and its competitive theatre and sculpture prizes of heroes hid the fact that ordinary women, slaves, and foreign "barbarians" were disenfranchised subhumans. The ancient Roman Empire's capital had splendid spaces like the noble forum, and engineered marvelous aqueducts and also amphitheatres for the provinces where gladiatorial spectacles could be staged at public expense for the idle masses on the 159 holidays and 93 game days per year—the luxury of those in charge of the predatory "*pax romana*" empire.

Medieval cities took kindlier to artisans and converted grandiose spaces into a warren of streets following land contours rising and falling so the surrounding countryside inhabitants could easily walk in for marketing produce. When a cathedral dominated the city enclave even peasants were invited in. The Church welcomed all walks of life into its building and meant to be a uniting common center, to be sure, in the proper hierarchical order of pope and emperor, kings and bishops, ab-

bots/abbesses and princes, barons and arch deacons, cathedral canons and knights, gentry, merchants, artisans, and parish clergy, and peasants. But "feudal" city life was less serrated and more mutually protective a society than latter-day Democrats suppose who reject the privileges of Church and Crown. The Church was also a major contractor for artisan services, to glorify the church and its God, of course. Fights between church and city were often over who collects which tithes on what lands.

Later cities like Versailles and Paris which Louis XIV's *Surintendents des bâtiments du Roi* orchestrated had grand avenue regularity, spacious gardens of impressive formality, perspectival approaches to monuments, broad flights of steps for promenading, large monumental fountains; and the royal *École des beaux arts* had a monopoly on teaching figure drawing! If you wanted to be an artist during the generations of the French Louis' and Napoleon, you matriculated at *L'Académie française* and followed the royal taste of conspicuous city consumption somewhere in the realm, or you found other hack work.

It is this Newtonian planetary conception of spacious city short on human-sized, live interactive social relations that got exported to the New World too, Washington, D.C., for example, albeit with a touch of do-it-yourself Enlightenment rationalism gone somewhat academic in Monticello. The show of stability and unquestioned authority, the cool cosmopolitan look of towering white marble columns (e.g., British Museum), defines the power capital cities of world empires, but they are not panhandler-friendly. Such great cities have extensive treasuries of masterpieces; diplomats, legislators, executives, the highest judges have their chambers here, but workaday artists, kids for street-hockey, the poor— where is their place in this kind of a city?

The plot thickens and unravels in Western civilization when Profit became god, when land became real estate instead of a stewardship, and when good christian men adopted a Darwinian laissez-faire policy for entrepreneurs to break through the stifling network of stale privilege, franchises, and elitist control of city and cultural life they faced. I have to select what I mention now to focus down on the city as habitat for artwork, but I come to our immediate historical inheritance: the commercialized city.

Not the palace but the ocean port of the city became what was newsworthy in the heyday of the colonializing expansion of investing empires. Not the cathedral but the stock exchange became the hub of the city leadership—financiers, clerks, accountants, who work with numbers on piec-

es of paper. The metropolises of wealthy European nation states became imperial: Lord Elgin brought back ancient marbles from an expedition in Greece; and world musea "collected" Northwest Coastal Indian totem poles, after the Canadian government forbade potlatches in 1884 (repealed in 1951), as well as priceless carved wooden chests with totemic figures overlaid with abalone, "Ebenezer"-type stele (cf. Joshua 4:1–9, 1 Samuel 7:9–12), if you will, of peoplehoods who for decades only counted as customers trading for hardware, guns, and liquor.

The commercialized cities became cursed by the epidemic of Industry, because "industry" no longer meant a human attribute of diligent skilled work, but had been metamorphosed into the sweatshop "factories" of the textile Industry, the fateful underground fumes and tombs of the mining Industry, the deadening piecemeal monotony of the assembly-line mass production automobile Industry. The cities of industrial workers run by the ethic and creed of "survival of the fittest businessmen" consequently bore slums, uninhabitable hovels of those men and women who were not fit to survive the monopoly of money. Those who succeeded in the commercialized city moved out to the greenbelt yonder for a more relaxed managerial life, and let the devil take the hindmost . . . children with rickets.

I recite this thumb-nail history of the city so that any postwar Generation-X artists present will not be tempted to think the cities on our hands dropped out of heaven and are normal. Capital cities today are incredible repositories of cultural treasures earned, stolen, being forgotten, put on the world-wide net, and are exciting kaleidoscopic opportunities for those who are not its outcasts. But the "melting pot" ideal Walt Whitman championed for the USA, where ethnically incompatible immigrants would all be melted down into a new composite race of Americans, turns xenophobic today under the strain of an insistent stream of refugees pouring into the teeming USA ghettoes pursuing happiness. Canada's root metaphor of a "mosaic" society, which better honors the shalom of diversity, it seems to me, also frays under the current prospects of continuing job shortages. Especially after "the consumptive turn" of the commercialized city, city as Consumer Paradise—where you can buy anything from anywhere in the world—our cities, I dare say, are courting failure as cities, tend to be abnormal as cities, could be on an anti-city tack: **no more a local meeting place, a community of neighbors living together**, but more like a mammoth, crowded shopping mall with SALES! SALES! world without end.

A symptom of the dystopic is the suburb. Suburbs built from around 1850 to 1920 used railroad technology transport and moderated the conurbation, *la ville tentaculaire*; but once Henry ("History is bunk") Ford's motorcar became ubiquitous and ruined the pedestrian sanity of so many cities, sidewalkless suburbia—which was neither fish nor fowl, neither downtown city nor countryside where the next door home is a mile away—the mishmash non-entity of commuting suburb became urban sprawl. Big cities hardly have limits; a metropolis can become a megalopolis of staggering size and complexity, replete with disconnected individualists in their lookalike bungalows to which Chris Anderson shows our "private property" desires have banned us [*NA* #9]. Technological sky-scraping brilliance and amazing bridges slung in the sky can mesmerize like a cathedral of reflecting car headlights shining through the darkness in your face. The riches of musea, libraries, universities, hospitals, and sports arenas are there for the taking, at a price naturally, while homey human activities like playing ball in the streets sometimes seem to be endangered—

How does the consumer city affect the artist?

Artworld in the Ghost Town of Babylon
Most everything I say could stand supplements, but there are a couple of concrete realities I want to point to that I think deserve our careful christian attention.

An abundance of kitsch for sale haunts our daily lives because kitsch rhymes with the order of the customizing commercialized city. Kitsch is something fake to which you are indulgently attached, like most airport tourist souvenirs—a six inch plastic imitation-marble replica of Michelangelo's *David*, an eight inch bronzed *Statue of Liberty* for a coin bank. Kitsch is a luxurious trifle that gives inoffensive pleasure to an immature sincerity as Hummel figurines do. Kitsch can be fun if you don't take it too seriously, like a flock of fake flamingoes [#13] and a couple wooden storks scattered on the neighbor's lawn to celebrate the birth of a baby girl for a few days. But the satisfaction kitsch affords quickly wears thin because its imageic universe erases the possibility of evil and therefore distorts reality. The *Head of Christ* fashion-designed by Warner Sallmann to a coiffured "matinee idol" pose of movie stars in the 1940–50s was distributed wallet-size in the millions to American soldiers in so-called World War II, propagating false knowledge of the God revealed in history and the Scriptures.

Kitsch tries to make you feel good, absolving you of responsibili-

[#13] Yard flamingoes as baby storks, Willowdale
suburb of Toronto, Ontario, Canada, 1980s

[#14] Miracle Mart parking lot, Toronto, 1980s (now destroyed)

ties, by taking things out of context and pretending everything's normal.[3]
What is a campanile doing in a Miracle Mart parking lot [#14], or is
it a wishing well without water, in this suburb of two million high-rise
inhabitants, pretending to a small-town folksiness? This bell tower [#15]
has facsimile bells, . . . do not move, through which amplified taped mu-
zak is played to cheer on the shoppers.

3　Celeste Olalguiga argues that the "postmodernist" brief for the eclectic, melodra-
matic, for pleasure-giving sentimentality, the disdain for history or public leadership,
all decided for with arbitrary whimsicality, is the epitome of kitsch (*Megalopolis,* xiv).

[#15] Bell tower, a mall north of Toronto, 1980s

The falsity of kitsch and its pacifying nature dulls a person's sensibilities. I have watched elderly folk gather in small public squares amid one or two benches in the city of Thessaloniki, in an Italian piazza outdoors, in a tiny park in Amsterdam, for conversation, interacting with the children playing there too, reproving rowdiness but not missing a speck of gossip, peacefully alert under the shade of a tree. I have also watched Seniors spend long daylight hours lounging in our city shopping malls, relatively safe, sheltered, kept busy by the bustle of people buying stuff—malls are private property corporately leased—who face continuous window displays and thus seem to be everywhere but really nowhere special; so you seek concreteness in the consumption of fast foods (you know you are when you are eating). Even if it is not the West-End Mall of Edmonton with a sculptured whale fin outside the Grand and Toy store or the Mall of America in Minneapolis turned standardized Disney fairy tale and amusement park, to my consciousness, a mall, like a Hollywood happy ending, programs response, cheapens taste, and consumes life time. And such cheapening of taste affects the songs we sing in church, the attention span of students in school, the un-Churchillian speech writers of our prime ministers and presidents who focus on image and want to push the right buttons to sell a policy. Provocatively put: visual, tabloid, formula-three-minute tunes, and environmental kitsch is cultural murder, aesthetic AIDS to city life.

Who is, I wonder, my bekitsched brother's, sister's, neighbor's keeper (cf. Genesis 4:1–16)?

An other commercialized city reality, which you CIVA members know more intimately than I, is the art gallery scene. An art gallery is a business with overhead, percentage commissions on consignments, curated opening shows, and sales of artworks or not. A commercial art gallery outlet is related to what some have called "the Soho phenomenon." Artists who

need studio space and want access to an art public aim to cast their tent toward the Big City. Unestablished artists find a loft or relatively inexpensive unused warehouse space in the inner-city; as the area becomes gentrified the rent goes too high—checkmate. So you live somewhere more affordable, scrounge out a studio, try to get an agent or be invited to join the "stable" of a decent gallery, and struggle to make ends meet combined with other work, preferably with a gainfully employed spouse.

I deeply respect the many of you artists I know whose *modus vivendi* in our secularized society hovers around this pattern—artist with second job. Most good professional Dutch artists in the 1600s survived that way too—Jan van Goyen, Jan Steen, Ruisdael, Hobbema, Rembrandt. The tradition of art as small-business person or part-time teacher is a noble one and more wholesome, in my judgment, than the more famous Romantic tradition of bohemian artist who lives in a Parisian garret, sacrifices all for art, dies of consumption in the last act of the opera, and becomes famous posthumously.

When I pray for you christian artists, one of my requests to God is that you not be too quickly successful. Why? Bruce Cockburn is grateful no big American record company picked him up when he was starting because it would have stunted his own gradual seeking-and-finding lyrical-musical development. And I am reminded of the Inuit John Tiktak's experience. His six-inch figures can have an enigmatic votive cast, no narrative, just a stolid waiting, wizened cut stone look; he's also caressed stone to the rough-hewn tenderness of a mother plodding along with heavy child on the back, a congealed metaphor of ageless love. Well, when Tiktak was flown in from Rankin Island to the city of Winnipeg for his first ever "one-man show," arranged by George Swinton, he was flabbergasted to see dozens of his carvings all together **on show**. (Normally you made one and gave it to a friend, or used a piece to pay a bill.) After the 1970 city show Tiktak went home and started to mass produce pieces, which became hollow echoes of his original work, more like the many tourist items of musk ox dancing! In other words, I am suspicious of the kiss of Midas.

Understand me well: when a young christian artist asks, "What language shall I borrow to thank you, dearest Friend" (medieval Latin hymn), you usually begin communicating in the tongue in which you were trained at art school, on the streets, as autodidact from the books you consulted. Whatever the ruling vernacular language be in the city and artworld, it is not innocent.

Time was when the New York '60s minimalist art lingo, in tune

with Mondrian's *De stijl* and Mies van der Rohe's mighty International Style for the city, certified by Greenberg's Good Flat Housekeeping seal, carried the day in artworld conversation, with Hard Edge and Op Art dialects also in vogue. Late Mondrian's *Broadway Boogie-woogie* (1942–43) already tested the limits of this idiom, and an early Elsworth Kelly, *West Coast Landscape* (1961), shows how strangely reminiscent of the most lovely, watery, mountainy, pastoral scenes a gifted artist can be in simple, contoured color. With Josef Albers, however, the Greenberg language for me has become a rather in-house jargon making a minute point too many times. An Italian artist I met whose maestro had been a personal student of Mondrian, so he himself was proudly third-generation Mondrianic, painted, it seemed to me, a kind of derivative, technological esperanto close to industrial design, and hung many, many of these pieces at two foot intervals, like no-name portraits, throughout every room in his house, up and down the stairs, on pure white walls.

The point I am after is that your artistic speech betrays your heritage, and that's fine, if you know where you are. Somebody can probably praise God in pig-Latin. But I have known a commercial art gallery owner to tell a novice what size, colors, and themes sell best at the moment, if you want "to make it." One should be wary, it seems to me, of adopting what is currently the fashion in city artspeak (or philosophical jargon) on pain of quickly being out of date and having lost in the process the prospect of developing your own voice. If you would prefer your artwork to be glossolalia, see to it you have a reliable interpreter on hand who can translate. Maybe it is best as artist to be (*au moins bilangue, zweisprächig*) Pentecostal and speak in several tongues visitors to the city can understand (cf. Acts 2:1–13).

Just a footnote comment yet on artworld galleries in the city: since Money like God is no respecter of persons, the reputable artworld of the commercialized city is not immune to kitsch.

At the Barnes show in Toronto a guard politely told me Barnes' regulations stipulated I could not take notes with pencil on a pad in front of paintings, for security reasons. But in the last room at the AGO of the Barnes exhibit you could buy Renoir printed on trinkets and coffee mugs and Cézanne on T-shirts, so hullabaloed people brought in for the first time by the extensive advertising campaign could have their Cézanne and wear it across their chests too.

Jeff Koons exposits regularly at the prestigious Anthony d'Offay gallery in London, England. Everybody knows Rodin's *The Kiss*, which at

the time went scandalously public in showing intimacy on the ground with heroic Michelangelesque bodies. Their nudity and the chiseled white marble surrounds the post-coital passion with the chill of an Ideal. There is a whole Greco-Roman Renaissance tradition masking with rationality this act of tender corporeal sensuousness, intending a distanced purity.

Jeff Koons mocks the whole glorious enterprise by posing a naked man and a naked woman live in a frozen tableau, with a spread-fingered male hand on a willing thigh, as her right leg is thrust tightly against his as if ready to move. Because the people are real it carries the incitement of soft porn, as it is euphemistically called, and it is devastating toward the supposed "High Art" of Rodin's museum piece. Koon's parody is Dadaesque, Derridean, ironically leveling Rodin's artistry to something smutty, with just enough perverse insight to make the mockery a "hot commodity" in the artworld—books of Koon's pornographic living statues are for sale in the prestigious Tate Gallery bookstore, London. But the camp is third-degree premeditated kitsch, to me a cheap parasitic offence becoming common in the commercialized city. Maybe Robert Hughes judgment is right: the art market has become to culture what strip-mining is to terrain with trees (1990, 20).

Does the approved artworld—musea, commercial galleries, showpiece city spaces—in the megalopolis have the makings of becoming a cultural ghost town? When you stand before Jackson Pollock's *Blue Poles* in Camberra, Australia ($2 million) or the Getty's Van Gogh's *Irises* in California (several million US dollars) or the National Gallery of Canada's Barnett Newman's *Voice of Fire* ($1.76 million, 1990)—every Art Center worth its salt should have a resident King Tut treasure to bring in the scandalized tourists—$2 million could feed a dozen artists' families for more than five years (imagine!). You stand there and ponder the artwork for $1.76 million dollars: is this real?[4]

Upon entering the squalor of a windowless, corrugated aluminum shack in a shantytown called Top City in South Africa a few years ago, when I became accustomed to the darkness, I could not believe my eyes: a TV run off a car battery was showing an American sit-com. Was what

4 Visiting New York with my graduate students and Patmos artists in the '70s, I think it was a gallery on 57th Street: returning from using the restroom I stopped unseen to eavesdrop on the curator who was instructing his assistant speaking to a client, with her hand over the mouthpiece of the telephone, "Tell her it will go up in value $2000 in the first year. Massage her into it." I wonder what the stock in Larry Poons nugatory painting is today. (This footnote was written in 1997; my editor in 2011 AD tells me I should have invested, since Larry Poons' canvases are selling now for between 8,000 and 33,000 British pounds sterling.)

I was seeing real?! Exposited or exported kitsch is neo-colonialism in a terrible way, foisting market mirage over sad realities.

I realize many visionaries have called the industrialized, commercialized city a cursed Babylon, from William Blake, Balzac, Dickens, Ruskin and Morris, John Martin, Gustave Doré, to many more. "Babylon" could easily be a sour-grape, oversimplified putdown. The "angel of light" (cf. 2 Corinthians 11:1–14) is usually more cunning than to show up undiluted; the specialty of the Evil One is adulteration. But an articulate cultural critic close to Los Angeles today (cf. Norman Klein) describes L.A. in more secular terms but with the same thrust: L.A. is a city of erasure and camouflage, a series of side shows without a main tent, an actual *film noir*—Watts rebellion (1965), Rodney King videotape (1993), Sunset Boulevard not far from UCLA campus; the freeways allow one to pass through to arrive at exits but rarely to stop, so you have a sense of speed, removal, and homogeneity, the introversion of public space where amnesia is daily practiced.

French Jean Baudrillard's indictment of *l'Amérique*[5] rather unforgivingly exaggerates the same point: the American way of life, its cities and culture, is a realized utopia, a living populated cultural desert where the demon of images overlays, supplants ordinary things, and it is the screen of Walt Disney hyperreality that remains.[6]

But maybe we need to think of the artworld in our commercialized city as a hologram of virtual reality we are walking through? especially if St. Augustine's favorite text from 1 John 2:15–17 plays a role in our lives: are the fascinating sights before our eyes and the arrogant display of untold riches *parágetai*, "passing away," fading out, disappearing? We inhabit this culture, it is indeed where we exist. Is it the environs in which we can freely live and move and have our enduring meaning?

5 "La culture américaine est l'héritière des déserts. Ceux-ci ne sont pas une nature en contrepoint des villes, ils désignent le vide, la nudité radicale qui est à l'arrière-plan de tout établissement humain. Ils désignent du même coup les établissements humains comme une métaphore de ce vide, et l'œuvre de l'homme comme la continuité du désert, la culture comme mirage, et comme perpétuité du simulacre" (*Amérique*, 63).

6 I understood my long winding taxi-bus trip from airport to university in Los Angeles and Baudrillard's vignettes analysis better after I was invited by my son-in-law to play a squash game at the Bally's Fitness Center in Toronto. We walked past what first looked to me like multiple torture chambers where trim men and women were shackled to shiny machines with heavy weights they had to lift again and again, while scores of others read *Macleans* and *People* magazine propped up as they were forced to keep on fast walking on a series of automated treadmills. I felt unreal, as if I had become a character in Jean-Luc Goddard's futuristic 1965 science-fiction film *Alphaville*.

"Body of Christ," "City of God," and "Worshipping Church"

Before I try to give a nuanced shape to the direction of my answer, and dare mention—for your critical response—normative steps people like yourselves have taken/could take today as artists in the city, artists whose "commonwealth" (*políteuma*), whose citizenship is already a heavenly one, as Paul puts it to the Philippian Christians (3:1–11), let me say very concisely what I understand about "the city of God" (Psalm 46, Hebrews 12), what Augustine called *civitas Dei*.

According to the Bible, under King David's administration, when the Ark of the Covenant of the old tabernacle was finally brought to its resting place in Jerusalem (2 Samuel 6, Psalm 132), the capital city of the twelve tribes of Israel became "the city of God," because that is the place from where God's blessed justice would be dispensed to God's people and eventually to the nations at large (Isaiah 2:1–5, Zechariah 2:6–12). When the temple was built around the ark in Jerusalem, the temple became the place where priests in the line of Aaron mediated sacrifices and prayers of God's sinful people when they repented (Psalm 122:3–5, Psalm 133). The LORD God "rested" by the ark yet ruled the whole world—Nebuchadnezzar, Cyrus, Artaxerxes—from heaven.

After Jesus Christ was conceived by the Holy Spirit, born of the virgin Mary, suffered under Pontius Pilate—as the church universal has always confessed—crucified, died, was buried, raised from the dead, and ascended to glorious Rule from heaven, God's people became international (although it took a while for the apostles Philip, Peter, James, and Paul to sort things out; cf. Acts 8:26–40, 10:1–11:18, 15:1–35).

As I understand it, since Pentecost the temple of God is the communion of saints, the Spirit-filled body of Christ at large in which every faithful disciple of Jesus Christ is self a royal priest in the order of Melchizedek. God's temple is no longer a carpentered construction of material, but we living corporeal "temples of the Holy Spirit," two or three together (cf. Matthew 18:15–20), like right here and now, are centers of God's delegated good news and forgiveness.

And "Jerusalem" for Newer Testament believers is not the contested real estate in Palestine, not ancient Byzantium, eternal Rome, Mecca, Wittenburg, or Montréal. The "holy nation" is not Israel, the United States of America, or Canada. The city of God, "Zion" is there wherever God's will is done in faith. Wherever in the city on earth the Messiah's redemptive Rule takes place, there is a manifestation of the holy city of God's ordering.

As for the crucial Older Testament ark of the covenantal LORD God,

its rough, post-resurrection biblical equivalent is found in the official, organized center of congregational or parish worship presided over by ordained elders, deacons, bishops, pastors, or charismatics. For this last matter of celebrative resting in liturgical union before the Word preached and enacting eucharistic response I reserve the term "church."

So for me "body of Christ," "city of God," and "worshiping Church" are intimately related but not identical.

I realize I am speaking with conviction from just one of the major confessional christian traditions extant; so I shall be careful, ready to learn more from you other servants of Christ who have enriched my faith life for years.

Having once joined the pilgrims to Mount Athos I see how Greek/Russian Orthodox monks, eunuchs for the sake of Christ's rule (Matthew 19:10-12), can act like a ceaseless session of prayer in a Holy of Holies, as it were, far from the madding crowd on their sequestered isthmus, but now know that they indeed are praying for the city, for the woman in Athens far away being raped at 2 AM; and prayers of the righteous do affect God's mercy (James 5:13–20).

After a year-long of worshipping in San Anselmo outside the walls in Roma, *Liber Usualis* in hand, I am grateful for being able to submit trustfully to the age-old liturgical patterns that lift hearts up to the Lord; and I find the Roman catholic stance not to privatize the christian faith correct, although I stumble at an ecclesiastical state where the church assumes political credentials.

After worshipping with evangelical Baptists and especially Black "Holiness" churches, where even a Dutchman can come to feel at home to raise his arms in praise, I am excited at trying to mix and mesh the blue notes hidden in rifts of gospel with the phrygian modal lament forms in certain Genevan psalms—to play a song that will make the Lord smile when he comes back! But I am sorry many fundamentalist Christians, like John Bunyan's solitary pilgrim, think the "city of God" shows up only on the other side of the Jordan, and you have to spend six days a week now trying to stay out of Vanity Fair and the Slough of Despond.

From my historic Reformation christian position, Calvinian warts and all, I can say this: CIVA as I understand it is not a church (that needs to defend an orthodoxy), although Prof. Dyrness appropriately leads in "devotional reflections." CIVA is not an arm of a municipal city government of some sort, although you do have an elected Board of Directors, which makes rules and executes decisions for the members. CIVA is not

a business, although you have bills to pay, levy dues, and underwrite projects that cost money. CIVA is "the body of Christ" busy in the area of the arts.

CIVA is not just a collection of freelance artists who say they are Christians, but by your express interest in the vital intersections of the city, art, and faith, you are intent to grapple together, if I do not misunderstand you, with being a special imaginative, communal, artistic presence—in my terms—of "the city of God" in society, in tandem with the commercialized city at hand. You want your art quietly to bespeak the multifaceted wisdom of God, the compassionate eye of Christ, the winsome humor, comfort, and joy of the Holy Spirit. You can see it in the art exhibit that Robert Young and Dal Schindell put together for this CIVA 1997 conference.

And if you have any Augustinian blood in your communal veins, you know that *civitas Dei* service freely given will be countered by powers of *civitates mundi*, "commonwealths" opposed to the love of God, accomplices of Babylon (who could even be hiding in the church! (cf. Psalm 1, 2 Thessalonians 2:1–12, 1 John 2:18–27, 4:1–6).

Tent cities of christian artistry

The radical, liberating—I think—and arduous proposal the insights of this Reformational christian perspective brings to christian graphic or performing artists (as well as to christian teachers, theorists, workers, citizens, journalists, professionals) is: **form tent cities in society**; claim squatters' rights in the commercialized city for yourselves as a community of practicing artists who want to bring the bittersweet shalom of sinful saints to bear upon the common neighborhood. The cultural tent city of christian artistry is not gypsy-like, scavenging; it is not counter-cultural. Let's think of it as an un-Christo project: we **unwrap** stationary buildings in the city at hand, convert them into hospitality tents—a tent blowing where it lists, welcoming especially those who are intimidated by the sophisticated artworld of the commercialized city (maybe in your co-op, alternative gallery, and educational program, which has to move now and then as the Chicago/Toronto *Patmos Gallery* did, so you can pay the rent).

The biblical rationale for this imagend[7] of christian artists forming

7 "Imagend" is my coinage for "an image that ought to be imagined" (rather than just seen). The "imagend" coinage follows the old formula that *ecclesia reformata semper reformanda est* (A reformed church always ought to be reforming itself [to be more in line with God's will]).

tent cities throughout the land comes from the thrust of Christ's high priestly prayer to God (John 17) not to take his (artistic) disciples out of the worldly city but to **send them** *as a community* **into the worldly city**—not to turn the city into a church, not to muscle power together for a theocracy, but to do what Jesus did: feed the poor good (artistic) bread, heal those who have been (artistically) violated by kitsch, giveaway a holy surprise to any comers who have never had their feet artistically washed. Such a tent city of artistry, a mobile, innocent-dove-and-snake-wise (cf. Matthew 10:16) cohering community of redeeming artists might indeed just act the way the ironic biblical image says, like sour yeast in the un-baked loaf of New York City or Calgary, or better, take a mid-sized city. The key matter, so difficult for us individualists to take, is the condition that we **breathe a common Holy Spirit**, and are able to act as a living body of Christ, **a community of saints publicly** busy as an **artistic tent city of God**, not a "church."

Let me specify three things to make this concluding proposal vivid and discussable.

(1) **The vision of tent city means one does not withdraw to the church, as if christian artistic practice needed to be churchly liturgical art.**

Hans Rookmaaker jokingly told me once he hoped to take Billy Graham on a private tour of the Rijksmuseum in Amsterdam someday and was prepared to tell him that the *Still Life with Overturned Goblet* by Willem Claeszoon Heda (1643) was the most christian painting in the museum. Rookmaaker meant that the artist gives burnished pewter and translucent glass on a bare wood tabletop highlighted halos of quiet splendor. The shattered glass and the lemon peel drying out, footnotes of *memento mori*, still glory in the texture of fruit, glass, metal, wood, and teach the eye to come to rest and to joy in how grace can illumine mean, inanimate objects with unspeakable repose. "**Christian artistry**" **does not have to add something to art; it is simply competent artwork presented with holy spirited insight, the way God wants it done.** It is non-christian art that distorts from the norm.

Ecclesiastical art, like political commemorative art, needs to satisfy artistic requirements *and* also the task of the host institution: liturgical praise for church worship (Graham Sutherland's tapestry in Coventry cathedral), the Dutch national government's declaration for justice (with Ossip Zadkine's memorial that remembers Hitler's bombing Rotterdam to bits). Since for me the institutional church is the centering rest point

for all the saints at work communally in the tent city of God, ecclesiastical art ought to be imaginatively worthy, deeply holy, aware of the turbulence outside its church walls, and able to reassure the faithful of their anchorage in the Lord's sure Rule.

Montréal-born, Saskatchewan-based Canadian sculptor John Nugent has Constructivist leanings, heightened by contact with David Smith, but his liturgical art comprises wonderful, weighty, simple, wide-brimmed chalices, strong crucifixes whose genitals ward off sentimental identification, and other almost African-toned fragile Christs who seem wasted by the awful judgment of God. Since the more traditional John Paul II became pope (1978) Nugent's ecclesiastical commissions have dried up.

Would any church be brave enough to house Australian Warren Breninger's *Gates of Prayer* [#16], a series of 84 praying mouths? To see

[#16] Warren Breninger, example of *Gates of Prayer*, 1993-2008 [detail]

these 50x75 cm. crying, screaming, pleading mouths in banks of twelve makes the Psalm laments and Job's tenacious pulling on God to come through with help for the Lord's beleaguered people unsettling enough to restore agonized grit to one's sloughed off, formulaic, selfish, petty requests to God. Imagine preaching with *Gates of Prayer* as backdrop!

And I've heard of John Bakker's performance-construction where for Advent last year they hung a dozen Christmas trees upsidedown in the sanctuary at different heights on pulleys and ropes like grotesque crosses, adjusting them for different Sundays—who knew what it meant? But the sight and smell and feel invigorated expectancy in that urban Chicago church for celebrating the Christ child's birth in a Bethlehem stable, so contrary to any Establishment calculations.

And one of Ted Prescott's stream-lined, neon-lighted, coal-piece cross bar icons [#17] would be perfect, it seems to me, for a multifaith chapel at an international airport where apprehensive meditation or grief may drive people to their knees and stir the troubled to seek peace with God.

[#17] Ted Prescott, *Icon*, 1978

In other words, the adventure of tent **city** christian artistry does not neglect the centering place for **church** art, but **I do not consider the limited focus of the institutional church at rest in public worship to be the summation or culmination of the christian life in God's world.** It is not more "sacred" to pray than to do artwork. The old Benedictine tenet (*ora et labora*) has it right: Pray and work in symbiotic unison so that heart devotion suffuses the work of our hands. It is so that we do not experience the **community** of the working artistic saints as a tent **city of God** often enough in our separate studio cubby holes. That fact does not mean that the quality of liturgical art at "the comfort station" of the church, where the weary workaday communion of saints on our historical journey is replenished, may be humdrum, meretricious, or vain: church art should also be edifying, faith-bracing, deserving our strongest talents.

However, (2) have you artists ever considered the ministry of murals? which is the epitome of art for the city, civic art, to dress up imaginatively a specific neighborhood.

The Mexican Marxian muralists of the 1920s are fascinating because they had the gumption and enough local government support to try to make public art that rejected the Western-American world-society

creed of "Winner-take-all" and "Join-us-technocratic-Darwinians-or-be-swallowed-up-anyhow." Early Diego Rivera told the story of campesinos trying to educate themselves under protected rifle guard while the men were at hard labor, and how security foreman frisked peasants working in the mines for any stolen metal, giving them a brief crucifixion pose. Enjoying fruit from the land and a brief book lesson is set next to the Capitalist crowd caricatured à la Georg Grosz for its dissolute partying way-of-life (1920s).

In a huge fresco inside Hospital de la Raza [#18] Diego Rivera depicts (on the yellow side) native Mexican herbal treatments, setting splints, and human midwifery, blessings curling around the newborn child, while on the bloody red-tree-of-life side Diego depicts the mixed evil/blessing of "progressive" scientized civilization medicine: the patient's legs are manacled to the table, x-ray machine aimed at your head like a cannon, and for childbirth doctors and nurses masked like gangsters in antiseptic white uniforms under strong greenish light extract a baby from the unseen mother's cavity covered by sheets. Up above on the "progressive medicine" side the massed poor press forward, wait, wait, clamoring for admission to medical attention—practically a documentary picture of the throng my wife and I experienced the day in Mexico City we went to examine the mural.

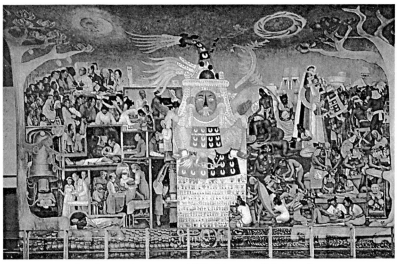

[#18] Digo Rivera, mural "The History of Medicine" in Hospital de la Raza, 1953, Mexico City

Meanwhile out at the university Siqueiros, who is too machinal à la Leger for my taste, covers a large wall with a gigantic mosaic extol-

ling education. Other muralists decorate whole buildings with intricate symbols giving the historic culture of indigenous Mexico a place and a voice. Sometimes mythic creatures [#19] and apocalyptic scenes frame an outdoor court where students play basketball. But a Siqueiros mural is not an ad for Coca-Cola.

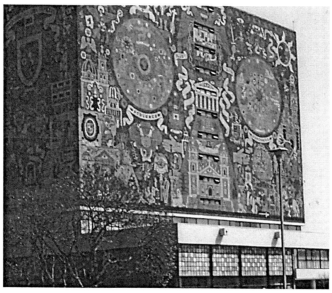

[#19] David Alfaro Siqueiros, mural on the library of the National Autonomous University of Mexico campus, 1950s.

The *Wall of Respect* at 43rd and Langley [#20], Southside of Chicago, was born out of William Walker, Sylvia Abernathy, and a dozen other artist leaders at home in that local city community who, in the tradition of the Mexican muralists, aimed to give voice to the downtrodden there who wanted to claim kinship with Muddy Waters, James Baldwin, Malcolm X, Rev. Martin Luther King Jr., Muhammad Ali, Sidney Poitier, and other "greats" who were pictured in the mural. Behind this 1967 mural is also the 1930s precedent of the WPA organized by the Roosevelt administration and its Federal Art Project. *The Wall of Respect*, however, was a community project aimed at black self-respect *and* reconciliation with everybody.

Murals lightheartedly dress up your environs, show you are imaginatively proud of what you stand for in the city, like Toronto Leon Kaminsky, junkyard dealer who paid a couple of Ontario College of Art students hourly wages to paint the history of junkyard disposal on the outer walls of his city establishment.

[#20] William Walker and colleagues, *The Wall of Respect* at 43rd Street and Langley, Chicago, upper panels, 1967-1969, destroyed in 1971

[#21] Matthew Cupido, Psalm 46:4, Redeemer University College, Ancaster, Ontario, 1996

I know, it takes two to tango a mural. Redeemer University College in Ancaster, Ontario, had to commission and Matthew Cupido had to paint this mural [#21], with a restful bouquet of cascading colors, to cover lost wall space by an open indoor staircase. Maybe making murals is not "your thing"—it certainly pulls an artist out of the easel studio privacy and demands that one work, like an architect, with a public. Jackson Beardy designed this mural [#22] for the Winnipeg Family Center both outside and inside, and First Nations youth did the painting under supervision. It was the only building in the area not defaced in a bad rumble a few years back.

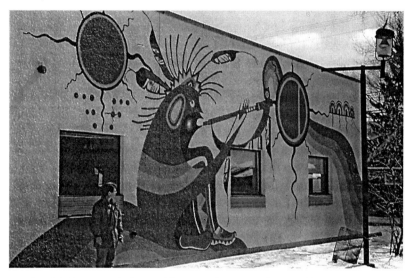

[#22] Jackson Beardy designed "Peace and Harmony," painted by local youths, Family Center, Winnipeg, Manitoba, 1985, repainted 2006

If the Marxist art community and Black artistic community and the First Nations art community and the local junkyard city community can brighten their living quarters with a self-respecting artistic identity, could not the christian artistic community with a heart for the city of God's tent-presence in the commercialized city find openings to do such a holy service that is not a tract? give the art away free to the neighborhood, like a concert in the park, like street theatre, to engage and grace the neighbors with artistry who may otherwise never enter an art museum.

I've sometimes thought Ed Knippers' huge Bible story panels with their Tintoretto-Caravaggian bodies are like a movable mural, too overwhelming to be inside an ordinary building—I saw their impact on viewers in the large tents of the Greenbelt Festival in England. Maybe Knip-

pers' panels [#23] should be rented out for a shopping mall near you, and a christian Samaritan businessman or woman would pay art students an hourly wage to discuss with passersby why the muscular saints are naked and the evil guys like Judas Iscariot often wear clothes.

(3) Tent-city-of-God artistry surely has a mission in the professional art galleries, musea, and sculpture parks of the commercialized city. Artistry of seasoned professional quality coming from the hands of Christ's disciples that wins the attention of sophisticated, art-educated observers is a valuable gift of Christ's body to the cultured world. The church has often forgotten to pray for its artists finding footholds in the city . . . of Babylon. Who else will go for Christ's sake to the rich who frequent these chic boutiques where art pieces have prices most of us cannot afford?

Timothy High's *Placebo* [#24] of prisma color and enamel on paper has a certain garish American pizzazz that will catch a second look. The camera-toting tourist is just rumpled enough out-of-place to make the gaudy amusement park seem all-show trivial, an enigmatic Vanity Fair. With St. Catharines, Ontarian George Langbroek's intaglio viscosity etching you have a more subtle collage of artistic memories—Gericault's *Raft*, fragments from *Guernica*, Van Gogh's *Potato Eaters*—with a phantom Red Cross figure at center holding an abandoned, crying child, with vignettes of the Boat people no longer of interest to journalists, and a left red band telling the story of someone visiting the sick and naked, bringing relief [#25]. The faint laconic title of *Home* lets the disturbing print issue a deep-throated plea to give succor to the displaced refugees, O Canada! O Church! in the unmentioned name of Jesus Christ.

What is important to me is to end with this unpopular point: city of God artistry meant for the commercialized art gallery in our generation, I believe, needs the faith grit to reach deeper than beauty to make our knowledge of forgiveness for sin stick and be audible to strangers who are neighbors. The old Beauty theology, where Beauty is the stunning penultimate step toward Truth and Grace,[8] is suspect to me personally because, in spite of the *Divina Commedia*, all does not end well for everybody. The

8 I have in mind especially the involved position developed by Gerardus van der Leeuw who generalizes, citing Jacques Maritain for support, that "genuine art is Christian" (371/336), "art which has stood before the holy" (304/280) (in *Wegen en Grenzen* [1932]/*Sacred and Profane Beauty: The Holy in art* [1963, translated by David E. Green, Chicago: Holt Rinehart and Winston]). There is a considerable body of reflection that takes this tack on art and beauty as the staircase **to** God and "divine revelation," which is beyond; cf. *The New Orpheus: Essays toward a Christian poetic,* ed. Nathan A. Scott, Jr. (New York: Sheed and Ward, 1964).

[#23] Ed Knippers, *Identifications: The Baptism of Christ*, 1988

[#24] Timothy High, *Placebo*, 1984

[#25] George Langbroek, *Home*, intaglio, 1994

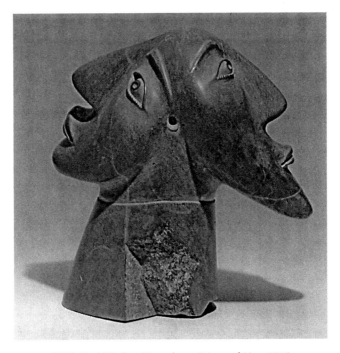

[#26] David Ruben Piqtoukun, *Priest and Nun*, 1995

Church too may no longer speak, "Peace, beauty, peace," when there is no peace and beauty for those we have abused.

Inuit David Ruben Piqtoukun's *Priest and Nun* [#26] have no ears—they never listened to the Inuit, says the artwork. Piqtoukun, aged 46, is trying to relearn the native language of his parents because he was sent to residential school where Inuktitut was forbidden and the nuns taught you English. "Beauty" sounds false to many in the city who have lost their way. Instead we need to expose placebos and recognize the ache for *Home* with gritty, riveting, artistic embraces.

Swiss Martin Disler's room full of bronze human-like figures called *The Shredding of Skin and Dance* [#27] was both quieting and disconcerting, but somehow not frightening. Several of the maimed creatures were caring for the others; they seemed busy and next to one another. Since all were mismade, it didn't count against you. Everyone seemed intent, although there were cries for help; like the one sinking into the floor that went unheeded. There was a "snake pit" feel as you walked among them—how is such grotesqueness actually possible in God's(?) world? The young security guard, with whom I talked, was surprised anyone would stay looking for 25 minutes, thinking out loud about wholeness, isolation, Down syndrome, retinitis pigmentosa, the egg fragility of living and loving someone.

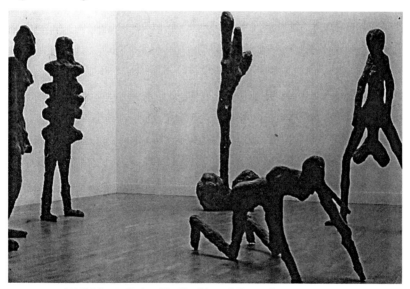

[#27] Martin Disler, *The Shredding of Skin and Dance*, 1990-91

Brazilian-born Ana Maria Pacheco carves wood into over-sized painted human figures, around the theme of "Some Exercises of Power" [#28]. A prone, screaming, trussed, bloated, naked-white body on a plank has two men in black suits shrugging off in cramped stupidity any responsibility, pretending to be as helpless as the victim. "The Banquet" [#29] intensifies the macabre confrontation between the painted black-suited judges with their imbecilic smiles and jerky, infantile body language as they surround the contorted, tortured, supine captive, as if the terror of evil is out of human control. One catches a whiff of the fear experienced in the underside of

[#28] Ana Maria Pacheco,
Some Exercises of Power, 1980

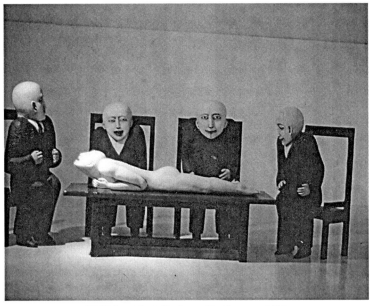

[#29] Ana Maria Pacheco, *The Banquet*, 1985

a city society strangled by corrupted power; it is a reality that appalls Pacheco, the inexplicable human inhumanity of cruelty to one's neighbor. "Man and his Sheep" [#30] gives parable character to following the leader, where someone who is halt leads the hesitant, lame, and nondescript people to who knows where? A kind of timorous complicity and sinister, gullible uncertainty hovers over the arrested pilgrimage ensemble. The hand-chipped wood, gouged, splitting, has an uncanny resemblance to a sedentary arthritic person's body for whom each wooden step is painful.

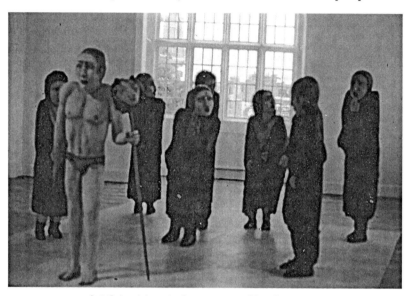

[#30] Ana Maria Pacheco, *Man and his Sheep*, 1989

Britt Wikström's installation of five poles and figures for an Amnesty International artistic invitational, entitled *Cathedral of Suffering* [#31], makes one cry. The vulnerable woman figure is bent to shield herself helplessly from the unstopping attack; the little child, arms raised to protect its face, has its own solitary grown-up pole; the spread-eagled man is crucified between the torture of hanging from two poles; and the empty pole stands waiting for another victim. Evil and human sin are insatiable. As you walk away from this poignant artistic testimony to our horrendous allowance of such terror happening even as I speak—too cruel for earth to bear it, and chillingly unacceptable to the heavens, placeless—it occurs to you that maybe the empty pole is meant for me. (This artwork still needs to be cast, bought, and sited in some Western city as a redemptive artistic lament on our complicity in the evil and woe of the world.)

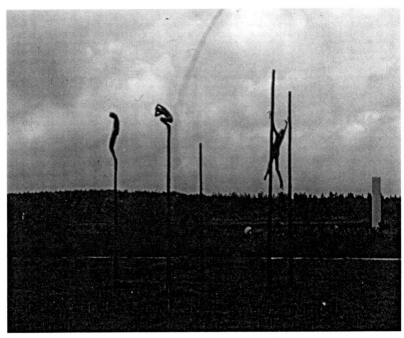

[#31] Britt Wikström, *The Cathedral of Suffering*, 1994

My tale is told. I envision CIVA as an artist community facing Babylon and the City of God. The blessing comes when together we enter the ghost town and spread out our tent city, welcoming one and all to the artistic feasts, or merely glasses of cool water, we hand to the thirsty. The new purely holy city of God will someday descend from heaven, says the Bible (Revelation 21) (so we can see firsthand what the saints in glory have been up to all this time!), transforming tent cities on earth (which for now is our God-given task, says Psalm 115:16) into an exorcized permanent city-of-God-presence. Nothing unclean anymore. Everything, if you believe the promise of Zechariah 8:1–8, will be so safe old men and women will be able to sit amid playing children in the very core of downtown streets.

In the meantime, brothers and sisters (and any guests), be sturdy in producing metaphoric art pieces like the ones I saw in the gallery last night, and even . . . greeting cards for tough times like Joyce Recker's collage of ripped paper called *Shadows Crossing* [#32]. The burnished golden space around the inner black long center is quieting and steady, and the large rectangular frame on the brown background does not show ripped edges; so the black shadows crossing this field of subdued color are indeed crossing, passing, going to move on, as the superimposed pieces stand their torn ground.

[#32] Joyce Recker, *Shadows Crossing*, 1992

Yes, since every city still has a cemetery, give birth in faith, as Britt Wikström has done, to a memorial stone with a bird bath incised in its top [*NA* #19], so the birds of heaven can come wash their feet and drink the gift of rain from an artistic basin shaped like hands open in prayer to receive blessing. Maybe even one of Noah's doves will bring a sprig of olive leaves to hint of new life beyond the grave.

Bibliography

Baudrillard, Jean. *Amérique* (Paris: Grasset, 1986).

Brooke, Christopher. "The Cathedral in Medieval Society," Introduction to Win Swaan, *The Gothic Cathedral* (New York: Doubleday, 1969), 15–20.

Churchill, J.H. and Alan Webster, "From Close to Open: a future for the past," in *Close Encounters: English cathedrals and society since 1540*, eds. David Marcombe and C.S. Knighton (University of Nottingham: Department of Adult Education, 1991), 161–83.

The City Reader. Eds., Richard T. LeGates and Frederic Stout (London: Routledge, 1996).

Clifford, James. *The Predicament of Culture: Twentieth Century ethnographic literature and art* (Cambridge: Harvard University Press, 1988).

Conrad, Peter. *The Art of the City: Views and versions of New York* (New York: Oxford University Press, 1984).

Fleissig, William B. "Artists as City Builders" in Kevin W. Green, *The City as a Stage: Strategies for the arts in urban economics* (Washington, D.C.: Partners

for Livable Places, 1983), 122–25.

Geertz, Clifford. *Local Knowledge: Further essays in interpretive anthropology* (New York: Basic Books, 1983).

Gilroy, Paul. "Urban Social Movements, 'Race' and Community," (1987) in *Colonial Discourse and Post-Colonial Theory*, eds. Patrick Williams and Laura Chrisman (Toronto: Harvester/Wheatsheaf, 1993), 404–20.

Girouard, Mark. *Cities and People: A social and architectural history* (New Haven: Yale University Press, 1985).

Hall, Stuart. "Cultural Identity and Diaspora" (1990) in *Colonial Discourse and Post-Colonial Theory* (New York: Columbia University Press, 1994), 392–403.

Hubbard, Jim. *Shooting Back: A photographic view of life by homeless children* (San Francisco: Chronicle Books, 1991).

Hughes, Robert. *Nothing if not Critical* [1983] (New York: Penguin Books, 1990).

Jacobs, Jane M. *Canadian Cities and Sovereignty Association* (Toronto: Canadian Broadcasting Corporation, 1980).

Jacobs, Jane M. *Edge of Empire: Postcolonialism and the city* (London: Routledge, 1996).

Klein, Norman M. "Inside the Consumer-built City: Sixty years of apocalyptic imagery," in *Helterskelter: L.A. art in the 1990s*, Exhibition catalogue and essays, ed. Catherine Gudis (Los Angeles: The Museum of Contemporary Art, 1992), 23–32.

Marcombe, David. "Cathedrals and Protestantism: The search for a new identity, 1540–1660," in *Close Encounters: English cathedrals and society since 1540*, eds. David Marcombe and S. Knighton (University of Nottingham: Department of Adult Education, 1991), 43–61.

Morgan, David. *Icons of American Protestantism: The art of Warner Sallmann* (New Haven: Yale University Press, 1996).

Mumford, Lewis. *The City in History: Its origins, its transformations, and its prospects* (New York: Harcourt, Brace & World, 1961).

Mumford, Lewis. *The Culture of Cities* (New York: HarcourtBrace, 1938).

Norwich Cathedral: Church, city and diocese, 1096–1996. Eds., Ian Atherton, Eric Fernie, Christopher Harper-Bill, and Hassell Smith (London: Hambledon Press, 1996).

Olalguiga, Celeste. *Megalopolis: Contemporary cultural sensibilities* (Minneapolis: University of Minnesota Press, 1992).

Pacey, Arnold. *The Culture of Technology* (Cambridge: MIT Press, 1983).

Relyea, Lane. "Art of the Living Dead," in *Helterskelter: L.A. art in the 1990s*, Exhibition catalogue and essays, ed. Catherine Gudis (Los Angeles: The Museum of Contemporary Art, 1992), 33–43.

Rémy, Jean, ed. *Georg Simmel: Ville et modernité* (Paris: Editions L'Harmattan, 1995).

Robbins, Jane. "Helping the Artist to Live and Work in the City," in Kevin W.

Green, *The City as a Stage: Strategies for the arts in urban economics* (Washington, D.C.: Partners for Livable Places, 1983), 126–33.

White, John Franklin, ed. *Art in Action: American art centers and the new deal* (London: Scarecrow Press, 1987).

Williams, Raymond. *Culture and Society 1780/1950* (New York: Harper and Row, 1958).

My hearty thanks to C.T. McIntire (University of Toronto) and Phyllis Rozendal (York University) for sturdy bibliographic help in preparing for this address.

GOD'S GIFT OF THEATRE IN OUR HANDS

My intent as philosophical aesthetician—a theorist of imaginative human activity, which includes artistry—is to engage you in exploring and celebrating the good gift of making and sharing theatre, which the sovereign God of heaven and earth, fully revealed in the historical Jesus Christ, put into human hands.

To provide biblical lighting to frame my remarks, please listen to a brief account of our believing forbearers from the Older Testament (1 Samuel 13:19–22) and then a vivid paragraph of revelation from the Newer Testament (Revelation 18:21–24).

This is the Word of God:

> You couldn't find in all the land of Israel an artisan who worked in metal. The Philistines had said, "Otherwise these wandering Hebrews will make themselves sword and spear."
>
> So every Israelite had to truckle over to the Philistines to get his plow or mattock, his ax or sickle sharpened up. It cost two-thirds of a shekel for sharpening a plow or mattock, and one-third shekel for fine-tuning axes and repointing goads.
>
> So on the day of the battle [with the Philistines] not a sword or spear was to be found in the hand of any of the folk setting out to fight with Saul and Jonathan. Just Saul and Jonathan had a sword and a spear.

That was so c. 1080 BC in "the promised land."

> And one strong angel picked up a rock, big as a millstone, and heaved it into the lake, saying, "That's the way—boom!—the great city Babylon shall get the heave and never be found again.
>
> "The sound of guitarists and folk singers and flautists and trumpeters shall nevermore be heard in your city; no artist, in any of the arts, shall be found any more in your [great] city.
>
> "The sound of the mill [stone grinding] shall be heard among you no more forever, and the lamp light shall shine no more among you forever, and the voice of the bridegroom and bride shall nevermore be heard among you

This lecture was presented at the Christians in the Theatre Arts conference in Chicago in May 1996.

—your business men were the big shots of the earth!—
nevermore, because all the people were misled by your clever artistry."
They found blood too in that [city] Babylon, blood of prophets and
saints and all those [believers] who were butchered to death on the earth. . . .

This Word of God holds true today "to discipline" those with ears who
can hear "in right-doing" (2 Timothy 3:16–17).

Just one more thing as prologue to my reflections: I want to recount for
you one of the most unforgettable half hours I have ever experienced. It
was announced in London, England's *Time Out* magazine of what-to-do-
this-week as "lunchtime theatre."

I went to this day-care rehabilitation center in a poorer-class outskirt
section of the sprawling city of London at 12:30 noon, early September
in 1986. For sixty pence I was the only non-inmate person present, along
with the orderlies suited in white who were wheeling in the spastic adults,
giving an arm to the halt, the blind, and the dumb, various "simple" crea-
tures with grotesque faces who made uncontrollable gurgling sounds, all
being assembled in the rec room for a performance of *Working Hearts* by
a touring troupe of actors. I stood near, half sat on a cold metal radiator,
trying to be inconspicuous.

The play was performed by a blind man, a deaf and dumb woman,
various injured persons, and a dwarf with ugly, misshapen arms. The play
was a powerful statement on the deep desire of handicapped, malformed
people to be treated as full humans who have ordinary problems, self-
respect, hopes, and anger, often hidden in silence. The actors made fun
of the "make-work" jobs people with injured brains are sometimes made
to do in institutions, as if they are robots or simply need to be kept busy.

The dwarf especially was a spokesman for the dreams such unfor-
tunate creatures have, imagining himself to be an angel or a daffodil, an
inventor or a statesman, "What I want to be I'll never be allowed to be by
them, because of what I am," said the real dwarf playing himself.

We are so alone and closed down, said the voiceless woman, in sign-
language (being interpreted by the voice of a thalidomide victim); but
then she exclaimed poetically in mute, captivating, exuberant signing
and excited face, how rich the world around her was.

And all the while one of the actors, in a dark suit, playing a "nor-
mal" person, forced the others to smile—"Say 'cheese'!"—for the camera
pictures he was snapping of their industrious automaton-job misery, for
publicity purposes, to get the government subsidies renewed, making a
veritable grinning imbecile of himself—"Say 'cheese'!"

The play was full of wry grit, stinging insights, happy in a crazy sort of way. Watching the absorbed interest of the hundred or so in the audience, their intelligent assent to the barbs against "regular folks," and their hilarity at some of the scatological lines, I felt warmly attached to them, and walked out afterwards into the sunlight somewhat in a daze.

What joy Christ must have had to heal those who were hurt, who had been harmed, maimed, to see them whole again, able to realize corporeally the modest hopes and desires of normality.

For a brief, intense thirty minutes, these unfortunate, blemished human creatures of God cooped up in London were given a voice, a prickly, sparkling artistic theatre voice that resonated the inarticulated, mysterious truth of their very creaturely being, and their being cared about.

Ordinary historical reality is a mortal cosmic struggle between Christ's Rule (*civitas dei*) and sinful civilizations (*civitates mundi*), but it is not a play.
In my Reformation faith-thought tradition world reality is called *theatrum Dei*, theatre of God. John Calvin chose that metaphor in 1536 AD (*Institutes of the Christian Religion*, I, vi, 1–2) to focus on the fact that what happens historically on earth is important to the Almighty Covenantal LORD God of the universe. History is not an intermission. Things happen that make God's stomach sick (Genesis 6:1–8); humans sometimes actually change so radically the angels laugh out loud in heaven (Luke 15:1–10), even if Prof. Nicodemus couldn't understand it (John 3:1–21). Devil creatures have to scoot around frantically to screwtape people; evil powers even cause epidemic havoc at times, although since Jesus Christ's ascension to the right hand of God, the outcome of the war between the curse of Sin and the redemption of all creation back to God is utterly certain: the end coming will be a new earth of ongoing shalom, with no more tears, no more polluted trees, no more death (Romans 8:12–39).

This biblical insight of mortal cosmic struggle taking place, what Augustine called the *civitas Dei* (city of God, Christ's Rule) opposed by *civitates mundi* (sinful civilizations), is as real as digestion and the change of day and night. Shakespeare's Jacques speech flattens out the Armageddon horizons to a more diffident, personally morose chronology (*As You Like It*, II, 7) but keeps Calvin's metaphor:

> . . . All the world's a stage,
> and all the men and women merely players:
> they have their exits and their entrances. . . .

born in your mother's pain, forced to learn to spell, maybe you fall in

love, lose a leg in Viet Nam, take a high-rise office job, become a paunchy Senior Citizen, get Alzheimer's disease, until you end up, as Job said, sans everything (Job).

Whether you take the metaphor from John Calvin or William Shakespeare, about "the world's a stage," it imaginatively depicts the actual struggle against evil at large in history, and suggests that humans born move through pleasures and troubles toward death, whether you like it, believe it, or not. The warm-blooded living and breath-taking death metaphorically referred to in "all the world's a stage" is not a make-believe reality, however, but is the basic, primary, residual fabric of post-lapsarian creaturely existence.

When cancer (or its chemotherapy cure) kills you, the corpse left behind is buried in the ground or burned and does not take a bow to polite applause. When Lisbon in Portugal was destroyed by an earthquake in 1750 AD, that "act of God," as the weaseling-out insurance companies call it, was not an act in a play, but a veritable disaster so terrible it even changed Voltaire's optimistic philosophical mind. When my wife and I attended a Black Panther artistic event on the north side of Chicago in the 1960s and then had to pay double the entrance fee for the Huey Newton Defense Fund to get out, it may have seemed a bit surreal at the time—theatre of the absurd—but the big fellows standing waiting at the exit with their collection containers were not imaginary personae.

This messy initial point is important for me to be able to talk about the peculiar nature of theatre today because Paul Ricoeur, somewhat like Hayden White, thinks of "emplotment" for history, Suzanne Gearhart leans toward *The Open Boundary of History and Fiction*, and Artaud with Derrida promotes primal theatre not as mimesis of reality but as a revelatory plague that our pallid contemporary life weakly doubles and obscures.

It is not a question of "Will the real reality stand up?" One needs to realize, I think, that there are different kinds of realities. You cannot kick forgiveness as you can a stone, but if you have ever experienced genuine forgiveness, that absolution has ontic "substance." Dramaturgical acting is as much real work as building the bedrock underlay of a highway; but some parents still doubt whether "giving to airy nothingness a name" on a stage is bona fide, serious, professionally actual, because you can't bring home a living middleclass wage by doing it.

But it is also true that some phenomena, appearances, are unreal mirages, falsifying impersonations, or deceptions. That is Jean Baudrillard's analysis of America: a utopia, a no-place that cannot be, but like

Disneyland it exists. When young millionaires stand to religious attention for the singing of "The Star-Spangled Banner" national anthem sung in a country-Western style before a baseball game in a huge stadium filled with paying customers only a stone's throw from abject ghetto poverty, is that actually happening, or is it a real farce?

As a Christian I want to honor the struggle and suspense to history in God's world, but want to keep historical happenings distinct from fictional acts, which have their own kind of imaginative reality. And I am happy to think of the whole creation as the place where the fall into sin took place (Genesis 3, Romans 5) and the ministry of reconciliation was initiated (2 Corinthians 5:17–19), but such doings are not a plotted artistic performance God arranged. To take the stage metaphor literalistically rather than truly in its imaginative reach would be to convert the provident LORD God into a panoptical dramaturgist, mistake the historic eschaton for a plotted telos, and denature the human task of obedient initiative to one of learning a script.

It is the nature of theatre all right to have its source in "ordinary" real life, but the distinctive glory of theatrical as-if reality, imaging, enacting primary meaning-realities through the sieve of actual imaginative fiction-making deeds, has a wonder all its own that God provides for our edification. "The theatrical," however, does not define the workings of the world. If you make everything theatrical, you lose the legitimate splendor of theatre's specific diaconal ministry.

Theatre for me is a rather complex artistic event held somewhere for so long by a community of persons skilled to enact characters that usually struggle through a conflict to some kind of resolution, which is watched and listened to intently by other fellows gathered for this special occasion.

I am trying, more simply than Aristotle did, to circumscribe the creatural structural girders extant in theatre throughout its maturing history and myriad ethnic embodiments. I want to avoid the essentialist purism of a Rationalistic definition, but I will not accept the "anything goes" tack dictated by current powerful voices correctly fed up with Western blockbuster commercialized theatre as definitive paradigm.

To posit that theatre is artistry means, from a biblically christian perspective, that the endeavor commands adequate control to enact nuanced meaning gathered to a focus dominated by an imaginative quality. Artists do not gather rosebuds where they may, but daily collect the manna of nuances in God's world, and (professionally) distribute such

ludic bread of life especially to their imaginatively impaired neighbors.

A technical term I am wont to use is that artistry is by nature *symbolific*: the songster, sculptor, storyteller, composer, or actor has the ability to craft something or to perform an event that alludes to more than meets the eye, ear, or touch. The special point of the undertaking is in between the lines, an overtone to the sound, or hovers around the slow walk across the space to meet her. When the gesture is not a sign but a symbol, the movement has an artistic cachet. The artistry of a young child drawing hazy purple trees on hot red grass under a black sun as well as the *Second City* cabaret comedian's consummate timing for a riposte carry hints of something more to be discovered: there is an obscure, prelingual ambiguity lurking nearby; a penumbra of informative, oblique shadows characterize the deed.

(1) Aristotle and Japanese Noh theatre: solemn ennoblement

Aristotle molded his conception of drama around the works of master poet practitioner, General Sophocles, which were performed for polis competitions in the amphitheater arenas at ancient Greek festivals. Aristotle, as you know, conceived drama to be an ennobling natural *mimesis* of a single ἀγών (troubled struggle) unfolding, performed with quasi-liturgical seriousness so as to absorb the polis audience (including women) to identify apathetically with the tragic-heroic confession Oedipus or Antigone declaims. Sophocles' dramatic poesy still had intimations of the cultic aura and piety brooding in the works of Aeschylus; but the tenor of Euripides' plays is more secularized, in touch with the sophists' Athens rather than the generation of orthodox Pericles. Yet Aristotle gives both Euripides and Sophocles high marks (*Poetica* 1453a 24–31) because their enacted (δρώντων, not narrated) speech honored the catharsis inducing law of περιπέτεια, the plotted reversal where contrary to all expectation yet necessarily because of what took place the terrible resolution justly follows (*Poetica* ch. 6 and 9).

It is so that Aristotle elevates dramatic confrontation into a somewhat disembodied, spoken mental combat, and finds unabashedly ethical the drive to divinize humans (*Nichomachean Ethics* 10.7 1177b26–1178a2, *Metaphysica* 12.7 1072b14–28). But Aristotle fingers correctly, I think, a crux to theatrical artistry: the conflict performed needs to take a surprising turn that seems somehow just, deserved, ironically so, even if "the poetic justice" be dismaying; the resolution must not be rationally predictable but needs to remain mysterious, inexplicable, despite its stunning, inexorable dramatic finality.

I wonder whether the classical, highly stylized Noh theatre of Japan, once it became fitted to court patronage in the late 1300s AD, and deeply Buddhist, might not help us secularized Western Enlightenment figures better appreciate the historical context Aristotle breathed, and the invisible world proper to the syncretic Hellenization, in which he was remembering the great tragedians. Noh theatre has masks, chorus, stately dance, poetry, minimal movement, and was more ritual than "action," more oratorio than drama, and it is this nondescript prayerful state of being worshipful that Aristotle was invoking with κάθαρσις as the "final cause" or τέλος of tragic dramatic poetry.

(2) Brecht: a defamiliarizing underdog, alternative theatre

Bertolt Brecht, as is well known, could not stomach such solemnity. Although his purposefully anti-Aristotelian bark is worse than his pragmatistic bite, B.B.'s position is that theatre is a montage presentation of episodic conflicting incidents performed with a gestic skewering awareness of artificiality, exposing the false facade of everything respectable. Actors must teach spectators entertainingly to think through the cruel hilarity of our topsy-turvy culture, which needs to be changed. (I wonder how the Willow Creek Drama Team considers Brecht.)

Brecht strains to subvert the abiding Aristotelian schema of a fixed plot fatefully snapping shut like a steel trap on human acts: theatre tells a tall tale (Fabel), a clutter of jolting snapshots only connected like stray knots on a string. Yet Brecht's interruptive songs act like a Greek chorus (without the gods-eye-point-of-view) affording caesurae to the on-going loose run of declamatory scenes. And Brecht's *Verfremdungseffekt* is his formulation of what is crucial to theatre: you have to "strangeify" the particular incident—"defamiliarize" would be the cinematic lingo—you squint/wink the vagrant matter you wish to present so it acquires a disconcerting look, as if something inconsequential suddenly becomes a general, unsupportable principle (*Kleines Organon*, par. 67). That is a perceptive way, I think, to get at the gift of what a dramatist and director with actors do normatively do in making theatre.

I am personally drawn to Brecht's gutsy, Brueghel-Hogarthian underdog slant on what is funny and miserable in our world that too often is passed by on the other side by us comfortable people. Brecht's *Galileo* and *Mutter Courage*, and his collaborations with Kurt Weill (*The Rise and Fall of the State of Mahagonny, Die Sieben Todsünde*), probe evil with too quirky a lightness perhaps, too fleeting usually to be able to reach down and grapple with sin, which cannot be treated stereotypically. But Bre-

cht's opening to alternative theatre, which avoids the staid living room proscenium, the Stanislavski method of an actor's becoming the character, and calls into question the passively consuming, consumptive audience who want to go-home-with-a-good-feeling, deserves a Christian's explorative attention.

(3) Artaud and Schechner: toward primal scream and ritual

Although I may expect more blind alleys than breakthroughs, it is probably important also to hear carefully what Antonin Artaud and persons like Richard Schechner are grasping for. I hear their pained dismay at the formulaic, cut-and-dried routine of dinner-plus-show package—take it as a business entertainment expense, or use it for a Senior Citizen outing—to which theatre has often been reduced, whether it be Broadway, Niagara-on-the-Lake, or regional community repertory troupes.

The pageantry of medieval cathedral festivals and public carnivals that stirred up whole cities once upon a time for a week, accustomed to the Moralities and Mysteries played for the populace, knew theatre was integral to human lives. Elizabethan England too produced marvelous theatre that thrived on the confluence of Humanist literati and professional university writers with a vital popular culture quickened by the Reformation, where the rhetoric of preaching and a painstaking sifting of Anglo-Saxon and Latin elements in the language for translating the holy Bible with dignity yet in the vulgar tongue buoyed the protean Shakespeare's portrayal of human foibles in a moral universe. But after Puritanic excess closed the theatres in England for eighteen years, Restoration comedy from 1660 onward confirmed the sleazy tack theatre took in England when the court and aristocrats cornered the market, so to speak, and held their expensive, private, self-indulgent masques.

The breakdown of artistry into High Art and popular low art, which continued apace as Europe and the Americas industrialized, affected theatre, one might say, by polarizing the art into keen avant garde theatre run by experimenting professionals—*l'art pour l'art*—and art as pastime, extremely skillful amusements that do not stretch your competencies and consciousness, but affect "The importance of being earnest," and are successful gigs with the populace who want "a night out," although frothy entertainments like most of George Bernard Shaw's plays are un-deep, and, dare I say? if not shallow, without genuine refreshment.

Artaud wants theatre to teach us the necessity of screaming again, because the stratified, respectable ordering of civilized Western secularity is a calcification of life and has robbed us of our religion taproot. Plays

have become pedestrian contests or verbal soufflé for peeping Toms to view and chat about over their dessert coffee. If theatre cannot shock us into understanding that life originates in what is bloody, and that we need to divulge "our world's lies, aimlessness, meanness, and even two-facedness" (*TD*, 22), then we will have succumbed to cultural impotence and tedium, writes Artaud. (Iannis Xenakis' music, it occurs to me, is a precise example of Artaud's score for theatre.)

Because Artaud's cry for meaning has no place for the gospel of being forgiven upon repentance from sin, and being enabled to walk even through the valley of the shadow of death thanks to the gracious hand-holding of Jesus Christ, Artaud's poignant plea for theatre's role in cultural exorcism lapses into the occult. Artaud consciously affirms a Gnostic rigor to transcend the continuous evil we experience daily, and believes that if we can re-mythologize theatre with incantational staging, like Balinese dance-theatre for the gods, with hieratic costumes, then theatre will again be an efficacious ritual, a sacrament "to express objectively secret truths" (*TD*, 51) and initiate us deracinated people again into "the intense poetry of Nature . . . [preserving] its magical relationship with all the objective stages of universal mesmerism" (*TD*, 54).

Richard Schechner is less rigorous than Artaud, and thinks that when the ritual and entertainment features of theatre converge, you have the most vital theatre. And actors need to off-set their (ecstatic) shaman metamorphosis ability dialectically, says Schechner, with their almost (trance-like) trained ability to be possessed by another character (*TP*, 175–79). In his attempt to unsettle the standardized patterns of performance fixed in Western playhouses and approximate more the fluid participation of spectators in dramatic events found in Oceanic and African cultures, Schechner, in his "Environmental theatre," has the audience move around to catch successive scenes from different vantage points and to intermingle with the actors before, during, and after the presentations, trying to alter the "pay-me-to-be-entertained" setup and recapture the easy intimacy of folk all together engaged in something festive.

As a christian thinker I support our possibly refiguring the secularized tradition of "theatre" we have inherited. Much of what is performed to journalist and advertising acclaim in venues like the West End of London, England, I unfortunately—maybe because of a Calvinian background, although I consider myself a joyful Calvinian—find to be pat and effete, almost a respectable form of exquisite cultural prostitution. But to try to sacralize the secular, rededicate playwriting to an unknown god, and import a nondescript spirituality (like an alchemical meltdown

of Taoism, Zen, fertility cult rites, holiness traditions, mesmerism, and the civic religion of civility) so that theatre be more gripping than a pleasant, fairly expensive outing, and become an impressive rite like an inauguration or a wake, would be a mistake, historically regressive, in my judgment.

That's what a gala theatre performance attempts to be, says Peter Brook (*ES*, 50), an Orphic rite. I've only attended one Gala in my life, *Parsifal* in München, fourth row center main floor among the elite, who did parade decorously at intermissions before one another sipping white wine, since we were indeed costumed. I failed the sacred ritual performance, however, since my requisite tux borrowed for the occasion was too small, an awkward fit.

Artaud and Schechner are correct in sensing that European norms for theatre are not exclusive, and that the word-text may need to be humbled somewhat by dramaturgical inventions—the way representational features in painterly art came to be challenged by the symbolific expressivity of designed color itself. Yet the plight of desiccated playwriting and a mediocritized audience cannot be saved, I think, by trying to take pagan ritual as theatrical watershed. The Way to go in our impasse is to discover anew the creatural glory of theatre, critically distilled by bartering thoughts with Aristotle, Brecht, Artaud, Grotowski, Brook, and any *magister*, and then sacrifice the result in theoretical deed and dramaturgical direction as a sweet-smelling, living offering of thanksgiving to God.

Let me begin to try to flesh out this last mouthful by sketching a philosophically responsible taxonomy for the variety of bona fide sorts of theatre, and also reflect most briefly on "christian" theatre, before I propose as philosophical aesthetician a few theses for discussion by women and men at home in the world of theatre.

Taxonomy of theatre artistry
In my book there are human acts with results that can be called (1) "aesthetic events," like playing games, telling jokes, inventing surprises, clowning around, giving your children (proper!) names. Everything humans do has a latent aesthetic feature, an imaginative aspect, which may be well exercised, warped, or still-born, as shows up in one's eating and drinking, sharing caresses, meting out punishment, or voicing prayers. This aesthetic color in life is normally called the style to one's deeds. Well, when that styleful moment or imaginative ingredient that deals particularly with nuance-meaning dominates a person's act and qualifies the result, however brief it be, that deed may be called "aesthetic." Playful

aesthetic events have emotional, social, conceptual, political dimensions naturally present in phenomenologically submerged fashion too. But the point right now is: "aesthetic events" are normal to the daily life of God's human creatures; whether this specific good aesthetic moment of ordinary human life be stunted, hyperactive, or mature normatively deserves care.

When "aesthetic" activity goes professional, so to speak, it becomes what I would call (2) "artistic activity." I realize every professional artist begins as an amateur. What I am after is this: when an imaginative person spends lifetime to learn the skilled, crafted underlay needed to construct results of one's imaginative forays so the results of the nuanced activity receive their own entitary identity independent of the original composer, that is, become a styled event that can be repeated, let's say, and takes on a more enduring structured entitary nature, then one is busy in God's world making artworks.

The lovely humor of joking is largely circumstantial and transient, and it is difficult to repeat a surprise (aesthetic events); but if you develop a comedy routine, hone the skills of a jester or stand-up comedian, you have entered the neighborhood of professional artistry (artworks). A parent can read or tell bedtime stories with flair to their children (aesthetic events); when a person trains in puppetry to narrate the adventures of Punch and Judy, you get *commedia dell'arte* (artistic happenings).

There is no intention to pit "artistic" acts against "aesthetic" events as better, and there will probably be boundary disputes on whether certain charades are heightened aesthetic activity (games) or have the stuffing of improvisatory theatre (artwork). I only want to have recognized that a structural deepening can take place when one's leading imaginative activity is firmly grounded in steady technical control appropriate to realize the imaginative result with professional sureness.

I believe further it would be good for the discipline of theoretical aesthetics (and theatre departments in colleges, christian or otherwise) to recognize the full-fledged legitimacy of (3) "borderline imaginative work." That is—I don't know precisely how to describe it—I have learned from Albie Sachs, Ari Sitas, and other cultural leaders in the new South Africa that what an oppressed people need at a certain early emerging point more than "creative fine artists" are "cultural workers"— literacy officers, teachers of the folk's old songs, drummers and dancers contagious with their faith-tradition identity and aware of the need to build imaginative self-respect in the currently uprooted and deprived youngest generation.

Augusto Boal in his *Theatre of the Oppressed* sounds a similar note: the custom of choosing theatre of the world's "great cultural centers" as model and goal for underdeveloped lands forces Brazil to absorb alien cultures without having a firm foundation in its own native participatory drama tradition (*TO*, 174)—cultural colonialism.

I myself have seen what that can mean, when I attended a conventional plotted play performed at the Indian Native Cultural Center house in Toronto, which was written and directed by the same First Nations fellow who took the lead role: it was painfully stilted, unconvincingly hollow in its earnestness, and simply misbegotten. I wonder what could not have been achieved if the theatrical inception had been instead worked out of a native drum séance in a sweathouse ceremony setting with a frightening shaman figure coming in from an imaginary wild to curse the rotten life and mimic the debilitating alcohol/drug scene that often eviscerates a displaced urban Indian. . . .

My guess is that many Christians from world-flight Anabaptist traditions may suffer from a similar lack of sophisticated, cosmopolitan theatre awareness. If there still be (post-TV) a rural generation who are relatively pure, it would be an affront, it seems to me, to throw them into a class with Aristophanes, Ibsen, Eugene O'Neill, or *Cat on a Hot Tin Roof*, without much preparatory "cultural work." But I could see naive christian students being led by a skilled theatre teacher into writing and performing skits that rise up out of the drama of full immersion baptism on the prairies, simple plots that explore the Mennonite peace that destroys many, and maybe there are even birds in the bush of the church like the phalarope that come too late and could conjure up compelling tragic reversals.

My idea is that there is a place to honor developmental training in theatre, to honor half-way theatrical knowhow, the process of enacting meaning theatrically. So I would be willing to consider agit-prop as not simply the propaganda tool of totalitarian thought-police it has at times been, but recognize its "beautiful simplifications" (Brecht! 111) as good practice for amateurs. Jim Leach has made convincing in his thesis on Brecht's *Lehrstücke* that they were meant as exercises to develop a performing community of actors—*Lehrstücke*—not didactic tracts to impress spectators. So the systematic point I am making is that, if we are not obsessed by professionalism, we may be able to value "grassroots" movements toward art like tribal storytellers, "township art" constructions, ghetto murals, and agit-prop workshops as worthy citizens in the realm of theatre.

A systematic overview of the theatre world will also identify what I call (4) "theatre-as-such": theatre that has come into its own is fully, consciously theatrical, communally conceived, normally with scripted text, to be enacted by professional (or amateur) actors within society for an audience gathered simply to experience its imaginative presentation of nuanceful meaning-realities compacted by a contested struggle leading to comeuppance, triumph, or an uneasy indecisiveness.

It may be moot whether theatre-as-such has an ontological structure specifically distinct from fictional narrative artistry, choreographed dance artistic events, or cinematic screen artistry. I happen to think so, and the phenomenal properties of live theatre coming across the boards, where there is an intimate two-way communication breathing, may indeed come to be precious as technological advances in the mechanics and pace of communications web us in. To watch theatre on television, says John McGrath, is like listening to a chamber orchestra over the telephone (*NO*, 112). Theatre is also not performance of a script the way music is performance of a score: something different happens because in theatre the performers assume characters to do the imaginative honors, actors let *personae* other than themselves unveil the nuanced meaning; symphonic orchestra musicians are not supposed to become characters. Great cinematic art, so highly complicated by the close-up, moving camera able to magnify the insides of human strengths and weaknesses, structurally valorizes *mise-en-scène*, it seems to me, for telling a story, which does not happen in the subtle but frontal confrontation of wills indigenous to mature theatre.

> Excellent wretch! Perdition catch my soul,
> but I do love thee! and when I love thee not,
> Chaos is come again. (Othello III, 3)

The theatre evoked by those lines is not tied to any perceived scene as it necessarily is in cinema.

So the theatre-as-such does not mean theatre-for-its-own-sake, or theatre purified of poetry, song, dialogue, or costume. "Theatre-as-such" is a limiting concept or philosophical idea on the propriety of having theatre be historically differentiated to a specific kind of artwork where everything (like plot, dialogue, music, scene, staged movement, costumes, and characters) involved in the imaginative, covert tensed combat-to-be-right, in all the interactions, is geared to be enacted.

And that is the legitimate glory of theatre-as-such in God's world. It is not the function of theatre-as-such to evangelize, to socialize, to bring honor to the French nation, or dispense sweets. The definitive function

of theatre-as-such is to be compelling theatre! Theatre itself can be an act of neighborly love, and so fulfill the law of Christ (Galatians 5:22–6:2), if it artistically serves nuanced knowledge in a holy spirit surrounded by tough hope and a helping hand.

That said, I want to describe lastly what I call (5) "encapsulated theatre." Professionals who make art-as-such, like sculptures, brass quintets, a novel, or gouache painting, can decide upon occasion voluntarily to submit their artistry to complete the task of some societal institution whose job is not to produce art, like the federal government, a business, or the church of Jesus Christ. The result is a sculptural monument like the Vietnam Veterans Memorial wall by Maya Ying Lin, or Sir Edward Elgar's *Pomp and Circumstance March* so fitting for British coronations and American academic graduation processions, or local Advent banners for a church sanctuary that declare imaginatively Christ's followers count the succession of years differently than those who start with the old pagan bang of January 1.

That is, encapsulated art is called upon to meet a double norm: the symbolific allusivity due good art, and whatever the norm is for the host institution with which the encapsulated art is willingly bonded. For example, advertising art should be crackerjack attractive with a lingering, elliptical suggestivity (aesthetic norm) and also meet the criterion of promoting a good product or resource for people who need it (economic norm), rather than seduce one to buy wasteful luxuries. Encapsulated artistry can fail on two or either counts because encapsulated art is double-duty artistry.

Street theatre, for example, is encapsulated theatre. The acting core of street theatre should be strong and fresh so that the disciplined mime movement base to acting catches the attention of the novices on the street, sparking focused fascination, crowding out the many non-dramatic distractions present—noise, ignorance, undefined stage. Because the neighborhood or city is the host for street theatre, the overriding thrust to the theatrical event should be developing neighborhoodedness, socializing strangers into acquaintances by common laughter and shared experiences, as a concert-in-the-park does. Whether the theatre troupe tackles a serious topic like the police or local drug trade for its theme, or adopts a traditional dramatic text for the streets, street theatre correctly best employs the argot of the locale, slips subtly in and out of stereotyping, exaggerates and underplays a point to keep the neighbors guessing, amid an abundance of acrobatic tricks and pantomimic gestures that can

carry when words fail: you legitimately bend theatre toward the fun of circus, which entertains, because street theatre aims to enliven a section of the city with good neighborly jostling, light-hearted, imaginative self-respect.

Jane Addams' theatre program at Hull House in Chicago back in the 1890s to 1910s, as I understand it, meant to do precisely that in rehabilitating street youth. (Director Bob Sickinger brilliantly carried on that tradition in the '60s at Hull House, mixing non-actors off the street with professionals to stage amazing, knockout theatre-as-such.) I understand Boal's "Joker system," which tries to eradicate the line between protagonists and chorus, interpolating a kind of roving, educative wild-card figure into the theatrical melee, to be finding a canonical element for such urban "guerilla" street theatre praxis in the arena of Sao Paulo.

Chancel drama like the old *Christ in the Concrete City* (1960s), liturgical plays, theatre-for-the-institutional-church is also what I would call "encapsulated theatre." The writing, acting, staging, performance of church theatre deserves to be as professionally thorough as what happens at the Guthrie or Winnipeg Theatre, if you can achieve it, but is called to serve more narrowly the *ecclesia*, and presumably the institutional church congregated for directly meeting and worshipping the LORD. What shape the encapsulated theatre-for-church takes depends upon the double norm you adopt: is theatre artistry a well-crafted imaginative act that hangs fire with sparks, or a more pacific, beautiful placating gesture? and is church-at-worship for you a loose-knit evangelistic occasion for prophesy, testimony, Bible-teaching, and altar call with special music and activities to keep the pitch exciting, or is church worship a more set, liturgical ritual where confession, forgiveness, proclamation of the Word with eucharistic response takes place amid song and prayer and offerings?

I am not going to dictate from my Reformation evangelical orientation the papal answer, but I will share this: I know that in church worship I want God to talk me into repentance in the presence of unbelievers so I am free with my sisters and brothers to lament, shout thanks, taste the body of my Savior every resurrection Sunday, and be recharged for the week to go out where you really serve the Lord, outside the church building, on the job, when teaching, in the streets, in the theatre district, making political decisions to provide justice for the outcasts. And I believe that encapsulated church theatre like liturgical dance can proclaim God's Word and can be employed in response to the Word preached—and that it is important to know the difference. The principle of encapsulated church theatre I am willing to posit for discussion, however one con-

ceives artistry and church worship, is that the tail must not wag the dog: in church theatre the theatrical artistry must be integrated into being the church worshipping. Otherwise the theatre could become a sideshow to the main event in the center ring.

(Although it is not theatre, *glossolalia* needs the same curbing in public worship, in my judgment. I have experienced at the Nottingham Hill temple in London, England, how finely tuned speaking-in-tongues can be orchestrated by the musicians and prayer leader of the service, so that this wonderful chattering, like a flock of birds descending from heaven alighting briefly in nearby trees, refreshes the air, and then softly leaves again as you are prepared to hear God's Word preached.)

A note on quality / "christian" theatre / audience

I hope you have not mistaken me scholastically as I delineated this (incomplete) taxonomy of theatre artistry. I mean to say that there are many "mansions" in God's home for theatrical service, that it's good to envision the whole, which may be more than your particular preoccupation, and that it helps one to pray for the other. There can be quality and inadequacy in every category.

I recently saw an ancient hula dance choreographed to music, by the group Luba, that became theatre because the five middle-aged women seemed to be dancing tête-à-tête with another invisible presence, oblivious of me and spectators. Stable black-clothed torso with long flowered dress, expressive hands and face, feet precisely positioned, with the slowly rising and falling, revolving hip movement, sensuous, mesmerizing, but not sexy: onlookers at this program of "sacred dance" were caught off guard—here was being acted out something deeply human, deeply feminine, mysterious, reserved, even holy. The protagonists were not professionals, but the performance was superb (choreographer Gioia Seerveld, *Image* dance school, 4 May 1996, Thunder Bay, Ontario).

Two weeks later my wife and I attended a glittering production of Edward Albee's *Three Tall Ladies* (Royal Alexander Theatre, Toronto, 22 May 1996) that seemed rather tiresome. The arch talkfest with Pinteresque pauses seemed awkward rather than poignant—the timing was off—maybe because it was late in the Toronto production run, and as Peter Brook says, a play must be invented afresh each night. When woman C says stage center, "I'm not a virgin, but I'm a good girl," the predominantly female audience laughed. Repetitions of the line, however, seemed canned, a somewhat tired joke even as one laughs again. The performance was highly professional, but weak theatre, it seemed to us. Michel Trem-

blay's *Albertina in Five Times* (1984) at the Tarragon years ago explored the same nuanced reality with much more forceful, dramatic insight.

Would you understand me if I said, encapsulated church theatre is not the model for "christian" theatre?

You don't make something christian by hauling it into church or by doing it churchily. What happens in church worship, as we all know, can be a vain show, a cache of moralisms. Theatre-as-such deserves the adjective "christian" (applied gingerly), I dare say, when the whole theatrical production, like a good late Shakespeare play, has the surd of sin, a palpable threat within the theatre's horizons, and a spirit of glimpsing redemptive hope hovers in and around the performance like an invisible Angel of the LORD. Aesthetic events like telling jokes, borderline imaginative work like the usual "school play," and encapsulated theatre can also all be basically quietly sanctified activity ("christian"), rather than sanctimonious ("antichrist-like"), as well as just secularized (indifferent to Christ's lordship).

I bring forward, as a philosophical aesthetician, this matter of having theatre obedient to the Lord—it need not necessarily be so conceptually up front and articulated for dramaturgical artists and actors in theatre— because it is crucial, I think, to realize you don't make theatre "christian" by adding something to theatre—a conversion in the last scene, or an explicit appeal to believe in Jesus, or by prohibiting certain features, speaking only in ten-letter polysyllable words. Normal, normative theatre in God's world is the way theatre should be, breathing a holy, joyful spirit: when theatre becomes a technique in the grip of an evil spirit, violent, smug, or blasphemous, then the theatre artistry has been distorted.

When I am struck by the opening tableau of Gombrowicz's *Yvonne, Princess of Burgundy* (1935/1957) directed by Ingmar Bergman, where you would swear it was a collection of two-dimensional cardboard cutouts life-size on stage, like a department store display of mannequins, until after a half minute they moved and you were theatrically fixed, without a word having been said, to know that the courtly culture you were entering on stage was a thin fake veneer of posture, intrigue, and venality: you don't then go look up whether Gombrowicz still went to church and where Bergman's Lutheran credentials are at, but you thank God for such powerful theatre exposing corruption ambiguously.

Developing an informed audience is crucial to production of good theatre. That is not first of all the task of playwright, actor, or director, I think, but is the spot where communion of the critic, theorist, and pa-

tron saints should come into play, to educate potential audiences.

It is fascinating to read the history of American Socialist and later Marxian theatre theory as American theatre found its feet, because these left-wing leaders tried to have their faith permeate all they practiced. Before 1917 they debated whether theatre should be a handmaiden to sociopolitical protest as well as popular and viable. After 1917 they wanted revolutionary experimental theatre, but discovered that American laborers had little proletarian consciousness and certainly were not into avant garde theatre. So American Marxian theatre leaders had to decide whether to serve a working-class unaccustomed to serious drama, or unsettle the bourgeois theatre audience with startling, unpleasant truths (*ILA*, 38).

The *Workers Laboratory Theatre* aimed to shuck the sedentary proscenium stage and themes of heroic individuals, and moved toward mass recitations, mobile stage, and proletarian agit-prop protagonists dramatizing revolutionary themes. Politically left-wing theatre foundered in the difficult 1930s because their melodramas entertained only the converted.

I firmly support communal christian theatre activity because saving faith, as I understand it, is not a solo operation, and cultural action with a certain (holy) spirit is inescapably communal. And there is great need for "middle-persons" with vision, savvy, money, and the trust of God's people to teach them from pulpit, lectern, and in check-writing sessions, to shun a ghetto mentality as Peter Senkbeil wrote in *Christian Drama* (17:2 [1994]: 16–17) and spurn "the-star-who-made-it-big" mentality, and get set for the long generational haul in supporting normative (christian, redemptive) theatre of all sorts, not theatre for the converted or to proselytize the unconverted, but simply to be a gritty, winsome blessing to the neighbor.

Theses for discussion
My last three brief imperatives hoping for your response assume that every follower of Jesus Christ connected to the gift of theatre God has put into human hands—playwright, actor, director, producer, stage hand, audience, editor, critic, theorist, teacher, publicist, patron—is determined to make their offering to be of sterling quality. The principal thrust of the Older Testament book of Leviticus for Newer Testament believers is that holiness prompts one to give back to God the best goat you can find in your flock, a lamb in so far as possible without blemish (Leviticus 1:1–3; 19–20; Deuteronomy 17:1; 2 Corinthians 6:4–7:11; Ephesians 5:15–21, 25–27; 1 Peter 1:13–21). The LORD asks us to play our instruments and (artistic) parts skillfully before God's face (Psalm 33:1–5), thoroughly

dedicated as a living, life-giving sacrifice (Romans 12:1–2).

(1) Beware of success, and be content with bona fide diaconal theatre.

A major Beast in the Americanized world culture is commercialism, where the bottom line to any enterprise (which one should respect) is made the top line (and driving force to one's deed). The idolatry of profit—will it make more money?—kills an act of love, the value of a profession of faith, a group organized to bring about justice, practitioners of art. A more biblical question to ask a theatre enterprise would be, I think: can we arrange to pay a living wage to those worth their hire and break even, as non-profit nursing homes do, since theatre-as-such is more like foot-washing the imaginatively handicapped than like a fast-food business outlet.

And to make a splash on Broadway, it seems to me, is not the pillar of fire to follow, since Broadway is not the way to enter the Promised Land, but is to be mixing it up with the Philistine American culture where all the heavy-duty iron weaponry of theatre is in force. That's why I pray fervently for the children of God who do work there in theatre, besides waiting on tables. I'm not proposing you try to fail, be mediocre, or hide in the Midwest to escape the polluted commercialized cultural air of Babylon we all breathe. My caution is: be wary as a snake in the grass and as innocent as a dove (Matthew 10:16), because secularized success comes with a price for each man or woman—for whom Christ also paid a price. "The kingdom of God," says Scripture, "does not mean food and drink (and the acclaim of marquee lights), but right-doing, shalom, and joy in the Holy Spirit (Romans 14:17).

(2) Treat all of life in the theatre, especially sin in its self-righteous meanness.

Whether you be a Catholic (universe-wide) and Orthodox, or Protestant (not protest but pro a thesis! thetical) disciple of Christ, as Christ-believer you are creaturally at home in God's world and therefore best equipped to deal wisely with what displeases God and violates one's neighbor. God's people often do not come through with wisdom for brokenness because we are so wasted by sin ourselves. Sin is usually sensationalized as daring and exciting or found to be funny by the bored secularized mind: only followers of Christ can know sin's despicable deceit and violent waste to what is good.

You are asking for trouble, I know, if your audience is primed for

satisfying entertainment rather than an invigorating challenge, and you face them with theatre grappling with life, death, and wrong-doing as gripping as the Bible does. I am not naive on this difficulty. Many years ago after exposing the texts of Marx and Engels to christian critique in philosophy class at Trinity Christian College, I thought it would be good to have my college students question a Communist in person; so I invited one to class—which caused a lot of trouble and had to be canceled. The next year I did it by conference telephone, with edifying results.

One needs to have trust to do scary, upbuilding acts to foster the faith maturity Hebrews 5:11–6:8 pleads with those who accept the priesthood of Melchizedek to implement. And it's true you need skillful actors to deal redemptively with scarlet letters and themes like "The man who corrupted Hadleyburg." Peter Schafer knows how in both *Equus* and *Yonadab* to let nakedness imaginatively expose our terrible human vulnerability to molestation. The London production of *Angels over America I* even had a dark scene of sodomy that tastefully seared your heart with its desperate grunt of thrusting pain. And David Edgar's brilliant play named *Pentecost* (1994) has an in-character line about not "selling yourself to fucking Disneyland," where the bad word is not gratuitous and almost elicits from you a silent "Amen."

I am not suggesting we Christians start with the hardest matters and try to be subversive to bring God's little children roughly and critically into our hardened-to-God age. But when I see how the Older Testament *Song of Songs*, which I conceive as a unified chorus of voices able to be performed, can convince simple believers, turning the pages of their King James translation to check out the dialogue spoken, that chapter 7:1–9a—right there in the Bible—is a Solomon speech of lust, so you suddenly understand the book and God's blessed frank call to erotic purity and to have sexuality cradled within a vow, then you will not be apologetic about the power of theatre to expose our corruption, but be grateful to God for such a vital imaginative gift! We Christians need to get theatre into the schools, not to be shocking but to show young people that theatre is not just pretty and jolly, like *The Pirates of Penzance*, and comedy, but can be as gutsy as the Psalms, and is able to treat their sheltered and precarious, invaded and unsure real life with a holy twist of lasting imaginative insight.

(3) Be building on the cultural ark with the theatre in your generation.

In the Kuyperian, Dutch Reformational biblical faith-thought tradition I come from we are especially grateful for the covenantal faithful-

ness of the LORD God revealed in Jesus Christ and made certain in our hearts and lives by the Holy Spirit: God's faithfulness kept throughout the generations of God's obstinate people. We are grateful because God's generations-long covenantal embrace means that I and you do not have to presume to finish bringing about the fullness of the kingdom of God in our lifetime! The LORD God shall raise up a new generation of disciples to carry on the work of cultivating the earth until Christ returns. Our calling is only to be obedient to the Lord and faithful in re-forming what our generation inherited, making it, God willing, a more acceptable thank-offering than we received.

I see Christians In Theatre Arts (www.cita.org) building on an ark of modest christian proportions going back to the York mysteries and beyond, with prow and planks added throughout the centuries, becoming culturally flood-worthy. (Although it will be the fire next time, we may still expect several major floods.) Maybe the Philistines today still have most of the iron tools, and many people on the sidewalks may be gawking at your concerted redemptive efforts to make theatre pleasing to God. But I know Gillette Elvgren has a saw, Dale Savidge a hammer, Lloyd Arnett pockets full of nails; Dan van Heist and the regional directors have wood mallets (and a few have David sling shots in their pockets), and all of them are intent upon building a place of refuge with an open door where for a couple of hours a person can come in from the acid rain and undergo the imaginative wink of theatre dedicated to the LORD who made theatre creaturally possible in the first place.

May God bless all those building on the ark. Invite in all kinds of strange animals, multiple ethnic traditions, especially the handicapped and displaced persons. And see to it that the grace distilled in your ark theatre is admission free for the poor (Isaiah 55). That's how God's people are called to pass on the gift of theatre the LORD has put in our hands: give it away to your neighbor freely with a tear and a smile.

I am grateful to James Leach for priming my reading for this address.

Relevant readings

Aristotle. *Poetics*, trans. Kenneth A. Telford (Chicago: Henry Regnery, 1961).

Arnett, Lloyd. "'Evangelical Correctness'" *Christian Drama* 17:2 (Winter 1994);3-5.

Artaud, Antonin. *The Theatre and its Double* (1964), trans. Victor Corti (London: John Calder, 1970). [TD]

Boal, Augusto. *Theatre of the Oppressed* (1974), trans. Charles A. and Maria-Odilia Leal McBride (London: Pluto, 1979). [BO]

Brecht, Bertolt. *Brecht on Theatre: The development of an aesthetic*, ed. and trans. John Wijlett (New York: Hill and Wang, 1964).

Brook, Peter. *The Empty Space* (Toronto: Penguin, 1968). [BR]

Edgar, David. *Pentecost* (London: Nick Hern, 1995).

Elvgren, Gillette. "Christian Theatre Artists and Their Culture: The university experience," *Christian Drama* 17:2 (Winter 1994): 20–22.

Gadamer, Hans-Georg. "The Festive Character of Theater" (1954), trans. Nicholas Walker, in *The Relevance of the Beautiful and Other Essays* (New York: Cambridge University Press, 1986), 57–65.

Goudzwaard, Bob and Harry de Lange. *Beyond Poverty and Affluence: Towards a Canadian economy of care* (University of Toronto Press, 1995).

Griffioen, Sander. *The Problem of Progress* (Sioux Center: Dordt College Press, 1987).

Grotowski, Jerzy. *Toward a Poor Theatre* (1968) (London: Methuen, 1982).

Keene, Donald. *No: The classical theatre of Japan* (Tokyo: Kodansha International, 1966).

Leach, James F. *Instructive Ambiguities: Brecht and Müller's experiments with* Lehrstücke (Toronto: Institute for Christian Studies, M. Phil. F. thesis, 1992).

Levine, Ira A. *Left-Wing Dramatic Theory in the American Theatre* (Ann Arbor: UMI Research Press, 1985, revised University of Toronto Ph.D. dissertation, 1980).

McGrath, John. *A Good Night Out: Popular theatre, audience class and form* (London: Methuen Drama, 1981).

Sachs, Albie and respondents. *Spring is Rebellious*, eds. Ingrid de Kok and Karen Press (Cape Town: Buchu Books, 1990).

Schechner, Richard. *Performance Theory* (1977), rev. ed. (London: Routledge, 1988). [PT]

Seerveld, Calvin. *A Christian Critique of Art and Literature* [1962–63], rev. ed. (Sioux Center: Dordt College Press, 1995).

————. *The Greatest Song in Critique of Solomon*, arranged for performance (Toronto: Toronto Tuppence Press, 1988).

Senkbeil, Peter. "Ghetto Theatre, and mapping the terrain to a wider culture," *Christian Drama* 17:2 (1994): 12–17.

Styan, J.L. *Modern Drama in Theory and Practice*, 3 vols. (Cambridge University Press, 1981).

Szondi, Peter. *Theory of the Modern Drama: A critical edition* [1965], trans. Michael Hays (Minneapolis: University of Minnesota Press, 1987).

Trotsky, Leon. *Literature and Revolution* [1922–23], trans. Rose Strunksy (Ann Arbor: University of Michigan Press, 1960).

Professional Giveaway Theatre in Babylon: a christian vocation

The title is my thesis; so I should explain first the title.

By "christian" I do not mean "sinless." "Christian" for me designates a sinful human witness to the forgiving grace of the LORD God of the universe revealed in Jesus Christ, whatever is marked—pock-marked—by the impassioned Way Jesus walked on earth with Holy Spirited wisdom instituting the reliable order of God's just-bringing peace.

By "vocation" I mean the whole-hearted response persons make in accepting the Lord's call to diaconal service with whatever gifts you have been endowed (1 Peter 4:7–11). "Vocation" is not a hobby but a kind of joyful full-time commission dated/located humans enact.

"Professional" signifies a master craftsman or woman whose amateur love for the trade has been honed with consummate skill. Whether it be an orthopedic surgeon pinning broken bones together in your body without disturbing any entangled bloody nerves, or a glass-cutter deftly breaking in one elegant gesture a pane of glass to the exact millimeter dimensions needed, or an actor whose momentary hesitancy conjures up a world of anxious unsettled details: "professional," in my book, refers to any certain kind of work activity quietly professing a dedicated, seasoned on-going mastery.

"Giveaway" for me is a quality I believe should characterize normative human deeds: you fill the bushel basket up full with a crown of grain overflowing the flat limit;[1] you go the second or even third mile extra (Matthew 5:38–42). From one's treasury of time and abilities and goods one freely and thankfully bestows gifts to one's neighbors, no strings attached—it's a giveaway! A human worker is certainly worth one's hire (Luke 10:7), but when the bottom line of enabling sustenance becomes the top line of what defines your activity, you run the danger of being

1 Cf. Leviticus 19:35–37, Deuteronomy 25:13–16, Ezekiel 45:9–10.

Keynote address for the Christians in the Theatre Arts conference in Chicago, June 2007.

denatured and enslaved as a hireling, a mercenary. To be "giving away" oneself is, in my judgment, the Way to own oneself (Luke 9:23–26).

As for "theatre": that is the collaborative art event CITA[2] members participate in as playwrights, directors, actors, stage designers, studio teachers, theorists and drama critics, and play-going audiences. As a theoretical aesthetician I will give my thoughts about "theatre" shortly.

Doing theatre "in Babylon" concludes the title of my remarks, and may be a bit more contentious; but mentioning "Babylon" is my way to pull us *in media res*.

Everybody human—missionary, terrorist, corporate CEO, haggard unemployed, children soldiers—all animals, trees, wells of water, mountains, and angels, are creatures **in God's world** today. But God's world globally and locally is in a mess. Historically, as I understand it, we are living in what the Bible calls "the last determinative days" (1 Peter 1.20), after Jesus Christ was raised from the dead, ascended to power at God's right hand, and anticipates coming back again to finish up things (cf. Matthew 28:18–20). That's the reality.

Because the faithful people of God are scattered on ten thousand hills in hundreds of nations worldwide, and are not in charge of the dominant cultures blanketing the earth, it is helpful for me to realize God's folk today are, as it were, in exile. God's people are not refugees in a strange land, not welcomed immigrants bursting in with enthusiastic plans to develop the commonweal. But followers of the Christ are virtual captives working, walking around in a great, glittering imperial Babylon Nebuchadnezzar proudly built with furnaces to other gods, idols.

Now I realize you may need to be convinced by the metaphor that "America the Beautiful" and "Canada: The true North strong and free" are Babylonian addresses. I know there are many Daniels in Canada who pray three times a day to the LORD at their open window (Daniel 6:10), and I'm sure there are numerous prophetic preachers made in the U.S.A. as fiery and eccentric as widower Ezekiel was in the ancient Middle East Babylon to which he was deported. But Military Power and Commercial Profit ratcheted up to brutal VIOLENCE paved with good political intentions and an insatiable systemic GREED hidden beneath a show of free trade talk and prodigious IMF loans seem to rule our times. Even promised lands of milk and honey to which the poor, the sick and weak

2 Christians in the Theatre Arts [CITA], whose director is Dale Savidge, has existed for more than 20 years. It is a continent-wide network of support for believers who also are theatre artists (information@cita.org).

(whom Christ tended) are scrambling to reach find the milk soured and the honey poisoned by deeply rooted hatreds.

It is not my purpose to rant or persuade anyone that to bask in the kitschy splendor of a gated Kinkade real estate paradise in the '90s is as much an abomination to the Lord as was the "Village People" disco group in the '70s perversely rejoicing in a boisterous rendition of their "YMCA" song, because I am not judging "Babylon" as Jonah initially judged and hated the fabulous, cruel city of Nineveh—"beyond redemption" (Jonah 4:1–2). I take my cue from the letter Jeremiah penned for God to the people of God stuck in Babylon at the time of Daniel and Ezekiel:

Don't believe the futurologists who predict a quick millennial rapture in your lifetime, writes Jeremiah (chapter 29). Neither hate your surrounding wall-to-wall culture as godless, nor, as you settle in, become Babylonian in ethos. Instead (v.7)

> **Work hard for the shalom of the city to which I have banned you people; pray fervently to the LORD God on behalf of Babylon's inhabitants, because shalom for you is inextricably tied in with the shalom of the city [where you find yourselves].[3]**

Trust the generations-long promise of the Covenantal LORD God to come through for the faithful (v.8). In the meantime, I hear Scripture say, backed up by the Newer Testament book to the Hebrews, the letter to Romans, and the Gospels: be a hand and a foot and a disciplined voice for shalom in Babylon, O people of God; get a mature, meat-eating Melchizedek faith (Hebrews 5:11–6:12) which knows how to overcome evil with good, leaving vengeance to the Lord (Romans 12:9–21, Philippians 4:4–7), which shows hospitality to strangers (Hebrews 13:1–6) and performs acts of sacrificial love—did you ever read that injunction?— love to enemies! (Matthew 5:43–48).

So the thrust of my title thesis is this: **if** you decide to follow Jesus in matters theatrical, then realize we sinful saints-in-the-making are called by the LORD, with other Christ-followers and whoever will join in, **to concoct skilled theatre events consecrated to proffer enriching insight, honest-to-God down-to-earth wisdom, and a startling tinge of repentant hope to the Babylonians**! because our measure of shalom depends, says God, upon the healing peace we spread abroad in the idol-crazed urban culture that holds us captive.

3 Makoto Fujimura makes this very point in his good article, "Planting seedlings in stone: art in New York City," in *Comment Magazine*, 25 (December 2005):1–5. www.cardus.ca/comment/archives/

And I do not posit this thesis as an ideal of an armchair philosopher, but hope to engage your reflection in it as a doable project worthy of hardship that will face difficult choices: does performing Oscar Wilde's farce, *The Importance of Being Earnest* (1895), meet the Melchizedek standard of bringing shalom to our neighbors, or would Tony Kushner's *Angels in America* (1992) be better worth our christian effort? Is resurrecting Gilbert and Sullivan's operettas for a night out in Babylon a sound move toward making peace on earth, or would staging Ionesco's *Rinocheros* (1959) be a more appropriate (globally aware, locally acting) **glocal** act of comic obedience to our Lord?

Again, these start-up questions are not meant just rhetorically (although you may sense my personal preference), but to stir our thinking in programmatic directions. . . .

Place and integral task of theatre in our generation

I should like to claim that acting, the seed of theatre-making, theatre experience, is and deserves to be as normal and integral to our daily human life as clothing.

Food and drink and a place to digest and defecate are **necessary** for human survival. One can stay alive without clothes or shelter, and live in fear; but a fearful, unsheltered, naked existence robs a woman or man of **elemental basics** to one's humanity. Or take the more complicated matter of intimacy: a person can live a fulfilled life unmarried, but if you as a single man or woman have never experienced genuine friendship, you miss an unmistakably **vital component** of being a neighborhooded human. It is not "necessary," but it is **residually native** to human nature to have welcomed a non-familial confidante into your personal life whose promises you can trust.

Likewise, making-believe is **inbred** in children, who make mud pies, play with dolls in the worst of wartimes, and dress up to pretend to be others. "Rover, red rover, I dare you to come over," is a group of youth imagining, "acting," as if they be vigilante ready to capture whoever challenges their control of the territory, although they are the ones already caught! That is, it is a **basic** human trait to make believe, to act as-if, and it is **a good normal feature** of being humanly alive in God's world, which if neglected or gone defunct constitutes a blight on your creaturely being here.

It's time to end the grudging Platonic apologetics about "acting," a line of reasoning that presumes imaginative presentation of fictional figures is at best a false show and at worst somehow suspect, deceitful

impersonation, which can only be tolerated in society if the ruse makes a moral point. No! **Acting imaginatively is grounded in human creaturehood, it is a gift of God to be exercised.** Just as sleeping is not a waste of time but a fascinating miracle of bodily restoration conceived by the Creator God, so playfully making-believe is not idle stupidity but an incredible human privilege and opportunity in which to jubilate and come to know the marvelous and curious range of subtleties afoot in God's world.

As a matter of historical fact certain humans throughout the ages seem to have had special gifts for making-believe in society. It was a feature of those who were officially designated "wise men" and "wise women" in Older Testament times to dramatize their counsel in imaginative roundabout fashion, like the charade the wise woman of Abel used, hired by General Joab, to reconcile David with his killer son Absalom (2 Samuel 14:1–20). Young King Solomon, recounts the Bible, play-acted in his judgment as if he would have a child murdered—"Cut the baby in half!"—to smoke out which prostitute was the mother (1 Kings 3:16–28).

In aboriginal nations like the Inuit in Canada, the long ago exterminated Aztec and Incas of Peru, or with oral tribal societies in Africa too, the *shaman* is recognized as a most aesthetically sensitive leader who doubles as a kind of priestly wise person. The *shaman* often dons head-dress and masks to suggest his or her intermediary role in exorcist rituals—the clash of forces, the *agon* at the heart of human ills and healings—similating[4] a *persona* with extraordinary power to set things right.

In what began as festivals honoring the god Dionysus, a public event, which in that male-dominated society even women were allowed to attend, ancient contesting Greek dramatists hired *hypokritai*! who used masks and stichometrically antagonistic poetic lines, backed up by a unison-chanting chorus of voices, to heighten the struggle portrayed of good versus evil moving inexorably towards a fated resolution, which voiced current polis polity. Ancient Indonesian Hindu culture also engaged throngs of orchestrated figures to perform their folk saga *Ramayana* with numerous heroes, villains, and sacred monkeys, to recapitulate their legendary origins as a people, long before it became exotic entertainment for tourists.

That is, in world cultures other than the Hebraic and Christian circles—where folk had a day off, Sabbath, Sunday since Constantine, one

4 Not "simulating" but "similating": cf. my article on "Imaginativity" in *Faith and Philosophy*, 4:1 (1987):43–58, p.50 {see *NA*: 11 n.7, 37}.

day free from work every week!—blowout festivals were popular events. Festivals afforded the leisural occasions for grownups to be playful, to reinvigorate one's resident feature of humanity to be imaginative. Rulers have always known the advantages of "bread and circuses" (managed discretely behind the scenes) to help keep the masses in tow. So poetic bards, troubadour and minstrels, clowns, jesters, practitioners of dumbshows, tableaux, *commedia dell'arte* puppeteers, were able to offer their special services on these occasions.

Institutions like the Western Roman Catholic and Eastern Orthodox Churches developed their own in-house processions and pageantry, utilizing dress-up and choreographed liturgical movements to accompany the ritual of the mass. The dominant medieval church also fostered didactic "morality plays" in the city square to catechize the mostly illiterate working poor. Over in Japan Noh theatre had Shinto shrine background and a Zen renunciatory simplicity begetting events breathing a solemn invocational aura. After 1300 AD Noh plays moved their highly stylized, declamatory poetry-and-dance routines away from rural districts into the court environs under patronage of the shogun Ashicaga Yoshimitsu where under master Ze-ami the Noh format and protocols were practically canonized.

That has always been a problem: special events for special festival occasions by specialized imaginative leaders open to . . . the public at large? or to only a select audience?

Hence the marvel of English Elizabethan theatre where you had seats on the stage for a few would-be performer aristocrats and the pit for the mob relishing comic relief. Elizabethan staged action happens in an open space where there is a wholesome mix of make-believe acting and actual smelly reality caught up together, for example, in an extravagant *Tempest* never-neverland where Caliban rasps like an angel (III,ii):

> Be not afeared. The isle is full of noises,
> Sounds and sweet airs, that give delight and hurt not.

And Shakespeare's theatre company shows that a time came when theatrical events of high-flown fancy and gutsy sword fights were no longer liturgical and churchy (or dedicated to Dionysus or Buddhist *yûgen*). Differentiated theatre companies at the time were legally protected by the governing royalty, to which sovereign a play might be dedicated, but the staged play floated or sank itself by the entrées paid at the door—at least one step up from passing the hat in the marketplace after a Punch-and-Judy show.

When the theatres closed in 1642 during English civil wars were "restored" to operation by Charles II (1660–1685), the prevalent comedy of manners in England was pretty much reserved for the decadent court circles—shallow, frivolous, colloquially coarse. At the same time in France, in the august *L'Académie française* and formidable *Comédie française* structured world, Racine and Corneille had their serious, classicist tragedies performed for the French elite who were also buoyed by Molière's impressive comic masterpieces. But in England from Dryden to Romantics Blake and Byron (*Cain*, 1822) drama faded behind poetry and the rise of novels deemed much safer than bawdy theatre by the literate middle-class.

An underworld of cheap Victorian melodrama was what entertained the British theatre populace until renegade George Bernard Shaw's bitter satires forced people to pay attention. Ibsen and Strindberg also brashly tried to correct the rhetorical bombast, artificial language, and mythopoeic world of traditional staged plays by pushing the audience's face into the facts of alienated personal lives in drawing rooms. Despite their aim to capture "natural" matters with astringent penetration, Ibsen and Strindberg's dramaturgy was very conventional: the room in which the pitched emotional battles of individuals took place was framed by the proscenium arch, so the audience was clearly distanced from the pictured action (the way laity were separated from clergy by the front railing in a Roman Catholic church).

The Dada movement had the luxury of safety in Zurich, Switzerland, during the war enveloping Europe 1914–1918, to call into question the rationality of society with absurdist artworks. The moment of truth in their endeavor, I think, was to try to dethrone the idolatry inhering Establishment ART ensconced in Robber Baron funded musea. Because the Dada spirit was not out to reform so much as to practice revolutionary nihilistic hijinks, for drama it dissolved *la pièce bien faite*, any well-made play, into "Happenings" or the planned anarchy taken on tour by "The Living Theatre," where the evening audience is invited to be co-playwright. (A "Living Theatre" performance I paid good money for in Heidelberg, 1967, began with a few actors seated on stage promising to levitate until after many, many minutes had elapsed with nothing happening, catcalls from those in the auditorium gradually rose to almost riotous level, and objects began to be thrown.) The "Living Theatre" was perversely dissolving plotted theatrical art back into the native human ability to imagine and make-believe, rightly assuming the given ordinary special quality of fooling-around, but wrongly making money out of ridiculing its gift.

I have rehearsed roughly how variously this basic human ability of being imaginative has been bodied forth in playfulness, in making-believe with or without masks, and just hinted at how **"acting" like somebody else in order to present indirectly knowledge of fantastic affairs in God's world—secrets, foibles, agonies, joys—to your neighbors has held societies, especially the well-off and educated, spellbound for ages**, in order to help us Christians who are close to theatre assess what needs to be done today . . . while we are in Babylon.

If theatre should be as normal and integral to daily life as clothes, should you go to a play or hire a ventriloquist just for birthday parties and anniversaries, or every time you put on clean underwear? If only those with a regular salary can afford to buy a season subscription to the local symphony or Goodman Theatre, what would Jesus do . . . for the unemployed? Should the christian community make do with unprofessional make-believing actors (and not pay Equity wages)? since getting a tooth pulled professionally is a more serious business than supporting stand-up comedy at The Second City. Or should we exiled Christians boycott the theatre district, maybe use skits in church worship and on street corners to evangelize, but get our diet of imagination more cheaply on advertising TV?

For me no artistry is more moving than to be seated in a front row cheap day seat at the Olivier National Theatre on the South Bank in London, England, and sense that the guy who just unobtrusively stepped out of a door on stage set to light up a cigarette is not a janitor, but is David Hare's Bertolt Brecht's *Galileo* who discovered that the earth is not the center of the universe, was broken by the authoritarian Church, and died an impassioned, visionary faulty human being—there he is! puffing away eight feet from my face! Not even engrossing close-up cinema of ecstasy or suave perfidy—it's shown on a screen—can match having a live human breathing being before you really making believe he or she is Galileo or Desdemona in a struggle to find meaning. Great theatre experience makes it easy for a Christian to grasp that acting and playwriting can be an imaginative act of neighbor love, waking up those who may be ignorant or fearful or closed to *la gloire et la misère de l'homme*, to use Pascal's phrase, in all their enriching, disturbing subtleties.

I say this from the perspective of my Reformation christian faith background, refracted through a Dutch Kuyperian lens: **we understand the kingdom Rule of God in Jesus Christ to be the calling of every Holy Spirited believer.** Ecclesial clergy do not have a corner or inside track on obeying the Lord: **all followers of Jesus Christ are Melchize-**

dek priests, and are expected to carry out their respective communal tasks in God's world with merciful justice. So theatre-making itself can be God-thanking redemptive service. But a theatre is not therefore a church. And a church is not a theatre. A Sunday church service, of course, may choreograph how the deacons collect an offering, but if the stylized movement tips over into a ballet, a categorical institutional mistake has been made. To end a stirring dramatic performance at a playhouse with an altar call is also a categorical institutional mistake. Making **theatre** and attending **theatre** should be as consecrated and holy an activity to which one could apply the apocryphal story about Martin Luther's planting trees: if it is certain Christ is coming back to earth tomorrow morning, as dramaturge you do not recommend we run to our inner closet to pray; instead, you say, "Play rehearsal tonight as usual, 7 PM sharp!"

Factors in the theatrical event with which Christians busy with theatre need to immerse themselves

What kind of theatre would be worth such devotion? How can the worldwide body of Christ bring theatrical shalom to the inhabitants of Babylon, who speak a language foreign to God's people with an idiom of Darwinian success, seductive violence, and often debasing expletives? Could we spell out dramaturgical responsibilities for actors, playwrights, directors, audience, and producers who wish to change things to make theatre into sturdy everyday clothing and the daily bread of life, manna?

The intrinsically collaborative nature of theatre events makes theatre difficult to parse, but a few things could be said up front: (1) There is no one formulaic christian way to do theatre; (2) you cannot certify a theatrical event with a Good Christian Housekeeping seal by having a doctrinally orthodox script, performing for a good cause, or by receiving pious endorsements; (3) nobody can ever fashion redemptive theatre *ex nihilo* because we humans have historical ground under our dated/located feet, and reform and innovation in theatre too happens "under the sun," where not much is new except God's eschatonic action in Jesus Christ and the outpoured Holy Spirit, which provide openings for epiphanies of grace.

As for the trouble Christians may have to be intelligible in a Babylonian culture: we need to learn the major cosmopolitan languages current as Daniel and friends did, even though Christians will probably always speak the lingo with a telltale accent. If as people of the Book our mother tongue is truly psalmodic and gospel-true, we should also be able to translate the conjugation of "Grace, creaturehood, sin, repentance, for-

giveness, and hope," into text and gestures at least partially understandable by those whose vocabulary is limited to "I am No. 1, evil, success, and failure," because Bible talk is, so to speak, the aboriginal universe of human discourse, even though much of its diction may seem obsolescent today. And the reality that all peoples—rich young rulers, *les damnés de la terre*, as well as God's adopted children—inhabit the same universe where injustice seems resident gives us a commonality to approach theatre, because **at the core of any theatre is the struggle around wrong-doing under an unseen Provident force that cries out for balancing redress if not restoration.**

Actors. Konstantin Stanislavski's (1863–1938) arduous training of actors for the Moscow Art Theatre (begun 1898) asked a person to live into the character of the play almost hypnotically if possible, developing an emotional memory of Hamlet or Cleopatra's life **pre**-textually, before they appear on the scene, so that you as actor are so completely attuned empathically to the character you are able to show his or her *persona* identity in the ensemble under the ruling idea of the whole play as a **real** living participant in the action.

It's true, good actors are able to melt down, as it were, their actual personal traits so that you hardly remember him or her as a different character in a previous play. American circles imported Stanislavski's rigors as "Method Acting," which was infamously trivialized by Charlton Heston's saying he gave up cigars to play "Moses" in Cecile de Mille's extravagant cinematic flick *The Ten Commandments* (1924/remade 1957).

Bertolt Brecht (1898–1956) thought Method acting was wrongheaded in its "kenotic" requirement (my term) that the wage-earning actor must empty out his or herself into the imaginary person, losing oneself in the presentation. Brecht wanted actors much more audience-aware, instead of pretending there be no spectators, and tried to teach a company of actors to portray their characters socio-critically[5] so **everybody** would be jolted by the "blink-and-wink" (my term for *Gestus*) performance to realize the duplicity required of people by the cursed societal setup we inhabit.

It's as if Brecht wanted actors to embody the stratagem Eugene O'Neill used in *Strange Interlude* (1928)—a character speaks to the other

5 James Leach exposits with precise care the "rehearsal" **performer**-teaching character of Brecht's *Lehrstücke* (1929–1931), misunderstood by so many critics as overly didactic, in *Instructive Ambiguities: Brecht and Müller's Experiments with Lehrstücke*, chapter 3, especially pp. 52–72.

person, then turns around, back to the same person, and says what they really wanted to say—Brecht wants an actor always to show the good woman of Szechuan Shen Teh is also/has to be! the bad man Shui Ta; Mother Courage is palpably an indomitable heroine in the war **and** a heartless profiteering victim. As Strindberg says of the valet Jean in his one-acter *Miss Julie* (1888/1889):

> He has learned to wear formal clothes with taste,
> but one cannot be so certain that his body is clean.[6]

Brecht asks actors to show humanity as compromised.

Acting I understand to be playing out the mask you self-consciously and self-critically put on.[7] You become a professional actor when, even on bad days, because of researched care and disciplined, wholehearted understanding of the adopted *persona*, you make the mask come bodily alive—flexible, complex, imaginatively intriguing. As a potential christian actor motivated to bring theatrical shalom to a harried Babylonian populace, I think Brecht's opening for actors trained to make audiences do a double-take on the action portrayed gives a window of opportunity for players to perform ordinary matters with a mysterious edge and serious messy affairs with biblical compassion so as to reach anyone who behind their facades is hurting.

Types of dramatic scripts and playwright traditions. While actors (and directors) implement and modify play scripts in bringing text across the boards, **what the playwright has authored does cast the prospective action within certain horizons and bespeaks a committed vision of the world, humanity, and history.** Although my categories will be a little clumsy, I should like to delineate four—I'm certain there are more—possible traditions of playwriting extant, which might give contours and serve as springboards for Christians keen to conceive and write theatre for today. **Unless as dramatist you stand and are working within some kind of living historical dramaturgical communion, tradition, your disconnected solo efforts, I believe, will be inescapably plagued by mediocrity.**

6 August Strindberg, preface to "Miss Julie" in *Seven Plays*, translation by Arvid Paulson (New York: Bantam Books, 1960), p.68.

7 A "preacher" in the pulpit, even if he says, "Don't called me 'Reverend,' just call me 'Charlie,'" adopts a *persona*, again, even if he not be a "Dimmesdale," because becoming **officially** a "preacher," "president," or "TV personality," is a **performance** for the nonce by an ordinary human creature. Because such "official" performances are often not self-consciously adopted, they are not theatrical. Teresa Ter Haar reinforces this observation with her article on "Teaching Performance Studies: The Word made Flesh," in *Christianity and Theatre* (Spring 2005), 9–15.

(1) William Butler Yeats (1865–1939) typifies for me what one might call a "**poetic drama**" predilection, where myth and legend, fantasy and lovely language are preponderant. Yeats wanted actors, amid minimalist scenery and costume, to slow down enough "to give poetical writing its full effect upon the stage,"[8] to conjure up a state of almost mystical reverie, dreaming of impossible life in bitter or beautiful verse. Such literary drama is not about presenting street life, but is after timeless, ethereal metaphysical ideas where, as in Noh drama, what is visible is symbolic and what is bloodless and invisible is what counts!

Whether it be the earnest dithyrambic poesy of Aeschylus (c. 460 BC), the screwball ecstasies of Monty Python routines (1970s–1980s), the sober blank verse of T.S. Eliot's *The Cocktail Party* (1949) or the cascades of shimmering English language in Christopher Fry's plays: **poetic drama**, like a Gabriel Marquez novel, would strangely make the mingling of heaven and hell on earth acceptable. The play is almost more for reading and listening to than for staging.

Yeats' attempt to build up Irish folk theatre at the Abbey theatre in Dublin (c. 1904) with dramatic literature that would outshine the censorious pulpit and criticaster newspapers was a noble fight. For me its focus was too esoteric and geared for initiates. Yeats himself said:

> I want to create for myself an unpopular theatre and an audience like a secret society where admission is by favor and never to many.[9]

I would admit, however, to be "almost persuaded" of minstrel-like **poetic drama**'s christian potency by the magnificent lines to be sung at the conclusion of Yeats' one-acter called *Easter*:

> Odour of blood when Christ was slain
> Made all Platonic tolerance vain
> And vain all Doric discipline.[10]

(2) "**Morality play with happy ending**" is a ubiquitous format in dramaturgy, from Euripides' comedies through medieval *Everyman* to Victorian melodrama, to the TV "soaps" today. Most people who have a pedestrian, relatively comfortable life are entertained by the spectacle of criminal activity, a little violence, and sexual deceit, if in due course the misdemeanors receive their come-uppance. This is the tried-and-true formula that structures the American musical song-and-dance play, from

8 William Butler Yeats, *Plays and Controversies*, 26.

9 Yeats in a letter to Lady Gregory, Ibid., 212.

10 New York artist Christine Anderson made me aware of these powerful lines of "Easter," in Yeats, *Selected Plays* (London: Penguin Books, 1997), 203.

the old *South Pacific* (1949) to the current *Wicked* (2003), and is commercially popular because like war the American musical oversimplifies things: it's good guys versus bad guys; and once the misunderstandings, misidentities of the stock characters, and conversions take place, it all ends happily ever after, and we can go home satisfied, without any postdramatic reflection except on how well executed the dance steps were or how novel the special effects.

The comic routine that "All's Well that Ends Well" is a tempting dramatic tradition for Christians to adopt because, like Job's friends, we often think we know the answers on good and evil—good is good and evil is wrong. But to teach such a moral code without probing the slow, debilitating intricacies of good-looking sin and the tentative, mixed ambiguities of doing right remains a shallow falsification, it seems to me, of human existence. Thornton Wilder's *Our Town* (1938) is pensive, gentle, good theatre in the **morality play** tradition; Shaw's *Mrs. Warren's Profession* (1902) debunks the whole business while minding its conventions. Maybe "bourgeois-friendly" drama is the place for new playwrights to cut their teeth, but in our Byzantine Babylonian circumstances where The Big LIE rules, and a crushing monetary violence stifles our many neighbors, and the drug of media Sensation is epidemic, if I send theatre goers home relaxed and laughing, I need to be sure I have offered them theatrical bread and not a quick-fix millstone (cf. Matthew 7:7–12, 18:1–5).

(3) Brecht epitomizes what I would call the "**Revolutionary subversion**" dramaturgical tradition. I do not mean just avant garde art that needs notoriety to succeed, upsetting as many apple carts as you can reach in one plot, like Genet's *Le Balcon* (1957). I have in mind theatre whose focus boldly questions any reigning societal order and depicts how the underdogs suffer, contend, and persevere: plays by Synge, Gorky, Clifford Odets, Piscator, the semi-improvisatory polemical South American "theatre of the oppressed" Augusto Boal champions, with the need for a "Joker" figure, and the "Bread and puppet theatre" (1960s) orchestrated by Peter Schumann. **"Revolutionary" theatre** easily unravels into agitprop (agitation and propaganda) where actors become marionette mouthpieces for a partisan political cause. At its best, however, in Brecht, the polarity of evil and good, purity versus power, is not tied to social class consciousness—it infects **everybody**!—and the push for subversive action is not a full-blown imperative, but a more subjunctive hortatory appeal to change one's consciousness and see the irony that **all** of us are hostages! even though some are more hostage than others.

As the son of a fishmonger I sympathize with Brecht's visceral rejection of both the Romanticist Broadway Revue escapism and the Zdanov Communist moralistic dogmatism that his *Aufstieg und Fall der Stadt Mahagonny* (ca. 1930) and *Dreigroschenoper* (1929) parody with verve. The locus of concern Brecht shares with Zola and Balzac, and his tiny Nietzschean touch to expose pretension and hypocrisy is also attractive, rightly disturbing. But the **revolutionary subversive** fixed horizons for such theatre avoid any possibility of peace: Brecht's drama presents only a **militant** church, courageously counterpunching in the episodic quagmire of an everlasting struggle to survive by the skin of your teeth, there is no reliable **eschaton** boding hope.

(4) A fourth set of visionary parameters I find shaping the *agon* of theatre I know has a "**troubled cosmic**" purview. For example, I saw a gripping production of Thomas Heywood's *A Woman Kilde with Kindness* (1603) where the trusty servants became a kind of medieval song-singing chorus, a broken cross on the wall gave you an inkling of God's presence, while the slippery, fascinating bondage of sin upon a person, the accidental fortuitousness of evil, along with the actual possibility that forgiveness might extricate someone from complicity, surrounds the struggle between generosity and lust with a wonderful cloud of mystery. And Shakespeare's great tragedies and later works have the **cosmic** dimensions that reveal the profound depths in human nature grappling with unnatural principalities and powers that wreak **havoc** in the lives of mortal women and men locked in love and combat together. *The Winter's Tale* (1610–1611) too limns the corrosive destruction of unnecessary obsessive jealousy and the steadfastness of the queenly Hermione and the forceful Paulina, a couple of amazing women in a world filled with treachery. The couple of times I have witnessed Schiller's *Sturm und Drang Don Carlos* (1787) I was impressed that the range of action—virtuous Queen, evil Duke of Alba, the Grand Inquisitor, fun-loving Don, and the King, an omnipotent man who has doubts!—it all happens under a gigantic justifying crucifixion figure of the Christ, which somehow heightened the enormity of what was transpiring.

This "**troubled cosmic**" tradition I am hinting at—I'm not talking a genre, or form, but the large visionary scope of the playwright's text where a heaven and a hell of sorts are taken as **real** horizons for human action—has dimensions missing, it seems to me, in dramatic work of the serious Pinter and the ebullient Tom Stoppard. Old Existentialists Sartre and Camus artworks explore and relish crises, but their stark, tight world

disallows what is not at bottom rational. Peter Schaffer's *Yonadab* (1986), even more than *Equus* (1973), reaches for a "**troubled cosmic**" spread by exploring guilt, innocence, intrigue, in the wicked Older Testament warren of King David's court. David Edgar's sprawling *Pentecost* (1994) play uses **an abandoned church**! as a home of the fugitive homeless and as the battleground that the destructive victors of the earth take possession of. Lebanese-born French Wajdi Mouawad's piece *Incendies*, written in Quebec 2004, which recently received its Linda Gaboriau English translated première called *Scorched* at the Tarragon Theatre in Toronto, puts profanity, violence, family secrets, humor, helpless women who persevere and rise above the stupid politicized war in the Middle East, in a panoramic welter of conflict riveted in a set of loose desert sand so hard for the actors to walk through, which stirs every onlooker with heartbreak at what man has made of humanity. That is, certain playwrights cast the struggle they portray not within a matrix of giving answers, not by taking sides, not by sidestepping the surd of disruptive sin, but by **asking the right questions about just-doing that assumes and knows human decisions and acts have everlasting consequences**.

My point here is that certain theatre lays down certain grooves, and sets up a kind of dramaturgical tradition. **It is wise, I think, to come to feel at home in a groove; it helps a playwright weave one's own particular plotted or episodic series of dramatic events in a time-honored tapestry, you realize is your visionary pedigree.**

If I were a playwright I would saturate myself with the **troubled cosmic** prototypes, because their horizon allows for inexplicable sin and rare joy to materialize as **real** dimensions of human struggle rather than confine our deeds to take place within the limits of evil and pleasure, faults and pain. I probably would be tempted to work within the corrective third option of **revolutionary subversion**, and conceive theatre to turn hypocrisy inside out and upside down—if I could manage to do it redemptively rather than judgmentally. But I believe other Christians might groove in **poetic drama** or in the **happy ending morality play** to be fantastic or homespun, yet gifted to make a quirky, deeper-going holy spirited difference in those traditions, or possibly reach out with grace in other playwriting traditions. Christian imaginative theatre will bestow a rainbow rich response to the opening God has given us to make-believe we have tremendous struggles in human history, so we may gather in bouquets of diversified wisdom while we may.

Theatre Directors. The director, in my judgment, is the lynchpin to a theatrical event. Like the conductor of a symphony orchestra, the coach of a team playing basketball, the principal who daily leads the teachers and students of a school in operation: the director of a theatre performance, assisted first of all by a set designer, is the lightning rod for the spirit that animates a particular performance of a playwright's text and the given company of actors embodying the script. **It is the director who fuses the whole collaborative event with a common dynamic.**

How the inspiring is done—friendly cajoling, autocratic arm-wrestling, shaming, salary-raise—differs, but it is the responsibility of the *régisseur* to instill a living spirit of questioning, of devil-take-the-hindmost, of sunny nostalgia, of sanctity, in the proceedings of the ensemble. You can't pull biblical silk out of a filthy script of a sow's ear, but I know from experience a good christian director can forge a redemptive piece of hope-giving theatre out of a mixed bag of solid unbelieving actors. No director could redeem Michael McClure's '60s cult shocker, *The Beard*, which I saw above a pub in London, England, recently: the litany of repeated dirty words was pointless, really boring. And it takes the sure hand of a wizard director with a cluster of exceptional actors to enact the horrible, excessively disgusting deeds of Shakespeare's Goths and Roman nobility in *Titus Andronicus* (1590–1593), and give it a credible but appalled spirit. I saw such a feat 20 years ago and will never forget it: when the justice you scream for inwardly happens staged as ruthless revenge, what human can bear it unmarked?

Peter Brooks' touring Africa under the Sufi banner of *Conference of the Birds* (early 1970s), trying to efface theatrical direction into a mystical, universal holy ritual failed, as I see it, because when you try to reduce directed theatrical symbolification to a natural enchantment welling up out of an improvisatorily smelting of actors and audience, you annihilate theatre in gestural suicide—precisely the agenda of Artaud's "theatre of cruelty." Theatre directors who call the shots have tremendous power to enliven, enfeeble, even miscarry the dedicated work of playwrights and actors. One could paraphrase James 3:1: "Do not many of you become theatre directors, brothers and sisters, for you who direct will be judged with greater strictness than others," because your responsibility is so great.

Audience. A spectating audience is integral to theatre. There are dull audiences, which drag down a performance, and alert responsive audiences, which invigorate the acting and can top off the whole endeavor as a climatic celebration or memorable lamentation. The best playwrights

will write scripts that can be enacted to reach the dramaturgically naive or handicapped at some level of ingestion, yet hold insights surprising the cognoscenti. Shakespeare's language, at the time of Tyndale's Bible translation which had both bite and dignity, could reach the very vulgar and also those who appreciated refined poetic formulations.

A general theatre audience of three generations, with varied attention spans, will have widely different motivations: to be amused, to have one's prejudices reinforced, to be imaginatively stretched, to meet the midnight deadline for a critical newspaper review. **A normative audience, I think, should be open, intent, relatively informed, that is, able to gather in the visionary thrust and groove of the struggle and to sniff out the spirit driving the performance.** For example, a mature theatre-goer watching James Joyce's *Exiles* (1914) will see the absorbing psychomachia thrust-and-parry raging between wife, self-centered husband academic, governess "girl," and old-boy school friend, and sense the maelstrom of conflicted, emotionally burdened lives chained together by misbegotten histories. Joyce's **poetic drama** is deeper than a wordy dialogue between bickering spouses.

A christian touch to audience formation? At least a dozen tickets should be given away for each performance to people in the locality who would otherwise never go to the theatre: indigents, delinquents, outcasts, the poor who may be ungrateful and smell. Knowing there be such representatives of Christ in the audience (cf. Matthew 25:31–46) every night would have a salutary effect, I believe, on the consciousness of playwrights, directors, and actors.

Steps for producing theatre honoring Christ's Rule on earth, while exiled in Babylon

What would it take/does it take to have quality theatre events honoring Jesus Christ's compassionate Rule on earth: is it possible that such theatre could become normally integral to our public life somehow while and wherever we live in Babylon?

Because making-believe is a creaturely good from God for us humans and has been operative in festive theatrical events in all human cultures throughout world history, underlying my analysis of actors, playwright traditions, role of directors and theatre audience, is the conviction that "christian" theatre (remember my careful definition: "sinful human witness to the forgiving grace of the LORD God revealed in Jesus Christ") is not a pipe dream, but is indeed a promissory injunction by our Lord through Jeremiah to give theatrical shalom to the citizens of Babylon

while we are here.

Someone may say: If we as God's people are exiled in Babylon, our first task should be evangelism, to convert the unbelievers to the truth—

But I am not talking to evangelists: I am talking with teachers (of drama). And I am not talking to pastors, but with bona fide actors, playwrights, directors of theatre, the way Paul distinguishes the different gifts of grace the body of Christ has been distributively outfitted with so God's people can become mature in their mission and not one-dimensional (1 Corinthians 12, Ephesians 4:7,11–16).

If you were sculptors, I'd say with Simone Weil,[11] don't become a second-rate cleric if that is not your gift, but put up a bronze serpent such that those who raise their eyes to it may be moved to repent (cf. Numbers 21:4–9). If you were song writers, I'd say write a contemporary lament close to the original Psalm 137 blues, which guts out sorrow so powerfully any jeers would be stopped in the listeners' throats. If you were wordsmiths, I'd say, do not strive to speak in unintelligible tongues, but go into backwater country and write a novel like Marilynne Robinson's *Gilead* (Harper Collins, 2004). . . .

Since we are gathered as CITA—Christians in the Theatre Arts—our vocation is to build dramatic bridges and theatrical events proffering shalom to all and sundry, whoever be our neighbors. So, as a theoretical aesthetician, let me dare offer a few practice-oriented comments for further reflection.

(1) Because theatre is highly communal artwork and necessarily involves a goodly number of persons, and because our cultural-societal circumstances in North America are largely structured by a corporate Capitalistic market setup, it is not wise, I think, to set about reform in building dramatic bridges all by your christian self, individualistically, as if I privately will let my little theatrical light shine. Many christian artists are indeed lonely witnesses to God's care, and we need to support them however they make their difficult way. What I want to highlight, however, is that **every professional artist needs non-artist back-up and out-front connecting persons**, especially in our post-artisanal society where the imaginative artist is no longer directly and officially enmeshed with those one serves.

A solo novelist can write her manuscript, but still needs a book publisher, and the books need a distribution network, or the novel is stillborn.

11 *Attente de Dieu* (Paris: Fayard, 1966), 52–54.

A song writer with a singer needs a manager to arrange a tour, an agent to sign you with a record company and mediate with disk jockeys for play time, or you remain largely unheard. A theatre troupe with free-lance actors needs a location, a roving director, and infrastructural personnel to organize and fund the expensive production of theatre performance, or as dramaturge you must hitchhike around the reigning system.

(2) A difficulty in joining the Commercial**ized** theatre setup in Babylon is you may not be able to get a food diet Daniel was able to arrange for himself and his friends. Theatre like any art, if it constitutes one's livelihood, always has a bottom line: it needs to put bread on the table. **Commercialized art transposes the foundational bottom line to the top defining line: then art is metamorphosed into a means to make money.**

When artwork is defined essentially to be a commodity for sale, a couple of things tend to happen: (a) artwork splits into expensive High Art for the elite, and cheaper Popular Art for the masses; and (b) distributive intermediaries for artists become production controllers who analyze what the market will bear and determine what products will sell. Then pared down costs and prices for profit come to play an inordinate role in the theatre that is produced: you move toward gala performances of world classics for those who can afford it, and toward perennial runs of *The Mouse Trap* (1952) and *Phantom of the Opera* (2004) for the general public. And if theatre becomes run-of-the-mill "culinary entertainment" (Brecht's not wholly unfair designation) or a pricey luxury, then restoring theatre as an integral event clothing human life (granted theatre is not a necessary like food and water), bringing theatre bearing wisdom regularly to ordinary people will not be very probable.

(3) Alternative (Daniel-Shadrach-Meshach-and-Abednego) theatre companies deserve consideration (which some of you, I know, already engage in). By "alternative theatre" I mean a professional not-for-profit (you still pay salaries and overhead!), possibly co-operative, differentiated theatre organization whose galvanizing purpose is to bring thought-provoking normative theatre live to people in regular PWYC (pay-what-you-can) venues, but also to schools, in the streets, at fringe festivals, in libraries, at summer camps, prisons, at civic functions in neighborhood barns and unused buildings. . . .

An alternative theatre organization is different from a breakaway avant garde movement of informally united, like-minded colleagues with

manifestoes and a brief identifying style or partisan focus. An alternative theatre company is also not an outreach arm of a church, although a church community may be the mother of its birthing. An alternative christian theatre organization in Babylon will have a constitution with a select curatorial board to which the theatre director and troupe are accountable. **WANTED are the non-artist entrepreneurs with vision, competence, insight, and persistent savvy to raise institutional support behind such independent, incorporated endeavors.** (Yeats' formation of the Abbey Theatre with the bequest of Annie Horniman, later receiving Irish state subsidy in 1925, struggling for a communal and viable identity is an instructive example.)

The patronage of arms-length cultural foundations must be secured; applications must be made to the governments for tax exemption and grants to put on performances of make-believe for the public welfare; businesses need to be encouraged to lend their names and subsidies for the theatrical good of the locale where they do business; churches need to be sought out for prayer and offerings to support the mission of theatre outside its doors; media contacts have to be courted to do in-depth reviews and interviews, not just PR and advertising. That is, Christians who are willing to act communally to initiate bona fide theatre events for Christ's sake rather than for satisfying what the Babylonian populace wants to pay for, must find the non-theatre persons who will patiently work at the massive operation to convince non-artistic institutions in society like the state (remember the US Federal Theatre project in the 1930s), business, media, and patronage foundations, to make Daniel-Shadrach-Meshach-and-Abednego theatre viable.

Could CITA, which has soldiered on with dedicated limited staff for many years, now that it is a generation old, continue its vital networking task and move from the stage of fellowship among theatre people, the *Christianity and Theatre* publication, and a yearly conference, toward also becoming a national resource for lobbying among non-theatre people (including the National Endowment for the Arts) for funding alternative theatre organizations?

What about the Church and Christian colleges with theatre departments in our Babylonian culture? What could/should their role be in forming the critical mass of a believing watershed conducive to professional theatre giveaways in Christ's name?

(4) It depends upon which kind of Church communion you specify. (In

Daniel's day there was even no ark or temple presence among the exiles.) Catholic and Orthodox Churches have their churchly liturgical pageantry and have blessed the didactic mummer tradition of acting out Bible stories. Evangelical churches in the "Revivalist" faith tradition, who have never felt much at home in earthly drama, have curiously learned the use of theatrics on TV, and have developed expertise not in agitprop but in what one might name "moral-prob" theatre—skits with humor that give biblical counsel on solving moral problems afflicting us. The "new Christianity" that Philip Jenkins has described in the two-thirds world[12] will be less inhibited than Western Christendom has been toward dramatic flourishes in worship, I think, because they live the festive element in worship services as a release from their burdened, constricted, weekly existence.

However, IF in our complicated developed Western Babylonian "civilization" members of Christ's body decide to bring professional theatre to our neighbors, it would be a mistake, I believe, to pull theatre back into the embrace of the institutional church and its particular preaching, sacramental, pastoring, and evangelistic focus. Daniel probably prayed at his window in Hebrew, but I bet he spoke Akkadian or at least Aramaic[13] at the court of Nebuchadnezzar and Belshazzar. **Christian theatre needs to speak Babylonian language with a christian accent, not just church-appropriate language**. If the organized church would set up a theatre group to do theatre not just for the church or to repackage and dramatize churchly tasks, but would develop repertory theatre **in the public square**, for doing theatre as a faith mission not to court converts, but to clothe strangers who are neighbors with the balm of compassionate dramatic insight and glimpses of the world where one's entrance and exit has meaning, then there would be great rejoicing in heaven and on earth! The way St. Paul's Lutheran Church supports Lisa Wagner as director of Still Point Theatre Collective for its doing theatre in jails and prisons is exemplary. The organized Church must also seek **first** the Kingdom, the Rule of God in cultivating the earth, which includes planting redemptive theatre outside its own particular task and environs.

(5) In my judgment, along with Debra Freeberg,[14] the Christian liberal

12 Philip Jenkins, *The Next Christendom: The coming of global Christianity* (Oxford University Press, 2002), and *The New Face of Christianity: Believing the Bible in the Global South* (Oxford University Press, 2006).

13 Aramaic was the international diplomatic language of those times; cf. 2 Kings 18:13–37, v.26, and Daniel 2:4.

14 Cf. her good article "The Mission is Possible: Theatre and the Christian Academy," in

arts college is a strategic place today to train christian actors, playwrights, directors, and audience, because our dramaturgical fits and starts, mistakes and failures there are "academic," that is, integral to learning the ropes for the time later when you present theatre professionally outside educational walls. Such enclaves of christian training in our Babylonian culture entails difficulties, I know, since an omphaloskeptic safety device kicks in as soon as a play requires a Babylonian scene or four-letter word, and the place of such indiscretions in the over-all redemptive theatrical constellation are missed; and one forgets **we need theatre to bring shalom to our neighbors, and is not primarily talking to our pious selves.**

I realize I am touching on a sensitive matter and probably will only say enough to be misunderstood, since I do not believe you need a little nudity on stage as a mark of being up-to-date with Babel-speak. And I do not know—it probably depends on what is locally available—whether it be wiser to perform choice, maybe unusual plays from the vast repertoire of world theatre, or practice writing our own beginning material of quality. Ron Melrose's *Early One Morning* (1991), which was performed for CITA once a few years ago, for me is an astonishing, vibrant piece of christian musical theatre, as good as Peter Maxwell Davies' *Eight Songs for a Mad King* (1969), and needs to be part of the repertoire for professional giveaway theatre in Babylon. Until we homegrow theatre pieces of such caliber, grit, and scope, it may be wiser to lean on normative texts already available and give them fresh treatment.[15] The strong drama department of Dordt College in Iowa for years had the wisdom, without subterfuge, to do experimental theatre and student written pieces in studio or showcase presentations in-house for college scrutiny and critique, and would do *Hedda Gabler* (1890) and Tim Slover's *Joyful Noise* (2000) for the paying public. Joyce Aldridge has noted the educational wisdom of such diverse performances, and rightly highlights, I think, the profound community and audience bridge-building of post-performance panel discussions with the cast present, updating the old custom of prologue and epilogue in an almost Greek chorus commentary.[16]

A most basic step for christian colleges to take, I think—and it involves the whole faculty and especially the administration—is to wean ourselves from a sanitized Bible and **develop a sense of how gutsy God**

Christianity and Theatre (Spring 2005): 20–28.

15 Strindberg is not my favorite playwright, but I wonder if his three act play entitled "Easter" might not be something worth doing in a homespun venue.

16 Joyce Aldridge, "Finding Christ in All Theatre Works," *Christianity and Theatre* (Spring 2005): 18–19.

talks in the Psalms and prophets, so we can translate the LORD God's worldliwise knowledge of the cracks and crannies of human embodied hearts and God's fiery appeal into trenchant Babylonian speech. If Jonathan Swift in *The Tale of a Tub* (1704) had known not only Protestant Jack but also his evangelical brother, he would have mentioned the chapters Jack's brother has excised from the Scriptures—like Judges 19–21, The Song of Songs, Psalms 69, 109, and Matthew 23. Until God's people realize how rough-and-ready the Semitic and Greek revelation of the LORD God is—the women Matthew purposely records in the genealogy of Jesus (Matthew 1:1–17) and the uncouth fellows of faith listed in Hebrews 11 (vv. 31–34)—we may be squeamish at the make-believe of the dark sides of human life. We need to challenge our preachers to let the Bible's grit show!

I wish CITA would hold a conference for pastors, elders, deacons, christian college administrators, and leaders of God's people, put on a convincing performance of *Equus* or Cedric Smith and Jack Winter's dramatization of Barry Broadfoot's *Ten Lost Years, 1929–1939*, to demonstrate the nature and disturbing power of theatre, to discuss pros and cons of make-believe "temptation," and help them understand, for example, that maybe the presentation Dostoevsky makes of murderer Raskolnikov and the prostitute in *Crime and Punishment* (1866) is possibly like a mirror conversation of Jesus and the Samaritan woman (John 4:1–42), veritably a communion of unusual saints (?). Somebody—why not CITA—needs to stimulate and school ordinary people and civic leaders to become theatre aware so they can deftly, trustworthily surround theatre events with historical and dramaturgical reflection that will give inexperienced theatre goers an entrée to grasp the allusivity of the make-believe whole, how to read in between the lines and gestures, and sniff out the gist and key spirit of a performed piece.

Perhaps it has been dangerous for me as a theorist to offer a few practice-oriented thoughts in matters so complicated, but I want to end by encouraging you for the long haul that God's people find an alternative groove for making professional theatre and giving it away not as harsh judgment but as deepening service to our hosting, hostile culture. Christ's body can identify with a crooked and perverse generation of an audience because we who are Christian are also always recovering sinners, thanks to the Lord's grace. We must not be timid and make do with trivia, but go for the jugular of the Babylonian Violence Abounding everywhere, domestically as well as in "foreign affairs."

Dutch woman Brit Wikström's (born 1948) installation of five poles and figures for an Amnesty International artistic competition, entitled *Cathedral of Suffering* (1994) [see #5, #31], waits for you to walk toward it in a field: the woman figure [#33] is bent to shield herself helplessly from the unstopping attack; the little child, arms raised to protect its face, has its own solitary grown-up pole; [#34] the spread-eagled man is crucified between the torture of hanging from two poles; [#35] and the empty pole stands waiting for another victim. Evil and sin are insatiable in our society. As you walk away from this poignant sculptural testimony to our own horrendous permitting of such terror happening even as I speak—too cruel for earth to bear it, and chillingly unacceptable to the heavens, placeless—it occurs to you that maybe the empty pole is meant for me.

[#33] Britt Wikström, *The Cathedral of Suffering*, 1994, detail

(I'll keep showing this to christian audiences until somebody raises the money to site it somewhere, preferably on an Evangelical college or seminary campus, since I think the abiding presence of this piece nearby might help bring theological reflection biblically down to historical earth and re-set analytic priorities, as well as make debate about a stray curse word in a play seem irrelevant.)

[#34] Britt Wikström, *The Cathedral of Suffering*, 1994, detail

We need christian theatre unafraid to wrestle in tears with the favorite no-gods in vogue, while being a courageous, cheering thankful

[#35] Britt Wikström, *The Cathedral of Suffering*, 1994, detail

presence on earth. God's people are not fugitives in Babylon; and we certainly do not need to be striving like the mythical Hercules to be virtuous model heroes. Those who remain faithful to their Holy Spirited calling in Babylon and have a genuine mentality of being exiled by God! cherish the Lord God's *chesed* (faithful Covenantal mercy) to come through now as well as in following generations; **exiled Christians are to be a manifestly thankful people! because we know intimately the prodigal mercy of God.**

There is a dramatic series of five photographs by the Czech-American Duane Michals [*CP* #32-36] that gives a vivid twist to "The Return of the Prodigal Son" (1982) and tells of that prodigal mercy of God we are called to emulate: like a mirror image of Massacio's Adam expelled from paradise, the naked son enters from the right into a room where the father is leisurely scanning the *New York Times*. The startled older man looks at the youth bowed in shame. The father loosens his shirt to protect the other's nakedness, and thoughtfully removes all his clothes to give them to the younger one. Finally the naked old man gingerly gives the returned son a hug offering reconciliation.

If I understand it correctly, more than theatre holds CITA members together: CITA is a motley community of Christ's followers who do theatre. **The biblical imperative operative for all of us with such interests and gifts is to be found faithful, thankful stewards of our theatrical gifts** (Luke 12:22–48). CITA as God's exiled people too only need to giveaway any theatrical clothes off their backs, their body, to outfit the neighbors with shalom, and do it quietly in Jesus Christ's name. And you may count on it, as God's Word of Ecclesiastes puts it: throw your theatrical bread out upon the Babylonian waters, and you will receive it back with the Lord's blessing strangely multiplied, maybe thirty, sixty, even hundredfold (Ecclesiastes 11:1–6, Mark 4:1–20). That's a promise straight from God!

Selected sources

Asaji, Nobori. *A Philosophy of the Japanese Noh Drama* (Tokushim: Shikoku, 1964).

Bentley, Eric. *The Theatre of Commitment and other Essays on Drama in our Society* (New York: Atheneum, 1968).

Chiari, J. *Landmarks of Contemporary Drama.* (London: Herbert Jenkins, 1965).

Christianity and Theatre. Theatre goes to school: Cultivating the dramatic arts in the soil of academia Greenville: CITA, Spring 2005.

The Creative Spirit: A journal of the arts and faith. Ed. Colin Harbinson (Jackson, Mississippi: Belhaven College).

Culture and Agitation: Theatre Documents (London: Action Books, 1972). Articles by Roger Howard, David Selbourne, Jonathan Hammond, Erwin Piscator, V.F. Pletnev, and others; no editor named.

Derrida, Jacques. "The Theatre of Cruelty and the Closure of Representation" [1966] in *L'écriture et la différence,* translated by Alan Bass, *Writing and Difference* (University of Chicago Press, 1978), 232–250, 331–333.

Ford, Boris, ed. *New Pelican Guide to English Literature: The age of Shakespeare,* rev.ed. (Harmondsworth: Penguin, 1982). Volume 2.

Harper, George Mills. *The Mingling of Heaven and Earth: Yeats's theory of theatre* (Dublin: Dolmen Press, 1975).

Heilpern, John. *Conference of the Birds: The story of Peter Brook in Africa* (London: Methuen Drama, 1989).

Hunter, N.C. *Modern Trends in the Theatre* (U.K.: University College of Swansea, 1969).

Leach, James. *Instructive Ambiguities: Brecht and Müller's experiments with Lehrstücke* (Toronto: Institute for Christian Studies, 1992. Master of Philosophical Foundations thesis).

Mitter, Shomit. *Systems of Rehearsal: Stanislavski, Brecht, Grotowski, and Brook* (London: Routledge, 1992).

Postlewait, Thomas and Bruce A. McConachie, eds. *Interpreting the Theatrical Past: Essays in historiography of performance* (Iowa City: University of Iowa Press, 1989).

Reinelt, Janelle G. and Joseph R. Roach, eds. *Critical Theory and Performance* (Ann Arbor: The University of Michigan Press, 1992).

Scheurer, Timothy E. "The Aesthetics of Form and Convention in the Movie Musical," *Journal of Popular Film* 3:4 (Fall 1974): 307–324.

Shiner, Larry. *The Invention of Art: A cultural history* (University of Chicago Press, 2001).

States, Bert O. *Great Reckonings in Little Rooms: On the phenomenology of theatre* (Berkeley: University of California Press, 1985).

Styan, J. L. *Modern Drama in Theory and Practice.* 3 vols. (Cambridge: Cambridge University Press, 1981).

Unwin, Stephen. *A Guide to the Plays of Bertolt Brecht* (London: Methuen, 2005).

Vos, Nelvin. *Inter-Actions: Relationships of Religion and Drama* (Lanham: Univer-

sity Press of America, 2009), chapter 18, "Tony Kushner, *Angels in America*," 169-173.

White, John J. *Bertolt Brecht's Dramatic Theory* (Rochester: Camden House, 2004).

Williams, Raymond. *The Sociology of Culture* (University of Chicago Press, 1981/1995).

Wilmeth, Don B. and Christopher Bigsby. *The Cambridge History of American Theatre* (London: Cambridge University Press, vols. 2 [1999], and 3 [2000]).

Yeats, William Butler. *Plays and Controversies* (London: Macmillan & Co., Ltd., 1923).

Thanks to William David Romanowski and Nelvin Vos for bibliographic help and discussion.

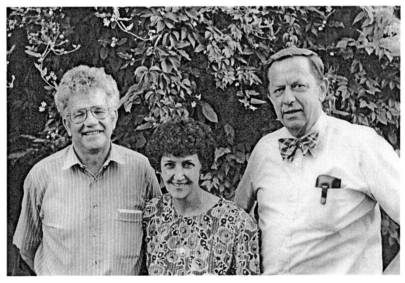

With Bennie and Hannetje van der Walt, Potchefstroom South Africa,
1994 (photo by George van der Walt)

NECESSARY ART IN AFRICA:
A CHRISTIAN PERSPECTIVE

My remarks on *Art: luxury or necessity? A Christian perspective on the arts* may be more contentious and demanding than you expect, because if we take the theme of this conference to heart—*Africa beyond Liberation: reconciliation, reformation and development*—also for art in Africa, then obedience to Jesus Christ necessitates action with a long-range policy. The Rule of the Lord does not lie in flowery words, says Scripture, but in committed, enabling deeds (1 Corinthians 4:18–20).

For me to communicate clearly and respectfully I should first confess succinctly what I understand to be the crux of a Biblically directed, Reformational-Christian stance and orientation towards human cultural activity. I am not an African. I come to you from Canada as a living white male, middle-class, American born, European trained; so I am handicapped by privilege.

Nevertheless, I claim to be "in the line of David" (2 Samuel 7; Psalm 89:19–37; Psalm 110); my life is hid with Christ in God (Colossians 3:3) who became a despised Jewish man on earth in history. The Bishop Augustine of Carthage I claim for my creedal lineage; the Genevan John Calvin stocks my thought heritage, along with Abraham Kuyper of the Netherlands whose vision that all societal life needs to be restored to the gentle Rule of Christ orients my focus upon art.

The Toronto Institute for Christian Studies where I teach, like the Institute for Reformational Studies here at Potchefstroom University for Christian Higher Education, means to carry on the task of scholarship in this fallible, Scripturally responsive Augustinian, Calvinian, Kuyperian tradition, where liberation means the freedom to be more obedient to the constraints of Christ's Rule of mercy; where *reconciliation* means communion the Holy Spirit effects when neighbors and enemies practice repentance and forgiveness (make good for the wrong-doer); where *reformation* is conceived as the standing task of generation after generation, because

Originally published in *Art in Africa*, ed. B.J. van der Walt (Potchefstroom: Institute for Reformational Studies, 1993), no. 312:1-15.

shalom is a continuing blessing from the LORD, not a human achievement; and where *development* means building up what will withstand evil and provide cultural shelter for any homeless fugitives.

Within this Christian perspective for life in God's world, what is the place and task of artistry? Or is art optional in historical crises, superfluous or of low priority at times in the Christian mission on earth? What would art look like that liberates, reconciles, reforms, and edifies?

Art is inescapable and as given a reality as our being born into the world where language is *a priori*. Along with motherly milk and one's mother tongue come lullabies, and part of being father is telling your child stories. Everybody seeks constructed shelter, whether it be an ice hut on the Arctic tundra, lean-to in a tropical forest, brick bungalow in a concrete city, or shantytown of homemade architecture. I have watched grown-ups jitterbug unrehearsed in the 1950's to the fiddling of a few street musicians on Rembrandtplein, Amsterdam, on the Queen's birthday, with an exuberant gymnastic *naiveté*; and I have seen Muslim youth dance themselves practically into a joyous trance skipping rope competitively 200 miles inland, in Alikalia, Sierra Leone, to celebrate the reappearance of an unearthly full moon after a total eclipse in 1986. Tribal masks with fur and bone at initiation rites, or embroidered robes heavy with gold thread worn by bishops to carry out the eucharist can belong, it seems, to human commemoration of life and death.

That is, we don't need a statistical survey to document whether "art," in some philosophically refined definition, is logically necessary, or extremely prevalent, and a good thing if you can afford it. And I am not posing an evolutionary brief for the appearance of art among more cultured people. The basic, initial point is simply this, that song (*Puer natus est*/"Nobody knows the trouble I've seen") and dance and "Once upon a time" stories, the nuanced cut of clothes and shape of a habitat, merry-making and music, nursery rhymes, stately processions, pageants, sculptured objects, pigmented drawing in the caves of Lascaux and in the Christians' catacombs in Rome, the Wall of Respect at 43rd and Langley in the 1960's ghetto of South Chicago: all testify—demonstrate—that there is indeed melody in the mouth of humans full of laughter or grief, gracious choreographable movement given for human bodies to exercise, artistry in the very fingertips waiting for training, a whole imaginative dimension of playfulness and decoration and telling fantastic tales built in human nature that allows children, women, and men to be festive.

The ability for humans to be artistic is a gift from God, I believe. It is possible, of course, to reject the LORD's good gifts, to tie them up in cloth and bury them for safety in a hole in the ground (cf. Luke 19:11–27). Fathers could miss the time for telling stories to their children, and later only know the kind of distant taciturnity that blots out the son's name from the Book as the elder Van Vlaanderen did in *Too Late the Phalarope*. An evil apocalyptic time may come, intimates Ecclesiastes (12:1–6), when the singing of little girls will be stilled, when golden bowls will be broken and potted pitchers for carrying water will be smashed to bits.

We men and women are terribly prone not only to misprize artistry but also to twist its normal glory into idolatry. The tower of Babel, Babylon, echoed across the flood to the riotous society of Noah's day; the awesome massive pyramids of Egyptian pharaohs, the ancient Greek Parthenon, the grand triumphal arches of Caesar Augustus, were all cruelly fashioned on the blood of slaves. The magnificent Michelangeloed ceiling in the Vatican belies the earlier machinations of the Borgia papacy; the Crystal Palace of Queen Victoria's day diverted attention to *progress* and away from the industrialized rape of the countryside in England; the International Styled steel and glass, skyscraping bank buildings on Wall Street, New York, try to hide the reality underneath where it is dangerous to ride subway cars beschrawled with obscene, frustrated graffiti. Is it any wonder that the old Platonic fear of art as a seductive waste of time has often crept into the Christian outlook and led to condemnation of artistry as evil, if not demonic, because of its preening vanity?

But art has no monopoly on sin. To look at the historical track record one would also have to do away with politics and its wars, business and its greedy cartels, even the institutional church and its obtuse crusades. You cannot outlaw sin, however, by stopping creatural activity that God by its structuring made to be good. The only way to go, the Biblical way to go, in my judgment, is to acknowledge that imaginative human activity, ordinary artistic skill, is a creational given, given with human nature, that has its proper place. *Artistry is not pivotal, but it is integral to human life.* Artistry is not all-important in praising God, in loving one's neighbor and caring for material in the world, but it is not unimportant. Art is not a luxury, a *super-additum,* a possible surplus that can be, maybe, legitimated when everything else is in order: art is like the minerals in one's food, the fiber to one's diet, whose nutritives one hardly notices unless you become malnourished and it is determined that iron or ruffage has been missing from your daily bread.

To try to circumvent all the polemics and jockeying for cultural

power that goes with the pride of self-importance, let's say that art is as necessary as vitamins to human life. One can stay alive with some vitamin deficiency or being low on iron, but a cultural philosophy and policy that fosters anemia is unwise.

What about the matter of priority in our world of pseudo-liberated, un-reconciled, revolutionary/*status quo,* "underdeveloped" . . . cultures tempt-ed by a chaos of spirits coveting the power of success? Theoretically— Biblically envisioned, art is necessary; but so are a host of other cultural deeds: world relief for desperate, murderous poverty, humane preventive medicine, trustworthy media, reliable police protection, viable economic generosity, peaceable adjudication of combative ideologies. . . . Where should artistic endeavor be on the agenda of Christ's body in our times?

Since wisdom for setting priorities is prudential rather than theoretical, it is not likely there could be an abstract prescription on the relative worth of art independent of a shrewd assessment of circumstantive location, societal context, a given generation's preparedness, the service potential of the kind of reality—artistry—one is weighing. When the earth quakes or gunfire advances across the field toward you, it is probably not the time and place for you to start learning to play the French horn; but if the apocalypse is tomorrow, it would be a good time, says Luther wisely, to plant a tree today. Christian wisdom may be different than a secular-ist judgment on priorities, because the horizons contouring a Christian community's consciousness steeped in Biblical revelation will be differ-ent, primed by memories and foresight, expectations and patience, and an acute sense of human needs oriented toward the long haul in history rather than the short run.

The North American continent, where I come from, is overrun these days in academia, in the field of the arts and literature, with what has been called "postmodern" culture. "Postmodern" is a shallow, omni-bus term for describing the overwhelming post-Christian realization that Humanist art and philosophy and science have not led to the millennium! So artists, writers, theorists, have either lashed out in nihilistic camp at the Western cultural tradition of Renaissance and Enlightenment, which have made them possible, or agonized in brilliant, sophisticated skepsis on how to be a creative parasite. There is a terrible aimlessness and effete violence within the mainstream Western artworld of the last generation that has been confronted by the checkmate of positivist Rationalism but has only scotched the snake, not killed it. I mention this sorry state of

affairs (cf. Butler, 1980 and Kearny, 1988, esp. 111) so that you not be tempted to covet the reigning Western fashions and impasse as you look for orienting opportunities for art in Africa. It makes no sense to import the wages of artistic vanity and pride.

More fearful, however, in trying to get one's Christian bearings as a community for ranging artistry among the priorities of urgent cultural endeavor, where one cannot do everything at once yet there needs to be a simultaneous implementation of multiple cultural norms for the good of the common weal: most devastating, from a Christian perspective, in my judgment, is the undiminished force in culture at large today of Pragmatism. The century-old principality of Pragmatism, so common it is usually no longer identified as a distinct ideology, instills faith in methodical science to determine, in an open-minded, open-ended way, among our myriad contingencies the most useful and efficient form of self-affirming freely human activity.[1] Especially since the end of the so-called Second World War and the Americanization of practically most world culture, the invisible power of Pragmatism has had epidemic success. I doubt whether South or North, West or East Africa has escaped the plague whose simple creed is, "In the power of science we trust, because it gets things done."

Pragmatism skews the Christian vision on cultural priorities even worse than the resentful "postmodern" attitude of resignation, because Pragmatism tends to reduce culture to technocratic instrumentality, where history is discounted, art is metamorphosed into trophy, and any ongoing progress is the pearl of great price.

Both the "postmodern" gambit and Pragmatism oppose and occlude what I believe, from a Christian perspective, needs to be faced in weighing art in the balances. For example,

1. Art objects embody valuable knowledge apprehended and fashioned in olden times that is not even now obsolete.

I do not mean art is somehow timeless, as if you could not detect the pagan spirit in Euripides' *Trojan Women* (415 BC), or find a dated heroicizing slant to late Rodin's sculpture of *Balzac* (1892–97), or not experience the Siberian labor camp trauma of an intellectual's revolt against Tzarist Russia in Dostoevsky's *Letters from the Underground* (1864). And I do not wish to rehash the old "quarrel" about whether poetry makes progress the way scientific inventions, let's say, gun powder, make earlier technologies,

1 Zuidema (1961: 133–57) presents a succinct analysis of the thrust of Pragmatism with its main tenets.

like swords in warfare, rather obsolete. My point is that a performance of the keening Greek chorus of Trojan women exposes the cruelty of "victorious" soldiers that should stigmatize with shame everyone with ears to hear; and the gross vitality of the Rodin artwork *Balzac* should give pause to both the fastidious and the coarse person at this monstrous possibility of our being a version of *la bête humaine;* and the peevish talk-talk-talk tirade of the *Underground Man* confessing his everlasting, hardnosed, and sentimental discomfiture should catch off-balance by its parody every lonely "decent" fellow in the world who pretends not to be insecure at one's failures and secret sins.

That is, theatre pieces, sculpture, and fictional narrative constitute a thesaurus of incredibly nuanced knowledge available as gift to anyone, including budding artists today, who are trained to read and receive the wealth of insight. Earlier artistry also primes one to remember, to become historically conscious, to be grateful for (and not threatened by) the millennia of artistic offerings, which can liberate one from the pragmatic parochiality of the present when we pretend to live as if the cultural bed we make every day has not ever been well slept in.[2]

When one considers cultural priorities it is also crucial to note that:

2. Artistic activity and its grounding fund of aesthetic imaginativity belong to the basic infrastructure of human societal culture.
Art is not to be the contemplative summit, *summa,* of human ingenuity, the reward of leisure after the hard labor is done. Such a traditional Humanist conception of the arts, as well as a Marxian idea of art as superstructural reward, or a Capitalist-consumer, consumptive view of art as enjoyable surplus, mistake the quality of human life artistry engenders, misplace art's sparkle, and therefore invite its being idolized, politicized, commercialized out of art's God-given nature and task.

Just as learning to walk and swim, to control and show one's emotions, to learn to speak, to write, are basic to what a person's societal existence can become, so elementally basic and supportive for a person's life is learning to be imaginative, to sing, to act a part, to be eloquent, to be conscious of nuanced behavior in others. If the ingredient of aesthetic humor and an artistic play of hovering, surprising meanings is missing from family life, societal relationships, institutional functioning, then the complexities of such interpersonal intercourse and highly structured activity tend to oversimplify, to grate, and the human gears may strip.

2 For an inconclusive but provocative discussion of the problem history poses for certain contemporary artists, cf. Lyotard, 1982:357–67; Belting, 1983.

Church worship without a liturgical sensibility, political dealing without finely tuned diplomatic tact, business transactions without an awareness of pauses that refresh, soon turn harsh, develop lockjaw, or go manic. Just as a country's economy and order of civil law, the prosperity of cities and well-being of a people, depend upon the world of transportation (roads, waterway, bridges) and a communication network (travelers, radio, printing press), so do the full-fledged public affairs of a land assume a measure of cultural artistry.

The very style of a people waxes and wanes with its attention to the world of imaginative realities apprehended in stories, songs, graphics, dance, architecture; and the style of society is infrastructurally critical to its public welfare, not something marginal to its "survival," an afterthought.

I am not referring to the monumental artistic variants of *panem et circenses* occasionally engineered by the totalitarian regimes of empires (cf. Golomostock, 1990), but I am pointing to the fact that underneath the waves of public shifts and cultivated showpieces at large lie the invisible ground swells of transport connections, imaginative style, and what we call "the media," which when *manqué,* cripple more visible cultural efforts and when solidly inlaid in public life tend to outlast crises. With a vital artistic infrastructure priming its inhabitants' imaginativity, a society can dress its wounds and be able to clothe and mitigate what otherwise might become naked technocratic deeds. It is precisely the attempts to impose a Western ethnocentric form of pragmatic economic "development" upon African lands, regardless of the artistic cultural infrastructure present, often squelching the resident imaginativity, that occasions, it seems to me from a distance, so much misery (cf. Van Nieuwenhuijze, 1983:3, 13–21).

One other feature of artistry I will just mention that Christ's historic body on earth could consider when struggling existentially to face cultural priorities, is that:

3. Artistic endeavors are intrinsically pre-argumentative and both carry and transmit norms in a way not complicated by words.

I know, *literary* art happens in Afrikaans, English, Zulu, Xhosa, Spanish, Chinese, or whatever language, but even a novel's verbal component is subsumed under the allusive lilt of connotations.[3] I also know that music and mime, architecture, painterly art, and dance movements anticipate

3 This is the point Bakhtin struggled to make in arguing for "prose" as a literary art, a "dialogue of languages" (1981:205), a system of images of languages (1981:416).

sets of expressive meanings sometimes found foreign to different civilizations, like the rhythms of Oriental, Western, and African music. I do not believe with Schopenhauer or John Dewey that art is a universal language or an experience akin to ecstatic immediacy between individuals effecting communion.[4]

Nevertheless, the preverbal subliminality of artistry accounts for much of its incredible suasion upon an unthinking, inarticulate populace, captivating you unawares. And precisely such disarming influence, so easily tendentiously misused, is relevant when Christians transnationally and interracially decide where to invest our limited resources. There is no doubt for me that a caring physician who administers drugs to anaesthetize pain during life-altering surgery practices an act of mercy. It is also true, I think, that a mime's poignant, dramatic gestures laden with shared grief, or drummed rhythms and a chorus of voices rollicking with joy, which bring relief to any downcast soul, buoying human spirits with smidgens of cheer, are also deep-going acts of mercy. I must admit that artistic offerings strike me as being structurally more basic and winsome for showing love-priming fellowship than trading arguments often is, competing for success in the job market, or badly *stating* what one stands for. And often it is the art of the underprivileged folk that has the most to give to those in power.

Without trying to spell out the relative priority of art in the matrix of your historical decisions pending in Africa, I have posited what I find to be philosophically true for judging the task of art in Canada as well as art in Africa. I am not sanguine about any salvific properties inhering artistry; art is also not sure means to the end of post-liberated reconciliation. But in the worldwide arena threatened by a monolithic Pragmatistic culture (with the defeatist, disintegrative vibrato of "post-modern" dilemmas), I believe artistry faithful to the Lord is a neglected avenue for uniting us humans caught in unholy disarray. If "development" is restricted to economic concerns, with a one-way movement from the controlling rich to the helpless poor, while all struggle to minimize political instability, one has only planted a cultural time-bomb, because aesthetic life and artistic expression lie *underneath,* are ontically prior, to "standard of living" or political authority; and imaginative realities infuse such other matters with *shalom* or disquiet. So redemptive artistry would have high priority for me despite its low pragmatic cash value, if we are indeed intent upon honoring this wonderful, life-penetrating gift of imaginativity from God

4 Cf. Schopenhauer, Volume 5, §219, 1987:507–8; Dewey, 1958:50; 55–57; 105; 345–349).

in serving up the priestly Rule of Melchizedek in Christ's name to our neighbors in such unsettled times.

That becomes my final point: if artistry is built-in human nature, and if artistic imaginative activity is so fundamentally at work in personal, family, and public societal life, though often unobserved, then artistry with its cultural potential left in the hands and to the whims of a godless direction will go to hell. An overwhelming portion of the contemporary Western artworld—painting, song, cinema—has indeed lost its way, I think, because disciples of Jesus Christ generations ago ignored the terrain, or merely domesticated the least offensive varieties of the secularist fashion. Much art today has inherited a distaste if not hateful anxiety of history, and meanders into doing its own idiosyncratic arty thing with escapist happy endings or a gratuitous perversity (cf. Rosenberg, 1972; Hughes, 1980; Fuller, 1980). My counsel on what is to be done for art in Africa, art in Canada, in this generation, given the biblically christian horizon of liberation for reconciliation, reformation, and constructive development *coram Deo,* is that Christ's body—those who are professional artists, apprentices, amateurs, and those who are not artists—act with concerted love, judicious hope, a faithful service without demands for tangible results.

Artists who follow Christ are called to forge a community with faithbrother and faith-sister artists, aestheticians, art historians, art critics, art patrons, an artistic communion within which artistry can be reconceived and reformed from what passes as normal, so that art's presumed privilege or art's esoteric, adventitious capriciousness be ended, and the peculiar, subtle creaturely glory of artistry be reinstated as an ordinary diaconal ministry: *artists skillfully, imaginatively collect nuances in God's world and present them like manna to their neighbors.*

Such a directive is easily said but historically embodied with enormous difficulty because the consecrated talent and persevering vision needed by a Christ-believing community is fraught with mistakes and sin and petty unforgivingness. The artists need to be convicted of their single-minded calling to remember and celebrate with excitement how God deals with rocks and trees, antelope and owls, human foibles, evil suffered, the blessings of healing. Christian artists do well to realize that their preferred, differentiated artform, or their choice to encapsulate their artistry expressly into an extra-artistic engagement like advertising, a neighborhood mural, commemorative monument, portraits, or hymn, is entirely proper so long as the artwork be truly art and is dedicated to

open up and deepen one's neighbor with *suggestie-ryke,* allusive insight—that is the chief biblically directed guideline for artistic *praxis.* And the non-artist component of the christian community—I am talking about the communion of saints that extends outside the church door—faces the injunction to receive artworks from artists gratefully with compassionate, informed taste and critical, enabling patronage, since artistry that is borne and contexted by Christ's body at large is a communal project, a communal testimony and mission that gives away, obliquely, good news.

The different institutions in society—church, state, business, city, university, media, and others—have different responsibilities toward artistry depending upon their proper, restricted authority; not one institution may claim art as its possession, solely for its interests, on pain of raping artistry. It would be wrong if the institutional church were to requisition artists just for church art, or play the sour older brother's part when the prodigal artists who have wasted their inheritance return to serve the Lord artistically in the public marketplace. It would be good for a government not only to protect reproduction of art by copyright, but also to foster public artworks, not mega-projects, but neighborhood, site-specific art and street theatre, festival events, so that artistry be poured like perfume over the body of the least of the civic inhabitants, who could never afford to go to the theatre or opera.

Especially the schools and university, where parents are formed culturally, where leaders of industry, lawyers, doctors, scientists, teachers are trained, where the most critical, interracial mind-setting will take place: educational institutions are called to nurture students in the arts, not as a dainty, humanist embellishment, but as a solid, integral constituent of human life where one's whole elemental outlook is shaped. To be disciplined in reading novels and viewing paintings, staging theatre productions, and exploring the satisfying suspense of choreographed bodily movement, so one comes to appreciate good ambiguities and upbuilding subtleties, is a kind of insurance policy against forming one-track minds. A school without regular singing and a choir has rickets. A university without a concentrated commitment to specialized study in the arts, as I see it, courts cultural beriberi for its graduates, and misses a prize opportunity to meld a rainbow of backgrounds into an imaginative cultural strength! If artistic cultural diversity is left alone, neglected with ignorance, the potential for bonding is lost, and under any forced technocratic unification of society, the artistic difference will simply chafe on divisively (cf. Kuper, 1983:113–115).

Naturally one cannot be prescriptive, because the confluent factors

of talents and needs, opportunities and options, shift.

Artists and a program for the arts in Africa would be wise, I think, to build on indigenous strengths, whatever they be. If oral culture has been a vibrant tradition in tribal life, then story-telling and song, music and dance, may be the arts to develop. If Afrikaans is a tongue as tender as Welsh, and if Zulu sounds are as bittersweet as I gather when reading Vilakazi in translation, then encourage your poets! Twenty-three years ago in Potchefstroom I heard/saw Mimi Coertse's singing songs of S. le Roux Marais and poet Elizabeth Eybers brought a scintillating élan to those present. One of your own Potchefstroom lecturers Gudrun Kuschke (1981), has shown how believing poetry distilled a resilient hope among the faithful of God in the emergency of Nazi Germany when the church there faltered or was repressed. Times change but human nature endures. If art is integral to human life, and if artistic imaginativity belongs to the infrastructure of societal culture, woe to us if we exclude such sustenance from our diet, if we neglect to bring such imaginative potential captive to the Christ (2 Corinthians 19:3–5), with all of its gift for healing, especially when busy with "development."

In my country on Friday nights youth die by the thousands culturally at the movies, and ten thousands are stunted with their weekend videos. The best defense against attractive superficiality in the arts is a tough, home-bred imaginative fiber. It may be just too complicated and expensive to institute African cinematic art as an alternative to the celluloid reels and tapes made in the USA. The National Film Board of Canada has even had to make drastic cutbacks. But the LORD asks us Christians to be faithful with our inheritance, cunning as snakes and as innocent as doves (Matthew 10:16) in the historical steps we take together to be more obedient culturally than our forebears. Maybe that means painterly artists will forego the secular gallery circuit, put up the easel, and take paint to the walls, murals, or pursue graphic prints the way European Reformation artists did, stone lithographs the way the Inuit of Canada do, to get cost-available artistry into the homes. Good cultural leadership may at times try to step back from the current stage of differentiation in a given cultural sector in order to reset the direction that has specifically gone wrong.

But let me end by referring to a few pieces of contemporary artistry from my cultural habitat that, in my judgment, undramatically but surely please God as sweet-smelling offerings, proffer nuanced love to the neighbor, edify the faithful with eyes to see, and are capable of instigating the

reconciliation in God's world we pray for. Then I'll make a brief closing remark, and finish with a psalm.

Australian Warren Breninger depicts (*Apparition of Puberty as a Gift Offering*, [#36] an awkward young fellow with head akilter, in an olive,

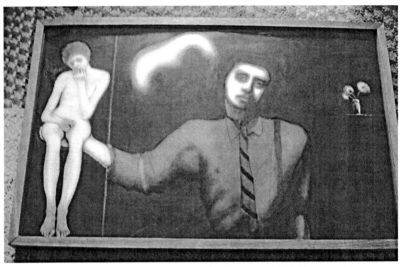

[#36] Warren Breninger, *Apparitions of Puberty as a Gift Offering*, 1986-87

khaki shirt and black-striped tie wound around his throat rather than under the collar, holding up in a huge right hand a girlish adolescent figure, nail-biting, looking out morosely, mostly covering herself; her extremities are bluish-gray as if the circulation be poor. In between (mid scene) the two hovers a Holy Ghost (?) shape, while in the right background is a trinity of illuminated straw flowers in a vase. The sheen to the youth's face is a little unearthly, and a halo of fire is faintly visible around her hair, as if this mysterious, clumsy presentation—ecce *ego*—with overtones of sexual shame and delicate uncertainty is somehow, in the dark, transfigured into a holy rite of passage with a future. Breninger has artworks in the National Gallery of Australia, but a garage filled with unsold paintings; Christians there find his artistry difficult, troubling, unpleasant, and secular critics dislike his absorbing themes.

Canadian Violet Holmes' jolt of an ink drawing is titled *Just Keep the Chin Up and No One Will Notice* [#37]. The lips of the mouth are tightened, chin raised, neck fixed, eyes inked dark; shock waves of brown radiate around the bruised head until they hit the upper horizontal and right vertical bars of black. Black tears smear like dirty rain down the window pane of her traumatized face. Yet the whole is not hysterical like Edvard

Munch, and not just stoical, to my eye, but resolute through the pain, determined, going to come through *de profundis* to the comfort of the morning light.[5]

For art to be Biblically-Christian one does not have to *add* something to art, but simply practice artistry the way God intended art to be, permeated by a holy spirit. Art put historically in Christian perspective for Africa, or Canada, means that Christ's body—that's us—*in faith* (with utter certainty of what cannot be overseen, Hebrews 11) *consecratedly enact artistry in its limited, integral, elemental service, and give it away to our neighbor,*

[#37] Violet Holmes, *Just Keep the Chin Up and No One Will Notice,* 1991

like bread thrown out upon the waters (Ecclesiastes 11:1–6), and then expect the Lord God's blessing, with surprises.

Demographic studies hint that there will be more Christians in Asia, Africa, and South America in the coming generations than in Europe and North America. Perhaps we who stand here will not live to experience before the last Day the fulfillment of God's promise that the cultural inheritance of the nations will be given—not taken by—given! to God's people purified by the Lord (Revelation 21:22–27); but the generation of believers here before me is a *covenantal* one, *covenanted* with God in Jesus Christ through life and death, even if we become a remnant of pilgrims as Christ's followers en route to the new earth amid hostile, disbelieving pragmatists. The only thing needful is for us to be found faithful, intensely praying (Luke 18:1–8), and making merry or sorrowing (Ps. 146–150) also with artistry before the Lord.

Hear Psalm 111:

O hallelujah!
I will thank the Lord with my whole heart

5 When this lecture was presented, images of Britt Wilkström and Gerard Pas were also shown at this juncture.

right here in the congregated circle of those who do what is straightforward.
Great are the deeds of the LORD God,
rich for investigation by all those who delight in their wonder.
Magnalia dei (the great deeds of the LORD) are stunning, jewels!
The LORD's tried-and-true trustworthiness lasts for ever.
The LORD has set up God's extraordinary deeds to be remembered.

Merciful and compassionate is the covenant LORD God:
the LORD gives nourishing food to those who stand in awe of God;
the LORD keeps remembering the covenant made with God's people for
ever and ever;
God has shown the power of the LORD's doings to God's own people by
giving them the possessions, the inheritance of the nations!

The doings of the LORD's hands are true and utterly just—
all the LORD's commanding words are perfectly reliable,
firmly established forever, world without end,
brought to fullness in truth and right-doing.
The LORD has presented liberating redemption to God's folk and put the
LORD's covenanted promises in place to stay for all time.

Holy and awesome is the name of the LORD God.
Standing in awe before the LORD God is a beginning headstart in wis-
dom:
a choice insight, good understanding, for all those who submit to God's
ways.
God's praiseworthy glory stands fixed forever and ever more!

Bibliography

Bakhtin, Mikhail M. "Discourse in the novel: 1934–1935," in *The Dialogic Imagination,* translated by Caryl Emerson and Michael Holquist (Austin: University of Texas Press, 1981).

Belting, Hans. *Das Ende der Kunstgeschichte* (München: Deutsche Kunstverlag, 1983).

Butler, Christopher. *After the Wake: An essay on the contemporary avant garde* (Oxford: Clarendon, 1980).

Dewey, John. *Art as Experience* (New York: Capricorn, 1958).

Fuller, Peter. *Beyond the Crisis in Art* (London: Writers & Readers, 1980).

Golomstock, Igor. *Totalitarian art in the Soviet Union, the Third Reich, Fascist Italy, and the People's Republic of China,* translated by Robert Chandler (New York: Icon, 1990).

Hughes, Robert. *The Shock of the New* (London: BBC, 1980).

Kearny, Richard. *The Wake of Imagination: Ideas of creativity in Western culture* (Minneapolis: University of Minnesota Press, 1988).

Kuper, Adam J. "African Culture and African Development," in *Development Regardless of Culture?* ed. C.A.O. van Nieuwenhuijze (Leiden: Brill, 1983).

Kuschke, Gudrun F.T. *The Representation of the Christian Ethics in the Poetry of Bergengruen: An integrated approach* (Johannesburg: University of the Witwatersrand, 1981).

Lyotard, Jean-François. "Réponse à la question: qu'est-ce que le postmoderne?" *Critique,* 38/419 (1982): 357–367.

Rosenberg, Harold. *The De-Definition of Art: Action art to pop to earthworks* (New York: Horizon, 1972).

Schopenhauer, Arthur. "Zur Metaphysik des Schönen und Ästhetik," in *Parerga und Paralipomena*. Gesammelte Werke, 5. Löhneysen, W. ed. (Stuttgart: Cotta Verlag, 1987).

Van Nieuwenhuijze, C.A.O. "Introduction," in *Development Regardless of Culture?* ed. C.A.O. van Nieuwenhuijze (Leiden: Brill, 1983).

————."Does development have anything to do with culture?" in *Development regardless of culture?*

Zuidema, Syste U. "Pragmatism," in *Christian Perspectives 1961* (Hamilton, Ontario: Guardian, 1961), 133–57.

Turning Human Dignity
Upside Down

For a God's-eye point of view on human dignity, to orient our reflection and vision, one could do worse than listen to the biblical Psalm 8:

> Lord, our Lord! How wonderful is your name in all the earth!
> Lord, our Lord! How wonderful is your name in all the earth!
> You who have set your glory in the heavens
> so that your adversaries, obstinate and vindictive enemies, may be stilled,
> you may now find that glory praised in the mouths of us babes and sucklings.
>
> When I look at the night sky, the work of your finger,
> when I look at the moon and the stars, held there by your hand,
> what are we mortal humans that you remember a man or a woman and pay them attention?
>
> You have made us humans almost like gods! crowning humanity with glory, a lordliness,
> making us rule over the work of your hands, with everything put under our feet:
> sheep and cows, wild animals of the fields, birds of the heavens, fish in the waters and whatever other creatures prowl the deep paths of the sea—
> O Lord, **our** Lord! How wonderful is your name in all the earth!

"Almost like gods!" is the way God created us humans, says the psalm. That men and women, unlike animals, have an affinity with God, are special counterpart creatures to the triune Creator Lord of the universe, is not just good, reports *Genesis* in the Bible, but "**very** good" (Genesis 1:26–31). That gift of God to humans—the glory, lordliness of being officially called to orchestrate the historical development of all other creatures in God's world—is a dignity structurally inherent, given in being human (Psalm 8:5–6).

But compared to the stunning glory of God, shown in the heavenly

Lecture for "The Invisible Dignity Project," in Winnipeg, Manitoba, October 2007. For more on the "Invisible Dignity Project," see footnote 2 (165).

bodies like the sun, moon, and stars, which flabbergasts God's enemies and goes on forever, it seems, humans are mortal! Even great nations of people look like dust in the scales of God's universe, says Isaiah 40:6–17 backing up Psalm 8:4. Yet a corporeal human is not just a makeshift assemblage, but a God-affirmed person, with a proper name and identity; each with a once-only lifetime of 70 or maybe 80 years on earth before the LORD takes back one's life breath (Psalm 90:9–10)—a shorter life span than most trees. Each human creature has a not interchangeable identity among other humans, with certain particular dated/located possibilities to praise God and love one's neighbor, while respecting one's own self (Psalm 8:8, Deuteronomy 6:4, Romans 13:8–10).

Human babies praise God with their baby talk and cries, says Psalm 8:2. It's also true that grasslands and tundra, mountains, eagles, buffalo, and seals praise the LORD (Psalm 104); but only humans praising God are up for adoption as children of God (Romans 8:12–18, John 1:9–13), says the Bible. Therefore, because the possibility of adoption by God holds for every human creature—that exceptional dignity is God's gift, not a human achievement—each human person's life is sacrosanct, requires ultimate respect from other humans (Genesis 9:6). Children incapacitated beyond repair by encephalitis, obnoxious middle-aged hypocrites, and even violent criminals with "the mark of Cain" (Genesis 4:8–16) do not become animals, they remain human creatures.

(1) A lot more needs to be said than Psalm 8; things do become complicated. But it is important to begin by positing the ineradicable primal, built-in special worth of humans to God the Creator. **One way this extraordinary intimacy and similarity of humans with God shows up is in the possibility for humans, only human creatures, to celebrate God's gifts in thankfulness and to be self-consciously reflective.**

When a woman and a man procreate: Jewish artist Abraham Rattner (1895–1978) paints *Mother and child* [#38] a birth mother happily dandling the fruit of her womb above her curvaceous body on a bed of yellow hair in a joyous blue-green watery bath, speaking nonsense language of endearment to the newborn. A young Japanese child is wakened to wonder at the marvelous fragile airborne shimmer of a soapy water reality, deeply roused to be fascinated, and eventually learns to give the creature a name, *awa* "bubble" [*NA* #24]. Once upon a time in a church culture boys were trained to read music and sing praise to God in chorus. Luca della Robbia (1400–1482) knows that a scrunch of boy choristers are not cherubs, but he catches the unselfconscious dedication in the

[#38] Abraham Rattner, *Mother and Child*, 1938

[#39] Luca della Robia, *Cantoria*, 1400

singing of these youth [#39], which is missing, for example, in the most lovely bird song. Animals, plants, minerals, the endless expanse of airy space surrounding a flat, oh so flat Manitoban paved road, directly praise God the Creator, **mutely**, says Psalm 19:1–6. But it is the peculiar dignity

of humans in the likeness of God to embody the **word** in celebrative praise, with the coefficient of thankfulness.

The human dignity of celebration can be rambunctious, as African American William Johnson's (1901–1970) *Jitterbugs II* [#40] color screen print of the '40s lets us see: the improvisatory regularity of 4/4 16-bar jazz honky-tonk music encourages a ragtime, moderated exuberance of laughter and dancing celebration, a blessed respite from hard labor. (Musical instruments have marked human culture since the time of Jubal in Genesis 4:17–22.) Jacob Lawrence (1917–2000) presents *Graduation* [#41] with an appropriate festive yet uncertain solemnity: the parents attending the first family academic success of their downtrodden black lives in America are a bit stiff, not knowing exactly how to take this ritual accomplishment, obtaining a diploma with its attendant authority; so now, you awkwardly stare and relax?

Yisa Akinbolaji's *Living by faith* [#42] print also marks a reflective pause in one's sojourn, which is typically human. If you are a faith-bound creature trusting what is to

[#40] William Johnson, *Jitterbugs II*, 1941

[#41] Jacob Lawrence, *Graduation*, 1948

[#42] Yisa Akinbolaji, *Living by faith*, 2007

come, it is normal to take time out to reflect, to second-guess your steps, to rest a moment, and tête-à-tête with your self, thank-think where you are at.

Elephants have an incredible memory, but do not ponder things in their heart. Milk cows and egg-bearing chickens never have a sabbath. But pondering and resting is part and parcel of human dignity. Just as God took a "rest" on the first Sabbath—which does not mean God did nothing when God "hallowed" the day (I'm certain the angels sang

at least one newly composed cantata)—just so humans are free to rest at times, to recollect, take stock of one's past deeds, to celebrate a new stage of development. Or—like one of my favorite sculptures (*Head* [#43]) by John Tiktak from Rankin Inlet suggests—to screw up your wizened face with a wrinkled forehead, squint through shut eyes, and reconsider the historical state of affairs; much as God did during the days of Noah when God agonized, "From the monsters men are making of themselves, it rankles me to my gut that I created humans on the earth" (Genesis 6:5–7).

[#43] John Tiktak of Rankin Inlet, *Head*, 1965

That *Genesis* 6 biblical remark of God on *nephilim* (human monsters, giants) introduces a grave matter for a christian conception of human dignity. Because the dignity of being human is an inescapable God-conferred status—men and women are by nature created **in** God's image (Genesis 1:26–28), set up to be responsive to the God-ordained task of mercifully ministering to/"ruling" whatever creatures exist (Psalm 115:16)—that God-dependent, God-conferred status cannot be erased. But humans are able to besmirch and default on their calling to fulfill such dignity, because historically we men and women are sinful.

Stones do not lie. Trees do not commit adultery. Animals are not sinful. Only humans have the capability to thumb their nose at God's ordinances, to be unwilling to accept the role of authority assigned to them, to misfire their prerogative, and thus act ingloriously and promote a pseudo-dignity.

You may not agree with the point **(2)** I want to make next, because I should like briefly to challenge the reigning idea of human dignity ingrained in our Western civilization and that has been so colonializingly dominant in the world up to now.

Humans have dignity, has been the accepted practice for centu-

[#44] *Unknown Greek God*, c. 470 BC

ries, if they are admired models of prosperous rational virtue—honest, just, prudent, liberal, with a decorum to match. Behind this down-to-earth Humanist Ciceronian (106–43 BC) idea of human dignity (*De Officiis*, book I) lies the ancient pre-christian world of Egyptian pharaohs, where the line between the divine and the absolute human monarch colossus is indistinctly drawn. It is also interesting that ancient Athenian artisans around the time of Socrates (469–399 BC) could portray their Greek gods as athletic men in their prime, pitilessly hurling a javelin to its mark [#44], and as paragons of womanly beauty [#45], perfect, without a blemish anywhere. Olympian victors were adulated, treated like heroes, demi-gods, after standing on the podium of honor.

500 BC is also about the time when Siddhartha Gautama, former prince turned wandering ascetic, became an "Enlightened one," a buddha [#46]. A buddha is any human who has transcended

[#45] *Aphrodite Braschi*,
1st century BC, after Praxitele

[#46] *Korean Buddha Sakyamuni*

[#47] François-Auguste-René Rodin,
Le Penseur, 1879-89

the *samsara* of competitive desires and unfulfilled frustrations and has escaped to the unruffled meditative composure found in *nirvana*. The Roman Empire stoic sensibility had no trouble combining such an apathetic contemplative state with military action, and would put philosopher emperor Caesar Marcus Aurelius (121–180 AD) up on a war horse to honor his steely mind as well as his fierce military exploits in battle [*NA* #67]. Such idolization of male brains and brawn as the epitome of lordly human dignity is captured later in the well-known sculpture of Rodin's bronze *le Penseur* [#47]—muscular strength and stern intelligence deserve our undying admiration.

What reinforced this prechristian conception of human dignity, which merges human, as it were, with what is quasi divine, and brought it up to date, so to speak, was the *Oration on Human Dignity* (1487/1496) by the famous Renaissance thinker Pico della Mirandola (1463–1494).

> Let a sacred ambition invade our souls so that impatient of mediocrity we aspire after the highest things and (since, if we will, we can) bend all our efforts to . . . become angels![1]

Intelligent, good-looking educated humans have the goods to become practically superhuman paradigms of loveliness— a faultless perfection deserving universal praise. You all know this standard ideal criterion of human dignity: St. Catharine [#48] with arm resting on the wheel of torture that led to her martyrdom is painlessly looking forward to heaven; Da Vinci's (*Mona Lisa*, c.1503–06) code of honor transforms a woman into an icon of pure mystery; the most powerful woman in France for almost 20 years (1745–64), Madame Pompadour [*NA*

[#48] Raphael, *St. Catharine*, c. 1507

1 "Invadat animum sacra quaedam ambitio ut mediocribus non contenti anhelemus ad summa, adque illa (quando possumus si volumus) consequenda totis viribus enitamur. . . . ut per eam [pacem] ipsi homines ascendentes in caelum angeli fierent." G. Pico della Mirandola, *De Hominis Dignitate, Heptaplus, De Ente et Uno*, ed. Eugenio Garin (Firenze: Vallecchi Editore, 1942), 110, 118.

#57], whose salons rippled with wit, poetry, amorous intrigue, and artistry, is envisioned as a delicate, ethereal poised matron of honor; Sir Joshua Reynolds pictures British Lord Heathfield (1787) with the keys to the rock of Gibraltar, his station of outstanding service, with the dignified aplomb of someone awaiting his apotheosis; not to be outdone, the American new world portrait painter J.S. Sargent (1856–1925) gives "*The Honorable Mrs. George Swinton*" [#49] a ravishing white dress and impressive statuesque pose that signifies the height of fashion circles in a gold frame.

That is, following Pico della Mirandola's injunction, one has dignity when you make something of yourself that sets you off above the crowd of ordinary humans by reason of fortune or fame for incredible ac-

[#49] J.S. Sargent, *The Honorable Mrs. George Swinton*, 1897

complishments. There is an aristocratic wealthy-class-bent built into this traditional, prevalent conception of human dignity that, after the European so-called "Enlightenment," is mixed up with a moralizing Kantian idealism of the beautiful, cultured set of people we should all strive to be. When an artist vamps this pose of aristocratic human dignity upon ordinary, midwestern North American farmers, the revealing portrait is truly a disconnecting humor [#50]): strait-laced, sober, church-going, farm folk do not cut the mustard, or the pâté de foie gras, with those who have earned their precious hyper-human dignity.

Now I realize times have changed. While the Renaissance gentleman with a distaste for ugly bloody scenes would coolly dispatch his rival with a goblet of wine steeped in slow poison, modern militia (Goya [#51]) shoot defenseless civilians as well as armed soldiers. Instead of years of exercise to excel at the skill of throwing a discus resulting in the by-product of a superb body, more men today [#52] would go lift weights, to be directly body-building; building "heavenly bodies" to be seen, letting go of the grace of throwing a discus. Rodin's idealized heavyweight "Thinker," even this example ensconced in the city of Detroit [#53], is

[#50] Grant Wood, *American Gothic*, 1930

[#51] Goya y Lucientes, *3 May 1808*, 1814

[#52] TIME OUT

[#53] Rodin, *The Thinker*, 1904

outdated by the tough thinking savvy and stance of current urban youth who rule the streets.

But the changing times, which Bob Dylan noted years ago, do not gainsay **the persistent thread of conviction that human dignity is manmade, hard won, or an inherited privileged position; a valuable possession held by only some favored persons to whom we should give special recognition.** Artist Ingres' *Napoleon* [#54] probably goes overboard when he almost deifies Napoleon like a Pantokrator god icon in a circle of holiness; but does the great Abraham Lincoln [#55] deserve to be enshrined in 6 meters by 6 meters of marble in a temple (dedicated 1922) to which we lift up our eyes? Of course, if it's more than 6 meters high, say, of Nikolai Vladimir Lenin with his granite cortege [#56], one might question such monumentality. And the enormous facsimile of Saddam Hussein's arms holding crossed swords in Baghdad reverts to the impossible colossi of Egyptian pharaohs. When is human dignity "human"? And when does it cross the line and pretend to creep up and be semi-divine, and take up the Serpent's gambit (Genesis 3:1–5) to eat

[#54] Ingres, *Napoleon*, 1806

[#55] David Chester French, *Abraham Lincoln*, 1920

[#56] *Nikolai Vladimir Lenin*, Dresden (1981)

and, not be similar somehow to God but, to be the same! as (like) God; to know and act as if you **be** god-like?

This is the troublesome slippage in the historically established conception of human dignity that I think we need to examine and the kind of human dignity that I should like to turn upside down, because the dignified renown of humans too easily harbors the human sinfulness of vanity and pride. Georges Rouault's painting of *"Condemned Man"* (1907) hemmed in by potbellied prosecutor and white-tied judge shows all three with dark visage and sour grimace. Is there that much difference between one who is condemned to die and those who decide to take away a human's precious life? Steve Prince's powerful print *"Steak and Fries"* [#57] goes further in exposing the champions of sport who bestride the cosmos like the "stars" of Psalm 8, the behemoths who slam-dunk balls through crown-of-thorns hoops and become playboy millionaires, media celebrities in sneakers, a law to themselves who run roughshod over bed-sheets with women on them, leave them behind exhausted playing with paper dolls or tossed aside after being misused. Stardom in sport entertainment may be one way out of the ghetto for a few, but anytime the fittest survive there will be trampled-on victims.

You don't need to accept William Blake's mystical theosophical trimmings to appreciate [#58] this trenchant presentation of how the mighty can fall: autonomous Nebuchadnezzar had his dignified human splendor humbled by God, as the true story goes (Daniel 4), to crawl on all fours and eat grass until he came to his God-given senses to confess that his human dignity had been on lease from the LORD of Psalm 8; a loan in trust rather than something he had built up and owned himself in perpetuity. And every time I look at this fastidious rococo painting [#59] of the Sun King—as he was called—Louis XIV dressed up in his ermine robes with a gallant turned leg showing, I think of Psalm 147:10 where it is written,

> The LORD does not have pleasure in the strength of a war horse;
> the LORD is not fascinated by the calf of a man's leg.

And that Older Testament revelation is ramified by the Newer Testament portion of God's letter the apostle Paul wrote to the Corinthians where it says, believe it or not: don't worry, people, about not having a super IQ, not having much power to speak of, about not being so good-looking wellborn; God chooses what seems to be weak, paltry, and foolish in the world to work out God's promises so that no humans can boast about their accomplishments (1 Corinthians 1:26–31).

That is the kind of upsetting message that incensed Nietzsche about the christian faith: the Way of following Jesus is for wimps! losers! for

[#57] Steve Prince, *Steak and Fries*, 2005

[#58] William Blake, *Nebuchadnezzar*, 1795

[#59] Hyacinthe Rigaud, *Louis XIV*, 1701

those who lack any will to power . . . and the dignity power bestows.
In my judgment both Pico della Mirandola and Nietzsche need to be
turned right side up. To that end, I would have you consider artistic
evidence of **(3) human dignity found in weakness,** the bravery in being
vulnerable, **and the glory hidden in the ordinary**—precisely the reality
that lies behind and has moved artists in "the Invisible Dignity Project."[2]

Henry Moore's pencil, pen and ink, finger wash drawing [#60] of
his mother, a coal miner's wife, does not show a beauty queen but a
formidably strong, no-nonsense woman who knows hardship. Despite a
back [#61] knotted with cords of painful arthritis, a huge wall of a back

2 "The Invisible Dignity Project" was brainstormed by Gerald Folkers and Cornelius
Buller, both of Winnipeg, Manitoba, which led to a conference, concert, and art
exhibition celebrating human dignity. Participants in the conference were singer-
songwriter Steve Bell (Signpost Village), Hannah Taylor (ladybug foundation), Jamie
McIntosh (International Justice Mission), Cornelius A. Buller (Urban Youth Adven-
ture), and Calvin Seerveld (Tuppence Press). Artists showing in the exhibition held
at the Mennonite Heritage Centre Gallery and the Salvation Army Booth College in
downtown Winnipeg in 2007 were Yisa Akinbolaji, Jo Cooper, Ray Dirks, Gerald
Folkerts, and Steve Prince.

[#60] Henry Moore, *The Artist's Mother*, 1927

[#61] Henry Moore,
Draped Seated Woman, 1957-58

[#62] Henry Moore, *Reclining Figure*, 1929

[#63] Jennifer Hillenga, *Seen but not heard*, 1997

he as a little boy had to rub with soothing alcohol this woman's posture shows a rugged, regal dignity. Moore captures the hidden earthy strength [#62] and ample inviting safety a woman can provide for those needing lookout protection.

Jennifer Hillenga's lithograph *"Seen but not heard"* [#63], has young girls staring out without submitting to the short-tempered men who have virtually crossed out their mouths. Jo Cooper's *"Red Women"* paintings [#64] thematize the same "soft despotism," one might call it, that women the world over have borne for centuries; the subtle repression of their particular womanly existence—so devastating because unnoticed by men—undergone for centuries and still borne with dignity. Notice the bending back of the older woman comforting, blessing the rather stiff younger one? The body language reminds one of Pascal's *pensées #347*:

> L'homme n'est qu'un roseau, le plus faible de la nature, mais c'est un roseau pensant.

. . . which I would modify to: "A woman may be only a slender reed, the most feeble thing in nature, but the reed bends under adversity and does not break"—it has a resilient dignity.

The brutality of men toward women is as old as prostitution. Georges Rouault presents the degrading exploitation of woman humanity [#65] from the underside and how women stripped for rape, as Bertolt Brecht's *"Lied des Freudenmädchen"* puts it, lament that "to convert sexual pleasure into small change never becomes easy."[3] Rouault's christian painterly compassion—he painted women who came into the studio to get warmed up from the chilling cold out on the streets—evidenced in the heavy, dirty smudge of the lines and flecks of blue and red on the body, suggests the cold and the wounds, the ugliness and shame, the bitter falseness of putting a gay red flower in your hair, all the while sitting on moth-eaten furniture [*NA* #8]. The figure is slumped; the charities of Rouault's colors make the whole business mercifully drab, not hard-hearted and coarse. The gesture of

3 Brecht's third stanza reads: Versed by C. Seerveld

. . . Und auch wenn man gut das Handeln *Even when you've learned to do business well,*
lernte auf der Liebesmess': *trading on the stock market of love:*
Lust in Kleingeld zu verwandeln, *turning human pleasure into loose change*
wird doch niemals leicht. *is still never an easy trick.*
Nun, es wird erreicht. *Oh well, it gets finished.*
Doch man wird auch älter unterdes. *One does, however, age under the process.*
(Schliesslich bleibt man ja nicht immer siebzehn.) *(After all, nobody ever remains seventeen for life.)*
Gott sei Dank geht alles schnell vorüber, *Thank God it all goes past so fast,*
auch die Liebe und der Kummer sogar. *both loving and even the sorrow.*
Wo sind die Trænen von gestern abend? *Where are the tears of yester evening?*
Wo ist der Schnee vom vergangenen Jahr? *Where is the snow of the last year lost?*

[#64] Jo Cooper, *Red Women Bending*, 2004-2007

[#65] Georges Rouault, *Two prostitutes*, 1906

arm behind the head is an age-old movement symbolifying seduction; but the mirrored figure's face reveals the misery humans have brought upon our human created bodylines—how hideously men have rioted against women . . . and God. Artist Rouault is not judgmental against these unfortunate women, but respects most tenderly their violated humanity and gives them suffering human dignity—this is not being proud of your humility.

African American woman Adrian Piper's work, *Vanilla Nightmares #2* [#66], focuses down critically on the trafficking in black women's bodies for sale on *New York Times* newsprint. The artist purposely puts the shaven head, blinded eyes, and sensual lips of a stolid face on the Sports page. Judy Chicago's *Sojourner Truth* dinner plate in *The Dinner Party* (1974–1979) symbolizes a crowned queen between a minstrel black face and a Negroid woman shedding a pearl of a tear. But a deeper tribute is the charred woman statue of "fallen woman" Mary Magdalene [#67] I found in the Budapest museum in 1987: the forlorn but stately figure is quietly holding the jar of perfume with which she anointed Christ's feet and wiped dry with her hair (Luke 7:36–50); the slightly bent head betokens repentance and acceptance of forgiveness, not obsequiously but surely. The statue was badly burned in a museum fire, but the art cura-

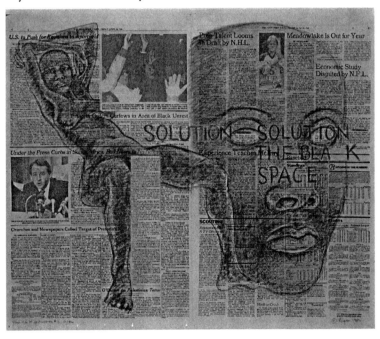

[#66] Adrian Piper, *Vanilla Nightmares #2*, 1987

tors did not try to refurbish its image but left it wonderfully charred, enhancing, it seems to me, her weathered womanly human dignity.

And the South African artist Penny Siopis makes a major artistic contribution, I think, to **righting the wronging disparagement of women's human dignity** with her painting entitled *Terra Incognita* [#68]. Siopis has ingeniously transformed Abraham Bosse's title page for Thomas Hobbes' *Leviathan* [#69], with a mythically crowned Giant figure signifying **total power**—state and church—in heaven and on earth; his colossal body composed of a mass of puny human figures like trophy medals or scales of a giant fish (cf. Job 41:1–11) swallowed up by Absolute Military Power. Siopis converts the Leviathan into a big Woman fallen on all fours—like William Blake's watercolor of mighty Nebuchadnezzar. This gigantic Woman,

[#67] Anonymous,
Mary Magdalene

[#68] Penny Siopis, *Terra Incognita*, 1991

[#69] Thomas Hobbes,
Leviathan, 1651

whose scarred body like an unknown continent, *terra incognita*—maybe the earth we no longer know?—is composed, like the scrapheap under her, of a blistered mass of semi-distinct scenes of struggle, destruction, steel girder construction sites, shattered railroad tracks. Her head is bowed low. Is this what we mighty men have done to Mother Earth, to Women throughout the ages? Siopis artistically reads the historical track record on the woman's body of the complex violence inhering the present we need to repent of, if we fallen men . . . and women would before God and neighbor ever be healed to get up again to fulfill our tasks with human dignity and walk on in hope, God willing.[4]

As for seeing Psalm 8 glory in the ordinary, all it takes is an eye wise to the promise of Jesus that those who are diligent and thankful waiters and waitresses with their native-born gifts in God's troubled world will be com-

4 Cf. Dirk van den Berg, "Painting History: *Terra Incognita* as anti-Leviathan emblem," *Acta Academia* 37:1 (2005): 56–98.

[#70] Anonymous, *Adam plowing the recalcitrant ground*, 1000s AD

mended, "Well done, good and faithful servant" (Matthew 25:14–30). Whether it be an anonymous eleventh-century artisan [#70] showing Adam deftly plowing the ground on the bronze door of St. Zeno's cathedral (in Verona, Italy), or a Barrie David *Globe and Mail* photograph [#71] of this shrewd brood of Mennonite farmers at a horse auction making notes, Rembrandt's (1606–1669) taking time to sketch a woman sewing repairs to old clothes, a stenciled vignette of a Cape Dorset man's elegant gesture in hunting at a seal hole in the ice (1959), an East European woman busy (1980s) at the daily milking of her single goat, or Chagall's (1889–1985) gentle portrait of a rabbi ready in his prayer shawl (1914): **there is human dignity in honest work, a dignity that is not faith-specific, gender-exclusive, or class-conscious.** Those who are unemployed in our urban society, unable to earn their bread, are indeed gradually shorn of self-respect. But Vermeer [#72] shows that the menial job of a milk maid in the bare kitchen pouring milk into a pitcher before an appreciative audience of sparkling freshly baked bread can be as honest-to-God dignified as the

[#71] Barrie David, *Mennonite farmers at a horse auction*

[#72] Vermeer, *Melkmeisje*, 1658-61

coronation of a prince.

We should be thankful for painterly, photographic, sculpting, song-writing, and literary artists who see and express the dedicated worth of what one's human neighbors do that is invisible to so many onlookers on the run, because recognizing the dignity and love hidden within reliable service may help undercut the push for superstar heroics and pseudo-dignity. Earlier Canadian artist Robert Harris ("*Harmony*" [#73]) honors the old-fashioned piano music teacher; Milton Avery puts oil paint to canvas to celebrate cleaning fish in the Gaspé [#74]; African American sculptor Richmond Barthé (1901–1989) is cheered by the local "*Black-berry Woman*" [#75] and Elizabeth Catlett's (1915–2012) linocut gives a "*Sharecropper*" [#76] respect, even nobility, much as does Langston Hughes wonderful poem, "Black like me." It is too late in Industrial Machine culture, which captures unwary men into thinking they too have become mechanical, to dress up work with a sunrise idealism found in Jules Breton's "*The Song of the Lark*" [#77]: an honest shot of the fateful, dangerous job of the miner, and a friendly look honoring "*Hairdressers' Row*" [#78] by John Sloan of the so-called American "Ash Can school" of painters accepts the normal as worthwhile. Sure, to go home, Peter

[#73] Robert Harris, *Harmony*, 1886

[#74] Milton Avery, *Cleaning Fish*, 1940

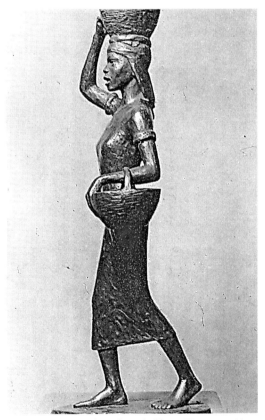

[#75] Richmond Barthé, *Blackberry Woman*, 1932

[#76] Elizabeth Catlett, *Sharecropper*, 1957

[#77] Jules Breton, *The Song of the Lark*, 1884

[#78] John Sloan, *Hairdresser's Window*, 1907

[#79] Peter Smith, *Leaving*, 1984

[#80] Aqjangajuk Shaa

Smith's wood-engraving shows "*Leaving*" [#79] with tired strangers in the crowded underground train station in a large city, and mount stairs to your walk-up apartment takes stamina; so it is good to be reminded by Aqjangajuk Shaa [#80] with this roly-poly greenstone figure alive with a grimace and jovial wave of one hand while the other holds his trusty ulu knife for cutting blubber, that **it is a joy to be alive in God's world with tasks to do before you sleep.**

But what about those whose **humanity** has been substantially diminished, let alone have their dignity go missing? What about those who defy God and deny the very substance of human dignity by torturing other humans so they cannot celebrate the goodness of being God's creature? Are there christian artistic responses to such sinful killing atrocities and the victims?

To try to give an answer I need first to make a brief digression to remind us that **there are multiple kinds of true human dignity:** the helpless naiveté of a newborn baby; [#81]the loving bond of mutual attachment between a child and the mother; (Klee, *Dancing girl* [*NA* #70]) the carefree abandon of a single girl making dance movements; (Picasso, *Two broth-*

[#81] Marian Nyanhongo, *Comfort of Love*, 2005

[#82] Rembrandt, *Jewish Bride*, 1669

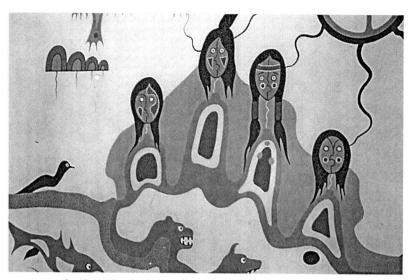

[#83] Anishinabe Jackson Beardy designed *Peace and Harmony,*
painted by local youths, 1985

ers, [*NA* #60]) the snug trust exercised by an older and younger brother together; [#82] the pledge of troth tendered by a man and received by a woman; [#83] the simple peace of an Ojibway-Cree family at home with their fellow creature animals, water, sun, and land.

Beside these diverse dignities appropriate to what Shakespeare's melancholic Jacques recited as the "seven ages" of men and women,[5] there are ethnic colorings to human dignity too (as I have quietly incorporated in my selection of artworks).

That is, the richly variegated character of human dignity needs to be kept in mind lest one become parochial and make one's own dated/located limitation the norm for "human" dignity at large. Yet without losing the variability of ages, historical periods, ethnic cultural and locational features, one must not let the commonweal of human dignity be dissipated into a bouillabaisse without a definite normativity to human dignity, because humans can degrade their dignity.

That said, how does one begin to deal with (4) human dignity that is vanishing with age (*Pennsylvania Coal Town* [#84]) and the decrepit isolation Edward Hopper (1882–1967) perceives descends upon those who must pick their way with a cane? or how can one deal [#85] with the catatonic

5 *As You Like It,* II, 7.

[#84] Edward Hopper, *Pennsylvania Coal Town*, 1947

[#85] Füssli, *The Silence*, 1799-1801

[#86] Ivan Albright, *Into the World There Came a Soul Called Ida,* 1929-30

[#87] Goya y Lucientes, *Fight with Cudgels,* 1820-23

silence of depression Füssli (1741–1825) depicts? *"Into the world there came a soul called Ida"* is the title Ivan Albright (1897–1983) gave this artwork [#86]: some people just seem to be a botch, mismanaged, grotesque, even if you cosmeticize your face to look into the mirror. Early Goya [#87] witnesses to the utter stupidity of two men viciously fighting each other as they both sink into quicksand!—

A good way to highlight any residual human dignity found in ravaging human misery is to **not** sugarcoat the pain but to admit *le dur métier de vivre* (the tough professional calling of living) as Rouault's *Miserere* plate 12 [#88] proposes. Käthe Kollwitz presents the unbridled grief of a hulking mother with her dead child [*NA* #42], whose swooning embrace would-to-God could reabsorb the hopelessly dead treasure back into her body to give it life again—this amazing etching (1903) has for me an overwhelming ache of human loss **and** compelling human dignity. "Blue period" Picasso [#89] gives this old busker whose lowered head is sunk below his shoulders, scratching out a few last chords on the only friend left, his guitar: artist Picasso strengthens the sad stature of the fellow by giving him the crossed legs of the macabre medieval dance-of-death prints, so you sense vaguely there is an illustrious tradition behind this sober scene. The catchy phrase "to die with dignity" is enmeshed, I think, in the reduced legalistic problematics of "individualist rights" in a post-christian hospitalized society. More "humane," it seems to me, would be the conception [#90]: "to die 'full of years' with grace" surrounded by believing family and friends tasting the eucharist and singing a psalm (cf. Genesis 25:8, 35:29, 49:33).

Hired as a British wartime artist Henry Moore (1898–1986) quickly sketched the countless people trying to sleep in the deep London underground train tunnels, the safest place to be during the Nazi nightly bombardment of the city, recalling unsung courage of the civilian populace. In a sculpture erected outside Dachau, Germany (1960) [*NA* #41], which I photographed through my tears, Nandor Glid commemorates the concentration camp victims who tried to escape and were caught, electrocuted in the barbed wire fence guarding the perimeter: these are the weak captives, the dead, who do not write the history books of the war; but the artist has given them, to my eye, their human dignity starkly outlined against the sky. Gerald Folkerts' *Forgotten in Chernobyl* [#91] also gives the prone woman's forlorn form under that thin protective sheet of cloth a certain stubborn perseverance under the blank walls' stare, blistered to bits by the nuclear radiant heat—no one remembers, except the artist who says: "lest we forget" and repeat our heedless deeds

[#88] Georges Rouault, *Miserere et Guerre*, 1948

[#89] Pablo Picasso, *Old Guitarist*, 1903

[#90] Rein Pol, *Uitzicht*, 1985-86

[#91] Gerald Folkerts, *Forgotten in Chernobyl*, 1996

killing people. The memorial for prisoners of war, standing outside the Red Cross museum in Geneva [*NA #22*], grouped disconsolately in nondescript robes, waiting and waiting, composed of a material that is gradually petrifying, nudges us to see the invisible human dignity of those women and men who are denied the freedom to be human.

I should like to conclude by emphasizing these last remarks and sum up the artistic evidence I have given to call into question the usual conception of human dignity, to turn it upside down, or turn it biblically right side up, if you will, positing that **self-conscious misery, undignified failure, the poor of the earth can maybe best reveal our God-given human dignity.**

Maybe my closing remarks will be a little controversial. I happen to be a sinful saint convicted with others to be followers of the God revealed in Jesus Christ's Way, Word, and Holy Spirit. So I should like to hold out the crucified and resurrected Jesus welcome sign for anyone interested in the rough hewn, tough, and delicate, wildly diverse kind of human dignity the biblical christian faith, as I understand it, encourages.

[#92] Peter Paul Rubens, *Christ on the Cross*, 1620

Peter Paul Rubens' (1577–1640) dramatic artistic painting of Christ on the cross [#92] sums up the kind of Humanist heroics I think misleads. This Christ's arms have biceps that could do chin-ups, and the arms are raised in a premature "V" for Victory salute against a royal blue sky. Emil Nolde's (1867–1956) crucified Christ [#93] is closer to the truth: Christ's rib cage is emaciated, abdomen draped with a dilapidated towel, arms scrawled with blood smears, crooked face in violent green and red bluntly saying he is dying in pain. Mary in the green smock has her arms twisted in anguish; John is next to her with a sad mouth in a

[#93] Emil Nolde, *The Crucifixion* (from *Das Leben Christi*), 1912

mask of a face, collapsing in the knees of his white pants. While on the right, under spear and armor, the soldier crouching over Christ's garment on the ground nonchalantly drops the dice, and the standing guards grimace—business as usual, another, execution. Nolde's artwork does not glorify Christ's death, but shows that the crucifixion of Jesus was violent! distortive, a curse laid on him.

A current sculpted version of a hanging Christ [#94] minus the cross! by South African artist Wim Botha has the crucified God-man physically carved from Bibles, reams of good newsprint, as if we Bible-quoting Christians today, more than the Romans and Jews of yesterday, have pierced the Christ's side and are implicated in this bloody lynching of the Son of God; are we Christians truly *tzadikim*, a company of restorative just-doing persons acting as living sacrifices for God's sake in society? or do we belong to the crowd of voyeurs who wonder what in God's world the hullabaloo is all about? Botha has dared to go on theatrically [#95] in turning the crucified human torso into a goat-legged figure: Christ as scapegoat has impeccable biblical theological credentials (Leviticus 16, Isaiah 53), but this image offends most "dignified" sensibilities, especially when installed in lurid red lighting with a kitsch backdrop of artificial clouds. A scapegoat is an innocent sacrificial animal being banished into the desert as a victim laden with our guilt: Jesus Christ, it

[#94] Wim Botha, *Commune: suspension of disbelief,* 2001

[#95] Wim Botha, *Premonition of War,* 2005

is true, went all the way as scapegoat to save us humans and the Psalm 8 world from evil. . . .

Given the pivotal historical reality of Jesus Christ's death, resurrection, ascension, and certain return acoming, there are (5) three ways I should like to mention in which followers of Jesus Christ are invited to witness to our human dignity,

(1) **faithful psalmodic lament to God**: Because our life time is a pure gift of God's grace, as the Lord's adopted children we humans in faith may holler at God in prayer to stop the systemic and inexplicable destructive evil going on in God's world. I do not mean the single psychotic *Scream* (1895) of Edvard Munch's (1863–1944) individual lost on a bridge. I mean Warren Breninger's series called *"Gates of prayer"* [#96], which has 42 "praying mouths," 50 x 75 centimeters each paint-

[#96] Warren Breninger, example of *Gates of Prayer*, 1993-2008

ing, that can be put in different arrangements to fit a given communion of Job-saints at prayer. These are mouths pleading and uttering godly curses against the evil powers we cannot match, the principalities—not specific people—the principalities of Greed, Rage, and Hate, which drive humans to become cruel, ruthless, violent, militaristic. Every imprecatory psalm in the Bible—two of which Jesus quoted on the cross[6]—is couched in faith, spoken through clenched teeth, appealing for God to come through and not leave Christ's brothers and sisters and neighbors

6 The Newer Testament gospels intimate what was running through Christ's consciousness as he endured the torture of being crucified: Psalms 22:1 is quoted in Mark 15:34 and Matthew 27:46, and Psalm 69:21 is referred to in Luke 27:36 and John 19:28–30.

in the lurch, while immediately confessing our own despicable sin,[7] but wrestling with God for a blessing through twisted mouths of prayer. In my judgment, when a follower of Jesus Christ utters *de profundis*, a gut-wrenching imprecatory psalm of lament in desperate trust before God's face, that act exemplifies a most mature human dignity. (Imagine preaching at a Good Friday church service or dispensing the eucharist after a tragic accidental death in the congregation with a background canopy of "*Gates of prayer*": it would humble any preacher or priest's speech to a muffled cry for deliverance, *kyrie eleison!*)

(2) **patient eschatonic hope for your life**: Andrew Wyeth intimates the young woman's determined handicapped life in *Christina's world* [#97] by the awkward bird-like arm movement, uncomfortable twist to her pink calico-clad body, and the lowdown, grass-level perspective way up to the horizon and far-off buildings. Gerard Pas gives the halt and

[#97] Andrew Wyeth, *Christina's world*, 1948

the lame a brighter future, albeit fraught with painful, piecemeal adjustments that may take years of exasperating patience. His *Red-Blue Crutch Installation* [#98] takes the basic crutch, stigmatized by primary colors, through a contorting metamorphosis, as if the crutch going through the twelve stages of the cross is finally brought to its knees, converted into a docile, balanced pyramid of expectant waiting. Another [*NA* #21] Pas

7 Whenever there is an imprecation for the Lord God to end the systemic evil decimating believers, the faithful psalmist immediately implicates us who dare pray curses also in the sin afoot in the world—*mea culpa*—asking the Lord to please cleanse us from evil-doing and forgetting God's authority lest the curse we utter boomerang on ourselves. Psalm 137:7–9 is directly preceded by vv. 5–6, and Psalm 139:19–22 is directly followed by vv. 23–24.

[#98] Gerard Pas, *Red-Blue Crutch Installation*, 1986-87

watercolor shows an assumption of the crutch in anticipation of the day when the lame shall indeed leap and dance for joy! Christian hope is not the ancient last delusory ill to escape Pandora's box, but is a sure, comforting grip of God's hand, which holds you close and gives you certainty of the relief acoming even though the long bouts of incurable trouble seem longer than the stations of the cross.

And (3) **giveaway love for your neighbor**: I walked into this room filled with Swiss Martin Disler's bronze human-like figures called *The Shedding of Skin and Dance* [#99]; it was both quieting and disconcerting, but somehow not frightening. The varied maimed creatures seemed busy and next to one another. Since all were mis-made, it didn't count against you. Everyone seemed intent on something, although there were cries for help, like the one sinking into the floor, that went unheeded. There was a "snake pit" feel as you walked among them— how is such grotesqueness actually possible in God's(?) world? I talked with the young security guard who was surprised anyone would stay looking for 25 minutes, thinking out loud about wholeness, isolation,

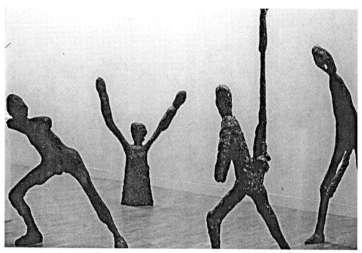

[#99] Martin Disler, *The Shredding of Skin and Dance*, 1990-91

Down syndrome, *retinitis pigmentosa*, Alzheimer's disease, the egg shell fragility of living with and loving someone. Because one creature was actually holding and caring for an other one, you had the sense of a strange human dignity hovering nearby. Gerald Folkert's *Head over Heels* series of unusual paintings shows a similar spirit of seeking out and caring for outcasts, the street people [*NA #79*] whose eyes betray their being imprisoned in loneliness, naked with homelessness, hungry and thirsty for a kind word, whose lives are as beaten down as their dilapidated shoes on the pavement. Each artwork in *"Head over heels"* restores respect to each forgotten person or derelict by honoring their human dignity in the bisected portrait by titling it with their proper christian name: Ralph, Toni, Monty, Carol, Timothy. In the panels of *"Daryl"* [#100], arranged in the form of a cross, Folkerts seems to quote in the background mounds of rubble the old Millet (1863) *"Man with a hoe"* piece[8]: picking valuables out of the dumps like hoeing the blasted ground is, honestly, exhausting worthy labor. I see Folkerts graphically washing the feet of strangers, showing hospitality to undesirables, as Matthew 25:31–46 puts it, acting diaconately—without knowing it!—toward the scapegoat Jesus Christ!

Britt Wikström's bronze sculpture *Caritas* [#101] also shows what happens when the selfless giveaway deed of Holy Spirited love takes place without expecting anything back in return: it multiplies human dignity.

8 Edwin Markham's (1852–1940) poem "The Man with a Hoe" (1899) made Jean Francois Millet's *"L'homme à la houe"* painting (1863) well known in the AFL-CIO labor movement in the USA.

[#100] Gerald Folkerts, *Daryl*, 2006

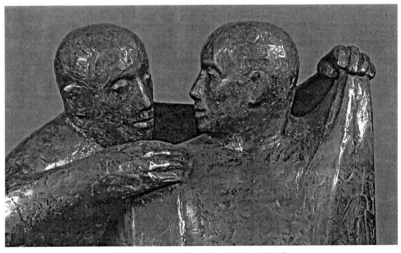

[#101] Britt Wikström, *Caritas*, 2006

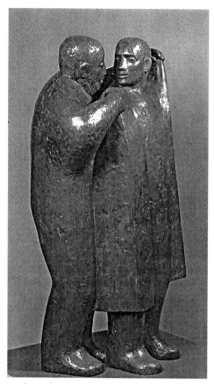

[#102] Britt Wikström, *Caritas*, 2006

Illness exposes a person's most intimate secrets to anyone who helps. Giving and receiving the mute touch of love in sickness often turns the tables around as the body language in the firm gentle lines of this artwork show: the older one patiently clothing the weaker younger one is himself [#101] given a slow look of wondering gratitude. I noticed when I visited the cancer ward where this sculpture stands in the University of Chicago hospital [#102], the care-giver's lower legs have a little sinking feeling to them; while giving consolation he also needs and . . . surprise! receives support. Compassion is truly mutual. Only when human dignity is shared communally does the invisible shine briefly like an epiphany to an eye of *caritas*.

Human dignity rings false, I believe, unless it silently testifies to a faithful trust in God, a firm hope for your own life's outcome, and bodes selfless love to the neighbor. Certain artworks, like those I refer to above, remind those with eyes to see of our history of human dignity—thrown to the lions [#103], burned at the stake like Jeanne d'Arc, Savonarola, John Hus, and many others, but surely awaiting the resurrection laughter

[#103] Entrance way to Cathedral of San Rufino (1140-1253), Assisi, Italy, where St. Francis prayed and preached

[#104] Joanne Sytsma, *God keeps all my tears in a bottle, Psalm 56:8*, 2001

of Rouault's *Sarah* [*NA* #87]. In the meantime we are called to hold on to the fact (by Joanne Sytsma [#104] that "God keeps all my tears in a bottle" (Psalm 56:8) while we celebrate the invisible praise to the LORD of Psalm

8 in the human dignity of mutual loving deed.

Selected sources

Duffy, Regis and Angelus Gambatese, eds. *Made in God's Image: The Catholic Vision of Human Dignity* (New York: Paulist Press, 1999).

Hoffmann, Herbert, ed. *Werde Mensch: Wert und Würde des Menschen in den Weltreligionen* (Trier: Paulinus Verlag, 1989).

Klose, Alfred. *Minderheit und Menschenwürde: Christliche Orientierungen* (Klagenfurt: Mohorjeva Hermagoras, 2000).

Kraynak, Robert and Glenn Tinder, eds. *In Defense of Human Dignity: Essays for our times* (South Bend: University of Notre Dame Press, 2003).

Rossen, Susan F., ed. *African Americans in Art: Selections from the Art Institute of Chicago* (Chicago: Art Institute of Chicago, 1999).

Sieh, Edward W. *Community Corrections and Human Dignity* (Sudbury, MA: Jones and Bartlett, 2006).

Soulen, R. Kendall and Linda Woodhead, eds. *God and Human Dignity* (Grand Rapids: Eerdmans, 2006).

van den Berg, Dirk. "Painting History: *Terra incognita* as anti-Leviathan emblem," *Acta Academica*, 37:1 (2005): 56–98.

van den Berg, Dirk. "Transformed and Transforming Images: *The Scapegoat* in Wim Botha's *Premonition of War* exhibition" (Bloemfontein: Department of History of Art and Visual Cultural Studies, 2006), typescript, 11 pages.

With Jim and Joyce Phillips and Joan Cots, Barcelona, Spain, 2003

With David Estrada, Professor of Aesthetics, University of Barcelona,
at Montemayor, Spain, 2008

THE CHALLENGE TO BE IMAGINATIVE SALT AS ARTISTS IN GOD'S WORLD

It would probably be wise for us not to take ourselves too seriously, even though we may deal with matters of life and death for our culture. The coming compassionate Rule of Jesus Christ does not depend upon us. The question is: do we have a wholesome biblical vision of our human task, a holy spirit of love respecting the neighbor, and a good sense of the costly labor to which we are committing if we as persons, as artists, want to be God's salt of the earth?

The Biblical Conception of Salt

The biblical conception of salt goes much deeper than the general understanding of being a mineral preservative against organic decay, or the image of one sprinkling salt on meat and potatoes to make them tastier. Salt in the Bible stands for an irrevocable guarantee of one's being purely, wholly bonded with the jealous LORD God of the universe (Luke 14:25–35). God's promises to Aaron and to David in the Older Testament are called a "covenant of salt" (Numbers 8:19–20, 2 Chronicles 13:3–12, v.5), an agreement meant to last forever.

The gospel of Mark gives the most provocative Newer Testament context for our hearing the biblical point about God's salty security: after Jesus found out his disciples were arguing among themselves who was the greatest, Jesus said, "Whoever wants to be first, let that person be last of all, one who waits on everybody else" (Mark 9:33–37, v.35b). After hot-tempered disciple John Zebedee said we told somebody who was casting out demons in your name! but was not "one of us," to stop, Jesus said, "No—whoever does **a mighty deed in my name** will not soon be able to speak evil of me. Whoever is not against us, you know, could become **for us**" (Mark 9:38–41, vv. 39–40).

This lecture was originally given at a Barcelona "Arts Gathering" conference in Spain, organized by Joyce and James Philips and Professors Frances Luttikhuizen and David Estrada in May 2003, and was revised for a lecture at Bethel College/University, Minneapolis, Minnesota, 20 October 2003.

Then Jesus said: If your sure hand, swift foot, or sharp eye trips you into thinking you are the greatest, and misleads any immature believers in me to throw their weight around, you will be "salted by fire"! That means, you will be permanently destroyed. "Salt is good, but if salt crystal compound breaks up and disintegrates, with what do you make it salty (again)? You people do have salt among yourselves; so be at peace—experience shalom—with one another" (Mark 9:42–50, vv. 49–50).

That is, as I hear the Scriptures affirm that followers of the Christ be "the salt of the earth," with the injunction to stay salty or you become worthless (Matthew 5:13), I hear this directive: do not try to be the greatest, a meteoric star in the heavenly constellation of the cultural sky; and do not think you Christians have a monopoly on the miracle of quality performance; but **season your neighbors with the peculiar self-effacing wisdom of God that rules by serving**—gentle sorrows by quiet healing, relax anxiety with the surprise of humor bearing hope, slip in an innocent fullness of joy, and give away one's gifted insights indiscriminately, counting others better than yourself (Philippians 2:1–11, vv.2–4; Romans 12:9–21, v.15).

How today do we little people in our globalized world of plural commitments and agendas respond to the challenge of presenting artistry worth its salt and of developing salted critical support of art makers?

Three Basic Matters for Orientation

If one takes seriously the biblical specificity on salt rather than think salting means just add spices to what you cook, or pour a piquant sauce on over the regular pasta, then in our post-christian day we have a difficult vocation on our hands. If you would rather not be fake salt, have the appearance of salt but really be only crushed aspirin, then, from my standpoint a person needs (1) a biblical vision of the world at large, (2) a creatural idea of art work, and (3) a live sense of the body of Christ in history outside the church door.

Let me explain these three basic matters briefly, since they are integral to the challenge of being imaginative salt as artists, art interpreters/performers, and art audience/viewing public in God's world.

(1) Mountains and rivers, trees and animals, human children, women and men, are **all creatures of different kinds whose common habitat is a cosmos ordered by the living Creator God.**

So the world is not a global market place. The created world we live

in is also not the Church. Commercial **industry**, with capital, managers, and laborers, is a structuring network within the world theatre of God with certain laws for thriftily recompensing resources supplied for needs of people. And the **church**, with its special task of being a retreat for the faithful disciples of Christ to be built up in the confession of the faith that motivates their historical existence: the Christian church, like a Muslim community or a Jewish synagogue fellowship, has a legitimate place in God's world order. But neither industry nor church defines God's created world.

Each of the various institutions there be, all together, in which we humans dwell as members, or enter for a time, like a family, nation, school, media, or a city neighborhood: **each institution has a proper, limited task to exercise towards the other distinct institutional bonds.** A state must mete out justice to fraudulent business or abusive parents rather than look the other way, and the media must report clearly to a nation about war and peace rather than broadcast misinformation; or there will be civil unrest and an "Empire of Fear." And if some people wrongly make the art museum their church, or if a confessional fellowship (Christian, Muslim, or Jewish) acts as if their communion-of-the-faithful be a governing state, you may also expect totalitarian trouble in society, because humans will have misjudged and violated **God's good societal ordering for us creatures in varied institutions with distinct inter-institutional obligations.** Institutions undergo historical modification to be sure, but woe to a society that confuses or denatures such a God-provident warp-and-woof of responsible relationships.

Art takes place in a society filled with institutions and often may develop its own sphere of an "artworld."

(2) Artistry is imaginative human activity by those trained to craft certain material, as durable as marble or as fleeting as words, **into an object or performed event that presents nuanced meaning with a metaphorical allusive quality for somebody to respond to in kind.**

The technical term for this idea of artwork is "symbolific": some initial meaning is made "symbolic" in stature; a given state of affairs has been grasped in its rich, indirect allusivity, and is skillfully presented for others to receive with imaginativity.

Maybe the artisan has simply made an elegant decorative vase that bespeaks the gracious loveliness of a bouquet of flowers, and the craft element is dominant in the artifact. Maybe a playwright like Brecht portrays a woman with a worldliwise survivor's guile and a crusty jaunty irony so

that his *Mutter Courage und ihre Kinder* (1949) theatre piece protects you from ever becoming idealistic about human nature and war waged "for God's sake."

Theatre, a concert of flute and harp music, a novel like Gabriel Marquez' *Cien Años de Soledad* (1967) need no justification, as Hans Rookmaaker put it, since **art-as-such** simply discloses nuanced manna to enrich our human imaginative awareness of meaning in God's world.

Sometimes art is willingly harnessed to do double duty, like advertising art or entertainment art. Such **encapsulated art** has two norms to follow: commercial art must be truly imaginatively designed **and** promote worthwhile economic goods; art-for-amusement like pop songs or the circus clown must be truly imaginatively crafted **and** rejuvenate one's interactive resilience instead of deadening or frazzling one's social nerves.

Making art is no more "inspired" or "creative" an occupation than conceiving and bearing babies. (Producing artworks is sometimes almost as painful a labor as a mother knows.) Making art of many sorts is an ordinary human activity chartered by the Word of the Lord who created people with persistent imaginative skill.

(3) It is normal for the salt of the earth to commune with one another, since whoever is indwelt by the Holy Spirit is a constitutive ligament in the body of Christ, as the Newer Testament calls such faithful disciples (1 Corinthians 3:16–17, 2 Corinthians 6:14–7:1, Ephesians 4:7,12–16).

Important to me is the fact that **the body of Christ is not identical with the worshipping church**. The communion of saints is not a church-only phenomenon. Somewhat as there is a lot of art outside the art museum, and not everything in the art gallery or museum is genuine art, so there is a lot of holy salting activity going on not in the name of a church, and not every church-goer is a bona fide salted saint.

This distinction may sound confusing, but not getting the connected difference straight between "institutional church" and "body of Christ" is a fundamental reason, I think, why so much christian activity in the arts either is confined to a spiritual ghetto or merges imperceptibly into the mainstream secular artworld.

Without being immersed in a vital Bible-reading/Bible-hearing church congregation and confessional tradition, a lone artist, or a political practitioner, or a professional educator, will wither on the vine, I think, since a person needs a living consolidating church center to stay strong and to mature in the vocation of one's daily task. A collection of

christian artists or a group of believing friends do not constitute a church, as I see it; the church institution is a much more messy, heterogeneous and humbling a grouping, even if its testimony is lively.

But it is wrong to expect Holy Spirit-filled artists, political leaders, and teachers, to act like agents of the institutional church, to preach, evangelize, and doctrinely proselytize on the job, instead of fashioning solid enriching art, forming just public legislative policy, and providing philosophical wisdom for students to chew on. **Followers of Jesus Christ who belong to the royal priesthood in the order of Melchizedek** (Psalm 110, 1 Peter 2:9–10, Hebrews 4:14–8:13) **form a community of salt, the variegated body of Christ, which is broader than and not confined to the proper activities of the institutional church at the hub of the christian life.**

I'll try to show the wholesome, provocative implications of this basic thesis in what follows.

Altering Mainstream Art—Is it Possible?

The splendid painting by Sandro Botticelli (1444–1510) entitled *Primavera* [#105] is an epitome of "the beautiful picture" desired by the Medici bankers who set the cultural pace of the city-state of Firenze in the mid-to-late 1400s AD.

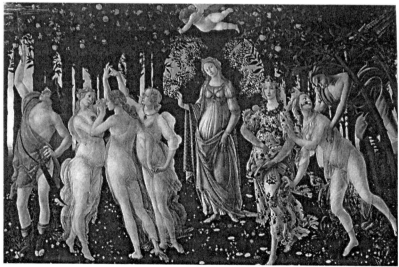

[#105] Sandro Botticelli, *Primavera*, 1477

Botticelli's lively line, delicate color, and sensuous bodily forms all together are highly erotic. But the cognoscenti in the circle of the

Medici knew—ordinary people did not get to see the painting—that the whole narrative scene of Zephyr, nubile young Eve-sensuous woman, and clothed Flora, and Eros up among the pomegranate love apples shooting flaming arrows in this mythical Elysian/Paradisiacal/Edenic flower-sprinkled forest garden, was overlaid with an allegory you were expected to read.

If you knew your Plato, Bible, Dante, Poliziano, and the NeoPlatonist mystagogue Ficino's writings and translation of Hermes Trismegistus, you would appreciate the stunning synthesis Botticelli has artistically presented here of Plato's erotic *Symposium* chastely christianized, as it were. Botticelli's artwork details how we humans are invited to move from sensual, vegetative bodily desire, even fearful a bit of the consequences of being clutched for in physical embrace: we viewing persons are invited to move on to natural maternal love—the decorously dressed Flora has an arm caressing her womb—and then onward to a pregnant **heavenly** Venus, this central pivotal personage like Diotima of Mantinea (or doubling perhaps as Virgin Mary?) who is pointing delicately with her right hand upwards while blessing the three graces: eros is meant to carry us to a contemplative heaven! A trinity of lovely, transparently veiled Graces! and Mercury, the divine messenger (mediator) between gods and humans, lead the lovely procession.

Primavera is about the journey of one's soul! Ficino's letters (1481) to Botticelli's patron Lorenzo di Pierfrancesco de' Medici explained, in whose villa the *Primavera* was ensconced.

I show this Botticelli art to recall for us the Renaissance world of sweet dalliance, mellifluous refinement, and aristocratic beauty that stands for *humanitas*, a Humanist humanity that obliquely provides an altar call and almost sacramental confirmation to the gnostic intelligentsia who enter and enjoy living in this beautiful world, which has gotten rid of imperfection, deformity, and anything ugly.

Young Michelangelo (1475–1564), coming a generation later, already as a precocious teenager, was initiated by Lorenzo dei Medici into this same culture of learned Beauty and magnificence. As a 20 year old invited to live in Rome, where he could study ancient Greco-Roman sculpture first-hand, Michelangelo at age 23 completed this elegant *Pietà* [#106] there, commissioned by a powerful French cardinal of the church. The quiet "classic" beauty of Mary's ample robes, downcast face, and the resignation of her left hand, shows a balanced harmony of marble that evokes wonder, as this noble very young woman holds out Christ's dead body for

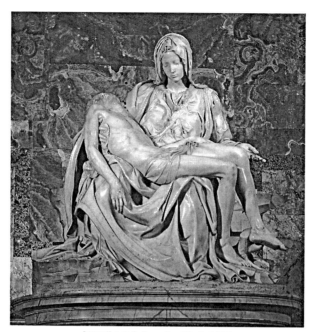

[#106] Michelangelo, *Pietà*, 1498

[#107] Michelangelo, *Day*, 1526-31

us to see, to admire. The Virgin displays the beautiful body of Christ as if he were sweetly sleeping rather than a dead corpse; the flesh is superbly styled to radiate perfection, and is held lovingly with impeccable, gentle firmness.

Many years later when Michelangelo portrayed Day and Night in the funeral chapel for Lorenzo dei Medici [#107], the coiled muscular tension of such a leonine body adds the attribute of power to such massive beautiful equanimity. And with the exploding Christ figure in the tumultuous *Last Judgment* wall [#108] of the papal Sistine Chapel, one faces the glorious bursting *terribilità* of Michelangelo's mature art at its strongest.

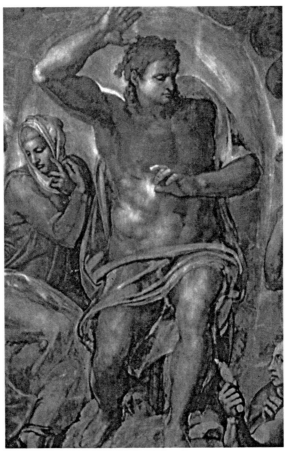

[#108] Michelangelo, Christ figure in *Last Judgment*, 1535-41
in Sistine Chapel, Vatican, Italy

The point I want to make now is that **both Botticelli and Michelangelo changed their mature artistic style when they came under the convicting power of the Holy Scriptures.**

In 1492 Botticelli went to live with his brother Simone who was a follower of Savonarola (1452–1498), the Dominican friar preaching apocalyptic sermons from Jeremiah and Revelation in the Duomo of Firenze about the corrupt papacy of Alexander VI (a Borgia pope 1492–1503) whose child Cesare Borgia was a profligate power monger and menace to Florence. Savonarola preached against the tyrannical taxation policies of the Medici, and thundered that the invasion of French King Charles VIII (king 1483–1498), like the Cyrus of old (Isaiah 44:23–45:7), was coming to sack the Florentines because of their ungodly lives.

As it happened, the Medici were expelled from the city (November 1494), Charles VIII came and inexplicably left Florence intact (November 1494), and a "popular government" was set up in the city with Savonarola's approval (December 1494) that was going to initiate in Florence "the new Jerusalem"! After a sermon on Haggai and Savonarola's preaching from Job, Amos, and Micah, a public bonfire was held of the "vanities," the frivolous worldly possessions of the populace in the main piazza, a repentant holocaust offering for God. (Michelangelo left Florence for Rome in June 1496, since there were not enough commissions for his beautiful artworks in the Christocratic Firenze of Savonarola.)

Botticelli's painting of a *Mystic Crucifixion* [#109] about this time shows Firenze in the background at peace in the sun (see the Duomo) protected by God

[#109] Sandro Botticelli, *Mystic Crucifixion,* 1497

up in a golden cubicle, with angels dispensed to ward off the dark cloud of war around the cross, bearing white shields with the red cross Savonarola used for the "penitence walks" carried by children and adults he organized for parading through the city streets. Notice the loss of ethereal finery and the presence of a more rough-hewn matter-of-factness about Christ on the cross and the angel about to slice off the head of the animal-devil. A constant theme in Savonarola's sermons was his excoriation of the allegorizing, mythologizing overlay in art because it compromised the simplicity of the christian life. (Savonarola was soon plotted against, excommunicated by corrupt Pope Alexander VI, arrested in Florence, tortured, and burned at the stake as a heretic on 23 May 1498.)

But Botticelli, after Savonarola's (Billy Graham) sermons in Firenze were ended, kept painting in this spare, unmythical idiom so different from his earlier artwork. The stable scene in this *Nativity* [#110] is a rock hut surrounded by a grove of normal trees. The kneeling shepherds in the olive bushes are ordinary blokes, and a no-nonsense walk zigzags in to where Mary, Jesus, and Joseph are centered, showing that this is a very earthy historical event. There are Bosch-like animal devils groveling in the green grass, while on top of the hovel a trio of faith-love-and-hope angels (instead of the three *Primavera* graces) link arms; and above the blue sky in a golden heaven girlish angels do a circle dance of rejoicing, dangling their golden crowns, because it is a Revelation 12 celebration of the downfall of the dragon from heaven now that the kingdom of this world is becoming the kingdom of the Woman's newborn son, as the Greek inscription says.

If there be any allegorical supertext to the images, it is certainly not a pagan mythology, but a hope expressed for the rebirth of the Church centered around Mary and the Christ child. The three men in the foreground "in whom God is well pleased" (Luke 2:14 on scrolls) being embraced by angels, some speculate could be a hidden reference to the martyrs Savonarola, Domenico Buonvicini da Pescia, and Silvestro Maruffi.

Michelangelo met Vittoria Colonna (1490–1547) when Michelangelo was 60 years old, and he read the Bible with her until she died. For a time Vittoria was mentored by Juan Valdès who held firmly to the biblical truth that one is justified with God only by faith, not by works. Old Michelangelo struggled to know the truth about atonement for sin, as his late poetry shows: in Sonnet 151 he says, "Heaven opens for us, my Lord, with no other key than your blood shed for us." Michelangelo also became increasingly dissatisfied with the luxury he knew at the Vatican.

[#110] Sandro Botticelli, *The Mystical Nativity*, 1501

Noteworthy is the unfinished (ten year) *Rondanini Pietà* [#111] Michelangelo was still working on six days before he died in his ninetieth year. Gone is all heroics, all display of beautiful form. In the last *Pietà* there are no broad gracious gestures, only awkwardness. Mary is leaning on her dead son. The Christ is utterly powerless, weightless; the silent sadness of ignoble death is sculpted, to my eye, with a sense of the wages of sin, which wastes us away. This final artwork resonates with the recantation and hope found in Michelangelo's Sonnet 147:

> Now know I well how that fond fantasy
> which made my soul the worshipper and thrall
> of earthly art is vain; how criminal
> is that which all men seek unwillingly.

. . . Painting nor sculpture now can lull to rest
my soul, that turns to His great love on high,
whose arms to clasp us on the cross were spread.[1]

Botticelli and Michelangelo were dominant figures along with Leon-
ardo da Vinci (1542–1519), Raphael (1483–1520), and Tiz-iano (1480–1576), for five generations of master artists in the cultural centers South of the Alps, where the power of money and the glory, pomp, and circumstance of brilliant learned Humanists was the artistic air you breathed if you wanted to be part of the scene. A different spirit and freshly biblical conviction of what is important about Christ, human life and death, caught Botticelli and Michelangelo late in their art making and made a drastic difference in their artwork. They were struggling to replace a synthetic christianity that attempted to have its pagan cake of Beauty and eat it like the Lord's Supper too, and to find a way to be true to the salt of re-

[#111] Michelangelo, *Rondanini Pietà*, 1554-64

pentant thankfulness for God's amazing gift of Christ's birth and death to save the whole world (John 3:16–21, v.17) and bring humankind the relief of meaningful service.

But even Botticelli and the great Michelangelo could not reform the reigning standard Renaissance style they had helped set or halt its shift to the extravagant artistic form the Council of Trent clerics preferred and

1 John Addington Symonds translation of:
 Onde l'affettuosa fantasia,
 Che l'arte mi fece idolo e monarca,
 Conosco or ben com'era d'error carca,
 E quel ch'a mal suo grado ogn'uom desia.
 . . . Né pinger né scolpir fia più che quieti
 L'anima volta a quell'amor divino,
 Ch'aperse, a prender noi, 'n croce le braccia.

[#112] Bronzino, *Allegory of the Triumph of Venus,* 1540-45

historians of art call "Mannerism" [e.g. #112], where "the beautiful picture" and the glitter of show seems to go to seed and become formulaic, without the conviction of discovery.

Late Botticelli and Michelangelo's imagination finds more resonance, despite a sharp difference in spirit, with Reformation art by Holbein the Younger (1497–1543) and Pieter Breughel the Elder (c. 1525–1569) [#113], for example, that is sober and homely, without sweetness and fat, and is salted with a stark awareness of the humility God underwent in Christ, and the flagrant, pretentious weaknesses of humanity.

One could show how art produced in the train of the Reformation, especially in 1600s North Holland, had the taste of good bread, where biblical artistic salt permeated perception of the home interiors, domestic work [#114], civic officialdom, and people weathered by the expectations and troubles of *la gloire et la misère de l'homme* [*NA* #62].

Let me turn now to a couple of particularly gifted artists in Germany

[#113] Pieter Breughel the Elder, *Blind Leading the Blind*, 1568

[#114] Vermeer, *The Lacemaker*, 1669-70

just a few generations ago, who were not exactly mainstream, but who persisted in their vision to make a contribution to their neighbors, mostly unappreciated until after they had died, and what that might mean for the challenge to be the salt of the earth.

Remaining Solitary Artists—Is it Good?

Early on Ernst Barlach (1870–1938) sculpted the blind women beggars he saw on a two month trip to Russia in 1906. The same stolid peasant aplomb grounds a late *Mother and Child* teakwood artwork too [#115]. Barlach felt close to those who did not count much or fit well in society, and gave them a durable earthy presence with dignity. Barlach's sure touch is not harsh or accusatory like the surrounding German "Expressionist" Berlin artists Ernst Kirchner (1880–1938) [#116] and Max Beckmann (1888–1950): Barlach's *Rest on the Flight to Egypt* [#117] is strong but gentle, and portrays with wood carving finesse tired rest experiencing a protective love, but not at all idealized.

Barlach's charcoal drawings can catch in a few deft strokes two young women absorbed in fingering cloth material—"Is it worth the price?"—or show a couple of frightened girls who are **normal**! And a woodcut to illustrate his drama [#118] of a quarreling couple with a baby in the driving rain is for me a gem of artistic service fully worth its salt: the cut does not have the careful stable glorious world of Vermeer [*NA* #56] or the embarrassing riches of Rembrandt's group portraits [*NA* #5], but Barlach's roughhewn insight and compassionate eye for the plight of indigent people—this is Germany soon after so-called "World War I" in

[#115] Ernst Barlach, *Mother and Child*, 1935

[#116] Ernst Kirchner, *Tanzschule*, 1914

[#117] Ernst Barlach, *Rest on
the Flight to Egypt*, 1924

[#118] Ernst Barlach, *Haderndes Paar im Regen*, 1921

[#119] Ernst Barlach, *Singing Man*, 1928

Europe—is a real act of love helping us to see ourselves as the obstreperous creatures we are. And whether it be a bronze *Singing Man* [#119] or a walnut *Laughing Crone* (1936), Barlach is in touch with folk who run the gamut of human experiences, which he as artist treats professionally with sure skill, disarming respect, and keen joy.

Much of Barlach's life was lived in the country village of Güstrow, and from 1910 until Paul Cassirer's death in 1929, Cassirer gave Barlach generous dealer advances on whatever work Barlach did; so Barlach could afford to do in solitude whatever he wished in his drawings, sculptures, and the theatre pieces he wrote.

In 1929 Barlach received a commission to do a memorial for the cathedral in Magdeburg [#120]. The artwork is more than 2.5 meters high, 1.5 meters wide, and .75 meter thick—a formidable tribute in hard oak wood to the stunning, stupid, silencing death and misery war brings. The tall figure blankly holds the cross for the graves of 1914, 1915, 1916, 1917, 1918 war without end, while the flanking standing soldiers tight-lipped obediently watch what goes on. Down below are victims of the terrible, unexplainable killing, next to a bony helmeted Death figure: the man with gas mask strapped to his chest, eyes closed at the unspeakable horrors witnessed, holds his head in utter despair; the woman with clenched fists has her face shrouded in pain and mournful sorrow. War as waged by men is a cursed, malevolent humanity.

This is a way artists could encapsulate their imaginative gift into a church setting with terrible poignance, like the grave stones you thoughtfully walk over in old church aisles, instead of giving us parishioners sweet Madonnas or endearing Pre-Raphaelitic kitsch. This is a "war memorial" (long before the Viet Nam Memorial in Washington, D.C.) that solemnly tells about the necessary bitter failure of war. Sympathizers of Hitler had it removed from the cathedral in 1934.

Käthe Kollwitz (1867–1945) as a woman was denied student entrance to official Art Academies; so her parents had to get her private training. Her father was a Social Democrat by political conviction, and for a time had assumed leadership in the first Free Religious Congregation in Germany founded outside the state church by her maternal grandfather Rupp.

Käthe Kollwitz lived her life among the urban poor [#121] whom her husband, a medical doctor, served in a Berlin slum. Her early incredibly sensitive drawings [#122] and etched prints documenting a poor mother with her dead child [*NA* #42] have an uncanny way of catching the vulnerability of the young and of expressing the enormity of the

[#120] Ernst Barlach, *Memorial*, 1929

[#121] Käthe Kollwitz, *Municipal Shelter*, 1926

motherly anguish felt when the fruit of one's womb is needlessly taken by death—the taut solitary clump of naked flesh catches the monumentality of the sorrow that shall never hardly be assuaged. No wonder she became the first woman professor at the Berlin Prussian Academy of Art in 1919.

Because Kollwitz exposed the underside of society—the oppression of the workers in *Weaver's March* #4, 1897, how the poor were treated like animals [#123], and when they revolted were made prisoners [#124] or raped [#125]—her truthful art was not popular in the mainline art circuit where critics could isolate her artwork and dismiss it as "Social-ist." The fact that one of her sons was killed in the war Barlach's memo-rial commemorated helped her become a confirmed pacifist. So, next to occasional happy drawings [#126] there were exposés, like *Volunteers* (1920), of the giddy chauvinism and drum fanfare that enticed young boys to go to war, to be killed.

But this art with a family focus and an anti-militarist message is superb artistry imbued with an integrated vision that does not preach, but by its very subtle indirection brings a sad wisdom to those who have eyes to see. Hitler's repressive power forced her to resign her professorship at the Berlin Academy in 1933, and articles about her art were banned until 1944. Her bronze relief lamenting Barlach's death in 1938 and the terracotta piece entitled *Resting in the Peace of His Hands* [#127] indicate artistically the biblical compassion for others and the trusting security Kollwitz herself knew surrounded her as she clutched on firmly to the cloak of the Lord who embraced her buffeted life.

Barlach had a wealthy friend-business patron and Käthe Kollwitz had a spouse with a sustaining livelihood, and both Barlach and Kollwitz are exceptionally talented artists whose faith, if not quite orthodox, seems to take the sobering good news of Matthew 25:31–46 to heart, and finds the despised and the weak of the earth, the least in society, to be worthy of being fed and clothed with artistic esteem, celebrating the fact—be-lieve it or not!—that **God** loves the outcasts and those of low repute (Isaiah 61:1–4, Luke 4:16–22, 1 Corinthians 1:18–2:5, James 2:1–5). Barlach and Kollwitz themselves felt like outsiders: their church connec-tion was tenuous; the state was distant or opposed; scholarship was not interested; and they were not members of the noted Blaue Reiter, Die Brücke, or Bauhaus.

But after the Enlightenment Rococo rejection of Christian Hu-manist historical narrative art had been seconded, so to speak, by Im-pressionist painterly art, and since the domesticated Idealist, Biedermeier

[#122] Käthe Kollwitz, *Sleeping Child and Child's Head*, 1903

[#123] Käthe Kollwitz, no. 1, *Plowers* in *Peasants War*, 1906

[#124] Käthe Kollwitz, no. 7, *Prisoners* in *Peasants War,* 1908

[#125] Käthe Kollwitz, no. 2, *Raped* in *Peasants War,* 1907

[#126] Käthe Kollwitz, *Mother with Child*, 1931-32

[#127] Käthe Kollwitz, *Resting in the
Peace of His Hands*, 1935

mentality [#128] had snuffed itself out, there was a ferment among artists after Van Gogh and Gauguin to prospect for new directions. Both Barlach and Kollwitz chose not to go mythical or mystical, not to tell heroic stories and champion climactic moments, but to explore human life in its frailties, perplexities, and momentary joys with earnest woodcut humor, grit, and tenderness. Such art, whether the artist be "one of us" or not, is exorcizing vanity and violence, it seems to me, and thereby is fulfilling the law of Christ (Galatians 5:22–6:2). Both Barlach and Kollwitz had counted the costs of remaining true to their convictions; though it kept them somewhat isolated from the ruling art circles, their artwork is a great gift for our generation.

Before I close with a few examples of how current biblically salted art is faring, let me briefly interject two quite different matters, although both items relate to the challenge of being salted artists in a tasteless, unsavory cultural world: Bertolt Brecht, and Icons.

Comment on the Invitation of Brecht and Icons

Brecht's alternative theatre deserves christian attention, I think, because his in-depth approach to avoid the staid living room proscenium, his questioning the Stanislavski method of an actor's becoming the character, and Brecht's challenge to allow a consumptive audience leave the theatre and go-home-with-a-good-feeling-of-a-happy-ending is an attempt to exorcize complacency from "art lovers." Brecht was enabled to do what he did because, beside his being a very gifted playwright, there was a *Berliner Ensemble*, a **group** of professional artists congealed around a Marxist vision of art as a hammer, sustained by state money, living out of a tradition to produce vigorous worker-friendly art in the public face.

Such features of a committed artistic vision, institutional support, and a community of gifted artists in it for the long haul, are matters crucial for christian artists to consider if they wish to become artistic salt of the earth, even though unlike Brechtian aesthetics, Christians understand art to be not a weapon but an offering of fresh olive leaves, signs of hope.

Since the Second Ecumenical Council of Nicea (787 AD), the Eastern (Greek and Russian) Orthodox Churches have adopted icons [#129] as consecrated, venerated images to act as a window to beckon believers directly into the very presence of Christ, the veritable image of God (Colossians 1:15–20, 2 Corinthians 4:1–6). This is not my faith tradition, so

[#128] Holman Hunt,
Awakening Conscience, 1853

[#129] Anonymous,
Virgin and Child, c. 1190 AD

I have much to learn here. I mention it because many evangelical Christians from image-starved confessional church traditions are gravitating to liturgical art and icons in a big way today.

Some make new the early [#130] prototypical church Maria and Christ child icons. Others originate striking reinventions of a crucifix like Prescott's *Harrowed Cross* [#131] with a torturing arc of fire as crown of thorns. Still others move the icon into an art gallery [#132] with the title "*I Have a Hand Grenade Sitting in My Chest*," where Christ's face and eyes are almost obscured by vignettes of Bosnian war victims.

My comments for discussion would be these: churchly art—I would include music—certainly deserves serious attention as *ancilla cultus* (an auxiliary to devotional response) but would tend to go astray, as I grasp it, if it seeks itself to mediate our meeting the God who speaks especially in the **Word** proclaimed. Also, given our post-christian day, the Church must beware of sporting ceremonial riches in its worship services that appear to be untouched by the destitution impinging on its churchly mission worldwide. The christian community at large must not support its employment of artists for liturgical art and ritual as if that task especially

[#130] Tatiana Romanova-Grant, *Holy Virgin*

[#131] Ted Prescott, *Harrowed Cross*, 1988

[#132] Tom Xenakis, *I Have a Hand Grenade Sitting in My Chest*, 1995

or by itself fulfills the vocation of artistry in God's world or is the canon for art worth its salt. That was a mistake, I think, of the Council of Trent: overwhelm the lowly faithful with the glory and power of our holding the keys to life and death.

I personally think the temptation for Christians to churchianity in the arts is as seductive as the temptation to christian anonymity in the artworld.

Alternative of the Saltlick

The lay of the land I know in North America today is quietly hostile and precarious for the salt of the earth, since the principalities arrayed against God's peoplehood shimmer like angels of light (see 2 Corinthians 11:12–15), also in the realm of art: the standard of living in the USA is sacrosanct; a creed of individual rights and lip-democracy has ideological status; corporate determination of economic production and distribution of goods is practically exhaustive; and the current dominating political policy, which seems to induce militaristic fear of terror in the population, is deeply self-destructive, in my judgment. So a man or woman either joins the crowd to make one's way, or has to improvise for survival, **since benevolent SUCCESS, which covers a multitude of sins in the Pragmatist framework, is the North star, in my judgment, largely guiding Western culture.**

For artists who want to make it in the big bad artworld, New York City still attracts would-be artists the way a lighted lamp attracts moths. If you stay regional as artist you need an agent, manager, or a gallery that will carry your work on consignment, with a hefty mark-up, and usually with a tip on what kind of work sells. And today the professional secular artworld is a wild place.

Since rock and pop art and revolutionary Joseph Beuys of the '60s mutated into gangsta rap, performance art, and the "Anything! goes"-for-outlandish-shock-value, the conception of artistry has exploded to smithereens. The most bizarre, farfetched, cruel, gross inside jokes and trivial artifacts clutter, in a highly mannered way, the art scene, often debasing viewers into voyeurs, or putting the onus on the spectator to provide imaginative meaning for the artist's gesture.

While the current indiscriminate (fashionably named "post-modern") anarchic fragmentation has been welcomed because it has pluralized a perceived Rationalistic representational artform into a smorgasbord of imaginative possibilities, I am afraid it does not really help christian artists get their redemptive voice heard in the popular media, because "chris-

tian art" by definition will **not** be sensational.

Two generations ago William Butler Yeats (1919) described well our mainline artistic milieu today:

> Things fall apart; the centre cannot hold. . . .
> The best lack all conviction, while the worst
> Are full of passionate intensity. ["The Second Coming"]

Christians who make art, I think, should not overload their imaginative fare with salt and make it brackish! As Christ said, "Not everybody who says (and shows) 'Lord! Lord!' shall enter the kingdom of heaven" (Matthew 7:21–23). Christ's metaphor of salt is precise, like his metaphor of leaven (Matthew 13:33; cf. 1 Corinthians 5:6–8). Too much yeast too long makes dough sour; excessive salt makes food inedible. Salt like leaven is best when it permeates the bread unnoticed but brings out the flavor of the grains. So **artistry by the salt of the earth, when it is right, will be artwork that presents nuanced sorrow or joy with the imaginative relish of an understanding buoyed by hope.**

A young Anglican priest whose charge is the Toronto Islands spent a good year crafting a response to the event of 11 September 2001 in New York, a date not when the world changed but a date when the U.S. joined the world. David Opheim's 2002 art exhibit was entitled *Dum Spiro Spero* (While I breathe, I hope).

Celestial Embrace [#133] has a figure of shattered glass pieces standing precariously on tiptoe to put arms around the two rainbow-colored fabric towers in which many of his colleagues died, as night falls. Survivors of nightmare happenings like war sometimes need to curl up in a deep pit to wait to be reborn; you tuck yourself tightly together to engender the energy needed to stammer out the "ABBA!" of *de profundis* Psalm 130. But soon, all too soon, one is manfully [#134] rebuilding the destroyed edifice, picking up the pieces, standing on one another's shoulders—a team effort—to put things back in place at Ground zero. Others angrily [#135] point their red machine guns at one another, nail themselves to their retaliation . . . for God's sake. Could we not instead [#136] offer up our coat and next generation of children as peace offerings to the Lord under the sun, God's faithful daily servant?

Opheim's artistry weeps with those who are weeping and thereby has healing power, and surprises those who feel blameless with the insightful caution to overcome evil by doing good (Romans 12:12–21). The message is cast in a playful symbolic imagery so that the ineluctable, complex meaning of it all is more imaginatively compelling and thought-provoking—well-salted artistry.

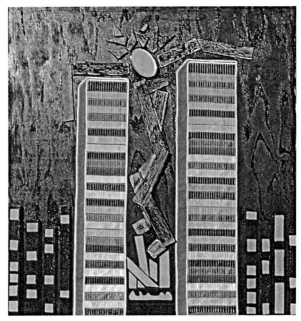

[#133] David Opheim, *Dum Spiro Spero, Celestial Embrace,* 2002

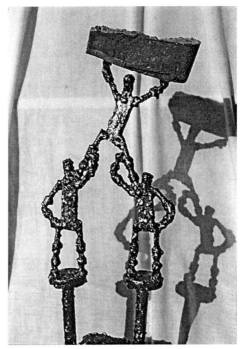

[#134] David Opheim, *Dum Spiro Spero, Dangerous Irony,* 2002

[#135] David Opheim, *Dum Spiro Spero, For God's Sake*, 2002

[#136] David Opheim, *Dum Spiro Spero, Offering*, 2002

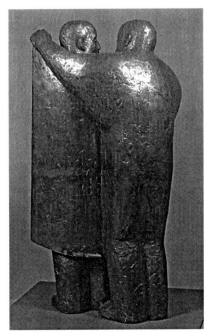

[#137] Britt Wikström, *Caritas*, 2006

Dutch sculptor Britt Wikström's installation of five poles and figures for an Amnesty International artist invitational entitled *Cathedral of Suffering* (1994) also enters painfully into the evil we hide our faces from [#6].

Wikström's recent *Caritas* [#137], commissioned by a Chicago hospital, enters deeply into the world of caring for the sick with respect. Illness exposes a person's most intimate secrets to anyone who helps. Giving and receiving the mute touch of love in sickness often turns the tables around, as the body language in the firm gentle lines of this bronze sculpture shows: the older one who questioning, patiently clothes the weaker younger one is himself **given** a slow look of wondering gratitude. Compassion is truly mutual, and artistry that can quietly make that wisdom tactilely available is truly worth its salt.

Both Opheim and Wikström's artistry has biblical salt, in my judgment, because its choice allusive quality has the grit of a full-orbed creational vision of the reach of God's grace, right down to a non-retaliatory response to terror and helping an infirm person put on a coat. Young Opheim and Wikström artwork is biblically salted not because it is influential, or makes an overt evangelistic pitch, but because their **artistic deeds are**

faithful to the Lord's calling to lead by serving up good tasty bread for the neighbor instead of stones (cf. Matthew 7:7–12). And they do not get caught in the false dilemma of either do Church liturgical art to be christian or park your christian faith at the door of the secular brand-name art gallery. Like Barlach—plaster cast for a wood *Freezing Woman* sculpture (1937) or a charcoal drawing of *Seated Lovers* (1922)—and Kollwitz' lithographs—*Thinking Woman* (1920) or *Seed which shall bear fruit must not be ground* (1941/1942)—Opheim and Wikström simply throw their art bread seasoned with love for the neighbor out upon the waters in the wide world of God and expect blessing (Ecclesiastes 11:1–6).

Opheim and Wikström's infra-structural support of a faith-community is very small, braced with a few patrons who see the mission of art as also bread for the world. Needed are more NGOs and NCOs (non-church organizations) of Christ-following art-enablers with the gifts to be managers, "promoters," critics in the media, buyers, liaison-persons who can link artists with the various institutions in society, so an artist does not have to be the pariah of a free-lance individualist. Only with an active enabling support **group** that goes beyond "fellowship" into **foundational** type organization will it be possible, I think, in our society for God's people to help artists function as a credible artworld with its own alternative, holy spirited, defining character.

Years ago *Patmos* was a little ten-year effort of such a sort (1969–1979); currently *Imago* in Toronto is getting on its feet. There are similar undertakings in many places, in a training, academic way at different christian college art departments too. A crux to such endeavors is to avoid the mentality of the churched ghetto or the melt-into-the-bigtime syndrome, and jealously to keep one's salt identity as professional artisans of neighbor-loving imaginative service at large, expecting God's surprise blessing.

Anselm Kiefer's art breathes an Existentialistic Norse mythical worldview, but his painting called *Lot's Wife* [#138] is a powerful warning issued in our chaotic bombed Sodom and Gomorrah mess Western civilization has made and is making of God's world, where Lot's wife hovers like a raw skin burn over the desolate train tracks going nowhere through the rubble: christian artists who turn around wistfully to return to the good old days of Beauty, Vanity, and Fame could become useless pillars of salt, like Lot's wife, lonely souvenir of a lost cause.

Instead, hints Ted Prescott from Messiah College, Pennsylvania [#139], think of a saltlick cross spliced with sharp steel for your salt metaphor. Prescott probably intends this artwork for a church setting; but for

me it is a wonderful symbol of the communality of Christ's body as artists, as educators (at Bethel, Northwestern, Dordt), as laborers, as Christ's disciples in a cultural neighborhood: imagine us people being a cross of a saltlick, Christ's one body **outside** the church door, God's peoplehood in the political, commercial, **and artistic world**, a saltlick that leads by serving—the winsome Melchizedekian royal priesthood with nothing to lose but our self-importance, becoming a vulnerable, veritable salt offering to the LORD which attracts all kinds of neighbors.

[#138] Anselm Kiefer, *Lot's Wife*, 1989

[#139] Ted Prescott, cows licking, 1991

CITIES AS A PLACE FOR PUBLIC ARTWORK:
A GLOCAL APPROACH

A city is not an artwork, I dare say, but is a meeting place of people, an organized dated/located social complexity where artistry does have an integral role to play—that is my thesis. And no city, I believe, worth its salt today in our technocratically geared culture can ignore the fact that local city inhabitants carry on their lives in a Good Samaritan proximity with happenings around the globe. So, to introduce the theme that cities are a place for public artwork—and what that means—I propose, in adumbrated fashion, a **glocal** (a global-local, bifocal graduated consciousness) focus for understanding city life and artwork good for a city.

First a few orienting thoughts about **city**: the importance of "place" for human life, and a thumbnail reference to the history of cities. Then I shall try to make clear the meaning of **glocal** as a christian conception for approaching daily life and cities in a normative historical way amid GlobalIZATION. Finally this chapter will deal with the problems and blessings open to **glocal** (=neighbor-minded) **city public art**.

Place, and city

Every creature always is somewhere. Placement is as fundamental to creaturehood as being inescapably dated. Place is not the same as "space." I take "space" (*espace, Raum*) to be an abstract quantitative amount of extension. "Spaces" are the measurable distance between markers, or "space" is the indefinite, practically measureless expanse of the heavens above us earthlings. A "place," you could say, is "concrete space," a location (*Ort, lieu*), a locale, a geographic site one can inhabit. Place has an entitary identity beyond its longitudinal-latitudinal coordinates.[1]

1 K.J. Popma examines how it is possible to conceive of the simultaneity of spatial reality as an aspect of creatural temporality, in *Inleiding in de Wijsbegeerte*, 3rd edition (Kampen: H. Snijder, 1951), 62–65; "Succcssie en Gelijktijdigheid", in *Philosophia Reformata* 19:1 (1954): 1–31. His analysis prompts me to understand spatiality as a modal

Originally published in *Globalization and the Gospel: Exploring the religious roots of a globalized world*, eds. Michael W. Goheen and Erin Granville (Vancouver, BC: Regent Press, 2009), 53-80.

You have a birthplace, which usually stamps the paper of your subsequent pilgrimage with its watermark. If you have ever belonged some place—grew up there, lived there so many years—that spot of earth or territory where you put down roots, served as a home base where you now come from. If a person has little or no sense of coming from somewhere, or of going some place, that fellow could be lost. Being no place in particular can get you down after a while, as if you **be** *en passant*—the struggle of many an immigrant family and certainly the plight of dislocated refugees.

The wandering Jews of Older Testament renown, after exiting from Egypt, were at least traveling to a "promised land," because the LORD God of the biblical psalms promised to be the true believers' "at-home" (ma'on to מָעוֹן, *Zuflucht*, safe refuge, Psalm 90:1). Lapsed Catholic Heidegger struggled philosophically with the incontrovertible "there-ness" (*da-sein*) of humans, and the human dilemma of **dwelling** unsettledly as a heavenward earthbound intermediary creature under an unknowable Divinity **building** things though we be mortal.[2] Crusty New England American poet Robert Frost was less agonized about our earthy placement, since "One could do worse than be a swinger of birches." But Frost knew too the sad displacement of the vagabond hireling: "Home is the place where when you have to go there, / They have to take you in." Even "the homeless" in Toronto and other metropolitan cities, who walk the daytime streets carrying sodden blankets and plastic bags on their backs like the portable houses of snails, do pitch their nighttime digs, take up their *pied à terre* under sheltering bridges around empty metal drums burning refuse for the centering warmth of a hearth.

A sheltering place where you are inside rather than outside, to be able to rest somewhere—"Gimmie shelter!"—**is an existential requisite of being human.** A person needs a place, a habitat for one's humanity to stay intact rather than unravel.

This ontic reality of **place** is the phenomenological grounding for my homespun understanding of **city.** My provisional working definition of city is this: a **city is an inhabited sheltering place of great population density whose fractal unity provides the clearing for an immense interdependent diversity of cultures, languages, commercial activities, beliefs and commitments strange to one another to become**

aspect of creatures, and "place" as an entitary spatial reality (like a point, a location).

2 Heidegger, "Bauen Wohnen Denken" (1951), and "…dichterisch wohnet der Mensch" (1951) in *Vorträge und Aufsätze* (Pfullingen: Günther Neske, 1954), 145–162, 187–204.

functionally structured toward societal exercise of our native human neighborhoodedness. A city is best grasped, is my thought, as a God-given institutional opening variously humanly embodied **somewhere** to highlight good, full-bodied neighborly sociality.

Naturally all kinds of activities go on in the settlement of a city, because we corporeal humans are constituted to act in a variety of ways: buying and selling takes place in a city; municipal governance and policing of sorts is necessary; families are raised, children are schooled, newspapers, libraries, sports fields, hospitals and cemeteries are operational. But a city is not first of all a business. A city is not primarily a political state or nation. A city is not a collection of families, partners, and singles. A city has a commercial side to it, an important political factor in its make-up, three or four generations of families, and has synagogues, mosques, and churches in its environs: but a city is a city is a city whose streets, houses, stores, offices and buildings holding people are **integrated by its common civic task of socializing neighbors and strangers coming and going facilitated by its geographic placement.**

Much more needs to be said to fill out this skeletal philosophical suggestion on the primal socializing nature of city. Different cities at different times have different characters in constituting and caring for its civil cohesion. Ancient cities, before Christ walked the earth, like Nineveh, Babylon and Alexandria, as walled citadels with ziggurats, germinated agricultural hinterlands around their city limits, furthering markets and becoming trade centers; record keeping and writing fostered city archives and libraries. When the republican city of Rome went imperial during the Caesars (c. 50 BC–100 AD), Roman citizenry had more clout than MasterCard (see Acts 16:35–40, 22:22–24): war, booty, the baths, *vomitoria*, dozens of holidays per year for the spectacles of chariot horse racing in the Circus Maximus (seating more than 100,000), and gladitorial "games" showed the brutal, cruel underbelly of Roman "justice" for the few in the city.

When Benedict of Nursia (c. 480–c. 543 AD) founded a monastic order, its cloisters showed a truly "anti-city" position since Benedictines were dedicated to relinquish property, prestige, and power for a community of prayer, Scripture study, and manual labor. But the regular Church itself, which assumed temporal as well as eternal authority over human lives, in concert with the feudal setup of noble lords and serfs, developed episcopal cities whose informal layout of streets for foot walkers followed irregular topography and whose city landscape was usually dominated by a towering cathedral. As guilds of artisans grouped in privileged trade

"quarters"—neighborhoods, you could say—comparable to the parishes of the ruling bishop's subalterns, Paris (and Cairo!) began universities (Paris, 1150 AD, Al Gazel in Cairo, 988 AD), which kept cultural storage firmly in the hands of clerics (and imams). But after the discovery of gun powder and cannon balls altered city fortifications and layouts in Europe and Asia, a mercantilist regime of oligarchic despots gradually formed in nation-state cities like Venice (and even Amsterdam), where moneyed capital, banking, bureaucratic licensing, and commercial taxation came to be a more valuable societal control than owning (medieval) real estate.

As Western cities became Capitalist strongholds laid out on a straightforward grid, private gain trumped public care for the poor, and London, Manchester, New York, Pittsburgh, and Bethlehem, Pennsylvania! split the city populace into sybaritic patrician estates and over-crowded slum ghettoes on the other side of the railroad tracks choked by factory pollution. The Romantic Idealism that impelled middleclass denizens to go reside in suburbs, trying to reinstate rural features into urban living, has foundered on the unreality of believing that the drive for survival and success at the expense of one's neighbors can insure lively well-being.[3] The boring conformity of hedonistic materialism is a blight on both suburb and many a post-industrial city today because corporate franchises, cybernetic fluidity of capital, and high-speed techno-communication tend to get people to tread habitat water and not feel at home anywhere in particular—every man and woman and our belongings seem to be in flight, and the city of endless desires is virtually consumptive.

Global and GlobalIZATION

The Christian faith charters a global outlook and action because the Bible says God created the whole world. And non-human creatures on earth and in "space" like the sun, winds, mountains, water, trees, and animals are not just a brute "environment" for humans to master and waste, but are actually God's theatre of operation,[4] in which we humans, who make our historical entrances and exits every 80 years or so, are to be caretakers (Psalm 104, Genesis 1:1–2:3). Humans who disbelieve that the Jew Jesus Christ was the Son of God in history—humans of all faiths, and even those who profess a no-faith—are still in charge of caring for and cultivating the whole world, and have often been more proactive than

3 "In the suburb . . . home domesticity could flourish, forgetful of the exploitation on which so much of it was based." Lewis Mumford, *The City in History: Its origins, its transformations, and its prospects* (New York: Harcourt, Brace and World, 1961), 494.

4 *Theatrum Dei* is a phrase prompted by John Calvin, *Institutio Christianae Religionis*, I.VI.2.

narrow-minded followers of the Christ.

The Newer Testament teaches clearly that once you accept the cosmic reach of God's injunction to us humans to institute the Lord's shalom of fruition and reconciliation everywhere,[5] then every child in need anywhere becomes my neighbor (Luke 10:25-37). And any place within reach is an opening for us humans to be wise to share in making it a winsome spot, safe to inhabit, with a spirit of peace.[6] No human should think he or she has to save the world—that's God's affair. But the biblical perspective, I believe, is markedly global: it is our inescapable human vocation to be responsible for building **wherever** we are, with whatever gifts have been entrusted to us, build concrete places and relationships to the uttermost ends of the earth that embody God's deep compassion for doing justice for God's creatures (John 3:17, 1 John 3:11–24).

"GlobalIZATION," however, is global on a power trip: you locally are not in control of your locality anymore because something GLOBAL has already decided the matter.[7] For example:

–Expect your severance pay package as die maker in 90 days, since General Motors is closing its auto parts plant in Oshawa or Windsor, Ontario, and building a new one in Mexico.

–You have lived all your life in Seattle? Get ready to move to Chicago since Boeing Corporation, enticed by a $60 million public money subsidy, is moving its corporate headquarters there (2001).

–There is **nothing** you can do as Japanese and German government representatives sitting on the World Bank council to stop Wolfowitz from being appointed president (2006).

–In 1997 Thailand, Indonesia, and South Korea faced bankruptcy as countries because of powerful currency speculators following the ideological policy of capital market "liberalization." When the International Monetary Fund bailed out the G7 dollar banks who held the bad debt, the IMF blamed the East Asian countries and crippled them with high interest rates, penalty taxes, and dictated trade terms that stifled those countries from being able to make any local economic policies as "sovereign" nations.

5 See βασιλείας τοῦ θεοῦ in Acts 1:1–8, and διακονίαν τῆς καταλλαγῆς in 2 Corinthians 5:16–21.

6 See Psalm 34:11–14, Matthew 5:9, Romans 12:9–21, James 3:13–28.

7 "Like Chicago, suburban towns are affected by globalization, immigration, and economic restructuring—converging forces that are largely beyond local control." Kenneth Fidel, "The Emergent Suburban Landscape," in John P. Koval, Larry Bennett, Michael I.J. Bennett, Fassil Nemisse, Roberta Garner, Kiljoong Kim, eds., *The New Chicago: A social and cultural analysis* (Philadelphia: Temple University Press, 2006), 77.

"GlobalIZATION" emphasizes the fairly recent intensification of worldwide interconnectedness of good and evil deeds because of the incredibly fast transportation now available, lightning-like telecommunication, increasing interdependence of production and consumption of food and goods, the massive migration of exploding populations and climate-changing pollution, and a nervous concern in powerful circles about the proliferation into very different hands of weapons of **mass** destruction. But there is more to it than the time-and-place compression that **forces us humans in the whole wide world to act as if we exist in a global high-rise.**[8]

The hidden "more" to our being "globalized" is that a deadly drive to be the fittest to survive seems to be the overpowering dynamic inside the Capitalistic economic order that dominates world cultures. Laissez-faire, Darwinian **un**economical wheeling-and-dealing—call it "Neo-Liberal," if you will, or "Casino Capital**ism**"[9]—has assumed the kind of covert almighty power in the world—no one person personifies it—it is **systemic** almighty power like what the Bible calls invisible "principalities, powers, and dominions."[10] Amnesty International and *Médecins sans frontières* will show up in person at any country open to receiving their services, but a truly "global" organization is more than inter-national and has a curious impersonal anonymity. The World Bank, IMF, and World Trade Organization are supra/trans-national bodies more like the internet, which is not so much here or there as nowhere in particular but can touch down everywhere there is a Bill Gates terminal. These organizations wield precisely the kind of inscrutable distanced covert centralization of pre-emptive decisive Power Saint Augustine feared would happen if the *civitates terrenae*, instead of fighting among themselves, would consolidate against the *civitas Dei*, the community of people rooted in God-obedient service.[11]

I am not suggesting a "conspiracy theory" for exposing Global**ism**, the Globalization affecting our cities. The fact that every one of my sold-

8 "Global village" is a wistful, dated metaphor, I think; in a "global high-rise" we exist urbanly on top of one another, also time-wise in each other's hair, compelled to respond, or be unresponsive, to the deeds of virtual strangers in one's face (like "junk" mail on your "personal" computer).

9 The way "financial managers" deal with the virtuality of "volatile global capital" (as described in Bob Goudzwaard, Mark Vander Vennen, David Van Heemst, *Hope in Troubled Times: A new vision for confronting global crises* [Grand Rapids: Baker Books, 2007], 140–141), seems much like players gambling at a casino baccarat table.

10 ἀρχάι, ἐξουσίαι, κοσμοκράτορες, (cf. Ephesians 6:12, Colossians 1:15–16).

11 This thought is hinted at in *De civitate dei*, XIV.28 and XV.4.

in-Canada Dell computer parts is marked made-in-China, and that the
software specialist walking me in Toronto through the steps to install my
high-speed upgrade is talking accented English on the phone from India,
is not the result of a malicious mafia conspiring to kill local manufac-
turing and servicing jobs. It is just that outsourcing is in the grip of an
all-embracing policy glut to maximize profits with cheaper labor. "Time
means money; place is unimportant": so goes the unfettered Capitalist
creed. The (American) Idol of competitive moneyed **Success**, as if wealth
and possessions bring happiness, runs roughshod over any other consid-
eration—let the devil take the hindmost!

Think of it like a drug, alcohol, or gambling addiction—how can
an individual alone overcome its hold on you? If our ruling corporate
culture respectfully serves an undercover Idol of Greed—always More!—
no wonder the few rich get richer and the many poor poorer, and the
gap between them increases globally, inexorably. The USA did not join
the international Kyoto Protocol (1997/2005) on combatting climate
change, which is becoming menacing, it was said, because the measures
required would affect adversely the unrivaled American standard of liv-
ing. To live in subjection to the no-god of "We First **Über Alles!**" is to be
blinded to the presence of neighbors, a deeply unbiblical, dehumanizing
pou sto (position, the place-where-you-finally-stand) that cannot help but
be resented albeit envied by the weaker peoples of the world. But the fact
that the hidden bankrupt status of the United States of America has be-
come exposed in the September/October 2008 global financial collapse
shows that GlobalIZATION induces the vanity (=a bubble of stinking
hot air) of pseudo-reliability. Money is no longer a token of exchange for
resourceful goods, but has become an idolized commodity itself, a false
no-god, sinking sand on which to build your earthly city.

However, instead of thinking GlobalIZATION is inevitable, and
our acquiescing in its wresting responsibility away from local authorities
for shaping one's city, and instead of promoting the idea that Chicago or
Toronto wants to become a globalized actor too with the Big City Boys,
even at the "Second City" level, I propose for consideration the alternate
tack of thinking and acting **glocally**. Even if "GlobalIZATION," which
is an utterly complex historical phenomenon, a human construction, has
assumed the juggernaut dimensions of a principality, I believe it can be
exorcized from our culture, God willing, so that a redemptive dynamic
can bestir a city and remake it indeed step by step historically "new."

A Glocal corrective to the power of GlobalIZATION
By "glocal" I mean a committed world-and-life vision that is "globally" (=cosmic historically) aware but acts *first-of-all* locally from the place you call home. The conception of "glocal" as a norm for reflecting, willing, and doing is as biblically simple as the imperative "Love God above all, and love your neighbor as you respect yourself."[12] Awareness that the Creator God has posited worldwide ordinances for all humans to follow (such as, practice justice, thrifty generosity, undeceptive speech, faithful partnering, reliable commitments, efficient instruments) and that Christ-follower you as well as your agnostic believing neighbor *both* can default historically in discovering and doing God's cosmic will for creaturely daily life should keep neighbor love and self-respect in tandem.

The biblical vision of an interconnected world of places with a peaceable kingdom of fauna, animals, and humans is sharply different from the skewed Darwinian vision of constant struggle of "bared tooth and bloody claw" where winner takes all as a matter of fact. But the biblical vision is not projecting an Idealistic Utopia, because Christians know about that dirty three-letter word people usually only use to describe others—"sin." Sin is not just a private matter, but a public global reality in a christian reading of the world. That's again where "glocal" comes in, humbling one's efforts: the biblical Scriptures enjoin humans to bear fruit in God's world beginning in your own locality—one needs to put your own house in order first before you offer to correct others— branching out as you through faithful seasoning receive broader openings and tougher assignments (Matthew 25:14–30, vv. 20–23). It is a biblical christian mission to redeem whatever is placed in your path and to show particularly a repentant saintly hospitality to strangers; that is, to be cosmopolitanly open and receptive, even vulnerable to what is not your particular cup of tea, and to let your service be educated, modified, and embraced by whatever worthwhile from a foreign neighbor comes to invigorate your Way.

It is critical for a glocal approach to act historically, not like revolutionaries who assume they can start with a clean slate to make something "new," and also not pragmatistically. A pragmatist has goals, and will use practically any means that work to achieve the goals: the end justifies the means. A christian approach, I think, affirms a norm for getting things changed that one steadily follows even if the goal is modified during the process and even if the attempt fails. I would formulate **the principle for those who wish to implement a glocal approach with historical sanity**

12 See Deuteronomy 6:4–9, Leviticus 19:18, Matthew 22:34–40, Romans 13:8–10.

as follows: (1) **regenerate**, (2) **speciate**, and (3) **diaconate the state of affairs you face in your generation**.[13]

(1) To **regenerate** the economic service the IMF and World Bank were originally intended to perform, that is, to **re-attach its provision of capital to local needs**, money policy should focus on creating jobs, improving vocational training, and land reform rather than aim at profits for financiers to take out of the country. That is, rich transnational organizations can best help a poor country by reining in the Profiteering dynamic and uneconomical economics of quick fix, by slowly building up the civic social domain of public institutions—its roads to local markets, literacy and health services, uncorrupted courts, labor unions, and fund the "unprofitable" time-consuming work, for example, to sequence a formerly Taoist community to understand let alone practice mutually respectful legal (property) rights, which is necessary for good commercial credit transactions. One **regenerates** an over-bearing Growth-economy import by trimming its sails to adjust to the local social fabric—you forge a **glocal** economics.

To **regenerate** a city milieu of 3 million inhabitants to the joy of different bustling neighborhoods, like the Danforth Greektown district of Toronto or the Asian international Devon Avenue community in Chicago, the municipal powers that be, who set budgetary priorities and zoning, should focus on **transforming public housing**; for example, as Larry Bennet proposes (*TNC*, 276), by incorporating poorer and ethnically diverse families into a neighborhood of affordable dwellings, both high-rise and town houses—that is not a market-based solution, which favors moneyed interests.[14] Chicago mayoral authorities need to listen to and help local community leaders upgrade their schools with imaginative "Blackboard Jungle" teachers—not turn them into military-style academies—and fund improving public transit to connect suburban regions with the downtown loop to regenerate pride in the place where one lives

13 My early exploration into the problem of understanding "tradition" and "normative historical change" ("Footprints in the Snow," *Philosophia Reformata* 56:1 [1991]: 1–34 {see *CE*: 235–276}) led to an attempt to reform Herman Dooyeweerd's three-fold conception of "historical development" as "differentiate, integrate, individualize." I first enunciated the formulation of "regenerate, speciate, diaconate" in the festchrift for Robert Knudson, *Westminster Theological Journal* 58:1 (1996): 41–61, 56–59 {see *CE*: 228–231}. Then I related the idea of "historical obedience" to the matter of "glocal culture" in my contribution to the volume honoring George Vandervelde: Michael W. Goheen & Margaret O'Gara, eds., *That the World May Believe: Essays on mission and unity* (Lanham: University Press of America, 2006), 45–66.

14 Larry Bennett, "Transforming Public Housing," in Koval et al., *The New Chicago*, 276.

and avoid the "gentrification" fix, which, as Charles Suchar says, commits "cultural genocide"[15] (*TNC*, 65 and 76), displaces the marginalized folk yet again, and composes a block of yuppie sameness that is deadening to city life. **To regenerate city life entails providing local rootage for the human activity that is integral to the setting of the whole large city complex of neighbors.**

(2) To **speciate** political responsibilities in the present uncertain climate of global quasi-supreme trans-national bodies like the United Nations (1945), International Court of Justice in the Hague (since 1946), the International [War Crimes] Court (begun July 2002), often bullied or unaccredited by the present faltering USA government, would be to have various legal nation-state authorities, regional alliances like NATO (1949) and APEC (1989), and NGOs like Amnesty International, act as a kind of confederated check to hold accountable in their own jurisdictions actions by the global organizations as warranted or not. The historical principle of speciating political responsibilities complements the policy of subsidiarity: the less inclusive organ to rule normally has priority for the decision-making judgment. (You don't use the Supreme Court to settle a minor neighborhood fracas.)

Trouble comes when there is a jurisdictional dispute or a quarrel on whether justice has been served. For example, a nation-state must protect its citizens against global powerhouses who exercise single issue concerns when the transnational organization manipulates interest rates and ruins a national economy. Nation-states should tax the unjust inflow and outflow of such transnational speculative capital. But Amnesty International rightly calls a nation-state to task when a legal government violates the rights of groups of individuals within its national borders; and the WTO Board (1994) correctly challenges those who talk free trade but make it unfair trade by setting up one-sided protectionist tariffs that undercut legal agreements. So sometimes the nation-state must regulate the unjust global organization, and sometimes the international body must challenge the nation-state's "legal" actions—"legal" is not always "moral"—as unjust. **The glocal norm of speciation rests with the clumsy normativity of confederated political regulative powers**, rejecting the Godfather Boss institution that overrides all other dispensers of justice throughout the world.

To **speciate** responsibilities of city life leaders could start by recognizing that **Money is not the only or the final horizon** looming above

15 Charles Suchar, "The Physical Transforming of Metropolitan Chicago: Chicago's central area," in Koval et al., *The New Chicago*, 65–76.

developmental decisions on city life. There must be at least wise political regulation of economic transactions: just-doing trumps profit-making. Historically sound movement toward a more normative city life gives specific dimensions of the city their relative interactive worth. Indeed, a police force needs to be converted from untrained blue-collar enforcement officers into salaried, educated professionals who are promoted on the basis of merit, not for being politically correct; but the media need to keep police honest by reporting critically on "community policing," keeping in public discussion the balancing of crime solving and crime prevention, since safe streets **everywhere** in the city is a priority. City leaders need to think "retail" as well as "wholesale," so to speak, but special business and labor union interests, political factions' aims, basic medical health concerns also for the poor, synagogue-church-mosque-temple needs, and other special projects all must be honored and adjudicated so that they **subserve the informal civic social institutional nature of the city**. As David Moburg put it, citing the "iron rule" of Alinsky's Industrial Areas Foundation: "Never do for others what they can do for themselves"[16] (*TNC*, 239), but the **social commonweal** must be the orienting horizon. **To speciate city life means to interrelate the specific, distinct decentered voices**—a city is not just buildings but is **the people** inhabiting the buildings[17]—**so they can each contribute their special gifts to a connected deepening of civil life**.[18]

(3) The **diaconate** step in the glocal mandate anchors how we humans may try to retrace our taking wrong turns and somehow undo cumulative misdeeds with a new start: **the christian world-and-life visionary mission diaconate move anchors opportunities to take up "global" matters in looking at them from the local starting point**. For example: wise proponents of human rights in an Inuit settlement or African tribal locality should tune such a basic question toward a communitarian rather than towards a democratic practice, because the communities in question live out of consensus rather than settle injustice by majority vote. Rather than introduce the animosity of litigation, "human

16 David Moberg, "Back to Its Roots: The Industrial Areas Foundation and United Power for Action and Justice" in Koval, et al., *The New Chicago*, 239.

17 "The city is not so much a mass of structures as a complex of interrelated and constantly interacting functions—not along a concentration of power, but a polarization of culture." (Mumford, *City in History*, 85).

18 I understand Ed Chamber's guideline that Morberg formulates—"Help the powerless in society organize to gain power to get what they *need*" [my emphasis] (Moberg, "Back to Its Roots", 240)—within this "social commonweal" orientation: city wide *need*, not special interest *wants* is the speciated criterion.

rights" would be melted into the rigors of reconciling victims and oppressors in the presence of the whole community. Or again: since the health of people is such a public matter, why should health services in a land be organized for private profit? Not-for-profit hospitals must cover their expenses, pay nurses and doctors good salaries, maintain the equipment and premises, but its patients are not to be treated like customers! The spirit in not-for-profit elderly rest homes is amazingly cheerful in distinction from the tight mercenary keep in many commercial ventures, because there has been a diaconate knowledge at work in the institution that does not treat health care as a business.

A corrective move on the world scene, suggested by Joseph E. Stiglitz' newest book, *Making Globalization Work* (2006), would be to give votes on key policy matters also to unpowerful, two-thirds world agriculturally struggling nations, so that decisions on reciprocal tariffs be taken, for example, by more than "free-floating" financial pluto-technocrats. Alternative proposals by NGOs for transparency, accountability, enforcement of conflict-of-interest protocols need to be given due weight so that "global" organizations tackle truly global problems like peace, HIV-AIDS and malaria epidemics, and environmental degradation, instead of fussing only with debits and credits.[19]

Diaconate work in the city would reclaim city streets for living. **A city street with sidewalks is a public people place**, and not merely a vehicular corridor or thruway. A neighborhood city street with sidewalks is for pedestrians and not just parked cars. A city street is lively when it is walked by different persons at different times for a variety of reasons—to go to the library, to buy milk, to walk the dog, to stroll and look at people, maybe even (miracle!) to walk to work or to visit a restaurant with friends. A well-used street is safe, because the residents, shop-keepers, and other walkers provide unofficial, casual surveillance over what goes on, like self-government. It is rather difficult to change the long avenues, wide boulevards, and monotonous gridiron layout of city streets once it is all in "place," but if instead of "slum clearance" there is an in-fill development opportunity to revamp a district, don't push the people out, says Jane Jacobs, but go for short blocks, cross-streets, keeping some old buildings—not just high profit new construction—mixed in, and situate family homes and elevator apartments for childless couples near work

19 Joseph E. Stiglitz, *Making Globalization Work* (New York: Norton, 2006), 281–285. How about an international convent, like the land mind treaty initiated by Canada's Lord Axworthy (1997), signed to place a heavy tax on all inter-nation military arms sales to be paid by the sellers and buyers to WHO or charitable foundations for salvaging women and children in war zones?

places, hide little parks and bikeways so they can be discovered.[20] **Diaconate action** in a city does not mean just dilute its cement with rural green spots, but **entails building up a rich diversity of districts whose places brim over with a kind of distinct cheerful hospitality.**[21] Greenwich village in New York City, Chinatown in Toronto, and Old Town in Chicago are vibrant sections of the city that invite strangers—"cities are, by definition, full of strangers"[22]— into their home territory, and so reach out to giveaway their special treasury of talents as part of the whole city. In my glocal judgment, even more than its architecture (which can be dictated by globalized fashion), a spirit of **placed hospitality** is the mark of a normative city.

If **"glocal" means a biblically christian outlook and approach to change matters of fact to be more in line with God's cosmic norm for a responsible human love of self and neighbor**, what does that entail for artistry in a city like Chicago and Toronto (cities where our family has lived—13 years in Chicago, 36 years in Toronto)? Be concrete. If I reject the GlobalIZED artworld of Mammon for setting standards and art policy—the renowned Getty Museum in California paying many, many millions of dollars for a single Van Gogh painting of *Irises* (1889), Sotheby's knocking down in the spring of 2008 a little old Tom Thompson landscape painting for 1.7 million, and if I think a tourist-centered city like Las Vegas is an abnormal virtual city—as Jean Baudrillard says in *Amérique* (1986), "Las Vegas is impossible! but there in the desert it is!"[23]—what in the world is God's will for human artistry? in a city? Could (how can) local city artists respect themselves and share their gifts with neighbors and help the city openly receive strangers as guests (=hospitality) so that the home art territory flourishes with its own city identity?

Chicago is not New York City or Florence or Frankfurt, but it is

20 Jane Jacobs, *The Death and Life of Great American Cities* (New York, Random House, 1961), 150–151, 175, 181, 187–192, 380–381, 393–396, 409–410, 416.

21 "Each ethnic group [around Devon Avenue] caters mainly to its own population but keeps its doors open to all" (Padma Rangaswamy, "Devon Avenue: A world market," in Koval, et al., *The New Chicago*, 225).

22 "Great cities are not like towns, only larger. They are not like suburbs, only denser. They differ from towns and suburbs in basic ways, and one of these is that cities are, by definition, full of strangers" (Jacobs, *Death and Life of Great American Cities*, 30).

23 *Amérique* (Paris: Grasset, 1986): "L'Amérique es un gigantesque hologramme. . ." 33 ; "Il est vain d'opposer *Death Valley* comme phénomène cultural abject. Car l'un est la face cachée de l'autre, et ils se répondent de part et d'autre du désert. Comme le comble de la prostitution et du spectacle au comble du secret et du silence" 67 ; "Les États-Unis, c'est l'utopie réalisée" 76.

midWestern America with the Old 1893 Columbian World Exposition behind it, then the Chicago Art Institute's (begun 1891) unusual exhibition of the 1913 New York Armory Show here, then the 1933 Century of Progress Exposition. Chicago is home base to the early skyscrapers along with the stinking stockyards and meatpacking plants Carl Sandburg's poetry made famous. . . .

And Toronto is not Montréal, Brussels, or Tokyo, but it is a former very British settlement in Central Canada that slowly became a city of annexed suburbs around the time of "The Great War" (1914–1918), where landmarks like Massey Hall with the Toronto Symphony and Mendelsohn Choir (1894), the Grange brick home bequeathed to be the kernel of the Art Gallery of Ontario (1910), and the Royal Ontario Museum filled with aboriginal and Asiatic treasures (1914) quietly continued their tasks next to Maple Leaf Gardens with its hockey (1931) and Toronto's Eatons and Simpsons shops renowned for their mail order catalogue business. Toronto gradually became a prosperous, good city of immigrant—Jewish, Italian, Portuguese, Chinese, and Caribbean peoples—multi-ethnic neighborhoods by the 1970s, home to Jane Jacobs and visionary Marshall McLuhan. Toronto city artistic life, one might say, seems today to be more events than repositories—active commercial art galleries, the Harbourfront Authors' reading series, New Music concerts, parades, and Caribana festival, while taking on the burden of being financial center, sprawling with one-tenth of the total population of the whole country. . . .

Glocal regeneration: bring fresh aesthetic air into the city
Underneath artistic practice is the resident imaginative trait of humans we call "aesthetic." All people by nature normally feel, speak, think, believe, and imagine things among the various ways one acts, even if they don't become therapeutic counselors, orators, scientists, evangelists, or artists by profession. It is this pre-artistic **aesthetic** feature of humans and God's world whose integral importance is sometimes overlooked in society.

To fool around, tell jokes, and play games is aesthetic activity: it takes imagination to make believe you have knights and bishops attacking the opponent's king in chess, and that certain squares in hop-scotch are taboo. To grow flowers in a garden or to swing on a rope in a tire is aesthetic activity that is good for nothing except day-dreamy wonderment at bodily movement in fresh air and loveliness. To blow bubbles is simply fun, and stirs a child or adult's imagination pleasantly. To watch

fountains, especially if illuminated at night, helps one while away time .
. . aesthetically. From a christian standpoint not all time means money:
aesthetic time spells leisure, and it is a gift God saw was good—"leisure"
is not the same as "luxury"—leisure like sleep is taking a deep breath in
daily **work** time. All kinds of time can be valuable and redemptive.

Parks are **aesthetic places** in a cityscape geared to encourage people
to take and give aesthetic time to one another: you sit on a park bench to
chew the fat, walk around arm in arm, throw Frisbees, or, in the city of
Geneva, Switzerland, you have a friendly game of chess [#140], that is,
congregate like those in an Italian city piazza to interact with newcomers

[#140] Outdoor chess game in the City of Geneva, Switzerland, 1989

and old acquaintances and exercise kibitzing neighborliness. This is why
if a park becomes unsafe gang turf, it is a deep wound in a city's life. A
park is by nature to be **public,** that is, **accessibly free to anybody will-
ing to accept the common good on offer**. "Public" is best if it is inter-
generational, inter-racial, for poor as well as rich, and handicap-friendly.

In contrast to a park, one needs to note that a mall is a privately
owned environs pretending to be park-like, a safe place for seniors to sit
around idly in-between coffees, but is totally geared to sell merchandize
and turn everybody on site into a consumer—"FOR SALE, from 30
to 50 percent off!" continually. There are fairytale bridges and an artifi-
cial lake with little harmless waves for the kids in West Edmonton Mall,

cluttered kitsch among the shops stoking a carnivalesque mood in Minneapolis's Mall of America to loosen your inhibitions and purse strings. The malls I've visited have pseudo-aesthetic touches, quite different from genuine aesthetic attention like a rainbow of paint around a bicycle path (formerly a cattle-crossing) culvert off the Don Valley highway in Toronto [#141], put there not to sell anything but for no reason except to brighten your commute as you pass by. So a city does well if it consecrates resources for **aesthetic places**, not just as relief from constant hard-sell advertising, but as an integral positive feature of the main sociable quality that defines a good city.

[#141] Rainbow culvert off to the side of the Don Valley Highway,
entering City of Toronto (1976)

Glocal speciation: interrelate the specific, plural decentered voices in the city so that each can contribute their specific gift to a connective deepening of civil life—encourage ethnic neighborhood street mural art.

Aesthetic activity assumes full-blown artistic nature when its imaginative background character crystalizes, you might say, **into the determined crafting of surprising objects and events that take on an independent entitary imaginative life of their own.** A lovely blue mural in the Mission district of San Francisco encourages you to think porpoises and cool water amid the sweltering heat. Such **street art**, like taking a whole wall of a building near a postage-stamp park in London, England, where office workers eat their bag lunch, or painting a humun-

gous, humorous ungainly dinosaur on a back alley wall in a tough section near Kings Cross railroad station [#3], tell you this neighborhood cares about you onlooker or inhabitant—"Have a good day, if you can!"

From a glocal perspective the famed *Wall of Respect* mural (1967–1969) at 43rd and Langley, Chicago—I took this photo in February 1970, about a year before it was destroyed by fire—[#20] epitomizes city street art at its best, saying "This place is our home, and we are proud of it. The rich may drive out the poor, but we are staying!" The hooded Klu Klux Khan exist in their upper red panel, but so do portraits of Muhammad Ali, arms raised in victory, and Martin Luther King (murdered in 1969). And this Wall of self-Respect conceived by an African American community, painted and repainted in public with a community of people watching and cheering them on, reaches out with its "Black is beautiful" open hand—not a fist with a knife—to clasp with a white hand and a brown hand together holding up a symbol of angry confronting faces circumscribed with the word PEACE! William Walker who lived in this neighborhood also did a 1977 viaduct at 56th Street and Stony Island (restored 1993), *Childhood is Without Prejudice*—overlapping faces of different races—[#142], to affirm the multiracial diversity of the city as a welcome strength.

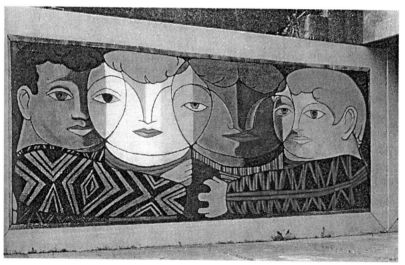

[#142] William Walker, *Childhood is Without Prejudice*,
Mural, Chicago, 1977 - restored in 1993

Since I left my teaching position in Chicago in 1972, more than 200,000 Mexican immigrants have made their homes in Chicago and have followed up the amazing precedent of their native country where

Diego Rivera (1886–1957) and David Alfaro Siqueiros (1896–1974) received government aid in the 1920s to cover whole buildings in Mexico City with historical scenes and symbols encouraging everybody to get education, training with tools, to honor culture Made in Mexico! To make Chicago home, neighbors and students followed the direction of Aurelio Diaz to decorate the railroad embankment on 16th Street in the Pilsen area with a confident variety of Chicano profiles. There are miles of murals below the railroad tracks, not all in mint condition. Current murals I saw this past spring (2008) get more aggressive to try to stop ruining this Mexican Chicago neighborhood, depleting its affordable housing being ravaged by the high financed clutches of so-called "developers." Artwork can elicit smiles or induce troubled sighs, protesting injustice. Public mural art can tend toward a simplified poster-like point because viewers normally read it as you are passing by. The Roman Catholic school there needs a barbed wire fence to protect vehicles in its parking lot, but you see on the parking space wall a mural presenting the happiness of being baptized into the church communion connected to the school. And across the street is a large 100 foot long mural sequence illustrating a dysfunctional family deciding to go for counseling and finally becoming a good family—a family that eats *tortillas* together stays together.

The Puerto Rican community in Chicago significantly placed a 46 foot cement mural on the National Guard Armory in their neighborhood with conga drummers drumming for *Paz Pan Libertad*, a glocal statement wanting to remind gangs in the area that worldwide issues of peace, poverty, needing bread, and the deep wish to be free from fear, are present right there at North and Kedzie Avenue in the city.

Our family was cheered when we first moved to Toronto to read in *The Globe and Mail* about a local scrap metal dump operator, Leon Kaminsky, who braved the catcalls of his colleagues to hire a few Ontario College of Art students to paint the illustrious history [#143] of collecting and disposing of refuse on his walls at Eastern Avenue (now destroyed). To us it showed respect for honest labor with imaginative flair.

The well-known Canadian Oji-Cree artist, Jackson Beardy, was ready when asked by the predominantly white Christian Reformed Church community to design murals for both the inside [#144] and the outside of a Family Center that ministers to First Nation needs at Selkirk Avenue and Powers in the city of Winnipeg, Manitoba. Beardy designed the mural; First Nations youngsters did the painting under supervision; it was one of the few buildings not defaced in a rumble in the area a few years afterward.

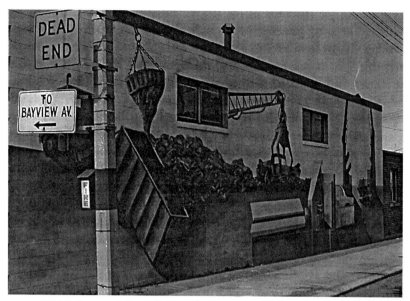

[#143] Ontario College of Art students Uldis Gailus and Harry Pavelson,
mural on walls of Leon Kaminsky's scrap metal establishment,
Toronto, 1975 (now destroyed)

[#144] Jackson Beardy designed, painted by local youths,
Family Center, Winnipeg, Manitoba, 1985/2006

Lining the corridors of the city of Toronto's international airport, which all entering passengers must walk through, are murals [#145] welcoming visitors from various continents and cultures, extending a knowledgeable light artistic handshake (now destroyed).[24] There are fine murals at Regent Park apartments currently undergoing renovation in Toronto, bringing a bright spot to the drab streets, honoring world diversity located right there [#146], pointing an upward-bound poster-like moral, showing a oneness of wanting a sunrise safe living quarters. Will the housing-in-progress complement the mural art? **Artistic activity from the bottom-up can serve a city well, reaching and enriching neighbors culturally who have never seen the inside of an art museum.**

Glocal diaconate: reclaim city streets for living so a spirit of placed hospitality marks the city—fund public quality artwork good for city life.

Art has the task in God's world, I believe, to open up one's neighbors to notice nuances of meaning we casually overlook. Artwork is to be done to help those who are imaginatively handicapped to experience enriching, maybe troubling, subtleties and ambiguities in God's world worth our becoming aware and wary of.

Painterly art and sculpture in art galleries, like symphonies in concert halls, like novels or poetry read (aloud) from books, are God-given opportunities to explore and share the surprising hidden riches of created creatures *coram Deo*. Those who are custodians of art like museum curators, symphony conductors, performers, and literary critics, for example, need to mediate artistry to the public who may only hear sounds at a concert instead of sonata formed tones, or read words rather than a plotted narrative, or see only strange shapes and a jumble of colors. So, when you bring the public into the art gallery, there should be docents to teach the children the language of pictorial art, and also informal instruction and free entrance one evening a week for adults who are too bashful or poor to investigate this strange world of artistry on their own.

And when you take art out of its curated **art place** and deposit it in the general public area you need to be wise in the selection. **There is a difference between art in public places and public art. Public art** does not put Rodin's *Thinker* (1880–81) up on a pedestal in the city of

24 These murals were designed by Ministry of Transport architect Malcolm Bett, and were painted by the non-artist Ministry of Transport painters during slow periods in the winters of 1972–1973. (This information was researched and provided by Lee Kathryn Petrie, Manager of Cultural Programs, Corporate Affairs and Communications, Greater Toronto Airport Authority).

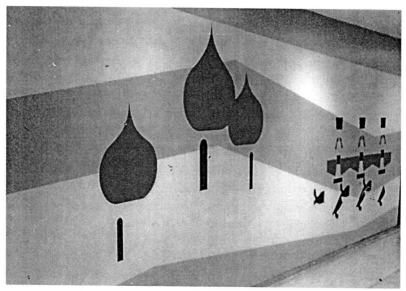

[#145] Turkey mural at Toronto Pearson International Airport,
1972-73 (now destroyed)

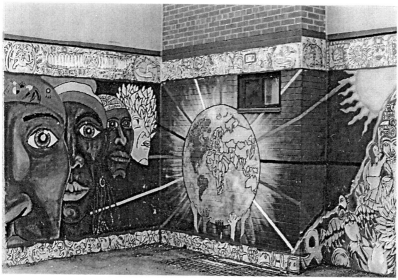

[#146] Regent Park neighborhood mural, Toronto, 2008

Detroit to see what the local tough guys make of it. Public art exemplifies what I call "double-duty" artistic engagement. Double-duty artistic activity encapsulates art-making within non-artistic activity so that the artist must fulfill two norms, do double duty. The product needs to honor well-crafted artistic ambiguity *and* serve the non-artistic purpose for which it was drafted. Advertising art needs to heed the aesthetic norm of metaphorical allusivity *and* the economic norm of supplying good resources for people's needs, if it would be good advertising artistry. If a given ad is engaging art but pushes wasteful luxury, the piece has failed its double duty. If an ad extols a thrifty project but the art is weak, it has failed its double duty. **Public city art, from a glocal perspective, is artistry conceived and executed to further neighborly interactive sociability**, and sometimes to commemorate outdoors the city's history and city life itself.

The *Tilted Arc* of Richard Serra (1981) thumbed its nose[25] at the people who walked across a bland New York City plaza between the Beaux Arts courthouses and the International style Federal Building around it. The art piece was 120 feet long, 12 feet high, and inches thick of industrial Cor-Ten steel, which deliberately held the place hostage to its implacable, unfriendly presence. When it was finally removed amid lawsuits in 1985, the place came to look rather empty.

By contrast, when a Henry Moore (1898–1986) reclining figure is put in a park near flowers, it seems to invite any sheep nearby to nudge against it. Moore's huge marble *Reclining Figure* (1957–58) beside the UNESCO building in Paris [*NA* #25] supplements that organization's caring for the children of the world by having the vulnerable mother figure's periscope of a neck and head stay on the lookout for trouble. Moore's 12 foot bronze piece at the University of Chicago on the very spot where the atom was split occasioning the first self-sustaining nuclear reaction on earth, 2 December 1942, coalesces a protective helmet shape, human skull, death's head, and mushrooming shaped cloud, and is called *Nuclear Energy* [#147]—public art destined to be a commemorative monument. And the huge Moore bronze vertebrae outside the Art Gallery of Ontario is a people-friendly child-climbable artwork [#148] that says, "Welcome! Touch me!" and brings a roly-poly quieting life to the street corner.

I was skeptical when told of Chicago's Millennium Park, since it was part of mayor Richard M. Daley Jr.'s attempt, well-funded by mega-corporations, to make Chicago attractive to tourists—he had authorized

25 "I am not interested in art as affirmation or complicity," writes Richard Serra in the "Introduction" to *The Destruction of Tilted Arc: Documents*, Clara Weyergraf-Serra and Martha Buskirk, eds. (Cambridge: MIT Press, 1991), 13.

[#147] Henry Moore, *Nuclear Energy*, 1964–66

[#148] Henry Moore, *Large Two Forms*, 1969

to put gondolas in the Chicago River in 2000! But an unhurried visit this past spring (2008) dispelled my qualms. British Anish Kapoor's (b. 1954) elliptical *Cloud Gate* (2004) [#149] is an incredible steel-plated bauble shaped like a drop of liquid mercury that reflects the cityscape, sky and clouds, and every spectator within sight. You can walk under through it and see your crazy-mirror-type elongated reflections. Its 110 tons looks like a warped bubble, fascinating, playing back whoever/whatever is in the neighborhood. And then nearby there is the inch deep pool of water between Jaume Plensa's (b. 1956) two facing 50 foot high fountains [#150] on which videos of 1000 different Chicagoan inhabitants' faces are projected every 13 minutes, smiling, slowly pursing their lips, until a stream of water gushes out of their mouths; and when that stops, splashes of water cascade down from the top of the facing fountains on all sides for children to get wet and scream in delightedly. Millennium Park in Chicago, as I see it, has gone beyond putting art in public places, and has now produced **public city art promoting neighborly interactive sociability.** (The corporate sponsors are discretely noted in the cement underfoot.)

In the University of Chicago hospital, Cancer Research Center, is an exquisite bronze [#102] by Dutch sculptor Britt Wikström highlighting out-patient, in-patient, palliative care, the deep need for compassion by those undergoing the searing, merciless, deceptive evil of cancer; the sufferer, too weak to put on his own cloak, whose look wonders at the gesture of love, is perhaps reciprocally steadying the care-giver whose knees are bent ever so slightly, with that sinking feeling. This is public art not meant for an art museum, but conceived, commissioned, and executed for a hospital whose defining nature is to dispense healing mercy.

Certain public art can speak for the city as a whole. Zadkine's (1890–1967) aching commemoration of the 14 May day in 1940 [*NA* #30] when without warning Nazi Germany bombed the inhabited heart out of the city of Rotterdam shows the city's contorted body rising up again, arms raised to heaven still pleading for relief—a moving symbol of an historic city event that forced the defenseless country of the Netherlands as a whole to capitulate and become enemy occupied territory. May Lin's well-known *Vietnam Veterans Memorial* (1981–1982) [*NA* #78] graces the city of Washington, D.C. as testimony to the utterly evil banality of ideological war—58,939 humans killed on just one side, for what? The polished black granite unites all who attend its reflecting somber witness in a quieting common sorrow—**good glocal public art close to home and crying out to curb a nation's penchant for ambi-**

[#149] Anish Kapoor, *Cloud Gate*, 2004

[#150] Jaume Plensa, *Crown Fountain*, north, 1999-2004

tious global control.

I am still looking for a city—even a corporate sponsor—with the vision to find a place inside city limits for *Cathedral of Suffering* (1994) by Wikström [#6]. This installation won a prize in an Amnesty International art competition but has not yet been cast in bronze.

Public artwork is not itself urban renewal, and does not necessarily reform an elected government plagued by militaristic advisors. But **glocal public art by its christian regenerating, speciated diaconate nature can appeal to all who experience its nuanceful power to act differently locally if we keep conscious the cosmic overview of God's will for neighborhooded human lives.**

Glocal mission

What can a city with a committed glocal christian vision do about art?

(1) Upgrade the aesthetic life of its inhabitants with projects like *Shooting Back*, where a band of professional photographers spent time with homeless youngsters in a New York city ghetto teaching them the art of themselves photographing the nuances of their own backyard lives, playing near the railroad tracks, bathing your younger brother in the sink, helping a wounded bird, finally getting a shot of your brother's doing the back flip just right! [#151] **Without developing people's underground aesthetic life awareness, taking up art can be a rootless put-on.**

[#151] Daniel Hall, *Flip*, 1989

(2) **Put in the city budget money for street art, school and library murals, site specific artwork for hospitals and public buildings and especially playgrounds.** Public artwork like the benches in a playground can unite different ethnic neighborhoods, get the children and watching parents to sit down together rather than allow diverse groups build up imaginary walls between us and them.

(3) Resist the temptation to go Disneyland global with gondolas in the Chicago River or a Wonderland permanently at Toronto's waterfront. **A city is to become a meeting place, home, first of all for its inhabiting citizens in neighborhoods, not a brief stopping/shopping site for tourists.** And if our major cities cannot handle the *Cathedral of Suffering* because our nations are complicit in militarist expeditions in Iraq or Afghanistan or who knows where, maybe municipal leaders could find it possible to commission artwork meant to be a **public** invitation to friendliness: go ahead, sit down on a bench [#152] outside the Glenn Gould studio on Front Street, Toronto, for a little chat with Glenn, and

[#152] Ruth Abemethy, *Glenn,* 1999

to thank him for his playing Bach's Goldberg Variations. A thoughtful, light-hearted public artwork that deserves to be a landmark, rests in the heart of Toronto's financial district downtown: there is carved out a minute park where seven large bronze cows by Saskatchewan artist Joe Fafard (born 1942) graze peacefully on the spot of grass [*NA* #23]. It is as if Torontonians know God spared the wicked repentant city of Nineveh years

ago because God cherished its cows! (says so in the last verse of the Jonah book of the Bible); so maybe God will accept Toronto's public artwork of cows as an offering to spare us in the coming world crises.

Jane Jacobs encourages a city not to come out with a "master plan" from on high to make a Utopia, because a city is not a "scientific design problem," she says, to be solved at the drawing board: **a city is a place of neighbors who need to build fruitful social relationships from the grass roots meeting places up.** To become a "city of refuge," if not "a city of God," will be a blessing upon generations of people faithfully "loving just-doing, being merciful, and walking humbly with God" (Micah 6:8), and probably will need to be fused with "prayer and fasting" (Matthew 17:14–21, v.21). **Glocally conscious artistry, I believe, can be a little step in planning to redeem city living from the power of GlobalIZA-TION and help make our cities "new."**

Selected bibliography

Bartholomew, Craig. "The Theology of Place in Genesis 1–3," in *Reading the Law: Essays in honor of Gordon J. Wenham*, eds. G. McConville and K. Möller (Edinburgh: T & T Clark, 2007), 173–195

Bass, Philip. *Till We Have Built Jerusalem: Architecture, urbanism and the sacred* (Wilmington: ISI Books, 2006).

Casey, Edward S. *Getting Back into Place: Toward a renewed understanding of the place-world* (Bloomington: Indiana University Press, 1993).

Crimp, Douglas, "Serra's Public Sculpture: Redefining Site Specificity," in *Richard Serra: Sculpture*, ed. Rosalind E. Krauss (New York: The Museum of Modern Art, 1986), 40–56.

Deupi, Victor. "The Bankruptcy of Ideas: Why modern schools of architecture ignore traditional urbanism," *Bulletin of Science, Technology & Society* 20:4 (August 2000): 271–274.

Goudzwaard, Bob and Mark Vander Vennen, David van Heemst. *Hope in Troubled Times: A new vision for confronting global crises* (Grand Rapids: Baker Academic, 2007).

Hubbard, Jim. *Shooting Back: A photographic view of life by homeless children* (San Francisco: Chronicle Books, 1991).

Inge, John. *A Christian Theology of Place* (Aldershot: Ashgate, 2003).

Jacobs, Jane. *The Death and Life of Great American Cities* (New York: Random House, 1961).

Koval, John P., Larry Bennett, Michael I.J. Bennett, Fassil Nemissie, Roberta Garner, Kiljoong Kim, eds. *The New Chicago: A social and cultural analysis* [TNC] (Philadelphia: Temple University Press, 2006).

Longworth, Richard C. *Global Squeeze: The coming crisis for first-world nations* (Chicago: Contemporary Books, 1998).

Malpas, J.E. *Place and Experience: A philosophical topography* (Cambridge University Press, 1999).

Meyrowitz, Joshua. *No Sense of Place: The impact of electronic media on social behavior* (Oxford University Press, 1985).

Mumford, Lewis. *The City in History: Its origins, its transformations, and its prospects* (New York: Harcourt, Brace & World, 1961).

O'Donovan, Oliver. "The Loss of a Sense of Place," *The Irish Theological Quarterly* 55 (1989): 39-58.

Pahl, Jon. *Shopping Malls and Other Sacred Spaces: Putting God in place* (Grand Rapids: Baker Brazos, 2003).

Relph, Edward. *Place and Placelessness* (London: Pion, 1976).

Robertson, Roland. "Globalization and the Future of 'Traditional Religion,'" in Max Stackhouse, *Religion and the Powers of the Common Life*, 1:53-68.

Rogers, Richard. *Cities for a Small Planet* (Boulder: Westview, 1997).

Rouner, Leroy S. ed., *The Longing for Home* (Notre Dame: University of Notre Dame Press, 1996).

Seerveld, Calvin. "Glocal Culture," in *That the World May Believe: Essays on mission and unity in honour of George Vandervelde*, eds. Michael Goheen and Margaret O'Gara (Lanham: University Press of America, 2006), 45–66.

Senie, Harriet F. *Contemporary Public Sculpture: Tradition, transformation, and controversy* (New York: Oxford University Press, 1992).

Stackhouse, Max L. "General Introduction," *Religion and the Powers of the Common Life, God and Globalization: Theological ethics and the spheres of life*, eds., M. L. Stackhouse and Peter J. Paris (Harrisburg: Trinity Press International, 2000), 1:1–52.

Stackhouse, Max .L. "Introduction," *Christ and the Dominions of Civilization, God and Globalization: Theological ethics and the spheres of life*, eds., M.L. Stackhouse and Diane B. Oberchaim (Harrisburg: Trinity Press International, 2002), 3:1–57.

Stackhouse, Max L. "Introduction," *The Spirit and the Modern Authorities, God and Globalization: Theological ethics and the spheres of life*, eds., M.L. Stackhouse and Don S. Browning (Harrisburg: Trinity Press International, 2001), 2:1–36.

Stiglitz, Joseph E. *Globalization and its Discontents* (New York: W.W. North, 2002).

————. *Making Globalization Work* (London: Penguin, 2006).

Van Pelt, Michael and Robert Joustra with Gayle Doornbos. *Toronto the Good: An investigative report by the Work Research Foundation* (Hamilton: WRF, 2008).

Ward, Graham. *Cities of God* (London: Routledge, 2000).

Wyzsomirski, Margaret and Pat Clubb, eds. *The Cost of Culture: Pattern and prospects of private arts patronage* (New York: American Council for the Arts, 1989).

HOW SHOULD CHRISTIANS
BE STEWARDS OF ART?

As a contemporary philosophical aesthetician, I come at this problem differently than theologian Nathan Jacobs does with his realist philosophical credentials. My response to the question posed, begins by asking a follow-up, defining question: "(How) does the artwork produced serve my neighbors wisely with love in God's world headed for the *eschaton*?"

If the work of my hands and consciousness as artist, art critic, art patron, art onlooker and audience, and aesthetician is marked by a redemptive spirit and somehow bears and/or lifts up the burdens of my neighbor with hope, then we have been faithful stewards of God's creational gift of making and responding to art in our generation (see Galatians 5:25–6:2).

When an Inuit carver such as John Tiktak (1963) turns a piece of stone into a seven-inch figure of a tired mother nobly plodding on, carrying her baby on the back, and gives it as a wedding present to a friend, Tiktak has brought joy to a household that struggles in the Arctic cold [#153]. When an impoverished Zulu woman intones an ancient pentatonic folk song while washing clothes at the river and other women pick up the voiced melody along the long river bank as they scrub

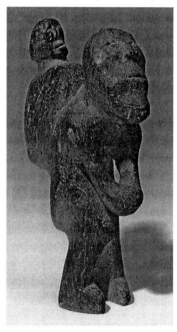

[#153] John Tiktak,
Woman and Child, 1960

their threadbare clothing on the rocks, the air carries the lovely pulsating stanzas and refrain happily over their labors like a caressing benediction.

The essay was written as an invited response to an essay by Nathan Jacobs under the same title in the online *Journal of Markets & Morality* 12:2 (2009): 377-385, 393-398.

When master craftsman Rembrandt van Rijn received the commission to do a group portrait of the *Syndics of the Cloth Guild* (1662) [*NA #5*] and portrays these industrious burghers so diligently busy at their financial dealings they hardly can take time, it seems, to look the portrait painter's way, the art object produced gives crafty imaginative insight into the Dutch ethic of doing business in the prosperous 1600s AD.[1] When Georges Rouault (1871–1958) gave prostitutes the opportunity to come into his studio off the winter Parisian streets to warm up, his paintings of their manhandled plight and desecrated bodies are artistic cries to God that parallel the biblical psalm laments: how dehumanizing we men can be toward women!

For me as theorist, these are examples of artistry that evidence *stewardship* when one conceives of the matter with biblically led reflection. *Stewardship*, we might understand, is "faithful implementation of appropriate resources to beget *shalom*."[2] Tiktak's carving, the Zulu song I heard, and Rembrandt and Rouault's artworks are resourceful artistic acts that answer well God's creational call for humans to be imaginative and to bring aesthetic blessings to our fellow humans in society and into the world at large.

Because this is a journal of markets and morality, readers probably have an interest in several interrelated but distinguishable matters connected with "stewardship of art": (1) Are the artists acting stewardly in their task? (2) Are those responding to the artworks produced being stewardly with their time and money? and (3) Do the criteria of stewardship vary for different kinds of art and/or in different historical circumstances?

First, artworks, as I understand the matter of artistry, are objects or events produced by imaginative humans who have the skill to give media (stone, paint, words, voice) a defining quality of allusivity that brings nuanced knowledge to others who give the object informed attention.[3] Although craft control (*techné*) is basic to art-making, a set of skills is not

1 Long ago, Swarthmore professor Léon Wencelius claimed, "L'idée de vocation calvinienne explique mieux que toute autre l'unité dynamique de la représentation des hommes par Rembrandt," in *Calvin es Rembrandt* (Paris: Société d'Edition "Les Belles Lettres," 1938), 78—79.

2 My formulation of the point Lambert Zuidervaart makes in "Unfinished Business: Toward a reformational conception of truth," *Philosophia Reformata* 74:1 (2009): 6n5.

3 See Calvin Seerveld. *Rainbows for the Fallen World* (Toronto: Tuppence Press, 1980/2005), 27: "Peculiar to art is a parable character, a metaphoric intensity, an elusive play in its artifactual presentation of meanings apprehended."

sufficient to qualify the production of art. I could play a piano piece with metronomic precision and not strike a false note, but the performance will be stillborn as artistry if it lacks an imaginative finish. As a good blues trumpeter would say, "Don't play the notes, man, play music!"

Artworks can be beautiful, like most statues of Buddha, or ugly like the grotesque painting of Christ's crucifixion depicted by Mathias Grünewald in the Isenheim altar at Colmar, France [*NA* #66]. If a would-be artwork misses being molded to a suggestion-rich metaphoric nature, the object or event could be a great show of technique, an honest burst of angry feeling, a lovely investment, but it is not *bonafide* artistry. Artwork is an entity or act defined by adequately answering in its very structural formation to God's creational ordinance, "Be imaginative!"

An artist is called by God, I believe, to serve the imaginative needs of one's neighbors with artworks.[4] An artful image, constellation of sounds, or staged dramatic conflict, can disclose states of affairs normally unnoticed by people whose habit of daily perception and thought is casual, if not slovenly. To surprise gently such persons with the glory of shadows in God's world or the flaws in a respectable public character such as Othello is the offering a poet or dramaturgic artist presents, especially to the imaginatively handicapped. Many disbelieving, godless artists ply this task well, albeit skewed by a myopic world-and-life view and often driven by a spirit of vanity. Stewardship is only one of the mesh of many concomitant norms an artist grapples with in fulfilling his or her professional (or amateur) art-making activity.

The Bible presents stewards (*oikonómos*) as shrewd managers of goods and of people working for them (Luke 12:41–48; 16:1–13). Stewards have the office of administrator, a householder or landlord entrusted with a commission to take care of the master's valuable possessions (Matthew 24:45–51; 1 Corinthians 9:17), like a proactive treasurer (Romans 16:23). God's parable injunction to stewards is to be a faithful trustee in tasks and open to initiative. This means to me that a stewardly artist will be responsible before God to be thrifty and generous with the materials he or she uses to spread around imaginative insight.

That which is stewardly art-making will always be moot. Artisan monks composing icons c. 1100 AD were chary in using turquoise because that color was the most expensive, but then that precious purple-blue-

4 See Calvin Seerveld, *Bearing Fresh Olive Leaves: Alternative steps in understanding art* (Carlisle: Piquant, 2000), 46: "God gave us artistry to open us up to nuances in the creation, to tickle our neighbor's fancy redemptively, to focus attention on things you never imagined existed."

green gave the most honor to the saint being pictured. Canadian painterly artist Gerald Folkerts, with Dutch frugal ingenuity, used palette paint left over from his major figurative paintings to concoct whimsical abstract art pieces, as a kind of complementing commentary on the main work, thus piquing viewer curiosity.[5] I have a question—not a judgment—about how stewardly are Christo and Jeanne Claude's huge artworks (paid for from their own monies) in which they wrap up prestigious public buildings or famed coastlines and orchestrate intercontinental happenings by installing mammoth umbrellas in California and Japan. Is the staggering imaginative bang worth the buck of resources spent?

My tentative hypothesis would be: artists whose sound artworks can be multiplied by repeated *personal* performances will tend to be good candidates for honest-to-God stewardship. The multiple prints of a woodcut still reveal the original artist's own hand, and the many covers of Bob Dylan's (1963) "Blowin' in the Wind" song establish an artistic communion that represents fruit of an artistic concept a hundredfold. If the original woodcut or composed song is mediocre or of shoddy construction, the fact that it can be more economically reproduced than a one-off oil painting or architectural monument is not worth much.

I am not talking about "mechanical reproduction," which Walter Benjamin wrongly thought would end idolization of artworks.[6] Benjamin's millennial hope for ending fetishization of art is disproved by the ubiquity of *Precious Moments* kitsch merchandise, and the enormous spendthrift salaries paid to cinematic "stars." I also do not mean to imply Alice Munro's short stories are necessarily a better return on the quotient of words than a Dostoevsky novel. Each kind of artwork has different resources that are needed and appropriate for its faithful implementation—to bring healing or to fascinate with cheer. I realize and cherish the profound imaginative wisdom one can only experience by being bodily present among other persons standing alongside the inscribed wall of lament of Maya Lin's *Vietnam Memorial* [*NA #78*] in Washington. D.C.— great understated stewardship of black granite placed in a dugout wound of the earth.

Second, what should mark the response of the art public, art critic, and

5 Calvin Seerveld, "Redemptive Grit: The ordinary artistry of Gerald Folkerts," *IMAGE*, 62 (Summer 2009): 57–58 {see *AH*: 273}.

6 Walter Benjamin, "Das Kunstwerk im Zeitalter seiner technischen Reproduzierbarkeit" (1936), trans. Harry Zohn as "The Work of Art in the Age of Mechanical Reproduction," in *Illuminations*, ed. Hannah Arendt (New York: Schocken Books, 1969), 217–51.

art patron if they would be good stewards of artistry? In my judgment, as Christians we should respond to art as worldly-wise (φρόνιμοι) as snakes in the grass and remain as innocent as doves (Matthew 10:16).

For ordinary followers of Christ to be worthy stewards of artistry, they need to rise to the imaginative occasion artworks present and respond first of all on an imaginative wavelength, not at the level of emotional likes and dislikes or with a judgment up front as to whether its dogmatic content be kosher or not. It may take time for simple, busy Christians to realize that God likes poetry (the Bible is filled with it in Job and Isaiah), God approves of sculpture (unless it becomes an idol Numbers 21:4–9 and 2 Kings 18:1–8), and God asks to be serenaded with songs (both praise and lamenting psalms). A Christian *Appraising Artwork for Dummies* manual would ask learners to relax, empathetically take in the subtleties of an artwork, trusting that your basic sanctified sensitivity (see πάσῃ αἰσθήσει Philippians 1:9–11) will give you dove-like protection while your serpentine wariness slips into gear. The more experience a person has in grasping that it is normative in God's world for artworks to transform dissimilars into a similative surprise (N.B. metaphor) that discloses resemblances of an odd sort that provide ambiguous, fine knowledge of nuances[7]—*and that is good knowledge* and has proven so throughout history—the more such a person will be a reliable steward in reception of art.

Let me give a contentious but relevant example: Serrano's two foot high cibachrome photograph of a crucifix in urine has a fashionable, chic gold-and-red appearance. That Jesus Christ, the Son of God, voluntarily left heavenly glory to be born through the legs of a woman, to be tortured and die on a Roman cross for my sins (1 Corinthians 15:3 4; Philippians 2:5–8) is indeed like being immersed in feces. What a Savior! Descending into the hell of our dirty human excrement. However, Andres Serrano spoiled his ingenious artwork with a "Piss Christ" title, letting his disaffection with the plethora of plastic crucifix junk sold at pilgrimage places in myriad Latin Catholic countries trip him up into a sophisticated, self-righteous dig at the Church, with malice aforethought, as it were.

Stewardly response to art objects will draw wisdom from whatever similated product is given. One's judicious reception of artworks will normally be mixed, if not conflicted, because human artistry is com-

7 "Similation" is a fine coinage introduced by Karl Aschenbrenner in *The Concepts of Criticism* (Boston: Reidel, 1974), 313–19, which I adapted in an analysis of "Imaginativity": "The singular, determinative feature of a human creature's imaginative act may be best described perhaps as a *similation of strange affairs*." Calvin Seerveld, "Imaginativity," *Faith and Philosophy* 4:1 (1987): 43–58 {see *NA*: 11 n.7, 37}.

plex, and the spirit of a piece or rendition may turn its embodied insight off-color. A seasoned, professional art critic such as Peter Schjeldahl will often use an oxymoron, like "this show's violent grandeur," to catch the flavor of Ensor's retrospective at the MOMA in New York.[8] In addition, Paul Borolsky is on track with his plea for art critics to write evaluative art history with flair, in keeping with the prickly, subtle nature of art, rather than assess artwork in pedantic, overly analytic terms, betraying the critic's positivistic lineage.[9]

It is so that Christian art critics remain subjective, as do surgeons contemplating surgery, but one must become the most reliable (subjective) surgeon one can be, plumbing and focusing on the intricacies or shallowness of the art product in one's exposition, so as not to mislead others. It is stewardly to point out Andy Warhol's orthodox Byzantine Catholic orientation with its tradition of icons, to understand his serial silkscreen close-ups of famous faces, but still brave Warhol's immense popularity by stating, "Warhol represents a typical postmodern stance of non-commitment, a cultivated stance of nonchalance and indifference that looks at the world with a kind of detachment."[10] If anybody has wasted several hours, as I have, watching a cinematic production of Warhol's *The Factory* highlighting the boredom of trivia, one is indeed tempted to characterize such pop art as a bad faith mystification of artistry, falsely pretending there is no difference between artistic events and/ or products and ordinary life.

An art patron acts stewardly when the patronage enables artists to serve their neighbors with pertinent artistry that has the wherewithal to make an imaginative difference that has staying power in their lives. To hire a fascinating storyteller for your children's birthday parties, or pay a poet to compose a sonnet for your graduation or anniversary, or splurge by having a portrait painted of the grandparents before they die, are all stewardly attempts to bring the specialness of artistry in to brighten up and freshen family life with memories that bespeak troth and intimacy.

A striking example of large-scale stewardship in art patronage is Jaume Plensa's *Crown Fountain* (1999–2004) in Chicago's Millennium Park [#154]. The two, 50-foot high towers of glass on which 1,000 different

8 Peter Schjeldahl. "The Id Factor: James Ensor's Irreality." *The New Yorker* 85:20 (July 6, 2009): 90.

9 Paul Barolsky, "Writing (and) the History of Art," *Art Bulletin* 78:3 (September 1996): 398.

10 Adrienne Dengerink Chaplin. "Art, Faith and Warhol," transcript of a lecture given at the Jubilee conference in Pittsburgh at the Hilton Hotel and the Andy Warhol Museum, February 2006.

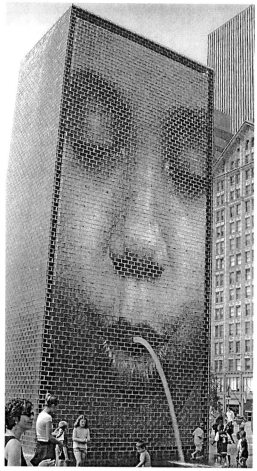

[#154] Jaume Plensa, *Crown Fountain*, south, 1999

Chicago inhabitants' faces are projected every thirteen minutes, smiling, slowly pursing their lips until a stream of water gushes out of their fountain mouths, preside over 2,200 square meters of black granite covered with a thin sheet (3 millimeters) of water. The wealthy Crown family has not sponsored an expensive piece of museum art plunked down somewhere (such as the Picasso and Miro sculptures a few blocks away) but has given a fortune for genuine public artwork that breathes neighborly life into the city—the distinguishing mark of real public artistry.[11] Children scream and splash and frolic in the spurting fountain, adults walk around on water, and tourists and locals mingle friendly; I even saw a young fellow without legs wheel his chair into the melee to get wet, hap-

11 See "Cities as a Place for Public Artwork: A Global Approach," {supra pp. 248–260}.

pily joining the crowd.

The very antithesis to the blessing of this patronage behind Plensa's people-friendly artwork is the Cor-Ten steel *Tilted Arc* (1981) by Richard Serra, which obstructed pedestrian passage across a plaza in New York City (until its 120 feet long, 12 feet high blank barren structure was forcibly, amid lawsuits, removed).[12] An art patron has great power to shape the imaginative life of artists and bystanders; patrons, from a Christian perspective, certainly need to know what artistry by nature is and does and also *what time it is* and *the place where* they intend to spread artistic grace.

Third, do the criteria for stewardship of artistic practice and responses, including patronage, vary in history? In my judgment, yes. Agricultural minister Joseph probably altered his economic policy during the seven years of plenty and during the seven years of drought in Egypt (Genesis 41).

It makes Christian stewardly outreaching sense to me to explore artistry such as cinema today where the original finished product can be marvelously reproduced and widely disseminated in our post-literate, techno-mediated world culture. However, when brilliant color photography of painterly art was introduced, it still did not make grand tours obsolete because to experience bodily a well-sited artwork in a given place, and to come unhurried under its spell, can generate unforgettable influential memories in one's lifetime, for good or for ill.

I should like to enlist Nathan Jacobs' help to update his wish for the Gothic cathedral experience of elevating onlookers to God, as he puts it. Given the incredible, unprecedented global plight of starving children and women who are *our* neighbors, and given the ongoing warring destruction fueled by our nation's profligate merchandizing of weaponry abroad, I think Christian stewardship in art matters would be well served if we found sponsors, for example, to cast in bronze Britt Wikström's *Cathedral of Suffering* [#6, 31, 33-35]. It would only cost about what the first-prize amount is that is being offered by Rick DeVos and Jeffrey Meeuwsen of the Urban Institute for Contemporary Arts, in their imagi-

12 Although Ted Prescott does not mention Serra's work, I think his remark is apropos when Prescott contends with James Elkins on the role of religion in the current art world: "If continuity is considered as well as change, a somewhat different story of modem art emerges. In that story some contemporary art looks pretty small." See "The Strange Place of Religion in Contemporary Art," *Books & Culture* (May-June 2009): 24.

native current ArtPrize competition in Grand Rapids, Michigan.[13]

The *Cathedral of Suffering* is an outdoor installation of five poles and three figures. The vulnerable woman figure is bent to shield herself helplessly from the unstopping attacks; the little child, arms raised to protect its face, has its own solitary grown-up pole; the spread-eagled man is crucified between the torture of hanging from two poles; and the empty pole stands waiting for another victim. Evil and sin in what we humans are making of God's world seem insatiable. As you walk away from this poignant testimony of cruelty, in which *we*, too, are implicated—too devastating for earth to bear it, chillingly unacceptable to the heavens, and suspended in-between placeless—it occurs to you that maybe the empty pole is meant for you.

Such a riveting cathedral could be a step in stewardly artistic reform of "spiritual devotion" tempted to absent itself from the reigning artworld. Anytime Christian leaders abdicate responsibility in a cultural field of endeavor—art world, labor world, political circles—that realm of human endeavor really goes to hell. If the *Cathedral of Suffering* could be located in the small lake outside Calvin Seminary in Grand Rapids, or maybe there is a quiet spot near Professor Jacobs' Trinity International University in Illinois, I'd wager it would affect redemptively for generations the temper of the biblical, theological, and religious studies programs carried on nearby—and might even become a well-known pilgrimage place. Such an artwork would reward potential *Markets and Morality* sponsorship stewards with its subtle but powerful testimony that we have indeed heard the angels' admonition to Christ's followers on the mountain top at his ascension: "Why do you remain standing here looking up into the heavens? Go back down to the city and do just deeds, giving away shalom to the destitute outside your indoor cathedral, lest it be only the dogs licking poor Lazarus's sores in the city square" (see Acts 1:6–11; Luke 16:19–31; Matthew 25:31–46). Artist and patron who understand what the LORD God requires of us (Micah 6:8) will be generous stewards of artwork that makes Jesus Christ's call to repentance and offer of grace to forgive known allusively in imaginative deed to those who never darken the insides of art museums or churches.

The text of Nathan Jacobs' response to the text above (as well as Jacobs' original article "How Should Christians Be Stewards of Art?" can be

13 A flaw in this well-intentioned project, it seems to me, is that popular vote is not necessarily able to ensure artistic quality or to select artwork that will bring regenerating shalom to inhabitants of a city.

found at http://www.acton.org/pub/journal-markets-morality/volume-12-number-2

What follows is Seerveld's continued response to Nathan Jacobs.

I thank Professor Jacobs for trying to clarify our apparent and real differences on the nature of artistry as we try together to reach wisdom on how Christians should be stewards of such concrete matters. He has difficulty understanding me, I think, because we subjectively set up our vision of God's world quite differently.

Professor Jacobs is a committed philosophical realist who believes that such "intellectual realities" such as "the beautiful" and "the sublime beauty of high classical artwork" is grounded in reason. He seems to state that if you are not an ontological realist, you must be an antirealist nominalist who "accepts perpetual skepticism" and makes "bald assertions" without "a systematic position on the metaphysical grounding of art."

This dilemma posed as exhaustive between either embracing ontological realism or holding on to antirealism is a logical fallacy, I think. *Tertia datur.*

My own philosophical position is to ground art-making in a scripturally led understanding of God's world as a theatre of historical operation for which the covenantal Lord God, revealed in the Scriptures, has posited various creational ordinances for us humans to obey if we would live in shalom. Because our God-ordained created world also reveals God's will, the task of humans who would be obedient to the Lord, is to discover the DNA ordinance for genetic flourishing, for example, and God's creational ordinance of just-doing for governing and policing societal affairs, and also God's ordinantial call for us humans to be imaginative. God's multisplendored ordinantial criteria for the varied facets of our creatural lives are neither "noetic reals" (νοητά) nor "archetypal ideals" and not "moral mandates in Scripture"—Professor Jacobs' apparent roster of logical possibilities—but are the redeeming Lord God's creational injunctions for obedient care of creatural life in its many dimensions.[14]

Mortals may reason that we should rule politically under the absolute criterion that "might makes right" (Thrasymachus), or "preemptive strikes are legitimate" (The National Security Strategy of the United

14 Cf. Dirk H. T. Vollenhoven, *Introduction to Philosophy*, trans. John H. Kok (Sioux Center: Dordt College Press, 2005); and Albert Wolters, *Creation Regained: Biblical basics for a reformational worldview* [1985], 2nd ed. (Grand Rapids: Eerdmans, 2005).

States of America, September 2002, art. 5), but such reasoned directives will distort and impoverish governance of civic society, says a follower of Jesus Christ, in my judgment (keeping both Revelation 13 and Romans 13 in mind). To obey God's will for instituting a redemptive political peace in society so prone to the evil doing of exercising power without the limits of restorative justice is a challenge fraught with our human failings. That is our Christian calling: to be faithful in responding to God's creational ordinance for right-doing, backed up by a consciousness that is oriented by biblical eyeglasses.[15]

Similarly, I believe God calls all humans to be imaginative,[16] and if some are gifted to develop the skill to become "professional imaginators," that is, bonafide artists, they are called by God to be presenting offerings of "metaphoric similations" (to repeat my defining jargon) that thank God for dappled things and finches' wings and strengthens one's neighbors' playful well-being. This project is what *any* artist is called to produce in God's world; God is not just Lord of the Christians.[17]

For genuine artwork, artists, art critics, and art patrons also to meet the Lord God's injunction to be stewardly in our art-making and art-receiving, I mentioned the need to be thrifty and generous. Professor Jacobs takes the matter of stewardship more broadly as "meeting . . . moral/spiritual obligations" to "cultivate the potential with which [one] has been entrusted, all with a view to the glory of God." Those sentiments sound pretty close to mine, but because he boxes me into holding "an uneasy mingling of realism and antirealism," he judges me to "oscillate among artistic objectivism, moralism, and elitism." Too bad.

If Professor Jacobs thinks there be no subjectivity among surgeons

15 This is John Calvin's fine image in the *Institutes of the Christian Religion*, I,6. See Craig Bartholomew and Michael Goheen, *Living at the Crossroads: An introduction to Christian worldview* (Grand Rapids: Baker Academic, 2008).

16 Professor Jacobs says I did not define the term, but I did briefly define "imaginativity" in footnote 7. Professor Jacobs is also in error when he states that I claim "there is no difference between artistic events and/or products and ordinary life"; that is precisely what I *rejected* as "a bad faith mystification" promoted by Warhol's pop artistry. Therefore, his follow-up accusation that I censure those who dislike "modem art" to be simpleminded, I consider unfair.

17 Professor Jacobs reduces my initial response to six propositions—Christian art should: display a redemptive spirit, bring aesthetic blessings to one's fellow man, bring hope to one's neighbor, be imaginative, stir the imagination of others, and display artistic finesse. In so doing he inadvertently reduces the *skandalon* of my thesis: **any and all artistry** is called to be skilled, imaginative constructs and events bringing hope. If artistry fails in such matters (as Christian artists do too), the artwork discloses marks of ignorance, weakness, or vanity.

(and aesthetic judgments), why do medical professionals often recommend getting a second opinion on a potential talus bone graft? If "morality" is an "objective-sphere" for Professor Jacobs, does that mean no subjective discernment enters into determining if and when an abusive marriage should end in divorce?

When I affirm the subjectivity of art critics, I am not proposing subjectivism. Because I deny there to be ontically an absolute intellectual(?) real BEAUTY, it does not entail that I be a relativist. Every person remains subjectively responsible for one's ethical, aesthetic, and, yes, surgical judgments, which are always made and enacted relative to a specific good creational call from God that orders (grounds) that kind of activity. The embrace of the Creator's abiding injunctions are willy-nilly assumed, consciously or not, by various communities of ethical, aesthetic, and medical pace-setting leaders. If the norms posited subjectively by a given generation are skewed, then living and dying under their aegis will likely be lackluster, bitter, or worse.

If a medical establishment were to phase out treating women and men as persons with (psychosomatic) diseases into being primarily instantiations of a malady primed for scientific research, there would be a dehumanizing hell to pay. If marriage devolves under general cultural pressure from being an ethical binding covenant into a legal dissolvable contract, family cohesion will suffer extra debilitating tensions. If Christian bookstores continue to make good profits from selling *Precious Moments* merchandise, they are unfortunately contributing, I am afraid, to the anesthesia of their many customers who may prefer artistic sweets to roughage.

It is not elitism, in my book, as a teacher of aesthetics, to offer prospective receivers and interpreters of artworks, including theologians, help to mature in their subjective reception of artworks and artistic events. Following the lead given by Hebrews in matters of faith (Hebrews 5:11–6:3), my lifework has been to coax and urge to discover what those who are involved in the blessing-and-curse artistry can bring to human life—to grow up from being milk-drinking babies to those able to chew and digest solid artistic food. So I can get angry with those who *sell* kitsch (not with those who have it and do not know better) because the suppliers are keeping people imaginatively immature, thus blighting their aesthetic life.[18]

18 See Seerveld, *Rainbows*, 63–70, and *Bearing Fresh Olive Leaves*, 153–54, 181–83; Frank Burch Brown, *Good Taste, Bad Taste, and Christian Taste: Aesthetics in religious life* (New York: Oxford University Press, 2000), 128–59: and Betty Spackman. *A*

To oppose elitism to a (postmodern) democratic leveling of literature to *écriture* is a misformed dilemma, as Murray Krieger argued long ago.[19] Opposing only two possibilities (e.g., realism/antirealism) usually oversimplifies matters. Granted, the Sotheby and Christie-run auctioneering art world is a corrupt charade as far as artistry goes, as debunking business economist Don Thompson has carefully shown:[20] the millionaire art-buying circuit is uneconomical casino capitalism at its worst, riveted upon money and prestige. Maybe the Urban Institute for Contemporary Art with its current ArtPrize is caught on the horns of this dilemma? "We offer Big Money too (US $250,000) for a new artwork in Grand Rapids, but we are not elitist because the prize will be decided by the votes of the common man and woman on the street, no matter whether they understand art or not."[21] It would seem more stewardly wise to me to have the art knowledgeable curators of UICA prospect for and sponsor several city-friendly sound young artists to make site-specific artworks, and then have a public confirming vote for additional honor and prizes.

There is one bone I need to start picking with Professor Jacobs on the matter of beauty and artistry, and it goes back to realist philosopher Plato who also believed that beauty is "part of the real" other world behind the visible world we bodily inhabit. The fact that Christian theologians have adapted and long held to the trinity of the good, the true, and the beautiful as (Platonic) idea-structures (now in God's mind?) does not make it right, any more than the long acceptance of a rock-bottom, infallible reason saves it from being challenged by Bible-believing Christians as a bogus concept.

I have space only to say this: exaltation of the invisible perfection of (real) Beauty has indeed long handicapped a sound grasp of the place and task of human artistry because art by its creatural nature is sensible, with a ludic quality, in this lived world. Plato's *Symposium* epitomizes the misconstrual; seekers of Beauty to achieve immortality are encour-

Profound Weakness: Christians and kitsch (Carlisle: Piquant, 2005).

19 Murray Krieger, *Arts on the Level: The fall of the elite object* (Knoxville: University of Tennessee Press, 1981).

20 Don Thompson, *The $12 Million Stuffed Shark: The curious economics of contemporary art* (Toronto: Doubleday Canada, 2008). See also Adrienne Dengerink Chaplin, "Pros or Cons? Young British Artists and the Turner Prize," *Comment* (24 July 2009), http://www.cardus.ca/comment/article/1128/ (accessed 23 November 2012).

21 Many have pointed out that "public opinion" in our technocratic days can be highly manipulated by partisan organizing in polls and votes. See Nick Crossley and John Michael Roberts, eds. *After Habermas: New perspectives on the public sphere* (Oxford: Blackwell, 2004).

aged to rise from pederastic love of physical beauty to soulful beauty on to beautiful learning until finally you reach contemplating beauty itself (209e5–212a7). This ladder from sensible beauty up to supersensible, purely mental beauty confines artworks to the lower rungs one seeks to surpass. Many theologians have indeed adopted this paradigm, modified and christened its ascent to end with a *visio dei*. The Orthodox and Catholic Church sacerdotal tradition employs and justifies art this way in its ecclesial settings, especially since the Council of Trent (1545–1563), for this very instrumental purpose: art is to focus believers for rising to an experience of celestial mysteries.

If I am not mistaken, I detect that this paradigm underlies Professor Jacobs' weeping nostalgia for the likes of Solomon's temple.[22] I shall try to honor the faith in that grand sacramentalization of artistry, to which many evangelical Christians are accommodating themselves today, but I must confess I come from the other side of the tracks and with Hans Rookmaaker believe artistry needs no ecclesiastic liturgical justification.[23] I am sorry Professor Jacobs will not help me raise the money for the stewardly placement of the *Cathedral of Suffering* (which he finds "a ghastly proposal"). I am still intent on placing somewhere its powerful artistic, ambiguous symbolific testimony to the atrocities we followers of Christ are allowing to happen, so that the theologians, realist philosophers, aestheticians, and the simple people (ὁ λαός, laity) Jesus particularly loved, will not pass by in the fast-lane side of the road on the way to their Crystal Cathedral, but shall stop in their tracks (indeed, aghast!), called to repentance by such stewardship in artistry to do something concretely merciful for our destitute and violated neighbors.

22 A small quibble with Professor Jacobs' formulation about "the sublime beauty of high-classical artwork": Because Edmund Burke and Kant's conceptual distinction of the sublime as that which is *not* "beautiful," but is monstrous or terrifying, aestheticians and art historians have usually realized this distinction was an important opening up of the restrictive notion of (Winckelmannian high-classical Greco Roman) Beauty.

23 Hans R. Rookmaaker, "Art Needs No Justification" [1977], in *The Complete Works of Hans Rookmaaker*, ed. Marleen Hengelaar-Rookmaaker (Carlisle: Piquant, 2002), 4: 315–49.

FOR THE NEXT GENERATION
OF CHRISTIAN WRITERS OF LITERATURE

In responding to Micah Mattix's thoughtful essay "On Christian Literature," I present a few thoughts on the complex problem of how followers of Jesus might best learn from and critically judge skilled art, literature, and culture that is considered chronologically pre-Christian, or aware of the Christian faith, or pseudo-Christian, or professedly godless.

Whatever exists or goes on under the sun in God's world is, I believe, open to treatment by artist, storyteller, songwriter, and performer. It is proper for people writing literature to discuss sin as well as good deeds rather than to pretend evil does not exist historically. The Bible itself is certainly graphic about how perverted we humans can act, and it does not take Philippians 4:8 as a proscription against probing wrong.

All human creatures are afoot in God's world. Because humans bear the special imprint of being structurally created to respond to the LORD God's call to be God's servants, to administer shalom in the world (Psalm 8, Micah 6:8), humans cannot help but couch their deeds as offerings—to the true God revealed in Jesus Christ, or to any of many ersatz gods or idols (Deuteronomy 30:11–20; cf. 1 Corinthians 10:7–33). So the redeeming Creator LORD God's gracious provision of the hug of gravity, the blessing of DNA, the laws for communication, and the norms for reflection and intimacy are gifts everybody normally is bound by. The question is, do we humans respond thankfully with a worldwide vision of the Lord's making all things new or wholesome, or do we humans act in some other spirit and committed or distracted outlook?

There was a time when humans were ignorant of the LORD God (Acts 17:22–31, especially verse 20), even though God was know*able* in creation (Romans 1:18–32, particularly verses 19–20) and had revealed God self for a time particularly to the Jewish nation as a special folk (Psalm 147:12–20, especially verse 20; Romans 9–11).

Homer's vigorous epic tales of *Iliad* and *Odyssey* (circa 800s BC) are engaging, sonorous, and racy poetic narrative, but they are ignorant of

Originally posted at *Comment*, 10 December 2010, http://www.cardus.ca/comment/article 2403

the biblical revelation of sin. Άμαρτία for the Homeric literature is the daring transgression of a limit by humans vying deceptively with gods, which when committed may hasten your end but will place you as a "never-at-a-loss" hero. This pagan heroic ethic is clean-cut and favored (to Plato's chagrin, *Republic*, II–III, 377b11–392c8) because we are only mortal.

Dante's *Divina Commedia* with *Inferno*, *Purgatorio*, and *Paradiso* (circa 1300s AD) is carefully structured according to a vision of tormenting payback for violating God's laws, a half-way habitation for "good" pagans like Virgil, but reserving heavenly bliss for those who have been sanctified holy. The spirit of the *Divine Comedy* is benign and human-friendly; it is honed to medieval ecclesiological contours and breaths a mixed dynamic of human achievement and God's gracious help.

When one takes up the dramatic literature of Tennessee Williams (1911–1983), as I do in *A Christian Critique of Art and Literature* (Toronto: Tuppence Press, 1963/1995, 130–139), things become more complicated. The increasingly post-Christian nature of Western civilization since the so-called European "Renaissance" (c.1400–1500s AD) and "Enlightenment" (1700s AD) periods presents an amalgam of Christian reflective fragments *and* a rejection of such a redemptive vision. And the secularized drive to "modern" culture can be rationalistic, pragmatic, nihilistic, or a curious ironic agnostic zetetic spirit that is hard to pin down. Tennessee William's theatre, as I understand it, explores as a whole the loss of tenderness in a God-forsaken world of survival of the fittest and most sexually potent, with all the ensuing tragedy of the impotent outcasts all around. The predominant spirit in his literature borders on a melodramatic, wistfully old-fashioned neo-idealism turning sour.

That is, as I understand the Holy Scriptures: When humans meet creational ordinances God has set for us creatures, humans can be *normatively* busy but are not *redemptively* responsible. Followers of Jesus do not have a monopoly on sound action in God's world.[1] God-damning humanists may, I dare say, have a more mutually enriching married life than a born-again Christian pair whose intimacy is basically holy but anemic. But that does not make the atheist partners "Christian in a lim-

1 But for the difference one's faith standpoint does make on critical matters of daily life, cf. Ken Badley, *Worldviews: The challenge of choice* (Toronto: Irwin Publishing, 1996). This is a vivid illustrated textbook (including cartoons) appealing to a high school age readership. Also, one thing worth learning from writers like Roland Barthes is that "texts," as well as "literature," disclose a committed stance, a hidden vision underneath the advertising slogan, toys, or billboard. Cf. *Mythologies*, selected and translated from the French by Annette Lavers (Herts: Paladin), 1957/1973.

ited sense."

Bertrand Russell's superbly written essay on "Why I am not a Christian" (1927) is sparkling literary prose, but I would have trouble to say his writing "glorifies God." I think Russell's brilliant prose style *betrays* God's gift. Albert Camus's inexorably intense *Le Malentendu* (1944) has a blasphemous, non-transcendent point, but it is gripping theatre. How can these conundrums be?

Even humans who "suppress the truth in unrighteousness" do not become devils.[2] Human enemies of God, so long as they breathe, still can be transformed into changed, saved persons. Both Σάρξ (like principalities of pride or the will-to-violent-power) *and* Holy Spirit wrestle within adopted children of God so long as we live, says the New Testament (Romans 7:14–25, Ephesians 6:12, James 4:1–10). So human saints continue to struggle with sinfulness, and the literary work of our hands remains mottled rather than singularly pure.

Therefore the task to recognize and to write "Christian literature," as I hear it, is the calling to test the **spirit** of the written piece (1 John 3:1). Is its dynamic redemptive? And does its word-embodied **committed vision** subtly disclose and make metaphorically palpable the LORD God's ongoing offer of justifying mercy for repentant sinners in God's historical world?[3] Spirit and committed vision are deeper and more comprehensive matters to me than theme, content, or function of literature.

Professor Mattix and I are both after the same pearl, I think: praise God in writing, and do *not* pass the ammunition. But our working categories and terminology are not in sync. So it would take time and a few face-to-face meetings for us to land clearly on the same page. And in brief remarks, you cannot say everything needful.[4]

His wish to talk "value" and (spiritual?) "transcendence" seems to me to dilute or make vague the biblical call to be obedient to the Lord Jesus Christ by loving your neighbor with your writing. Behind Professor Mattix's conceptions of "some truth," "relative truth content," "partial

2 I do not call Picasso's *Guernica* "Satanic," as Prof. Mattix intimates.

3 Cf. my thoughts on "characteristics of Christian culture" in the chapter, "Modern Art and the Birth of a Culture" in *Rainbows for the Fallen World* (Toronto: Tuppence Press, 1980/2005, 182–201. Also, "Import of Biblical Wisdom Literature for a conception of Artistic Truth," {see *BSt*: 215–231}.

4 Cf. my juxtaposition of "Exorcism and giveaway goods rather than *spoliatio Aegyptorum*" (which latter alternative Prof. Mattix favors) in "Antiquity Transumed and the Reformational Tradition," *In the Phrygian Mode: Neo-Calvinism, antiquity and the lamentations of Reformed philosophy*, ed. Robert Sweetman (Lanham: University Press of America, 2007), 254–259 {see *AH*: 106–110}.

revelations," and then the thought that "these values [of beauty, truth, justice, goodness] should be derived from the truth statements of Scripture," I detect an approach that seems to me to assume "truth" is basically propositional, "beauty" is a penultimate step toward "the holy,"[5] and "goodness" is a neutral transcendental quality not affected by one's rooted faith vision.

It seems to me that a tendency to hold to a "natural theology" supplemented by a "supernatural, fully biblical theology" compromises the radical nature of the biblical call to humbly follow the Rule of Jesus Christ from the get-go and to admit to the deep pervasiveness of sin in the unregenerated human heart. Therefore, while I learn from the truncated and slanted contributions of pagan and disbelieving authors who cannot escape the LORD's provident care and who do indeed often perceptively detect matters at large that are unnoticed by Jesus' followers, and who then ably present their findings under God's creational ordinance (of "allusivity"—my term) for literature, I cannot credit them as if they be testifying of the LORD God's faithfulness (which they indeed may be manifesting, skewed).

It is misleading error, it seems to me, to say Beckett's plays are "more Christian" than the Precious Moments kitsch of pseudo-Christian romances.[6] The comparison is odious. Let's compare Beckett's oeuvre with the literary works of Dostoevsky, Flannery O'Connor, Alan Paton—then we can give students a taste of Christian literature that has a vision of God's amazing, sin-plagued world and the promissory spirit of hope for redemption. And let's encourage the younger generation to be conscious of and to immerse themselves in a long tradition of vital world literature that breathes an awareness of sin and proffers earnests of joy (cf. *A Christian Critique of Art and Literature*, 60,62), so that, as Abraham Kuyper once put it, prospective Christian writers of literature in our generation will not need "to be content with the act of shuffling around in the garden of somebody else, scissors in hand [to cut the other's flowers]" but will learn to grow hardy plants in a garden with biblically rich soil. (Ibid., 8 n.4, 18 n.8).

5 This sacramentalist aesthetics is well represented among Protestant thinkers by Gerardus van der Leeuw, *Wegen en Grenzen* (1955), translated by David E. Green as *Sacred and Profane Beauty: The Holy in art* (New York: Holt, Rinehart & Winston, 1963), and is developed by the Chicago school of thinkers around Nathan A. Scott, Jr., ed., *The New Orpheus: Essays toward a Christian poetic* (New York: Sheed & Ward, 1964).

6 But cf. Betty Spackman's compassionate evaluation of "Christian" involvement with kitsch in her fine book, *A Profound Weakness: Christians and kitsch* (Carlisle: Piquant, 2005).

A NOTE ON POETRY

Poetry is always in a language; it is artistically fashioned language meant to be overheard. So, poetry is Greek, English, Afrikaans, Chinese, French, Zulu, or German language overlaid with subtlety and full of condensed elliptical meanings. The (written) speech is clothed in a metaphoric habit that brings insight to others by strange juxtapositions. Poetry is any language honed to an oblique, nuanced quality.

Poetry is language where the diction and syntactical rhythm of language is charged with more than semantic meaning. In poetry the language has undergone reconstruction in order to highlight imagery, alliterative, and onomatopoeic sound. Sentences are normally tailored to a lilting meter and stanzaic pattern that hint at hidden meanings around the semantic corner, which one can discover by an imaginative attention.

Poetry heightens the suggestive elements of spoken language so that an audience is brought, as it were, into a confessional for overhearing human experiential knowledge voiced with ambiguous, self-conscious frankness. In poetry the Spanish or Hebrew or English language is not so clear: the connotations of the language predominate and spark various possible references, which all coalesce in a hybrid, richly ambiguous way. Poetic language refers to realities, and it captures certain specific meanings imaginatively so that the shadowy facets of things and events are brought into play and given symbolic accents.

Poetic language is slanted by the poet's own committed world-and-life vision and driven by the cultural dynamic the poet shares with like-minded artists and cultural neighbors. So poetry—which is called to stay convincing poetry rather than be straight denotative communication or a propagandistic sell for a position—poetry, as artistically reinforced language, is laden with a dated/located communal spirit, which we need to understand historically to grasp the enduring, allusive import for present day readers/hearers of the nuances in God's world that the original poet uncovered and colorfully presented.

Originally published in *The Big Picture: The Gospel and our Culture*, no. 8 (December 2001), 11.

Please read the following poem by Luci Shaw out loud to yourself (1981, from *Polishing the Petoskey Stone* [Wheaton, Illinois: Harold Shaw Publishers, 1990] p. 201):

Judas, Peter

because we are all
betrayers, taking
silver and eating
body and blood and asking
(guilty) is it I and hearing
him say yes
it would be simple for us all
to rush out
and hang ourselves

but if we find grace
to cry and wait
after the voice of morning
has crowed in our ears
clearly enough
to break our hearts
he will be there
to ask us each again
do you love me?

Did you notice how the poet sums up a line in its last word as if a thought were suspended in a colon, only to swing back the other way? all . . . taking . . . eating . . . asking . . . hearing . . .

Repetition of "all" in the poem makes you wary, and rightly so: betrayers the first time, suicidal problem-solvers the second time, like Judas.

But "if . . . grace" touches us like the *persona* Peter: "morning" is sunrise, but mourning doubles up the morning with lament. "Cock" would be too sharp a word for the pain of repentance hidden here. "Crowed" is enough.

Judas, Peter is more than a descriptive title. Is it perhaps in the vocative case, addressed to us?

Luci Shaw's poem is as chaste as a poem by Emily Dickinson. The crasis of images can be sharp: taking pieces of silver—is that how I "take" communion? Suicide is simple?!

The oxymoronic rhythm and striking juxtapositions are strong: "grace to cry," "clearly to break." The last stanza is almost all monosyllables, as if stilled to the awful life-and-death question under one's breath, aching for "yes" as our answer.

The bold reticence and casual reverence of the narrator sound poignantly in my ear. The balanced picture of two even mirror images carry the spirit of calling the reader/hearer quietly, intently, to give everything one has back to the Lord.

Read the poem aloud again, perhaps to a friend or neighbor.

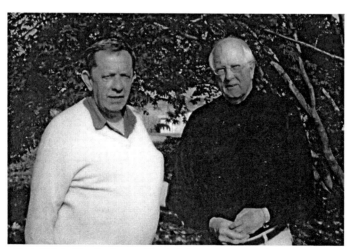

With Nelvin Vos, Professor of English Literature at Muhlenberg College, Maxatawny, Pennsylvania, 2004

A Review: Good Taste, Bad Taste, and Christian Taste

Frank Burch Brown, *Good Taste, Bad Taste, and Christian Taste: Aesthetics in religious life*. Oxford University Press, 2000. 312 pp. ISBN 0-19-513611-x.

This is a fine book that thinks through important problems. Brown's footnoted bibliography is rich with sources worth reading. The perspective from which he writes is close, I think, to that of Gerardus van der Leeuw, Jacques Maritain, and George Steiner, who are also intent upon relating our human taste for art with a desire for God or the Holy that transcends mundane existence. But Brown is brave enough to be practical in the last half of the book and to deal with the prevalence of kitsch, the nature of an ecumenical taste in music for worship, and the need for developing one's faith and art.

His conception of aesthetic taste is that a person is busy apperceiving, appreciating, and appraising the beautiful quality of a snowflake and of a symphony (xi). Such aesthetic activity is distinct from a private liking for something because taste, as Kant would say, makes one's claim for beauty public in some way (173, 179). A community's taste in music is tied in with their identity (164–66); so it behooves a congregation [1] to make discriminating aesthetic choices, yet [2] to be open to alternate good tastes (158, 169, 177–8, 218). A key factor for a communion to decide in selecting worship music is the liturgical appropriateness of the music (181).

Brown promotes the sanity of a "critical pluralism" in taste yet warns against adopting an eclecticism, which will weaken communal identity (12, 22, 192). He doubts that adopting "club-style soft rock" as the best music for youth-oriented worship is right (233), but is magnanimously gentle in specifying boundaries to good taste. Although "kitsch is forever immature, . . . there is a place for kitsch," says Brown, to release and exer-

Originally published in *Christian Scholar's Review* 31:4 (2002): 463-65.

cise "sentiments that otherwise might . . . atrophy through disuse" (147).

Such mild-mannered wisdom is couched within a very serious concern to encourage humans to experience art as a religious encounter with "the Holy," whether it be the transfiguration by beauty, as Abbot Suger believed, of one's mind "to a higher world" (58), or the *rasa* (perennial bliss) sought in Indian culture (xiii, 121, 261), or even taking Beethoven's Ninth Symphony as "a liturgy for a broad range of humanity" (263).

There is more to art than meets the eye, Brown is saying, and he carefully unfolds a modified Augustinian position that he conceives as a dialectical way to hold in creative tension William Blake's affirmation of art as intrinsically spiritual together with Kierkegaard's wariness for the seductive power of art (30–32, 94, 98, 101–104). The problem is that art is sensible while the spiritual or Holy is invisible; so how can one's perceiving aesthetic taste become religious and in touch with the sublime transcendent without leaving art behind (93, 107–8)? Is beauty (sensuous and spiritual) the missing link (58–59, 98)?

Brown adumbrates a supporting anthropology where the human spirit or mind and the body are "mutually indwelling": "We are not confined within our bodies," but "the body is *in* the mind" (110). "Because we are embodied souls and spirited bodies, the physical senses can themselves be spiritual senses, when rightly used and enjoyed" (110). Brown's distinctive emphasis, next to Kant, Ricoeur, and Karl Jaspers, he says, is that he "stresses the interaction and mutual transformation of the artistic and the theological, or the symbolic and the conceptual" (285 n47).

I warm toward Frank Burch Brown's genial christian spirit in this book and am very sympathetic toward the attempt to sort out how Christians should practice artistry "in God" (that is, in obedient thankfulness to the Lord for such a creatural gift and task) and how Christians should respond to the often marvelous contributions of non-christian neighbors including the Buddhist, Muslim, or secular Humanist. When Brown says that art objects are offerings of persons to their neighbors (116), that statement resonates with the gospel truth that when a Holy Spirit-filled person bears the neighbors' burdens, for example, by making art, you are fulfilling the law of **Christ** (Galatians 6:2).

But I struggle with the metaphysics in which Brown's insights are fixed. I realize that the theo-ontology of "the Holy" and "the ascent to God by way of Beauty" has a philosophical pedigree going back behind Augustine to Plato's *Symposium* (the Diotima of Mantineia section, 201d–212a7), and is brilliantly represented in *The New Orpheus* col-

lection edited by Nathan A. Scott, Jr. (Sheed and Ward, 1964), and is congenial to the thought of such figures as Rudolph Otto, Northrop Frye, and René Girard (202). Prof. Brown's book gives new voice to the attempt at "a full-fledged theology of art and taste" (5) in which art may be considered "a 'sensuous' mode of theology in itself" (6, 96–97).

(1) If one assumes a nondescript divine transcendent is the Holy that all humans naturally aspire to experience, one might decide to fuse "sacred" and "religious" and "theological," and wish that our human aesthetic taste and art-making be converted "spiritually" "into a mode of loving God" (25). But then "sacred art" becomes a "unique means of spiritual forma-tion and of spiritually elevated piety and prayer" (83), as it were, "in general." Such a tack correctly recognizes that "theological" is not spe-cifically Christian; there are Muslim, Buddhist, Hindu, and Humanist prayers too. But does this metaphysical conception of "the Holy" shap-ing Brown's reflection not abandon the *scandalon* of biblical Christianity, namely, that some "religions" are false faiths (1 Corinthians 1:18–25)? And Prof. Brown is intent upon configuring "a specifically Christian aes-thetic" (xviii).

(2) "Almost anything that is permissible or good for life can receive some sort of religious blessing," says Brown (121). But he hints, as I read him, that "artistic mediation of the divine-human encounter" is somehow "more intimate," more substantial, than any other medium whereby "God *becomes present* to us" (111, 119–21). However, in supporting the quasi-sacramental potentiality of art (11, 28, 35, 59, 224) it would be good to remember, I think, that Francis Thompson's "Hound of Heaven" does not give art privileged rank, lest we be tempted by gnostic heresy. Brown, however, does consequently approve of the Eastern Orthodox Christians "dedicated to the idea of the gradual 'theosis' or, in a certain sense, 'deification' of the believer" (253).

These two critical comments may signal a divide between the Catholic and the Reformation confession of Jesus Christ's lordship over life. To conceive development of faith to mean "sacralization of life" (219) as-sumes that non-church areas of life are "secular." For myself, a home is not a "secular sphere" one "sanctifies" by playing cantatas (54), but a home is a rich creatural sphere of human life open to direct permeation by the Holy Spirit in homey activities (what Prof. Brown would call "a kind of secular religiosity," 54). Nevertheless, both the Catholic and the

Reformation faith-thought traditions are allies in countering the wasting of human life in God's world perpetrated by our secularistic culture.

I also think it would be a worthwhile project for Christians from different philosophical orientations to consider how we might best understand the conundrum that gifted humans with evil intent and devastating consequence can be "good" generals, salespersons, reporters, . . . and artists. To meet the (aesthetic) norm, even at its highest level, is not a guarantee, it seems to me, that the product can never be perverted, a vain lie.

A REVIEW: A BROKEN BEAUTY

A Broken Beauty, ed. Theodore L. Prescott. Grand Rapids: Eerdmans, 2005. 136 pp. ISBN: 0-8028-2818-3.

This superbly color-illustrated book of essays, of almost folio size, edited by Theodore Prescott (Professor of Art at Messiah College, Pennsylvania) is an intriguing, curious *mélange* of art history, art critique, and "beauty theology." The book serves as a kind of catalogue for an exhibition of paintings entitled "A Broken Beauty" germinated by Bruce Herman (Professor of Art at Gordon College, Massachusetts), who was determined to galvanize both artistic work and studied reflection on the matters of the human body, our historical brokenness, and the reality of beauty (as a moral as well as an aesthetic affair [viii]).

The first essay by Prescott is a deft, learned treatment of "figurative" artwork and the role of "attitudes" toward "religion" in contemporary art. He shows how Philip Pearlstein, Cindy Sherman, Leon Golub, and Kiki Smith do anything but idealize beautiful human figures. They present "bodies" artistically as foci for sheer visuality or for socio-political critique of abusive power relationships that desecrate humanity.

In the next essay, Florentine Timothy Vedon affirms the "Christian Humanist" art of the largely Roman Catholic (Southern) European culture from 1200 AD until the Humanist fabric was shredded by "modern" doubt, fragmentation of the individual, and Romantic artistic attraction to evil. "The importance of the Greco-Roman past for the construction of the present, unquestioned from Dante to Diderot, was thus fatally relativized" (36), and a decadent aestheticism—epitomized by Walter Pater, Oscar Wilde, and Bernard Berenson—unleashed a revolutionary *avant garde* art practice that has led to the abstracting shipwreck of our Western culture's dehumanized consciousness (42), according to Vedon.

Then Lisa de Boer (Calvin College graduate, Professor of Art History at Westmont College, California) writes a fascinating essay entitled "A Comic Vision? Northern Renaissance Art and the Human Figure."

Originally published in *Christian Courier*, 60:2780 (19 December 2005), 10, 18.

Hubert and Jan van Eyck and Albrecht Altdorfer, she notes, give cosmic scope to landscape, which then shows the **little** place humans have in the spaciousness of God's creation (47). Also, Pieter Bruegel and Jan Steen depict ordinary scenes of unidealized humans busy in their daily work and wayward family ways (52). Such artistry, wrongly denigrated as merely "realism," says Lisa de Boer, really shows a kind of large christian, humorous awareness of the goodness to unpretentious human creatural life—so unlike the idealizing Humanism of Michelangelo's Sistine Chapel ceiling (53). She is confirming, in a different context, an evaluation made by Prescott (he gleaned from Paul Tillich) that "there was more genuine religious content in paintings of common subjects by Van Gogh than pictures of conventional religious subjects made by popular late-nineteenth-century painters" (4).

Gordon Fuglie (Art Gallery Director at Loyola Marymount University in Los Angeles), who with David Goa (Emeritus Curator at the Provincial Museum of Alberta in Edmonton) developed the conceptual framework for this exhibition (ix), has two essays, which constitute half of the text of the book (59–118).

The first piece is a spirited, tart-tongued indictment of "The Art World" he calls TAW (a term coined by Doug Harvey). TAW is that elitist coterie of influential Modernist critics (e.g., Clement Greenberg), patrons (Peggy Guggenheim), and artists located in New York City (from Marcel Duchamp to Hard Edge practitioners) who since 1913 have **excluded** from the major galleries and the art scene art that did not break with the tradition of ideal beauty, figurative representation, and narrative meaning. Pure abstract form was imposed as the canon for High Art (59–60). When the "Postmodernist" wave of eclectic whimsy gathered momentum and threatened the Modernist Art hegemony, says Fuglie, TAW co-opted Pop Art, Conceptual Art, Earth Art, Performance, and Video efforts (61) into their *Painted Word* stables for "discourse and commentary without conclusion" (63). Oddball artists like preachy Harold Finster and Afro-American and Latino artists who bring the Virgin Mary into their artwork were tolerated as if an apartheid Bantustan (65, 66 n.19).

To counter this domineering monopoly of TAW, which banned Beauty from an art public, and to give a setting and breathing space to discuss this exhibition of fifteen North American artists entitled "A Broken Beauty," Fuglie champions the Neo-Thomist aesthetics of Jacques Maritain (1882–1973) and Etienne Gilson (1884–1978), which tops up and completes Fuglie's approval of American art historian Meyer Scha-

piro's (1904–1994) thoughts on beauty. Maritain believed there is an objective beauty that instills in viewers a super-abounding delight in the goodness of life; artistic beauty can elicit a kind of ecstasy, a divination in viewers that transcends our mundane existence (71–72). Art has beauty for Neo-Thomist thinkers when perfect integrity, due proportion, and radiance (72–74) are present. Fuglie believes beauty holds a "key to intimations of the transcendent or the natural order of the universe," which, "when grasped by human reason gives us an aperture onto the transcendent, the divine Other" (68). So, for Fuglie, beauty in art can provide "the potentially dislocating encounter with a transcendent reality that all sacred texts, and especially the Bible, desire to convey" (79).

While I personally cannot adopt this metaphysics of transcendence mediated by beauty, I noticed that Fuglie's very perceptive comments on the artworks of the exhibition reproduced in this book hardly mention the matter of beauty. Fuglie exposits this loose group of artists' work by praising their rich sense of human body (Ed Knippers, *The Harvest: Adam and Eve*), the unblushing treatment of biblical themes (Bruce Herman, *Annunciation* [#155]), the strong narrative content dealing, for example, with Marian theology (Melissa Weinman, *Schutzmantelmadonna*), and the evils afoot in society (Richard Harden, *My Breath*). Some of Fuglie's

[#155] Bruce Herman, *Annunciation*, from the series *Elegy for Witness*, 2002

commentary needs to help the viewer along to make certain the viewer catches the "transcendent" import or "sacred text" analogue implied in the artwork. Patty Wickman's *Overshadowed* canvas [#156], for example, is meant to be read as a contemporary presentation of the adolescent Mary's being called to serve as "the womb of the virginal Church" (87).

[#156] Patty Wickman, *Overshadowed*, 2001

In my judgment *A Broken Beauty* presents provocative professional artwork that deserves attention. It is true, as Fuglie states, that the reigning curators of the Modern Art Establishment, who **believed** that our demythologized world was practically godless, were narrow-minded on what could pass for good art. Art that assumed and showed that this was God's world was almost taboo. We should admit, however, that artists who were more sound Christians than they were artists sometimes gave God-honoring "beautiful" artistry a bad name. And it would be a mistake, I think, to try to recover a tradition of metaphysical Beauty comparable to the way the Pre-Raphaelite brotherhood attempted, because such a move would distance artists from the societal turmoil where they are needed.

"Beauty" is a weasel-word. Maritain, Schapiro, and Fuglie claim that the perfection, coherence, and unity of form and content belonging to beauty do not mean the style of "academic classicism" (69); there are

different kinds of beauty (71). And Cardinal Joseph Ratzinger (now Pope Benedict XVI) wrote in the *L'Osservatore Romano* (6 November 2002) about "the Beauty and the Truth of Christ" that "a purely harmonious concept of beauty is not enough" (par. 13). Yet Ratzinger still maintained, echoing Plato—and would be applauded by Fuglie—that beauty wounds a man and "lifts him upward towards the transcendent" (par. 5).

I am heartened by good artists who weave their christian faith naturally, unostentatiously, into their artistry, since the awareness that there is more to things than meets the eye or occurs to those able to think is valuable grist for wisdom. And my whole consciousness resonates with Bruce Herman's note in the "Foreword" about "the surprising beauty found in moments of suffering or loss or brokenness" (x)—although my word would be "grace" rather than "beauty."

But the metaphysics of Beauty, which Sacramentalist Aesthetics adopts, prejudices artistry to have to be geared toward the *visio dei*, to have us creatures be transcending our nature toward God, experiencing an epiphany of the Transcendent. Such a framework goes wrong, I think, on two counts: (1) it assumes a philosophical ontology that admits a nondescript "spirituality" and a "God-in-general" with a mediator other than Jesus Christ; and (2) it lays a burden on artists to produce art that arrives at or imports a transcendent "sacredness" somehow.

Artistry in God's world, understood from the Reformational biblical faith-thought tradition that informs my outlook, is **not meant to be a striving to transcend** our human place into God's heavenly presence, but is conceived to be **thanking God for the Lord's Spirit presence here on earth**, thanking with the gift of being imaginatively alive with hope in God's messed up world. Beyond that, as Hans Rookmaaker said, "Art needs no justification" (*Complete Works* [Carlisle: Piquant, 2002] 4:315–349). To burden art with a beauty apologetics seems to me to be somewhat like dressing up artists in Saul's heavy armor to fight the Philistines of TAW and mediocrity. It makes more biblical sense, I think, to understand artistry in a diaconal framework and support artists whose artistic calling and labor show a perky or empathetic care for the neighbor, keeping one's slingshot of love ready in the back pocket.

List of illustrations•

• Links to many of these illustrations in full color can be easily accessed at www.dordt.edu/DCPimagesSeerveld

the Canadian embassy in Washington, D.C. Permission granted by the Government of Canada and Dr. Martin Reid. CS

12 Douglas Cardinal Associates, *Canadian Museum of Civilization* (1980s), Hull, Quebec. Photo by Malak. CSU

13 "Yard flamingoes as baby storks" (1980s), Willowdale, suburb of Toronto, Ontario, Canada. CS

14 Miracle Mart parking lot (1980s—now destroyed), Toronto. CS

15 Bell tower, at a mall north of Toronto (1980s). CS

16 Warren Breninger, example of *Gates of Prayer* (1993–2008) [detail], series of 84, each grid of 12 is 220 x 240 cm, mixed media on C-type paper. AP There are 7 grids of 12 (based on the Jewish breast Ephod). All are, as above, mixed media on C-Type paper. C-Type paper is traditional color photographic paper whose emulsion has been light exposed, not ink jet paper. C-Type paper has a water (ink) absorbent emulsion layer that exists as colored layers. These methods using photo-based material are problematic in that it confuses people: both painters and photographers suspect it – one for not being photographic and other for may be being photographic ! In essence the materials are photographic but the methods are both drawing and painting, with some added sculptural methods in regard to stripping away the emulsion layers. The confusion is in that they are not photo-based in the normal sense – they begin as photo-reproductions of drawings, which are printed and then the photo surface is worked on as a drawing or painting.

17 Ted Prescott, *Icon*, 1978, coal, stainless steel, and neon, 80 x 18 x 12 in. AP

18 Diego Rivera, "The History of Medicine," (1953), mural, Hospital de la Raza, Mexico City. CS

19 David Alfaro Siqueiros, "Mural on the library of the National Autonomous University of Mexico campus" (1950s). CS

20 William Walker and colleagues, upper panels of *The Wall of Respect* (1967–69; destroyed in 1971), 43rd Street and Langley, Chicago. CS

21 Matt Cupido, "Psalm 46:4" (1996), Redeemer University College, Ancaster, Ontario. CS AP

22 Jackson Beardy and local youths, "Peace and Harmony" (1985, re-painted 2006), Family Center, outside at 470 Selkirk Avenue and Powers in Winnipeg, Manitoba. CS

23 Ed Knippers, *Identifications: The Baptism of Christ* (1988), oil on panel, 96 x 144 in. AP

24 Timothy High, *Placebo* (1984), drawing with prisma color pencil and enamel highlights, from *The Vanity Fair* series. AP

Swinton Collection, G-76-425. Photo by Ernest Mayer, Winnipeg Art Gallery. Reproduced by permission of the Estate of John Tiktak.

44 *Unknown Greek god* (c.470 BC) bronze. PD

45 "Aphrodite Braschi", free copy (1st century BC) after a votive statue of Praxitele in Cnidus ("Aphrodite of Cnidus" type, ca. 350–340 BC), marble. PD

46 *Buddha Sakyamuni (Sokkuram #24)* (751 AD), bronze, in temple Pulguksa, at Kyung Ju, Korea. CS–taken on location in 2000

47 François-Auguste-René Rodin, *Le Penseur* (1879–89), bronze. Photo by Andrew Horne. PD

48 Raphael, *St. Catharine of Alexandria* (c.1507), oil on poplar wood, 71 x 53 cm, National Gallery, U.K. PD

49 J.S. Sargent, *The Honorable Mrs. George Swinton* (1896), oil on canvas, 228.6 x 124.5 cm, Art Institute of Chicago, Illinois. PD

50 Grant Wood, *American Gothic* (1930), 78 x 65.4 cm, Art Institute of Chicago, Illinois. PD

51 Goya y Lucientes, *3 May 1808* (1814), oil on canvas, 266 x 345 cm, Prado Museum, Madrid, Spain. PD

52 *TIME OUT*, 10–17 August 1988. CS

53 Rodin, *The Thinker* (1903), bronze cast, 200.7 x 130.2 x 140.3 cm, Detroit Institute of Arts, Michigan. CS

54 Jean Auguste Dominique Ingres, *Napoleon on his Imperial Throne* (1806), oil on canvas, 259 x 162 cm, Musee de l'Armee, France. PD

55 David Chester French, *Abraham Lincoln* (dedicated 1922), Lincoln Memorial, Washington, D.C. CS

56 *Nikolai Vladimir Lenin,* Dresden. CS (in 1981)

57 Steve Prince, *Steak and fries* (2005), linoleum cut on paper, 36 x 50 in. AP

58 William Blake, *Nebuchadnezzar* (1795–1805?). PD

59 Hyacinthe Rigaud, *Louis XIV* (1701), oil on canvas, 277 x 194 cm, Louvre Museum. PD

60 Henry Moore, *The Artist's Mother* (1927), pencil, pen and ink, finger wash, and scraping. Private collection. Reproduced by permission of The Henry Moore Foundation

61 Henry Moore, *Draped Seated Woman* [detail] (1957–58), plaster cast, 188 cm, Art Gallery of Ontario. Reproduced by permission of The Henry Moore Foundation. CS

62 Henry Moore, *Reclining Figure* (1929), brown Horton stone, 83.8 cm,

Leeds Art Gallery, U.K. Reproduced by permission of The Henry Moore Foundation. CS

63 Jennifer Hillenga, *Seen but not heard* (1997), lithographs. Collection of Inès and Calvin Seerveld. AP

64 Jo Cooper, *Red Women Bending*, 2004–2007. CSU

65 Georges Rouault, *Two prostitutes* (1906), watercolor with pastel on paper, mounted on canvas, 70 x 54.5 cm, National Gallery of Canada. © 2013 Artists Rights Society (ARS), New York / ADAGP, Paris

66 Adrian Piper, *Vanilla Nightmares #2* (1987), charcoal and red crayon, with erasing, on tan wove paper (newsprint), 22 x 28 in. Collection of The Art Institute of Chicago. © Adrian Piper Research Archive Foundation Berlin

67 Anonymous, *Mary Magdalene*, Budapest Art Museum. CS

68 Penny Siopis, *Terra Incognita* (1991), oil and collage on board. Collection of University of the Free State, Bloemfontein, South Africa. AP

69 Unknown, frontispiece for Thomas Hobbes' *Leviathan* (1651), intaglio. PD

70 Anonymous, *Adam plowing the recalcitrant ground* (1000s AD), bronze door of St. Zeno cathedral, Verona, Italy. CS

71 Barrie David, *Mennonite farmers at a horse auction,* 1970s photo in the *Globe and Mail.*

72 Johannes Vermeer, *Melkmeisje,* (c. 1658–61), oil on canvas, 45.5 x 41 cm, Rijksmuseum, Amsterdam. PD

73 Robert Harris, *Harmony* (1886), oil on wood, 30.4 x 24.6 cm, National Gallery of Canada. CSU

74 Milton Avery, *Cleaning Fish, Gaspe* (1940), oil on canvas, Whitney Museum of American Art, New York. © 2013 Milton Avery Trust / Artists Rights Society (ARS), New York

75 Richmond Barthé, *Blackberry Woman* (1932), 90.1 x 31.1 x 41.3 cm, Smithsonian American Art Museum. CSU

76 Elizabeth Catlett, *Sharecropper* (1957-1968), color linocut. © Catlett Mora Family Trust/Licensed by VAGA, New York

77 Jules Breton, *The Song of the Lark* (1884), oil on canvas, 110.6 x 85.8 cm, The Art Institute of Chicago. PD

78 John Sloan, *Hairdresser's Window* (1907), oil on canvas, 80.96 x 66.04 cm. © 2013 Delaware Art Museum / Artists Rights Society (ARS), New York

79 Peter S. Smith, *Leaving* (1984), wood engraving. Collection of Inès and Calvin Seerveld. AP

80 Aqjangajuk Shaa, *Untitled (Figure with Ulu)* (1967), Green Serpentine, 38.5 x 47 x 6 cm, Art Gallery of Ontario. © Dorset Fine Arts. CS

81 Marian Nyanhongo, *Comfort of Love* (2005), springstone. CS

82 Rembrandt van Rijn, *Jewish Bride* (c. 1669), oil on canvas, Rijksmuseum, Amsterdam. 121.5 x 166.5 cm. PD

83 Anishinabe Jackson Beardy and local youths, "Peace and Harmony" (1985, re-painted 2006), Family Center, Winnipeg, Manitoba. CS {see #22}

84 Edward Hopper, *Pennsylvania Coal Town* (1947), oil on canvas, 71.12 x 101.60 cm. Collection of the Butler Institute of American Art, Youngstown, Ohio. CSU

85 Heinrich Füssli, *The Silence* (1799-1801), oil on canvas, 63.5 x 51.5 cm, Kunsthaus, Germany. PD

86 Ivan Albright, *Into the World There Came a Soul Called Ida* (1929–30), oil on canvas, 56¼ x 47 in. Gift of Ivan Albright, 1977.34. © The Art Institute of Chicago.

87 Francisco de Goya y Lucientes, *Fight with Cudgels* (c.1820–1823), oil on canvas, 125 x 261 cm, Prado Museum, Spain. PD

88 Georges Rouault (1871–1958), *Le Dur Metier de Vivre* [It is hard to live] (1948), plate 12 of *Miserere et Guerre* series, aquatint, etching, and engraving, 25 5/8 x 19 7/8 in. 58.1.12. Gift of Mr. Leonard J. Scheller. Collection of the Haggerty Museum of Art, Marquette University. © 2013 Artists Rights Society (ARS), New York / ADAGP, Paris

89 Pablo Picasso, *Old Guitarist* (1903), oil on panel, 122.9 x 82.6 cm, The Art Institute of Chicago. PD

90 Rein Pol, *Uitzicht* (1985–86). CSU

91 Gerald Folkerts, *Forgotten in Chernobyl* (1999), oil on canvas, 60 x 54.5 in. AP

92 Peter Paul Rubens, *Christ on the Cross* (1620), oil on canvas, 221 x 121 cm. PD

93 Emile Nolde, *Crucified Christ* in polytych, *Das Leben Christi* (1912). © Nolde Stiftung Seebüll

94 Wim Botha, *Commune: Suspension of disbelief* (2001). Photo by Dirk van den Berg

95 Wim Botha, *Premonition of War (Scapegoat)* (2005), anthracite, epoxy resin, eco-solvent inks on satin paper, resin, gilt, wood. Photo by Dirk van den Berg

96 Warren Breninger, example of *Gates of prayer* (1993–2008). AP

97 Andrew Wyeth, *Christina's World* (1948), tempera on gessoed panel, 81.9 x 121.3 cm, Museum of Modern Art, New York. CSU

98 Gerard Pas, *Red-Blue Crutch Installation* (1986–87), detail (cf. *NA* #20). AP

99 Martin Disler, *The Shredding of Skin and Dance* (1990–91). CS (see also #27)

100 Gerald Folkerts, *Daryl* (2006), oil on canvas, top panels 24 x 60 in, bottom panel 36 x 24 in. AP

101 Britt Wikström, *Caritas* detail (2006), bronze cast, 125 cm, University of Chicago hospital. AP

102 Britt Wikström, *Caritas* (2006), bronze cast, 125 cm, University of Chicago hospital. AP

103 Entrance way to Cathedral of San Rufino where St. Francis prayed and preached (1140–1253), stone, Assisi, Italy. CS

104 Joanne Sytsma, *God keeps all my tears in a bottle, Psalm 56:8* (2001), acrylic on wood panel. AP

105 Sandro Botticelli, *Primavera* (c. 1477–78), tempera on wood, 203 x 314 cm, Uffizi Gallery, Italy. PD

106 Michelangelo, *Pietà* (1498–1499), marble, 174 x 195 cm, St. Peter's Basilica, Vatican City. PD

107 Michelangelo, *Day* (1526–1531), sculpture in marble for tomb of Lorenzo dei Medici, 155 x 150 cm, Florence. CS (1954)

108 Michelangelo, Christ figure in *Last Judgment* (1535–41), fresco, 1370 x 1200 cm, Sistine Chapel, Vatican, Italy. PD

109 Sandro Botticelli (Alessandro Filipepi), *Mystic Crucifixion* (c. 1500), tempera and oil on canvas (transferred from panel), 72.4 x 51.4 cm, Harvard Art Museums/Fogg Museum, Friends of the Fogg Art Museum Fund, 1924.27. Imaging Department © President and Fellows of Harvard College

110 Sandro Botticelli, *The Mystical Nativity* (1501), tempera and oil on canvas, 108.5 x 75 cm, Columbia Museum of Art, South Carolina. PD

111 Michelangelo, *Rondanini Pietà* (1554–64), 195 cm, Castello Sforzesco, Milan. CC

112 Angelo Bronzino, *Allegory of the Triumph of Venus* (c. 1545), oil on wood, 146 x 116 cm, National Gallery, London. PD

113 Pieter Breughel the Elder, *Blind Leading the Blind* (1568), tempera on canvas, 86 x 154 cm, Museo di Capodimonte, Naples. PD

114 Johannes Vermeer, *The Lacemaker* (c. 1664), oil on canvas, 24 x 21 cm, Louvre Museum, Paris. PD

115 Ernst Barlach, *Mother and Child* (1935), teak, 71.7 x 54.9 x 58.3 cm, Ernst Barlach Haus, Germany. PD

116 Ernst Kirchner, *Tanzschule* (1914). PD

117 Ernst Barlach, *Rest on the Flight to Egypt* (1924). PD

118 Ernst Barlach, *Haderndes Paar im Regen* (1921), woodcut, 31.7 x 24 x 0.8 cm. PD

119 Ernst Barlach, *Singing Man* (1928), bronze cast, 49.6 x 55.6 x 34.4 cm, The Cleveland Museum of Art, Ohio. CS

120 Ernst Barlach, *The Magdeburger Ehrenmal* (1929), oak sculpture, 2.5 x 1.5 x .75 m, Magdeburg Cathedral, Germany. PD

121 Käthe Kollwitz, *Municipal Shelter* (1926), crayon lithograph in transfer print technique on Japan paper, 43.4 x 55.5 cm. © 2013 Artists Rights Society (ARS), New York / VG Bild-Kunst, Bonn

122 Käthe Kollwitz, *Sleeping Child and Child's Head* (1903), charcoal, brush, and black ink, pastels, on brownish grey cardboard, 50.9-50 x 60.9-63.5 cm. © 2013 Artists Rights Society (ARS), New York / VG Bild-Kunst, Bonn

123 Käthe Kollwitz, no. 1, *Plowers* in *Peasants War* (1906). © 2013 Artists Rights Society (ARS), New York / VG Bild-Kunst, Bonn

124 Käthe Kollwitz, no. 7, *The Prisoners* in *Peasants War* (1908), drypoint, sandpaper and soft ground with the imprint of fabric and Ziegler's transfer, 327 x 428 mm. © 2013 Artists Rights Society (ARS), New York / VG Bild-Kunst, Bonn

125 Käthe Kollwitz, no.2, *Raped* in *Peasants War* (1907), softground, sandpaper, drypoint, and aquatint etching, 412 x 529 mm. © 2013 Artists Rights Society (ARS), New York / VG Bild-Kunst, Bonn

126 Käthe Kollwitz, *Mother with Child* (1931–32). © 2013 Artists Rights Society (ARS), New York / VG Bild-Kunst, Bonn

127 Käthe Kollwitz, *Resting in the Peace of His Hands* (1935–36), bronze relief. © 2013 Artists Rights Society (ARS), New York / VG Bild-Kunst, Bonn

128 William Holman Hunt, *Awakening Conscience* (1853), oil on canvas, 76 x 56 cm, Tate Collection, U.K. PD.

129 Anonymous icon, *Virgin and Child* (c.1190 AD), Moscow. CSU

130 Tatiana Romanova-Grant, *Holy Virgin*. 7"x8.75" St. Basil the Great Greek Orthodox Church in San Jose, California. Photo by Richard Otte. AP

131 Ted Prescott, *Harrowed Cross* (1988), tar over wood, grapevine, steel, neon, and transformer, 96 x 43 in. AP

North fountain. Photo by David Versluis

151 Daniel Hall, *Flip* (1989), silver print photograph, 20 x 24 in. AP

152 Ruth Abernethy, *Glenn Gould* (1999), bronze statue, CBC Glenn Gould Studios, Toronto. CS

153 John Tiktak (Canadian/Rankin Inlet, 1916–1981), *Woman and Child* (c. 1960), stone. 16.0 x 5.5 x 8.8 cm. Collection of the Winnipeg Art Gallery, Twomey Collection, Accession #: 2060.71. Photo by Ernest Mayer, Winnipeg Art Gallery. Reproduced by permission of the Estate of John Tiktak.

154 Jaume Plensa, *Crown Fountain* (1999–2004), Millennium Park, Chicago. South fountain. CS

155 Bruce Herman, *Annunciation* from the series *Elegy for Witness* (2002), oil and alkyd resin, gold and silver leaf on panel, collection of Mr. and Mrs. William R. Cross, Manchester, Massachusetts. 81 x 106 in. AP

156 Patty Wickman, *Overshadowed* (2001), oil on canvas, 78 x 104 x 2 in. AP

Index

Brief Biography

Calvin Seerveld taught undergraduate philosophy and literature at Belhaven College, Mississippi (1958–1959) and at Trinity Christian College in the Chicago area (1959–1972) before he specialized in aesthetics at the graduate Institute for Christian Studies in Toronto (1972–1995). Throughout the years he has given lectures in many places on the difference the biblical christian faith can make in performing, interpreting, and understanding human artistry and artwork in society. An abiding concern of Seerveld has been to show that good artwork—painterly artwork, theatre, poetry, and music—is called by God to be a gift to one's neighbors, to enrich their insight into the often unnoticed marvels of God's world. Such redemptive artwork deserves to be public. An earlier book that treats these problems is *Bearing Fresh Olive Leaves: Alternate steps in understanding art* (2000). www.seerveld.com/tuppence.html

CPSIA information can be obtained
at www.ICGtesting.com
Printed in the USA
FFOW05n0432240314